Lewis & Clark

VOYAGE OF DISCOVERY

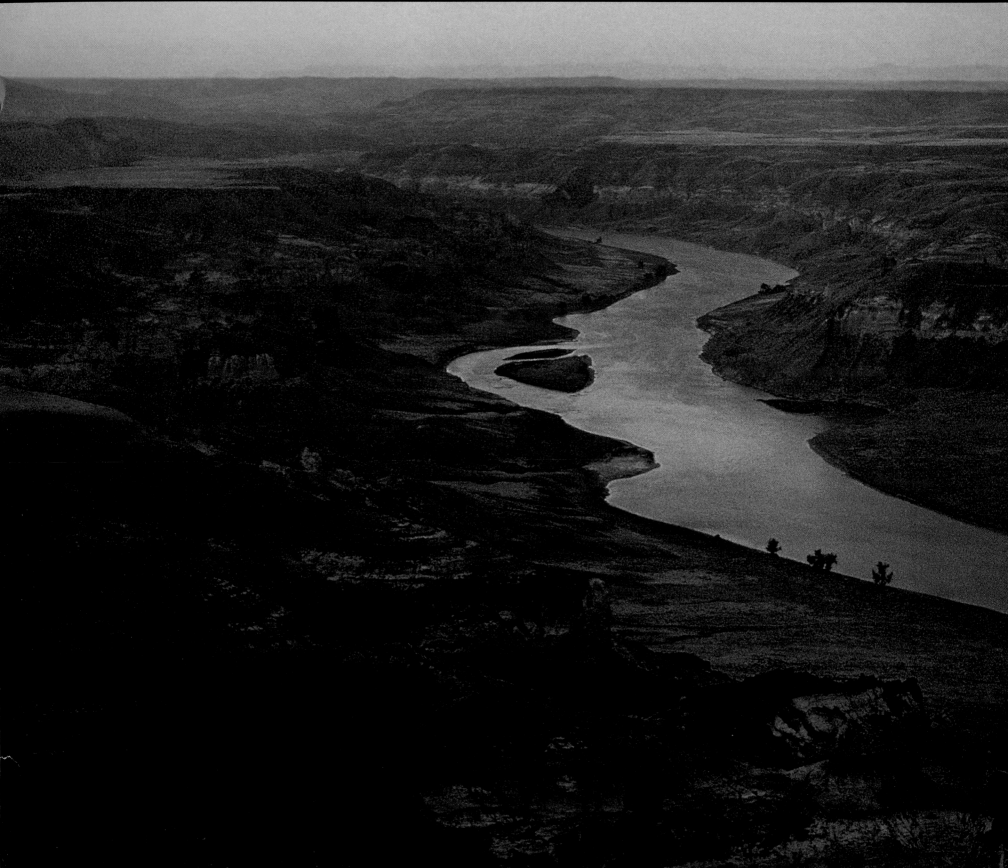

"The object of your mission is to explore the Missouri river [to] the Pacific ocean...."

THOMAS JEFFERSON ~ JULY 4, 1803

UNDER President's orders to find an all-water route across the continent, Lewis and Clark set out in 1804, going up the Missouri far beyond white men before them.

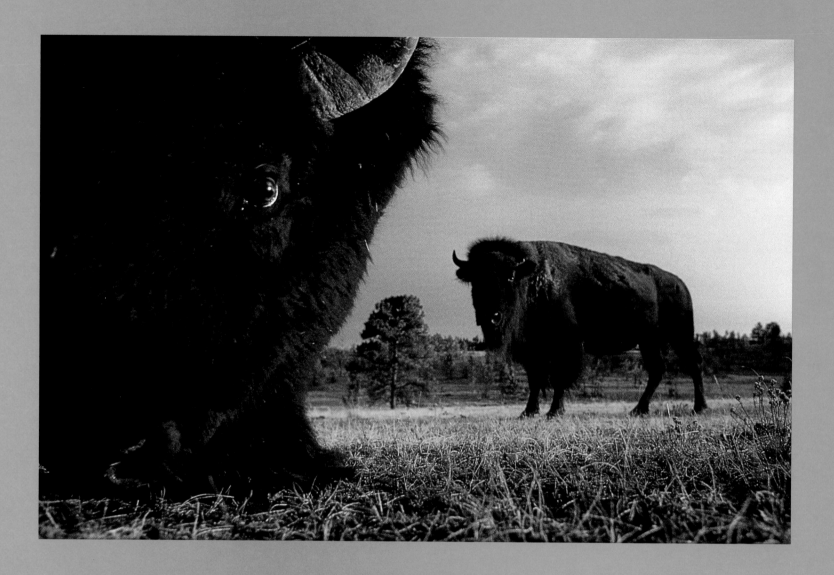

TRAVELING the breadth of the Great Plains—one of the world's largest grasslands—the captains saw "immence herds of Buffaloe, deer, Elk...in every direction feeding on the hills and plains." Today, fewer than 250,000 American bison inhabit the Plains. They are protected on a handful of preserves.

"I sincerely belief there were not less than 10 thousand buffaloe

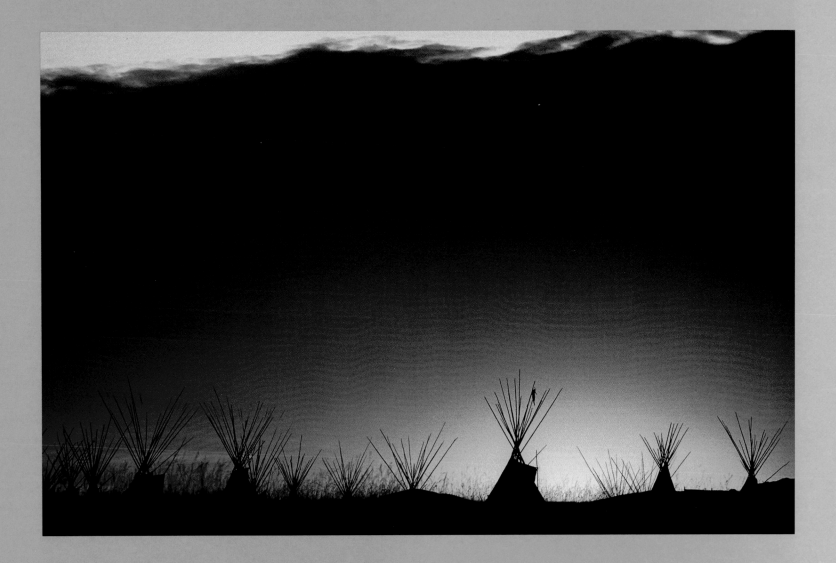

TWILIGHT of a tradition: Sunset lingers on an annual encampment of Blood Indians, relatives of the Blackfeet. While the Lewis and Clark expedition opened the West to white settlement, it spelled the eventual decline of the native cultures as they had long existed in their homelands.

within a circle of 2 miles." MERIWETHER LEWIS ~ JULY 10, 1806

"...[N]ature presents to the view of the traveler vast...walls of tolerable workmanship, so perfect...that I should have thought that nature had attempted here to rival the human art of masonry...."

MERIWETHER LEWIS ~ MAY 31, 1805

SUCH weather-sculpted sandstone bluffs as Hole in the Wall still make the upper Missouri's White Cliffs region, in Montana, a place of "visionary enchantment."

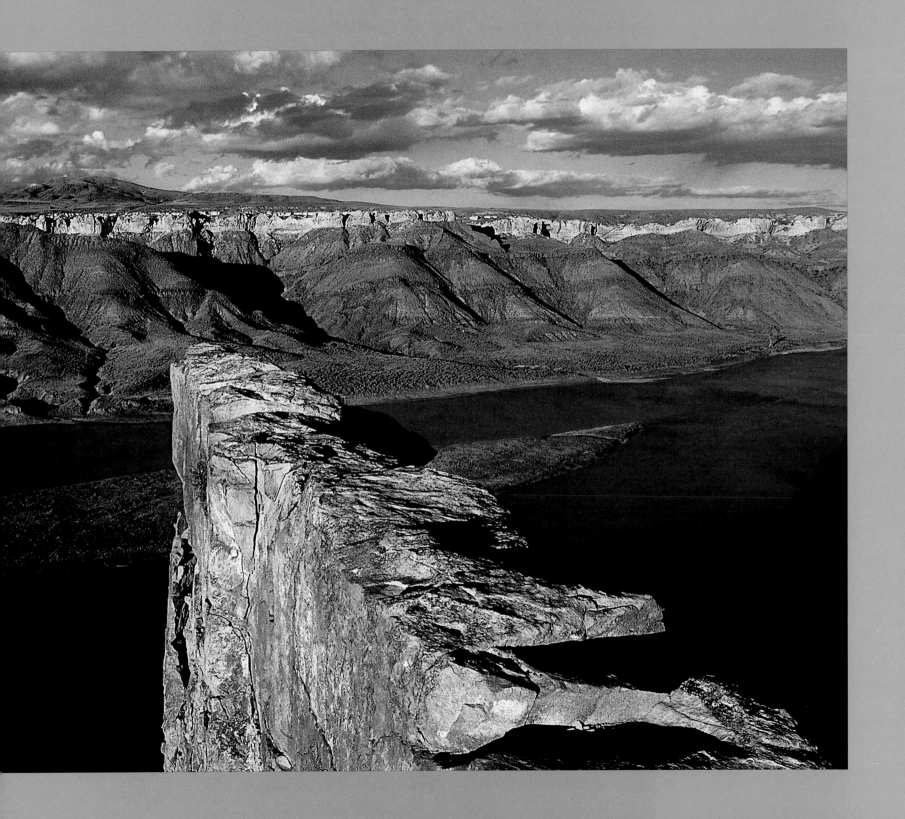

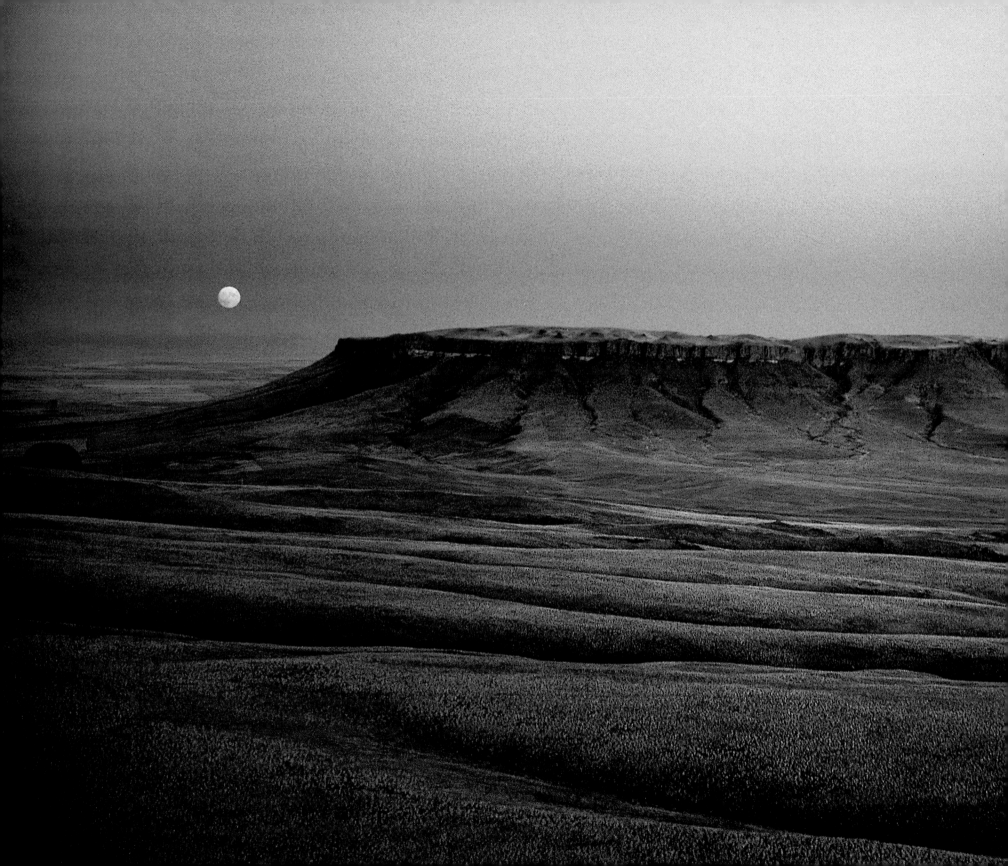

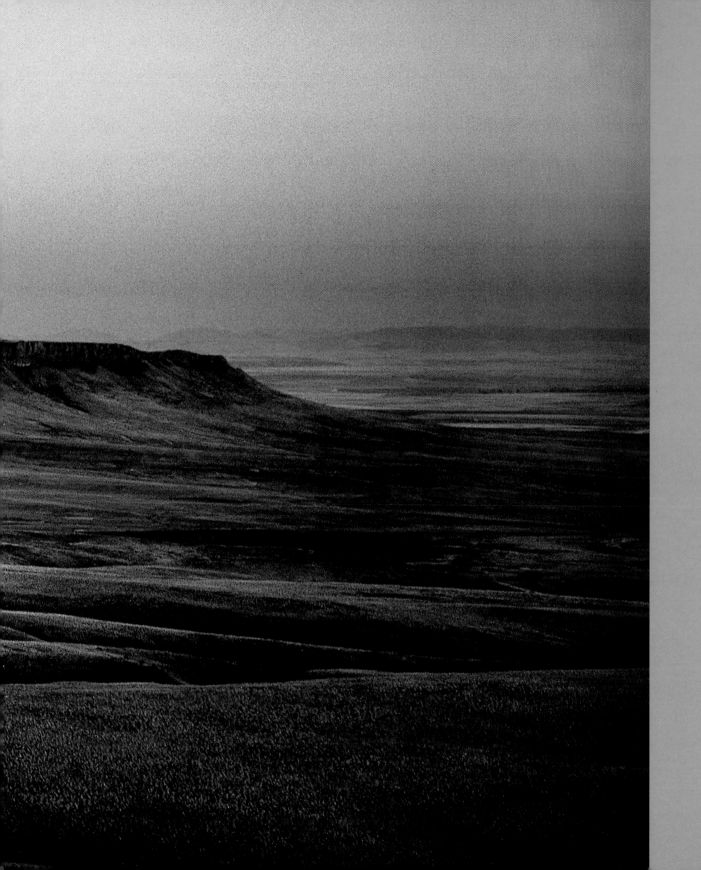

"A person by going on one of the hills may have a view as far as the eye can reach...."

PATRICK GASS ~ SEPTEMBER 1804

MOONLIGHT gilds Montana's Square Butte, a landmark that guided Lewis toward the Rockies on his way west and on his homeward trek as he left the mountains.

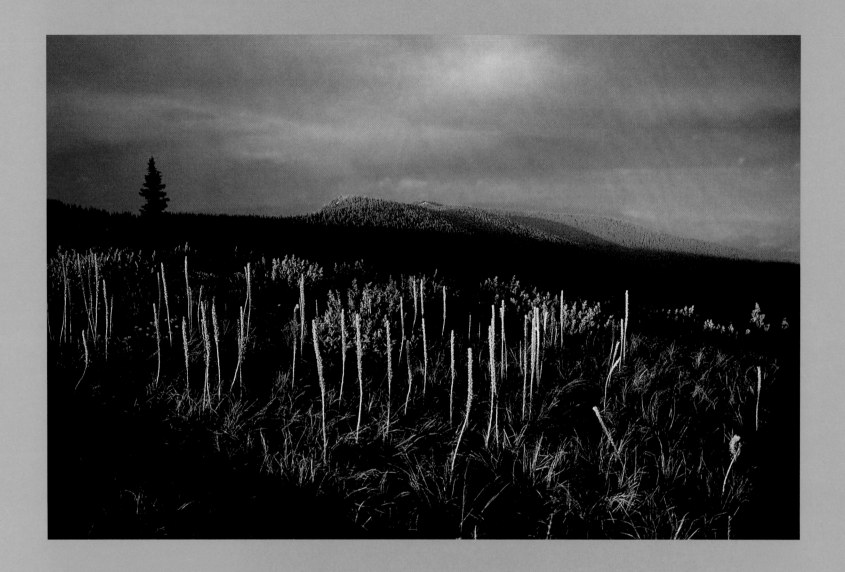

AUTUMN colors soften the high, windswept world of the Bitterroot Range, on the Montana-Idaho border. Here winter comes early and lingers long. Lewis had not anticipated this Rocky Mountain barrier that rose between him and the Pacific. Tackling those "terrible mountains" proved the most trying part of the expedition.

"[They] might have derived their appelation *shineing Mountains* from...

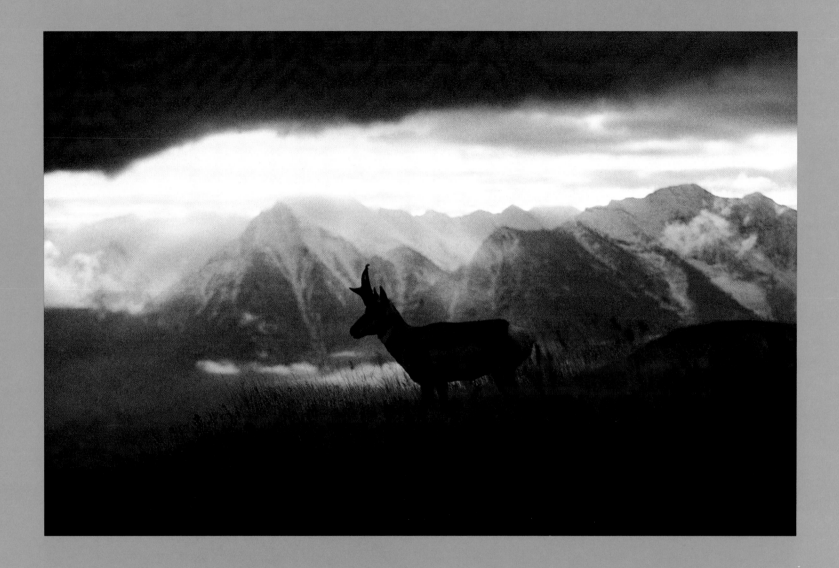

MONTANA dusk frames the delicate silhouette of a pronghorn, the antelope Clark admired as "keenly made…and butifull." Swift and alert, the animal eluded the Corps' flintlocks all across the plains. Clark marveled at its gait, describing it as "reather the rappid flight of birds than the motion of quadrupeds."

the sun shin[ing]...on the snow which covers them...." WILLIAM CLARK ~ JULY 4, 1805

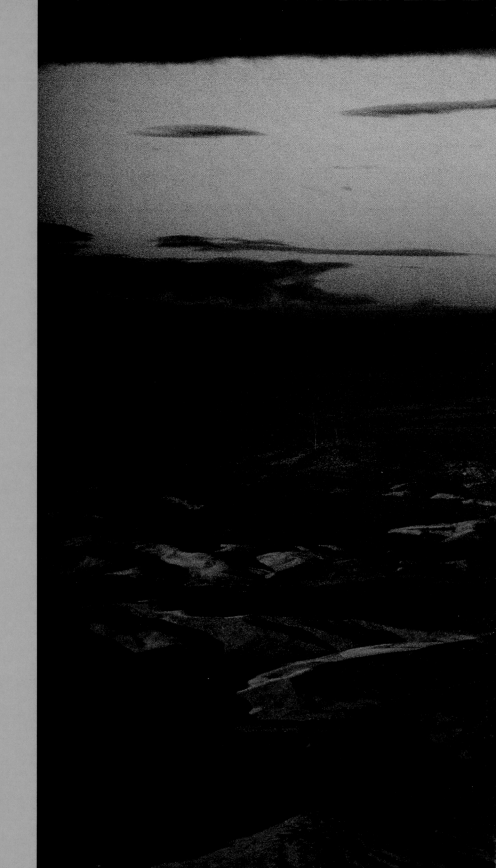

"A Mountain which we Suppose to be Mt. Hood, is...about 47 miles distant.... This Mtn. is covered with Snow and... is of a Conical form but rugid."

WILLIAM CLARK ~ NOVEMBER 3, 1805

LYING in the rain shadow of the Washington-Oregon Cascade Range, arid empty country flanks the Snake River as it winds toward Mount Hood and the distant Pacific.

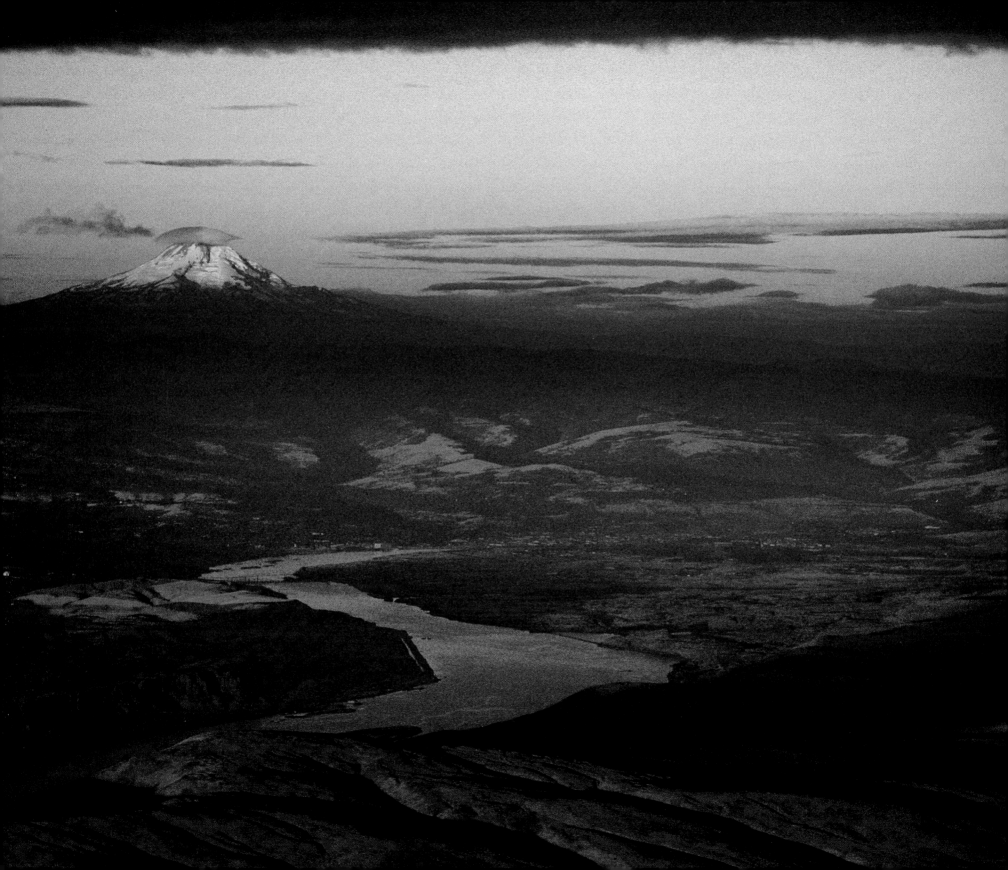

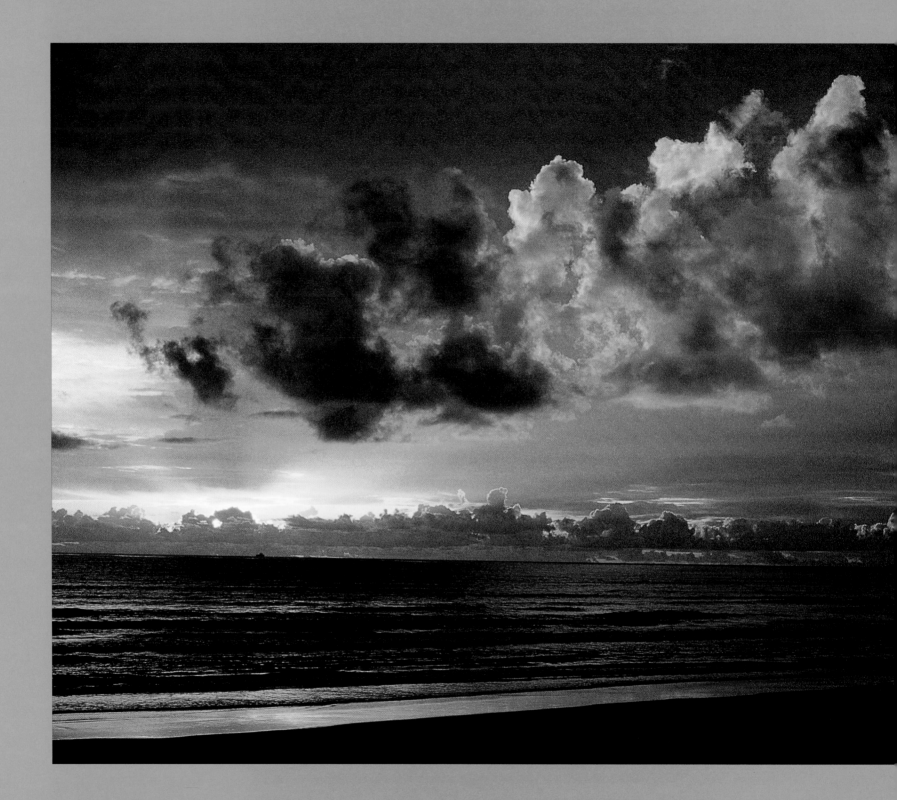

"We arrived in Sight of the Great Western; (for I cannot say Pacific) Ocian as I have not Seen one pacific day Since my arrival in its vicinity."

WILLIAM CLARK ~ DECEMBER 1, 1805

RARE calm tempers Pacific rollers that normally pound the Oregon coast. Clark called the ocean "the grandest...prospect which my eyes ever surveyed."

Lewis &

VOYAGE OF

Stephen E. Ambrose
Sam Abell

& Clark

DISCOVERY

LEWIS & CLARK VOYAGE OF DISCOVERY

By Stephen E. Ambrose
Photographs by Sam Abell

Published by The National Geographic Society

John M. Fahey, Jr.	*President and Chief Executive Officer*
Gilbert M. Grosvenor	*Chairman of the Board*
Nina D. Hoffman	*Senior Vice President*

Prepared by The Book Division

William R. Gray	*Vice President and Director*
Charles Kogod	*Assistant Director*
Barbara A. Payne	*Editorial Director and Managing Editor*
David Griffin	*Design Director*

Staff for this book

Editor	Barbara Brownell
Art Director	David Griffin
Illustrations Editor	Leah Bendavid-Val
Director of Maps	Carl Mehler
Legends	K.M. Kostyal
Researchers	Susan V. Kelly Christina Perry
Illustrations Researcher	Joyce Marshall
Illustrations Assistant	Meredith C. Wilcox
Map Researcher	Joseph Ochlak
Map Production	Jehan Aziz Beth N. Weisenborn
Map Relief	Tibor G. Tóth
Production Director	Gary Colbert
Production Project Manager	Ric Wain
Staff Assistants	Peggy Candore, Kevin Craig, Dale Herring
Editorial Assistant	Lyman Armstrong
Indexer	Elisabeth MacRae-Bobynskyj

Manufacturing and Quality Control

George V. White	*Director*
John T. Dunn	*Associate Director*
Vincent P. Ryan	*Manager*

CONTENTS

PREFACE 20

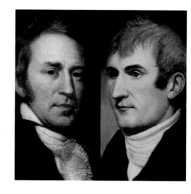

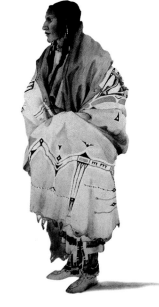

AUGUST 1802 – MAY 1804

Getting Under Way
24

President Thomas Jefferson appoints Meriwether Lewis, who teams with William Clark, to find an all-water route to the Pacific.

MAY 1804 – APRIL 1805

Up the Missouri
48

The Corps of Discovery follows the Missouri River north, meeting native peoples and finding new flora and fauna.

 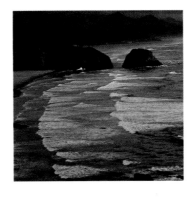

After wintering with Mandan Indians in present-day North Dakota, the Corps proceeds west across the Great Plains, through country of boundless wildlife and natural wonders.

Reaching the Continental Divide brings the end of the Missouri River, and of the dream for an all-water route. Facing the Corps is a near-fatal trek over the Rockies.

The explorers are the first white men to greet the Pacific Ocean from the east. They winter on the coast of today's Oregon.

The return trip revisits the peril of the Rockies and Indian attack. Two years after leaving, the men receive a heroes' welcome home.

PREFACE

FOR MORE THAN TWO DECADES OUR FAMILY HAS BEEN ENCHANTED BY LEWIS AND Clark. We name our dogs after members of the expedition—Pomp, Meriwether, LC. Our granddaughter's middle name is Sacagawea. The three generations of Ambroses, plus their husbands and wives, contain 13 people—10 of us live on or near the Lewis and Clark Trail in Montana. Hanging on the walls of our homes are photos from the Trail today, replicas of Clark's map, paintings of Lewis and Clark as imagined by Western artists, beginning with Charles M. Russell. Our bookcases—especially mine—are crammed with books on the expedition.

This common enchantment is surprising, given our distinctly different personalities, interests, principal employments, political views, places of residence. With children in Montana, New York, and Louisiana, it would be hard to be more widely separated, but at least once a year, more often two or three times, we get together to go camping, backpacking, or canoeing on some part of the Lewis and Clark Trail. We are drawn into the story of the Corps of Discovery as a magnet draws in bits of metal. Partly this is because of our shared experiences on the Trail, but mainly it is due to the power, range, and accessibility of the story. What Moira and I, and our kids, and now our grandchildren, respond to is the story. It is a never-ending source of delight.

First, because of the cast of characters. It contains at least one person with whom everyone today can identify. In our family, Stephenie is Sacagawea; Barry is George Drouillard, the hunter; Andy is Reubin Field, the fastest runner; Grace is never allowed to be Sacagawea, so she plays Jumping Fish, the Shoshone girlfriend of Sacagawea who managed to escape by dashing across the Jefferson River the day Sacagawea got captured; Hugh is George Shannon, the youngest member of the Corps of Discovery who was always getting lost, who is loved by everyone. For Moira and me—guess.

The story is just bursting with memorable characters. Besides the ones that we play, there are Charbonneau, Sacagawea's husband/owner; Cameahwait, her brother and Shoshone chief; Big White of the Mandans; John Colter; Thomas Jefferson; Twisted Hair of the Nez Perce; many others. Thanks to the vividness of the captains' journals, and the anecdotes they tell, all these characters emerge with distinct personalities.

A second factor in the magnetic power of the story is the range of experiences. This was the greatest camping trip of all time, and the greatest hunting trip. And one of the greatest scientific expeditions ever. This range provides material for every interest, and even draws in those who thought they would not be interested. For example, only Barry and I are hunters, and we are never allowed to tell our own hunting stories. As soon as we get started, the room empties. But a Lewis and Clark hunting story is different. Lewis's hunting experiences on June 14, 1805, which included killing a buffalo, getting chased into the river by a grizzly bear, shooting at but missing a wolverine, and encountering a rattlesnake, are compelling to all of us.

Everyone in our family enjoys bird-watching, a hobby that

gets about as good as anything can get when you set out to find a western meadowlark at the spot where Meriwether Lewis was the first white man to see and describe one. Or Lewis's woodpecker, or any one of the dozens of species he first made known to the literate world. Barry, Hugh, and grandson Riley are fishermen. They take great pleasure in catching a cutthroat trout named for Clark, *Oncorhynchus clarkii,* on the stream where Lewis first caught and described the fish—one of many. We all enjoy looking at the stars, through Lewis's telescope as it were. And finding trees, shrubs, cacti, and other plants where they were first discovered and described.

A third element in the appeal of the story is the setting. It covers two-thirds of the continent. It crosses the Great Plains of North America. The river that runs through the northern plains is the Missouri, and we can never get enough of it. Our favorite spot is the White Cliffs section below Fort Benton, Montana, where we see what the Corps of Discovery saw. Then come the Rocky Mountains, with their jaw-dropping vistas around every bend in the Trail, then the Idaho prairie, the Snake and Columbia Rivers, the Cascade Mountains, the Oregon-Washington Pacific Coast. These are among the great scenic wonders in the world, and wonderfully varied.

Fourth, the story draws us in and keeps us fascinated because of its inherent drama and importance. The drama is intense. Because the captains don't know what is going to happen next, the reader or listener suspends his or her knowledge and is caught up in the immediacy of the moment. This is narrative history at its best. The journals are our national epic poem.

As to importance, an empire—the great Northwestern

empire of Idaho, Oregon, and Washington—was at stake, and with it the future of the nation and the continent. Everyone responds to that aspect; some of our best campfire conversations are about what might have been had the British taken control of that empire, which could have happened had it not been for Lewis and Clark.

Fifth, and for me the special draw, the story centers around the twin themes of heroism and national unity. We began following Lewis and Clark in 1976, at a time when the national mood was cynicism, as Nixon had just resigned and Saigon had fallen and nobody wanted to hear about heroes and we as a people were threatening to tear ourselves apart. Patriotism was distinctly out of fashion, especially in the academic circles we lived in. We desperately wanted our children to grow up loving and appreciating our country, to realize that this empire of liberty we live in didn't just happen. Men made it happen, and we were determined to introduce our children to some of those who made our liberty and our continental scope possible, starting with Jefferson and Lewis and Clark. So we set out on a three-month camping trip to discover how they did it.

For our family, there is nothing to compare to driving across North America, camping along the way to experience the touch, smell, taste, sound, visual delights, and idea of national unity. And there's nothing like reading the journals to learn about heroes. Our patriotism runs deep, and each of us—in his or her own way—can be specific about why we love our country.

Being a father was by far the biggest job I ever undertook. It was the most of everything—difficult, frustrating, maddening, onerous, as well as satisfying, exhilarating, rewarding. Funny thing, I think back on 40 years of writing books and teaching and I'd hardly change a thing, except to write the earlier books better. Thinking back on my 40 years of being a father, there are a great many things I'd do differently. But there is not a single moment of our annual three months of camping I'd change. That is one part of fatherhood I did right.

In our house in New Orleans in the second half of the 1970s, we had five teenagers at one time. The tension between them was pervasive and almost palpable. They were competitive and devilish in their relationships. They knew how to annoy one another and did. They seldom talked to each other, but often yelled. The telephone and TV were the center of their universe and the cause of many fights, some physical. That was our home life, nine months of the year. I exaggerate, of course, but not by much.

But those three summer months we lived in a different world, one of cooperation, friendship, talking about ideas or history or feelings instead of whose turn it was next on the telephone. On the road, each child had specific responsibilities in setting up camps, jobs that required them to work together as a team. Reading the journals around the campfire, without distractions after a day together on the Trail, was magical. These were precious moments, Moira and all the kids concentrating on what I was reading aloud, leaning forward just a bit to hear what was going to happen to our heroes next. It is hard to be more together.

An aspect of this togetherness is our common delight at certain oft-repeated passages in the journals, phrases that each of us repeats at every opportunity. Mostly they come from Clark, the blunter of the two captains in his journal. Favorites include: "Mousequitoes verry troublesom," "some little Rain in the Fore part of the day," "and etcetera [written as & etc.]." When it rains on our campsite, someone is sure to call out, "It would be distressing to a feeling person to See our situation at this time all wet and cold," and the best of all, Clark's truly immortal line, used by the Ambroses for all triumphs, big and little, *"Ocian in view!* O! the joy."

Another magical experience for us is the sense of timelessness we pilgrims feel at the Lewis and Clark campsites on the Missouri River. The river flows past, as it always has and always will. We read from journals written almost two centuries ago that provide a better description of what we have seen that day than we could write. It gives me great joy, as I read to our grandchildren Alexander, Riley, and Corina at Lewis and Clark campsites, to think of them reading the same passage to their grandchildren on this spot midway through the 21st century.

Our first trip was in 1976, with the family and a handful of

friends and students. Over the next 20 years as the kids grew into their own adult lives, other people began joining us for one or another section of the Trail, including nearly all our close friends—Bob Stalder, Dan and Nancy Davis, Doug Brinkley and Tammy Cimalore, Yakir Katz and Edie Ambrose, John Holcomb and his son John and daughter Connie, Dick and Dottie Lamm, Jane Stickney, Jim and Sue Burt, Jim and Mary Alice Wimmer, among others.

Over the years a number of reporters and photographers have joined us on the Trail. The best reporters ask questions that make me think about the Trail in new ways. The photographers teach me to see things I'd never seen in the previous dozen or more visits to this or that site. In 1997, when I made the White Cliffs trip with National Geographic photographer Sam Abell, I watched him at work with amazement. To begin with, he was up at dawn and out until well past moonrise. He seemed never to stop. After making it back to camp and eating a late meal, he would bring out his camera and shoot campfire scenes.

I'm sensitive to weather, especially in Montana in the early fall, but only in the way it affects me—wind direction first of all, and of course rain. Traveling with Sam, I got sensitive to light. I studied his techniques. I asked him why this view and not that one. I asked for a verbal explanation of what he was looking for, or why this speed or that f-stop. Sam was willing enough to talk, but his mind was operating at such a level that he just couldn't bring his words down to my level. I finally gave up, figuring that asking Sam those questions was like asking a great composer what was going through his mind as he was composing. However he does it, Sam lets you see what was always there but you never would have noticed without him.

Our outfitters were Larry and Bonnie Cook. Sam and I, along with Will Gray, who directs National Geographic's Book Division, spent an hour at their ranch just before setting out on the Trail. The Cooks live on the Missouri River, just upstream from Fort Benton. Their living room has a splendid view of the river; the walls are lined with Western art, horns, Indian artifacts, and clothing. Charles M. Russell fans, they asked if Sam would sign their copy of the January 1986 NATIONAL GEOGRAPHIC with his photographic essay of

the artist who portrayed so many scenes from the first expedition. That same day, Will showed me a copy of the June 1953 edition of the magazine that contained an article by his father, Ralph Gray, of their family trip along the Trail in 1952, complete with photos of young Will and the family vehicle, a station wagon with wooden sides that would break your heart.

Then as now, with family or friends, the Lewis and Clark Trail remains accessible and irresistible. It is so American, this getting on the road, on the move, with a purpose and a destination, looking for scenes of visionary enchantment, looking for America, looking for ourselves. Much has changed. As I write this, I'm in a motel room in Council Bluffs, Iowa, looking west at the Missouri River. It is today but one-third the width it was in 1804, running at more than twice the speed, hemmed in and tamed by levees. Out my window, the railroad bridge built by the Union Pacific dominates the scene. Just beside it is a dockside casino, all neon and glitz. Across the river are the high-rise buildings of downtown Omaha. It all seems a long, long way from Lewis and Clark.

But on the bluff behind me is the Lewis and Clark monument. And near it is a monument to Abe Lincoln. It is on the spot where he stood in 1859 and predicted that someday not one but many railroads would cross into the West from this place. The Lincoln monument is a reminder that change is the rule of life, in this case change was an inevitable consequence of the Lewis and Clark Expedition's discovery that there is no Northwest Passage. It became imperative that America build railroads to the West Coast if the nation were going to encompass the continent. No one can doubt but that we all benefit from that Union-Pacific bridge.

Still, it is good that we have a few places left that are unchanged and can remind us of who went before and what they accomplished. The Trail is one that endures.

It is like Yellowstone National Park—as a citizen of the United States you have a duty to go. It is easy enough, by car, by canoe, by horse, by backpacking, whatever suits. When you go, I hope you find America and each other and yourselves, as our family has.

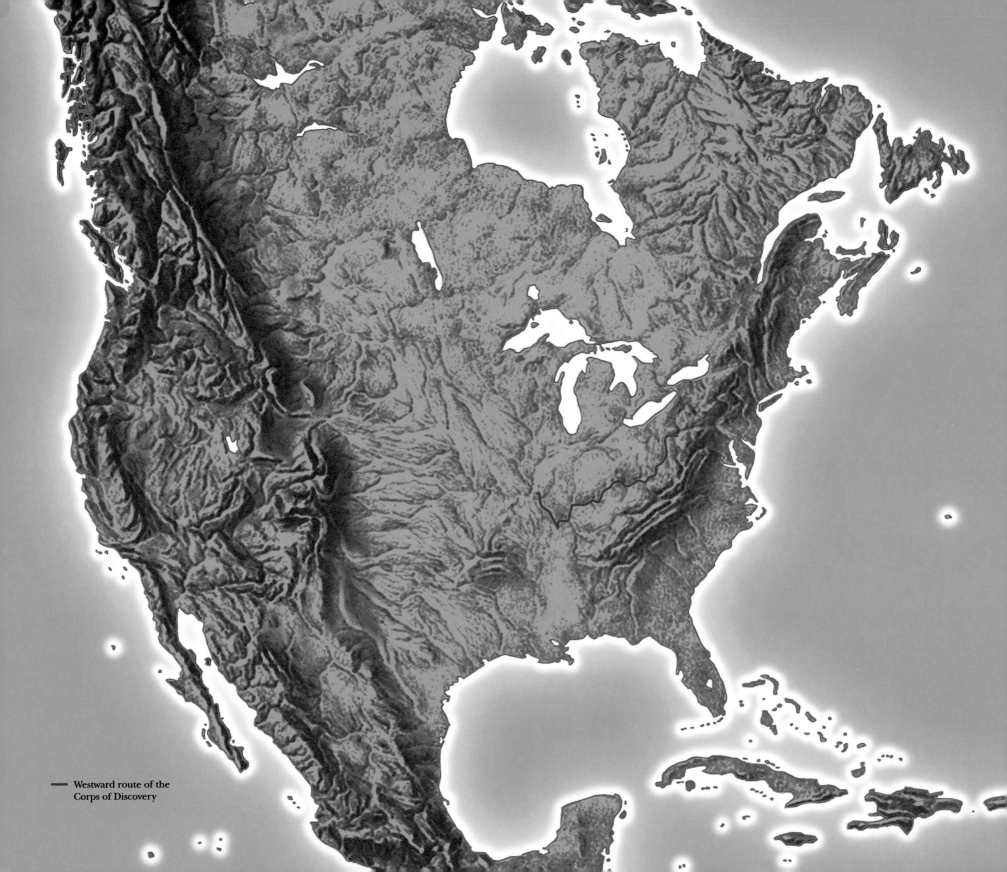

Westward route of the
Corps of Discovery

25

Getting Under Way

"to find the shortest
& most convenient route
of communication
between the U.S. and
the Pacific ocean...."

THOMAS JEFFERSON ~ APRIL 30, 1793

ORIGINS

ONTICELLO IN AUGUST 1802 WAS HOT AND humid, but nevertheless alive with activity. Slave artisans were hammering in nails, laying bricks, carving banisters, making changes in the home already famous as an architectural gem but not to be finished in the lifetime of the architect, who was never satisfied with things as they were. Other slaves were bringing in crops, cultivating, building fences, cooking, tending the horses, cattle, sheep, children.

President Thomas Jefferson and his secretary, Capt. Meriwether Lewis, sat side by side at a desk in the study, the calm eye in the middle of this activity, reading a just-arrived book resting on the book stand. Their excitement was so great it required some physical release, so one or the other was frequently jumping to his feet to pace, read a sentence aloud, and exclaim, "This cannot be allowed!" or "That is just as I expected!" Then they would talk. That afternoon, as a direct result of what they read that day, the Lewis and Clark Expedition was born.

The book was Alexander Mackenzie's *Voyages from Montreal, on the River St. Lawrence, Though the Continent of North America, to the Frozen and Pacific Ocean* (London, 1801). Mackenzie had led explorations of the western half of Canada in 1792 and 1793, for the North West Company, with the single purpose of finding a practicable route for the fur trade. In this he had failed, through no fault of his own: He was an intrepid explorer who had accomplished great things, but as to a commercial route to the Pacific, there just wasn't one, not in those high latitudes. But what stood out for Jefferson and Lewis was not the failure but that Mackenzie had made it across the continent.

They took that as a challenge, even though the United States' western boundary was the Mississippi River, a long way from the Pacific, and even though two-thirds of the 5,308,483 persons (nearly 20 percent of whom were black slaves) residing in the young country lived within 50 miles of tidewater. Necessarily, the nation looked eastward, to Britain and Europe, for commerce, culture, and communications. It was much easier to travel or trade between Boston and London than between Boston and Ohio. Only four roads crossed the Appalachian Mountains, all of them bad. Beyond the mountains, about half a million frontiersmen farmed and hunted. They felt so cut off from the nation that there was serious talk among them about seceding from the United States, forming a new country, then conquering New Orleans. A preposterous idea today, in 1802 it seemed more natural than the idea of a country that was divided by a mountain range. To the 18th-century mind, mountains meant boundaries. But not to Thomas Jefferson. For more than three decades, he had been a promoter of western exploration and had made various attempts to organize an expedition that would go to the Pacific, return, and report on what the western half of the continent looked like. Among other things, he was eager to know where the rivers ran; how high the mountains were; what flora and fauna flourished in this vast unknown; what Indian tribes, with what numbers, lived where; the fertility of the soil; the rainfall and climate generally; the mineral deposits. His curiosity was unencumbered. His mind thirsted for facts, not just for curiosity's sake but for useful improvements, what the men of the Enlightenment called practical knowledge. Thus he combined in himself the motivation of the North West Company—a monopoly of the North American fur trade—with his determination to use knowledge gained to advance

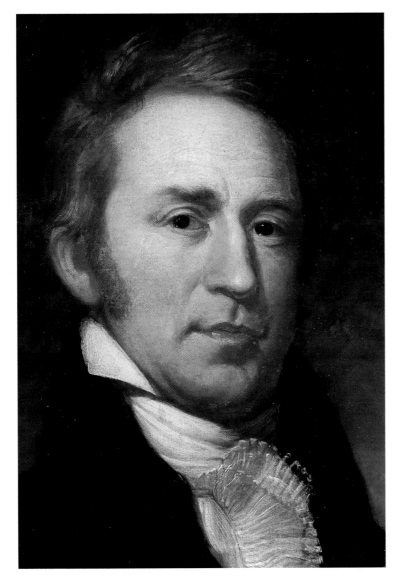

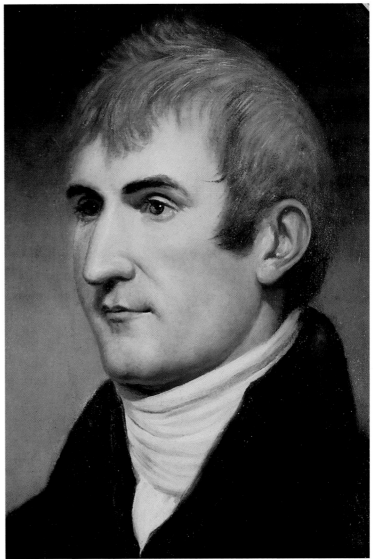

"OF COURAGE undaunted, possessing a firmness & perseverance of purpose...," Thomas Jefferson wrote of Meriwether Lewis (right). Impatient with life as a Virginia planter, Lewis volunteered in 1794 for the frontier militia, serving under William Clark (left). Eight years later, Lewis invited Clark to co-command an expedition of exploration across two-thirds of the continent, to share in "it's dangers, and it's honors...." On their triumphal return, portraitist Charles Willson Peale painted these likenesses of the heroes.

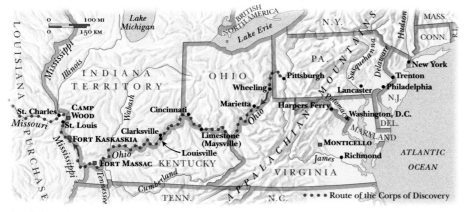

On all detailed maps, the route shows the Missouri and other rivers as Lewis and Clark traveled them. Black type reflects landmarks the explorers noted. Above, gray type and lines reflect 1803 boundaries. On following maps it reflects present-day landmarks and boundaries. Names in parentheses are as Lewis and Clark first wrote them.

science and the general good of mankind. Most tellingly, he had a dream of a United States encompassing the continent.

Lewis was a 28-year-old army officer, born in 1774 within sight of Monticello at Locust Hill, son of a planter and Revolutionary War officer who died during the war when Lewis was 5 years old. Jefferson had been close to Lewis's father and had no son of his own; in some ways a father-son relationship developed. Jefferson later wrote with a certain pride of young Lewis, who "was remarkable even in infancy for enterprize, boldness & discretion. When only 8 years of age, he habitually went out in the dead of night alone with his dogs, into the forest to hunt the raccoon & opossum. In this exercise no season or circumstance could obstruct his purpose, plunging thro' the winter's snows and frozen streams in pursuit of his object."

Lewis inherited his father's plantation, but he had a wandering spirit. At age 20 he turned the management of Locust Hill over to his mother and joined the army. In early 1801, President-elect Jefferson had called him to the President's House (as the White House was then known) to serve as his secretary. Over the next two years Lewis spent the days with the President, then dined with him—sometimes alone, more often in the company of America's leading personages, especially Jefferson's friends in the natural sciences. Lewis had less than five years of formal schooling, but he was a quick

learner. Jefferson became his tutor on the grounds of the President's House and in the surrounding area, as well as during summer vacations at Monticello. They walked together, at every hour. Jefferson pointed out and described plants and stars. He introduced Lewis to taxidermy, surveying, the use of the sextant, how to press plants, and other skills. And they talked of many things, but most of all about the West.

Virginians had always led the way west. George Washington had made his reputation in the West and was a heavy speculator in land there. Jefferson wanted to continue the tradition. Lewis was so drawn by the challenge and opportunity of leading an exploration into the unknown that in 1792, when Jefferson had persuaded the American Philosophical Society (APS) in Philadelphia to put up a subscription to sponsor an expedition up the Missouri and down the Columbia, 18-year-old Lewis volunteered to lead it. He was obviously too young—but the man chosen for the honor never got past Kentucky.

So the western part of the continent remained unexplored. It was so unknown that Jefferson imagined it contained a mountain of pure salt, that the Welsh Indians lived out there somewhere, that the lost tribe of Israel might also be there, that it was an easy portage over the dividing ridge of the Missouri and Columbia Rivers, in short that—along with unimaginable wonders—the West would provide that all-water route to the Indies, the search for which had been the single most important motivation to the Great Age of Discovery.

Jefferson and Lewis talked, too, of New Orleans, recently returned to Napoleon and France by the Spanish. It was a subject much on Jefferson's mind; as he put it in one of his more famous passages, "There is on the globe one single spot, the possessor of which is our natural and habitual enemy. It is New Orleans, through which the produce of three eighths of our territory must pass to market." Beyond the city, Louisiana beckoned. The British had kicked the French out of Canada; the Americans fully intended to do the same in Louisiana, which was mainly unexplored. It consisted of that part of the continent draining the territory from the Rocky Mountains to the Mississippi River, meaning principally the Missouri River drainage. Jefferson had in

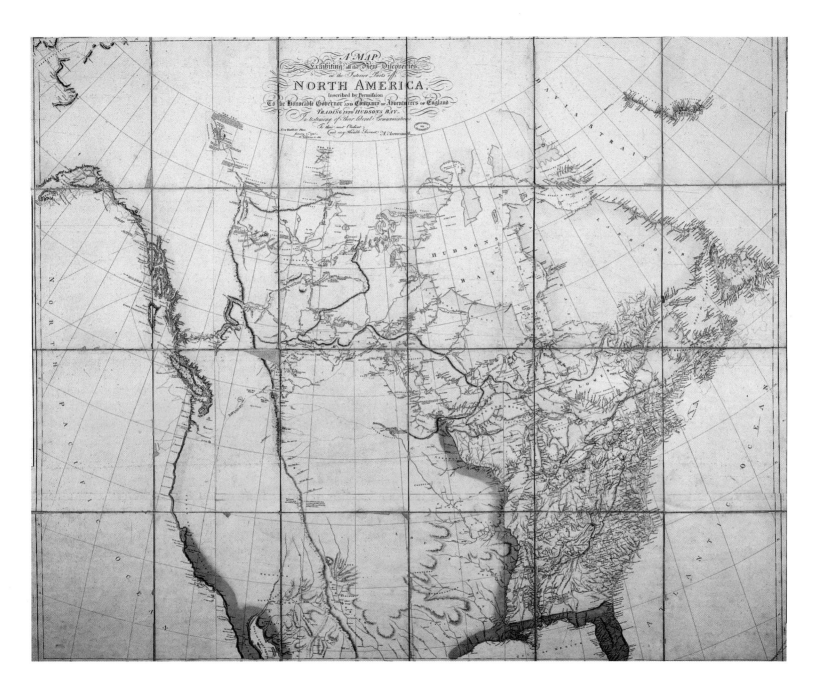

SETTING off into largely unchart-
ed territory, Lewis and Clark relied
on this 1802 map by cartographer
Aaron Arrowsmith. Though it left
much of the West blank, its details
of the upper Missouri Basin
proved invaluable to the expedi-
tion on the early leg of its journey.

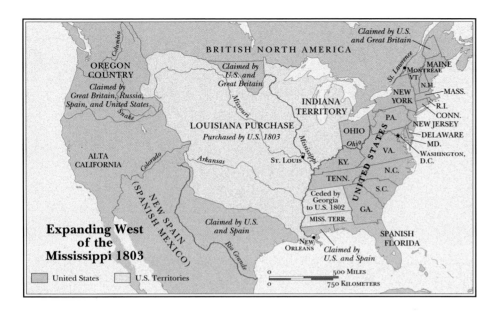

Expanding West of the Mississippi 1803

mind the extension of the territory of the young Republic not only across the Mississippi River to the Rockies but also all the way to the Pacific Coast. He wanted to create a country that was continent-wide, an empire of liberty stretching from sea to shining sea. The boldness and uniqueness of his vision were breathtaking.

Jefferson and Lewis had long since agreed that only the government could mount the resources to sponsor an exploration, but other affairs of state had taken priority. They assumed it would be done sometime, perhaps soon, who knew when? There was no hurry, as France was in no position to send settlers into Louisiana. Then came the news of Mackenzie's account. Jefferson immediately ordered a copy. When it arrived, the President and his secretary put everything aside to read it.

Every sentence was a magnet. For Jefferson, the strongest pull was to the line Mackenzie used in his report to the Governor General of Canada: "We carried over the height of Land (which is only 700 yards broad) that separates those Waters, the one empties into the Northern [Atlantic] Ocean, and the other into the Western [Pacific]." That seemed to confirm Jefferson's hope that the Continental Divide was an easy portage from navigable waters on the Missouri to navigable waters on the Columbia.

The sentence that drew Lewis in and aroused his emotions was Mackenzie's account of using a makeshift paint of vermilion and hot grease to inscribe on a rock overhanging the Strait of Georgia, "Alexander Mackenzie, from Canada, by land." It raised the matter of national honor. The name painted on that rock on the Pacific Coast was a direct, open, irresistible challenge, most of all to a proud young Virginian whose father had fought the British in the Revolutionary War. Everything in him ached for the opportunity to outperform Mackenzie by finding an all-water route and by making the scientific contributions his rival had utterly neglected.

For Jefferson, the sentence that galvanized him into action was in Mackenzie's final "geographical review," in which he urged Great Britain to develop a land passage to the Pacific for trade with Asia. He proposed opening trading posts through the interior, and on the Pacific Coast, which would give the North West Company "the entire command of the fur trade of North America, from latitude 48 North to the pole…. To this may be added the fishing in both seas, and the markets of the four quarters of the globe."

Furs were the most immediately available resource in the West. The exotic furs of America's West Coast and interior had sparked a lucrative worldwide commerce. The St. Lawrence provided the path for getting the furs of the Canadian interior to England. On the West Coast, British, American, and Russian sea captains entered the estuary at the mouth of the Columbia River to trade rifles and manufactured goods for furs, which they took to China, where they picked up spices to bring back to England. The profits were as immense as the risks. Diplomacy would follow where economies led. If the British set up the string of trading posts Mackenzie had recommended, why then the American Republic would be hemmed in by a Canada that would include the great (if unknown) Northwest empire, today's Idaho, Washington, and Oregon. Even with Louisiana, the United States would not extend from sea to sea.

Never would Jefferson allow these things to happen. The first step in prevention was to establish an American presence west of the Mississippi and over the mountains. Before that could be done, there had to be an exploration of the

territory. Without hesitation, the President told Lewis that he should drop all other responsibilities and concentrate single-mindedly on leading such an expedition. He said he would get the money from Congress.

What Jefferson was proposing had neither precedent nor Constitutional authorization. The expedition would be an armed foray into foreign territory. Never mind, Jefferson told Lewis. Two-thirds of a continent was at stake. It had to be American. The race was on.

He had no hesitation in choosing Lewis to lead the way. He later wrote, "I had now had opportunities of knowing him intimately." Through the summer of 1802 they rode or walked around Jefferson's "little mountain" as Jefferson taught Lewis botany, zoology, ethnology, and astronomy. He was delighted with his pupil, but he realized that he did not have the time or specialized skills to teach Lewis all he would need to know, so he told Lewis to plan on spending the spring of 1803 in Philadelphia, where Jefferson's scientific friends could provide him with graduate training. One of the men Jefferson wanted for his faculty was Dr. Benjamin Rush, the most famous physician of the day and a prominent member of the American Philosophical Society (APS). In his letter requesting Rush's participation, Jefferson described his protégé: "Capt. Lewis is brave, prudent, habituated to the woods, & familiar with Indian manners & character. He is not regularly educated, but he possesses a great mass of accurate observation on all the subjects of nature which present themselves here, & will therefore readily select those only in his new route which shall be new. He has qualified himself for those observations of longitude & latitude necessary to fix the points of the line he will go over."

Back at the President's House in the fall and early winter of 1802, Lewis read what few accounts there were of exploration of the Pacific Coast, especially what was available from Capt. Robert Gray, an American who in 1792 had sailed into the estuary of a river he named for his ship, *Columbia,* and fixed its position. The only other fixed point Lewis had available to him was St. Louis, whose latitude and longitude were established. Then there were some sketchy maps of the Missouri as far up as the Mandan Villages (near present-day

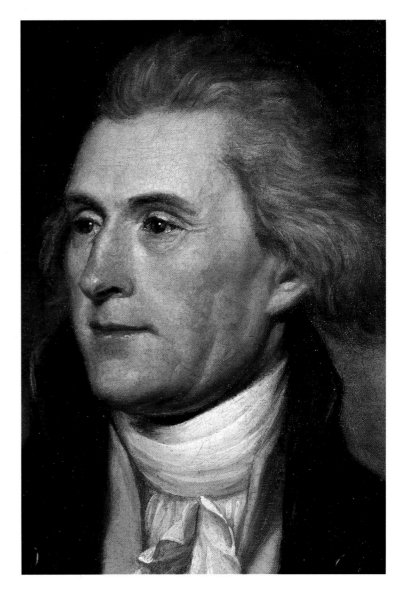

POLITICIAN and visionary, third President Thomas Jefferson well understood the need for America to assert her claim to the lands west of the Mississippi. His dream of an "Empire of Liberty" extending from sea to sea hinged on the explorations of Lewis and Clark.

Bismarck, North Dakota), which was as far up the river as any literate man had gone. Lewis pored over these maps, and meanwhile continued his studies in natural science and other subjects. He also drew up an estimate of expenses, to present to Congress as a request for an appropriation. He and Jefferson had tentatively agreed that the ideal size of the party would be about a dozen—one officer and 10 to 12 enlisted men. More might alarm the Indians and lead to war, while fewer would invite an attack. Anyway, Lewis was straining to keep the request at as low a sum as possible, to avoid Congressional criticism. With $696 for "Indian presents" as the largest expenditure, and other large sums for provisions, mathematical instruments, arms, medicines, and a boat, it came to $2,500 on the nose.

Jefferson in the meantime was pondering how to present the bill to Congress. As a strict constructionist of the Constitution, he could not ask Congress for an appropriation for a scientific exploration, or to invade foreign territory. He decided to describe the expedition as designed to promote commerce, which was a power given Congress by the Constitution. Still he made the request in a special, secret message. "The river Missouri, & the Indians inhabiting it," he wrote, "are not as well known as is rendered desireable by their connection with the Mississippi, & consequently with us. It is however understood that the country on that river is inhabited by numerous tribes, who furnish great supplies of furs & pelty to the trade of another nation carried on in a high latitude, through an infinite number of portages and lakes, shut up by ice through a long season." The Missouri, traversing an area with a moderate climate, would offer a better source of transportation, "possibly with a single portage, from the Western ocean." Put more concisely, "We can steal the fur trade from the British. And it would not cost much, only $2,500." There was some muttering from the Federalists, who always resented and resisted spending money on the West, but they were badly outnumbered. Congress made the appropriation.

The $2,500 went down easily compared with Jefferson's request made the previous week for an open-ended appropriation of up to $9,375,000 to purchase New Orleans. That request, too, violated his strict-constructionist views, but as with the Lewis expedition he was not a man to put his scruples ahead of his country. He had made it clear to Napoleon, through Ambassador to France Robert Livingston, that the United States would take New Orleans from the French by force, if necessary, but that he wished to buy rather than fight, as that would be cheaper and quicker. Napoleon, who had just lost an army in Haiti, and who was badly in need of money to finance his next war with Britain, saw the point. To seal the deal, Jefferson sent James Monroe to Paris to join Livingston in the negotiations.

In New Orleans, as in the West, Jefferson insisted that his only motivation was commerce. But he had other motives for the exploration, including seeking an all-water route to the Pacific, establishing an American claim to the Northwest empire, and fulfilling his scientific curiosity about the flora and fauna. Further, he needed to know about the native nations living in the country he intended to make a part of the American empire. Lewis would be his eyes and ears and his advance agent.

Lewis was well aware of the magnitude of his assignment. It would be nearly a year before his companion William Clark would enter the official planning, but already Lewis was thinking ahead, knowing that he would need another officer whose strength and skills matched his own. That would be William Clark. Clark, too, had been born in Virginia, but he was four years older than Lewis, and the two had not been boyhood friends. Shared was their love of their native Virginia and its woods and fields and open spaces. Clark's home, just miles away from Lewis's, in Caroline County, afforded him the same freedoms Lewis's surroundings had. Though Clark was too young for the Revolutionary War, all his brothers had fought in it; his oldest brother, Gen. George Rogers Clark, had won considerable fame in campaigns against the British forts in Illinois country.

In 1789, the 19-year-old William Clark joined the frontier militia and rose quickly in rank. A few years later, as a captain in the Regular Army, he took command of a company of elite riflemen-sharpshooters. It was here the future partners met. Lewis, an ensign, served for six months under Clark.

No anecdotes survive from the period, nor is there any correspondence between the two over the next eight years, but the stage had been set for the ultimate partnership.

Clark's own experience as a wandering man would serve him well. He'd spent much of his time on the frontiers of Ohio and Kentucky. Less schooled than Lewis in social and scientific arts, he had other skills Lewis would need: Clark knew how to fight Indians, and negotiate with them. He was a waterman who had developed his talents on the Ohio and Mississippi Rivers, along with a keen eye for details of the land, which he had honed as a surveyor. He had built forts in the wilderness, blazed trails through the unknown. He shared Lewis's enthusiasm and curiosity and was as strong as a bull.

Clark had retired from the Army in 1796, primarily to help straighten out the terribly tangled financial affairs of his older brother, General Clark, near Louisville, Kentucky. It would be seven years before the future partners were together again. But in those six months in the Army, Lewis and Clark had taken each other's measure. They had developed a mutual trust that was complete. Lewis knew that Clark's word was his bond, that his back was steel. Clark knew the same about Lewis.

FOR OUR FAMILY, THE ORIGIN OF OUR EXPLORATION OF the Lewis and Clark Trail came on Christmas Day 1975. After the traditional turkey feast we got to discussing where we wanted to spend the Fourth of July to celebrate our country's 200th birthday. I had just finished reading Nicholas Biddle's noted edition of the journals of Lewis and Clark, and suggested Lemhi Pass, where Lewis was the first American citizen to cross the Continental Divide. Our motivations were to see what Lewis saw, to learn, to be together as a family on a canoeing and backpacking trip, and not least—commerce. I was looking for a book subject, as it was the income from my books that made it possible for me to keep from teaching summer school.

We were experienced family campers. We had started when we lived in Baltimore, camping at various state parks on the East Coast. We had a VW bus; on our early trips Hugh, two or three years old, slept in the back of the van,

over the engine. We would stuff the vehicle full of kids and gear, leaving a crawlway behind the front seat for our black Lab, Bib. In 1970 we moved to Kansas and began camping in the West. We continued these trips when we moved to Louisiana a few years later.

During those summers we learned a bit about riding, a bit more about canoeing, and had our first ventures into backpacking. We learned to work as a team in setting up and taking down camp. The kids quickly learned to take care. If they didn't watch out for their own sleeping bag, cooking gear, clothes, and the rest, they were the ones who suffered. Our relations improved. Swimming together at a hidden lake, taking long walks on the trails, getting into campfire discussions with them about their hopes and dreams, marveling at the scenery, laughing at the dog's antics, we enjoyed each other.

And in the process, we saw our country. As Stephenie wrote in her journal, "In my family, summers are not just a break from school but an adventure into America."

We'd already camped three summers in the Black Hills at Wounded Knee on the Pine Ridge Reservation, in South Dakota, and at the Little Big Horn, in Montana, as I wrote *Crazy Horse and Custer,* so we felt comfortable with the idea of another summer yet further west. We were daunted, through, by a challenge that nearly finished the Lewis and Clark Expedition: backpacking our way over the Bitterroot Range's Lolo Trail.

To get in shape, we sent off for topographical maps and started hiking up and down the levees in New Orleans—the best we could do for hills that deep in Dixie. We spent much of the next three months preparing mentally as well, primarily reading the journals and the scholarly books about the expedition, as well as *We Proceeded On,* the quarterly publication of the Lewis and Clark Trail Heritage Foundation. The magazine served as an introduction to other Lewis and Clark buffs, gave up-to-date information about conditions along various parts of the Trail, and over the following two decades provided me with some superb scholarship and human interest material on the expedition.

Our "appropriation," or budget, was about $3,500, the majority of it for gasoline and food.

PLANNING AND PREPARING

In 1803, as soon as Congress passed Jefferson's requested appropriation, the President began drafting Lewis's instructions. It became a long, complex document, because Jefferson was making a list of the things he and his scientific friends wanted to know about the West, and they wanted to know so much, and because the first and most important part of the instructions dealt with political and military factors. To lighten political resistance from the Federalists, Jefferson adopted the cabinet's suggestion that he present the project as a mission to elevate the religious beliefs of heathen Indians.

To provide some measure of protection in the foreign territory, Attorney General Levi Lincoln had an important suggestion. Jefferson had written that if Lewis were faced with certain destruction he should retreat rather than offer opposition. Lincoln commented, "From my ideas of Capt. Lewis he will be much more likely, in case of difficulty, to push to far, than to recede too soon. Would it not be well to change the term, 'certain destruction' into 'probable destruction'?" Lincoln, and others, feared Lewis was a reckless risk-taker, one of those Virginia gentlemen who would overreact to any challenge to his honor or bravery. Jefferson made the change: "If faced by a superior force of Indians, you must decline it's further pursuit, and return. We wish you to err on the side of your safety, and to bring back your party safe even if it be with less information."

After lengthy discussion of the issues involved, Jefferson's final direct order to Lewis was: "The object of your mission is to explore the Missouri river, & such principal stream of it, as, by it's course and communication with the waters of the Pacific ocean, whether the Columbia, Oregon, Colorado or any other river may offer the most direct & practicable water communication across this continent for the purposes of commerce." Lewis should learn what he could about the routes and practices used by the British traders who were coming down from Canada into the Missouri River country, and make suggestions on how to take the trade away from the British.

Good maps were essential. Jefferson's orders read, "Beginning at the mouth of the Missouri, you will take careful observations of latitude & longitude, at all remarkable points on the river." Information about the native nations was crucial. Jefferson wanted to know their names, numbers, the extent of their possessions, their languages, traditions, occupations, politics, diplomacy, customs, and—last on the list but first in importance—"articles of commerce they may need or furnish, & to what extent."

Jefferson told Lewis to impress on the chiefs of the nations the great size and strength of the United States, but to temper that implied threat by assuring the tribes of the American wish to be "neighborly" and reliable trading partners. This was brash and bold of Jefferson. The expedition would be in territory owned by France, though still administered by Spain, where Canadian-based British traders had a monopoly on the fur trade. Yet Lewis and his men should steal these Indians away from the Europeans. Jefferson further told Lewis to arrange to have some chiefs sent back to St. Louis, then on to Washington, so that they could be properly impressed by the United States. He should also send back some Indian children, so they could be "brought up with us, & taught such arts as may be useful to them."

Jefferson realized that when Lewis reached the Pacific "you will be without money, clothes or provisions." He therefore gave Lewis a letter of credit, in the hope that he could use it with a sea captain trading off the mouth of the

"I, THOMAS Jefferson, President of the United States of America have written this letter of general credit for you, and signed it with my own name." The letter to Lewis was intended to gain members of the expedition, called the Corps of Discovery, supplies from trading ships on the Pacific coast, perhaps even passage home on an east-bound vessel. No ships ever materialized during their long, wet winter on the coast, and they were forced to make the arduous overland journey home.

Columbia. It authorized Lewis to draw on the Treasury of the United States for anything he wanted. It concluded, "To give more entire satisfaction & confidence to those who may be disposed to aid you, I Thomas Jefferson, President of the United States of America, have written this letter of general credit for you with my own hand, and signed it with my name." This must be the most unlimited letter of credit ever issued by an American President.

The second part of the instructions concerned the natural sciences. Lewis should take care to notice and describe plants and animals not known in the United States. He should look for dinosaur bones, and live mastodons, and salt mountains, and volcanoes. Lewis and Clark scholar Donald Jackson's description of Jefferson's instructions is perfect: "They embrace years of study and wonder, the collected wisdom of his government colleagues and his Philadelphia friends; they barely conceal his excitement at realizing that at last he would have facts, not vague guesses, about the Stony Mountains, the river courses, the wild Indian tribes, the flora and fauna of untrodden places."

As Jefferson worked on the instructions and orders, he and Lewis talked at length about what equipment, trade goods, provisions, and other things would be needed to cross the continent and return. How many men? With what skills? How big a boat? What design? What type of rifle? How much powder and lead? How many cooking pots? What tools? What books? How many fishing hooks? How much salt? Tobacco? Whiskey? How many beads of what color? Together, Jefferson and Lewis concocted the idea of a collapsible iron-frame boat, one that could be carried past the falls of the Missouri, wherever they might be, and assembled at the far end with animal skins to cover it.

In March 1803, Lewis got started getting his gear. He went to the U.S. Army's arsenal at Harpers Ferry, for arms and ammunition. He ordered 15 muzzle-loading, flintlock, long-barreled rifles, often called Kentucky rifles. They were the sine qua non of the expedition. Absolutely reliable, they delivered a lead slug on target with sufficient velocity to kill a deer at a hundred yards. On them depended the food supply and self-defense.

Beyond the rifles, Lewis put the Harpers Ferry artisans to work on pipe tomahawks, fish gigs, knives, and so on. He also supervised the construction of the iron-frame boat, and ordered a keelboat to be built in Pittsburgh. He wrote letters to commanders at the various Army posts in the Ohio River country, telling them that he was coming and would be selecting soldiers for the expedition.

In April he was off to Philadelphia, for the dual purpose of purchasing supplies and gear and to take crash courses in the sciences. In Lancaster, he ordered more rifles, to a total of 30. In Philadelphia, he bought a chronometer for $250, by far the largest sum expended for any single item carried on the expedition, but worth it because it was critical to establishing longitude. Altogether he spent $2,324 on gear.

Herewith a sample: 6 papers of ink powder; sets of pencils; "Creyons"; 200 pounds of "best rifle powdere" and 400 pounds of lead; "4 Groce fishing Hooks assorted"; 25 axes; woolen overalls; "30 yds. Common flannel"; a hundred flints and "30 Steels for striking or making fire"; 6 dozen large awls; 3 bushels of salt; oilskin bags to protect the instruments and journals; mosquito netting and field tables; oiled linen; candles; and "portable-soup," a dried soup of various beans and vegetables at more than a dollar per pound—Lewis bought 193 pounds for $289.50. Indian presents included 25 pounds of beads, 144 "small cheap Scizors"; "288 Common brass thimbles"; assorted trinkets, paint and vermilion, knives, combs, armbands, and ear trinkets. The emphasis was on the gay and gaudy rather than the useful, although Lewis was bringing along a metal corn grinder, as a gift from Jefferson to the Mandan Nation.

How well Lewis had done in making his purchases only the event could tell. Once under way he could only repair, never replace, broken items. One small peek ahead is appropriate here, however, because it reveals so much about Lewis and the point of view he held. During the expedition, the party ran out of many useful or pleasure-giving items, including tobacco, whiskey, salt, and beads. A frontiersman could live without those things. But when it got home, the expedition had sufficient powder and lead to repeat the journey (Lewis had designed lead canisters that when melted down

made exactly the right number of balls for the amount of powder in the canister), and all the rifles were in working order. Lewis had a frontiersman's faith in his rifle. As long as he had his rifle, ammunition, and powder, he would take on anything the wilderness could throw at him. Lewis also had plenty of ink and paper left when he got home, enough for another voyage. That ink and paper wasn't critical to making the trip, but it was critical to making the expedition a success by recording its findings. Lewis had his priorities right.

When he was not making purchases, Lewis was studying with Jefferson's friends in the APS. Andrew Ellicott, America's leading astronomer and mathematician, taught him to make celestial observation with the various instruments. Dr. Rush gave him medical training. Rush's specific for nearly all the ills of mankind were purging pills composed of calomel, a mixture of six parts mercury to one part chlorine, and jalap. Each drug was a purgative of explosive power; the combination was so awesome the pills were called "Rush's Thunderclappers." Lewis bought 50 dozen of them, along with 30 other kinds of drugs.

Dr. Benjamin Smith Barton provided the instruction in preserving plant and animal specimens. Dr. Caspar Wistar, foremost authority on fossils, taught Lewis about the dinosaur bones they hoped Lewis would find, and the live mastodons that might be out there.

In mid-June, Lewis traveled to Washington, for consultation with Jefferson before he set off. Uppermost in his mind was the need for another officer. Jefferson agreed to that, and to Lewis's further suggestion that the man be William Clark. Lewis immediately rekindled the friendship he and Clark had begun nearly a decade earlier. How close they were to each other was obvious in their exchange of letters about the expedition.

Lewis opened his June 19 letter thus: "From the long and uninterupted friendship and confidence which has subsisted between us I feel no hesitation in making to you the following communication." He described the expedition in matter-of-fact language that may well have left Clark breathless: "My plan is to descend the Ohio in a keeled boat thence up the Mississippi to the mouth of the Missourie, and up that

river as far as it's navigation is practicable with a keeled boat, there to prepare canoes of bark or raw-hides, and proceed to it's [the Missouri's] source, and if practicable pass over to the waters of the Columbia or Oregon River and by descending it reach the Western Ocean." He offered Clark a captain's commission and co-command, and concluded with an invitation to greatness: "If there is anything in this enterprise, which would induce you to participate with me in it's fatiegues, it's dangers and it's honors, believe me there is no man on earth with whom I should feel equal pleasure in sharing them as with yourself."

It was remarkable for Lewis to offer a co-command. Divided command is the bane of all military men. Lewis did it anyway. It felt right to him. It was based on what he knew about Clark, and what he felt for him.

In reply, Clark said he would "chearfully join" Lewis. He concluded, "This is an undertaking fraited with many dificulties, but My friend I do assure you that no man lives with whome I wold perfur to undertake Such a Trip &c. As yourself. My friend, I join you with hand & Heart."

The delighted Lewis replied that he would be coming down the Ohio in the keelboat in September and would meet Clark in Clarksville, in Indiana Territory, near Louisville. Clark, meanwhile, said he would try to find a few good men for the expedition, which he reported was the chief subject of conversation in Louisville and throughout the frontier. In the event, he was swamped with volunteers. He complained to Lewis that "several young men (Gentlemens sons) have applyed to accompany us—as they are not accustomed to labour I am causious in giveing them any encouragement." Lewis replied that he agreed entirely: He and Clark wanted young, unmarried, tough frontiersmen with special skills, such as blacksmiths, carpenters, hunters and trackers, boatmen. Even before they took their first step west together, Lewis and Clark were thinking alike.

On July 2, Secretary of War Henry Dearborn gave Lewis authorization to select volunteers from among the Army garrisons on the Ohio River. That same day, Jefferson got news from Paris: Napoleon had sold the United States not just New Orleans but the whole of Louisiana. This was stunning.

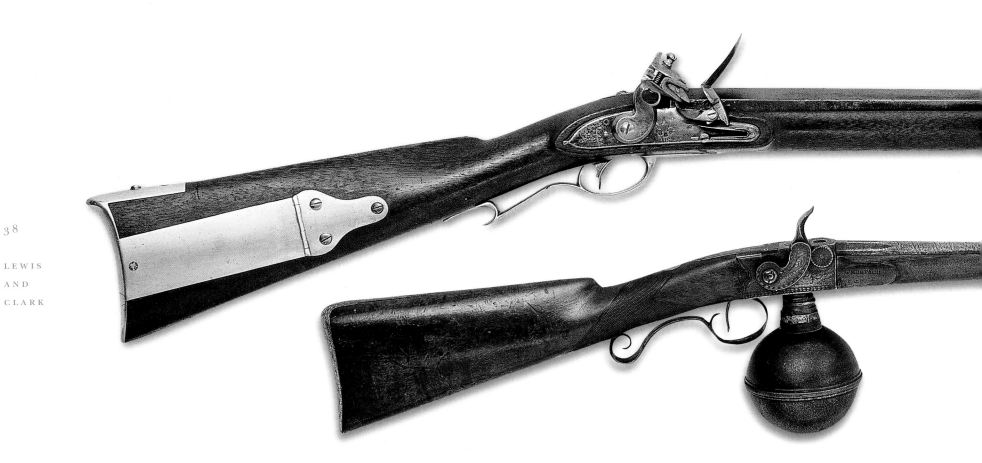

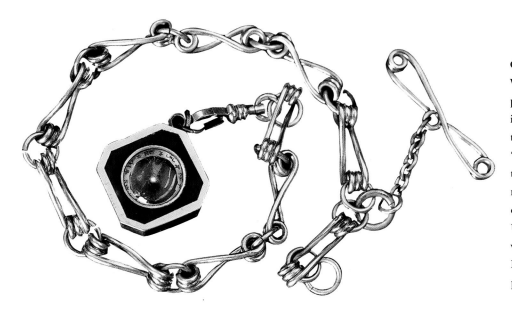

OUTFITTING an expedition: With Jefferson's input, Lewis planned carefully for the voyage into the unknown, making lists that included everything from "Indian presents" (opposite, left) to military hardware. Among his most cherished personal pieces of equipment: a prototype of the U.S. Rifle, Model 1803 (top), provided by the arsenal at Harpers Ferry. With his own funds, he also purchased a novel weapon—an air gun like the one above. Fueled by compressed air rather than powder, it could fire 40 shots from a single load without spark or powder. Beyond its value as a weapon, it also entranced Indians with its "magic"— as did Clark's compass (opposite, right). With it, the captain charted the daily course for the Corps of Discovery; the smaller version (left) he carried chained to his pocket.

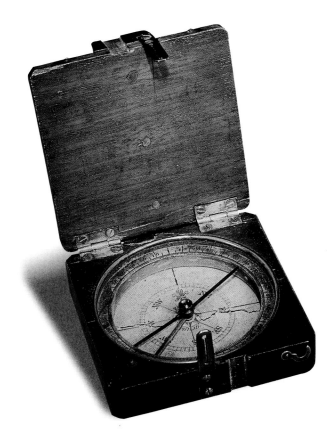

It gave a whole new face to politics and ranked in historical importance with the Declaration of Independence and the adoption of the Constitution.

Napoleon was delighted, and rightly so. He had title to Louisiana, but no power to enforce it. American frontiersmen were sure to overrun it long before he could get an army there—if he ever could. "Sixty million francs for an occupation that will not perhaps last a day!" he exulted. And, as he noted, a big bonus was involved: "The sale assures forever the power of the United States, and I have given England a rival who, sooner or later, will humble her pride."

For Lewis, the best part was that the territory he would be crossing from the Mississippi to the Continental Divide now belonged to the United States. As Jefferson nicely put it, the Louisiana Purchase "lessened the apprehensions of interruption from other powers." He further noted, the purchase "increased infinitely the interest we felt in the expedition."

Jefferson held back the news until the morning of July 4, when the National Intelligencer printed the story. That led to the biggest Fourth of July celebration yet held in the young Republic. The next day, Lewis left Washington for Pittsburgh, to pick up his gear, load it onto the keelboat, and be off. But the boat wasn't ready, and the Ohio's water level was falling daily. Lewis fretted. He was in an agony of anticipation. He reported to Jefferson that he spent most of his time at the boat-builders yard, "alternately persuading and threatening." He soothed himself some by buying a large black Newfoundland for $20—a staggering sum for a dog. He called the dog Seaman.

Not until the last day of August was the keelboat complete. It was 55 feet long, 8 feet wide, with a shallow draft. It had a 32-foot-high mast that could support a large square sail. There was a forecastle and a cabin in the stern. It could carry a cargo of about 12 tons. In 1996, Moira and I went out into the Missouri River in a replica of the keelboat, built by Glen Bishop of St. Charles, Missouri, based on Clark's sketch of the craft. Glen had brought it up to date with an inboard engine, but even with the power it was a cumbersone, awkward, heavy boat, difficult to control. But if it was slow, it was strong enough to withstand almost any hazard.

The only power available to Lewis—save that of falling water—was muscle. He drafted some local soldiers for his crew, plus some civilian volunteers, and set off that afternoon. After a mile or so, "we were obledged to get out all hands and lift the boat over about thirty yards." Then another shoal and ripple. And another. Lewis got out to help pull or lift the boat. Twice. A third time. When he put ashore for the night, having gone only ten miles downstream, he "was much fatiegued after labouring with my men all day. Gave my men some whiskey and retired to rest at 8 Oclock."

Over the following days riffles and shoals slowed progress. Twenty miles in a day was the best Lewis could make, and that not often. But wonders of the Ohio River compensated. On the morning of September 13, Lewis saw a natural-history phenomenon: Passenger pigeons flying over the river, migrating south, were there in such great flocks they obscured the sun. Squirrels were migrating, too, crossing the river north to south, a sight not seen since the magnificent hardwood forests of Ohio, Indiana, and Kentucky were cut down in the first half of the 19th century. Seaman started barking at them; Lewis let him go; Seaman swam out, grabbed a squirrel, and fetched it back to Lewis, who sent the dog out for repeated performances. Lewis fried the squirrels and declared "they were fat and a plesent food."

On October 14, Lewis arrived at Clarksville, in Indiana Territory. After tying up the keelboat, he set off for General Clark's home, where his friend was then living. When the two would-be explorers shook hands on General Clark's porch, the Lewis and Clark Expedition was born.

Their excitement ran high. The words tumbled out. The talk was of the future, not the past. What lay ahead they could only guess. So too about what they would need—how many men; how much and what kind of equipment; what presents for the Indians they expected to encounter, not to mention presents for the unknown tribes they would be discovering; what kind of and how many weapons they needed to add to the arsenal Lewis had already put together. They tried to estimate how long it would take to reach the Pacific. Lewis was a heavy drinker, as were the majority of the U.S. Army personnel on the frontier—how much whiskey should

LEWIS's brainchild, the expedition's 55-foot-long keelboat could be rowed, sailed, pushed, or pulled. Its western-style hull supported 12 tons and 22 men—the two captains in its stern cabin and 20 oarsmen, as Clark's sketch of it shows. Constructed by an inebrious boatbuilder in Pittsburgh, the vessel took six weeks longer to complete than Lewis had anticipated. Though sturdy, it proved hard to manipulate in the strong Missouri currents. More than once, Clark recorded similar mishaps: "the boat Struck and turned, She was near oversetting."

they bring? What animals, birds, fish were out there to be discovered? There was so much to be discovered. Only two things were certain—this was going to be the adventure of a lifetime, and they were determined to make it out and back, or die in the attempt.

The single word that best describes them at this moment is confidence. In themselves, in each other. Each man was around six feet tall, broad-shouldered, with the grace of a natural athlete. Clark was rugged in the face, with a full head of red hair. Lewis had a certain delicacy in his profile, with light brown hair. Their bodies were rawboned and muscled, with no fat, Their hands were big, rough, strong, capable, and confident. Each man was long-legged, capable of hiking up to 30 miles a day. They knew how to train and command, how to take boisterous young frontiersmen and turn them into well-disciplined soldiers who could be relied upon in any emergency and who could meet any challenge. They could scarcely wait to get going.

Over the next two weeks, they got started on selecting the enlisted men. There were hundreds of volunteers. They selected Charles Floyd and Nathaniel Pryor, and made them sergeants, along with Pvts. William Bratton, Reubin and Joseph Field, George Gibson, John Shields, John Colter, and George Shannon (at 18, the youngest in the party). Colter and Shannon had accompanied Lewis from Pittsburgh and were the only men from that contingent who answered for the permanent party. After making their choices, the captains swore the chosen men into the army in solemn ceremony, in the presence of General Clark. The Corps of Discovery was born. Besides the captains and the enlisted men, the party included Clark's slave, York, a big, very dark, strong, agile man who had been Clark's lifelong companion.

Planning and preparing for our own trip in 1976, we had relived their excitement, imitated their careful preparation. It had taken us weeks: making a rough itinerary, collecting maps, reading the journals and other books, purchasing gear, and getting in shape. We studied outdoor catalogs, and after lengthy discussion ordered our boots, backpacks, tents, sleeping bags, and the rest. Our friend Mickey Fluitt painted "Lewis and Clark Expedition, 1976," in block letters on the

doors of the Chevy pickup and the VW van, and on the Grumman canoe. I wrote the kids' teachers, asking permission to take them out of school two weeks early so that we could start from St. Louis on May 14, the date in 1804 that the captains would leave that same town to begin their official journey of exploration. The teachers all agreed and expressed the wish that they could come along.

The Corps, which planned to winter outside St. Louis, left Clarksville by keelboat on October 26, 1803. On November 11 it arrived at Fort Massac, on the Illinois bank of the Ohio, about 35 miles upstream from the junction of the Ohio and Mississippi. There the captains added a civilian to the party: George Drouillard, a locally renowned woodsman. Although Lewis never learned how to spell Drouillard's name—it usually came out "Drewyer"—he was impressed by him from the start. Son of a French Canadian father and a Shawnee mother, Drouillard was a skilled frontiersman, hunter, trapper, and scout. He was an expert in Indian ways, fluent in a couple of Indian languages and in French and English, and master of the sign language. He exuded a calm confidence. Lewis signed him to a contract to serve as interpreter at $25 per month.

On November 13, the party resumed its voyage. That night the captains made camp at the junction of the Mississippi and Ohio River, where they would stay a week doing scientific work. Lewis began passing on to Clark the lessons he had learned from Jefferson and astronomer Andrew Ellicott. That evening, they made celestial observations. The sky over the dark, murmuring rivers was black and transparent, free of any pollutants, far from any glowing village, perfect conditions for making their measurements to establish longitude, a procedure that involves tracking the moon's movement in relation to certain fixed stars. During the day, they used the sextant to measure the sun's height at meridian, which fixed their latitude.

In our own preparation, we tried to follow the captains' scientific procedures. We became fairly proficient with a simple sextant at calculating latitude, but we never mastered longitude, which required far more skill and perseverance with its series of steps: locating the known stars, noting the exact time of each reading, then consulting navigational tables.

On November 20, the expedition set out for St. Louis. Now it headed upstream, and would continue to do so until it reached the source of the Missouri River. At this instant, Lewis and Clark came to the same conclusion: We are going to need more men. The power of the Mississippi, with its boils and swirls and floating obstacles, awed them. In eight hours of rowing, the keelboat made ten-and-a-half miles. It was badly undermanned.

Not until November 28 did it reach the Army post at Kaskaskia, on the Illinois side, some 60 miles below St. Louis. Lewis asked for volunteers from the garrison for the voyage and this time did better; he selected a dozen soldiers to join the party. Not all would go all the way to the Pacific; Lewis intended to send a detachment with the keelboat back to St. Louis from the Mandan villages, where he anticipated spending the winter of 1804-05.

The following week, Clark set out to find winter quarters. He selected a site at the mouth of Wood River, upstream from St. Louis on the Illinois side. It was well timbered, with plenty of game. Lewis meanwhile went to St. Louis to begin purchasing the additional supplies.

St. Louis was four decades old, with about a thousand people, mainly French Canadians. For so young and so small a town, so insignificant in size when contrasted with the mighty river flowing past, St. Louis had a critical role to play in a vast empire. It was the center of the fur trade for the lower Missouri River. Business opportunities abounded. Lewis found most anything he wanted: Corn, flour, biscuits, barrels of salt, kegs of pork, boxes of candles, kegs of hog lard; 21 bales of Indian goods, tools of every description.

In the nearly two centuries since Lewis and Clark first saw it, St. Louis has become a great city—a grand spectacle of glass, steel, trucks, and automobiles. But St. Louis has not forgotten its origins. How can it, with its vibrant riverfront and barges covering the Mississippi River? Its heart's blood continues to be the Mississippi.

On a clear day, as I fly into St. Louis airport from the north or west the views all but overwhelm me. There flows the Missouri, containing all the water coming down from the northern Rocky Mountains and the Great Plains, meeting the Mississippi's waters coming from the northern Midwest. Shortly they will be joined by the waters of the Appalachian Mountains and the whole region from the Great Lakes to the northern boundaries of present Misssissippi and Alabama. These confluences are the heart of America. More than any other place, St. Louis from the air causes me to reflect yet again on what a great thing Thomas Jefferson did in creating a country that encompasses all those waters.

From St. Louis, during the winter of 1803-04, Lewis began sending specimens back to Jefferson. The first package included the slip of an Osage orange, which came from the Osage village 300 miles to the west of St. Louis. He described the tree in detail—the fruit could not be eaten—it was short with thick, sharp thorns, but its wood was the Indians' favorite for making bows. This was his first description of a plant unknown to science. I have seen two Osage oranges growing today in Philadelphia, one in a churchyard at Third and Pine, that grew from the slips Lewis sent; another on the campus of the University of Virginia, at Morea, a guest house.

While Lewis was in St. Louis, Clark at Wood River was in charge of establishing the winter camp. He planned and oversaw the construction of the huts and made improvements to the keelboat, including some cleverly devised lockers running along the sides of the boat, with lids that could be raised to form a breastwork, or shield. When the lids were down, they provided catwalks, or *passe-avants,* for men with poles pushing the boat. Crosswise between the lockers, Clark had 11 benches built, for use by the oarsmen. He added a bronze cannon, purchased by Lewis, and mounted it on a swivel that allowed it to be turned and fired in any direction. It could fire a solid lead ball weighing about a pound, or 16 musket balls with sufficient velocity to go through a man. At close range, it was a highly effective antipersonnel weapon.

As I prepared for the trip, it struck me how the captains' different experiences reflected their emphasis on weapons. Lewis had not been in an Indian fight. Clark had. Lewis put his emphasis on rifles; it was Clark who added two blunderbusses (basically large shotguns, mounted on a swivel) and a small cannon to the keelboat. Clark put his emphasis on buckshot; he was less interested in accuracy, which was

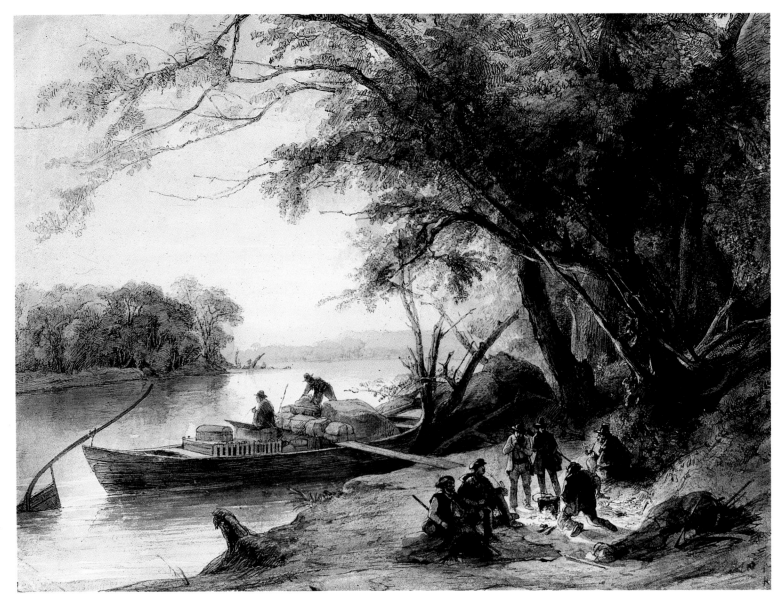

IN THEIR journals, Lewis and Clark often described the "butifull countrey" they encountered along the Missouri frontier. Swiss artist Karl Bodmer brought that country to life on canvas. In 1833-34 Bodmer traveled up the Missouri with Prussian prince Maximilian, painting scenes like this riverside camp as well as the daily life of the Plains Indians. In an age before photography, Bodmer's works became a record of places and peoples on the cusp of change.

critical to hunters but meaningless when confronted by a mass of attacking Indians.

In February, Lewis crossed over to Wood River; Clark then left for St. Louis to pick a crew of voyagers to paddle one of the canoes, or pirogues as the captains called them—they were flat-bottomed dugouts. There were two pirogues, one requiring a five-man crew, the other eight men. They would carry goods as far as the Mandans. Clark was the better waterman of the two captains; Lewis always deferred to him in such matters. On March 7, Lewis joined Clark in St. Louis. On March 9, the ceremony of transfer of Louisiana took place. Lewis was there as the chief official witness. On March 10, the Stars and Stripes was raised, the documents were signed, and the appropriate speeches were made.

When Lewis had left Wood River, it was the first time both captains had been absent at once. Lewis had put Sgt. John Ordway in command. Pvts. John Colter, John Boley, Peter Weiser, and John Robinson had gone off to a nearby frontier village to get drunk. Lewis wrote a detachment order: "The Commanding officer feels himself mortifyed and disappointed at the disorderly conduct." He confined the culprits to their quarters for ten days.

That didn't work. These young heroes were in great shape, strong as bulls, eager to get going, full of energy and testosterone—and bored. The only women they saw were the pioneers at the nearby settlement, all married. There was a whiskey seller around but he was expensive and hard to get to. With the huts built and the keelboat's alterations finished, the men had almost nothing to do—a little drilling on the parade ground, which they hated, and a little target practice, which they loved. Mainly they waited for spring. To pass the four months they were stuck at Wood River, they fought among themselves, challenged authority, and tested the captains to see how far they could go. Clark recorded various serious fistfights, sometimes with delightful comment: "R. Field was in a mistake & repents." "Frazer, has don bad."

In 1976, we camped outside St Louis and explored the area. We were getting ready mentally to follow the captains wherever they might lead us. Stopping at the little park at Wood River, we got the hint of the confinement the Corps

felt that winter. They were in a netherworld, between civilization and the frontier. We found special significance in the monument to Lewis and Clark. Although the monument is not at the 1803-04 campsite—the rivers have shifted and canals for barge traffic have been dug—from it we could still see the Missouri entering the Mississippi, and wonder what Lewis and Clark thought as they looked up the Missouri. We wondered, too, what lay ahead for us.

In March, Sergeant Ordway gave an order to Private Shields, who said he would not obey, then threatened Ordway's life. Confronted by Captain Clark, Shields said he wished to return to Kentucky. Private Colter had disobeyed orders and had loaded his rifle, threatening to shoot Ordway. The captains put Shields and Colter on trial for mutiny. The privates "asked the forgivness &c & promised to doe better in future." Despite the seriousness of the offense, they were persuasive and no punishment was noted. This speaks to the opinion the captains had of Colter and Shields—they wanted them along.

Two days later, on March 31, Shields and Colter were among the 25 men the captains selected to be members of "the Detachment destined for the Expedition through the interior of the Continent of North America." Another group of 5 soldiers would accompany the expedition to its winter quarters, then return to St. Louis with the keelboat, carrying messages and specimens. The permanent party would be on the keelboat; the other soldiers and voyagers in canoes. Sergeants Floyd, Pryor, and Ordway commanded the three squads. Besides the 22 men and 3 sergeants, the permanent party included the captains, York, Drouillard, and Lewis's dog, Seaman.

They were straining to get going. Pvt. Patrick Gass wrote in his journal that the local inhabitants had warned that the party was "to pass through a country possessed by numerous, powerful and warlike nations of savages, of gigantic stature, fierce, treacherous and cruel; and particularly hostile to white men." But, he insisted, "the determined and resolute character" of the men and the confidence pervading all ranks "dispelled every emotion of fear." Ordway wrote his parents, "We are to ascend the Missouri River with a boat as

far as it is navigable and then to go by land, to the western ocean, if nothing prevents, &c. I am so happy to be one of the party. We are to Start in ten days up the Missouri River. We expect to be gone 18 months or two years."

Gass's and Ordway's journals are among the five that survive from the expedition. Lewis and Clark would keep their own separate accounts. The captains also ordered each sergeant to keep "a separate journal from day to day of all passing occurrences...."

Like the Corps of Discovery, we kept journals of our first trip along the Trail. Like the captains' records, they have endured. The more than 20 times I've experienced the Trail since then, I find that our first impressions—the excitement, the challenge, the awe—still hold.

"Spring is here," Stephenie began her journal on April 5, 1976, "and our souls yearn for movement."

As the April 1804 sun grew warmer, the banks of the Mississippi exploded into color, beginning with green-gold, nature's first hue. The captains noted spicewood in full bloom on April 1, along with the white dogtooth violet and the mayapple. Soon the violet, the doves foot, and the cowslip were in full bloom.

"Let's go!" One can almost hear the men crying out to the captains. "Let's go, for God's sake." But Lewis needed more in the way of provisions, and he needed time to arrange a journey to Washington for an Osage chief who had agreed to go meet his new father, President Jefferson.

On May 2, Lewis wrote Clark to send to him "the specimines of salt which you will find in my writing desk, on the shelves where our books are, or in the drawer of the Instrument case." This invitation to rummage through Lewis's writing desk spoke to the absolute trust between the two men, and the sentence gives a tiny glimpse into what their quarters at Wood River were like.

IN EARLY MAY 1804, CLARK'S COMMISSION FROM THE War Department finally arrived. It was a lieutenant's, not a captain's: Secretary Dearborn explained that there were no vacancies so the appointment of Clark as a captain would be "improper." Lewis was mortified. He had given his word.

From St. Louis, he wrote Clark immediately, giving him the bad news first, but then by taking advantage of the independence he and Clark would enjoy—no mail would reach them once they set off—he solved the problem. "I think it will be best to let none of our party or any other persons know any thing about the grade." This was satisfactory to Clark—who like most Virginia gentlemen was rank conscious—and it was done. The War Department may have thought of it as the Lewis Expedition, with Lieutenant Clark as second in command, but for the men of the expedition it was Captain Clark and Captain Lewis (which was what they called each other). They were co-commanders, in their minds and in the minds of the men, and that was what counted.

By May 13, Clark was ready to shove off. It is hard to imagine that the Corps of Discovery would put in at almost the exact spot where the Gateway Arch today dominates the sky. Beneath the Arch, in the Museum of Westward Expansion, we marveled especially at the floor-to-ceiling photographs of sites along the Trail and became even more eager to see them. The captains did not have all that they wanted or felt they needed, but—as Clark put it—they had all of the necessary stores "as we thought ourselves authorized to precure." Yet not enough, he feared, "as I think necssy for the multitude of Indians tho which we must pass on our road across the Continent & &c."

The following morning, Clark wrote, he and the men were "fixing for a Start." That afternoon he set off at four o'clock, "under a jentle brease," and made four miles up the Missouri. He described the men as being "in high Spirits." In two decades of hobnobbing with Lewis and Clark buffs, I know that anyone who sets out along the Trail shares those "high Spirits." The thrill is little diminished from the time my family's first voyage got under way on May 14, 1976, from the mouth of the Mississippi.

Clark described his crew as "robust young Backwoodsmen of Character helthy hardy young men, recommended." A bit too robust, it turned out: Pvts. William Warner, Hugh Hall, and John Collins crept out of camp and went to a settlement for whiskey. Collins cursed the guard when they returned. Clark had the three court-martialed. The jury, made up of

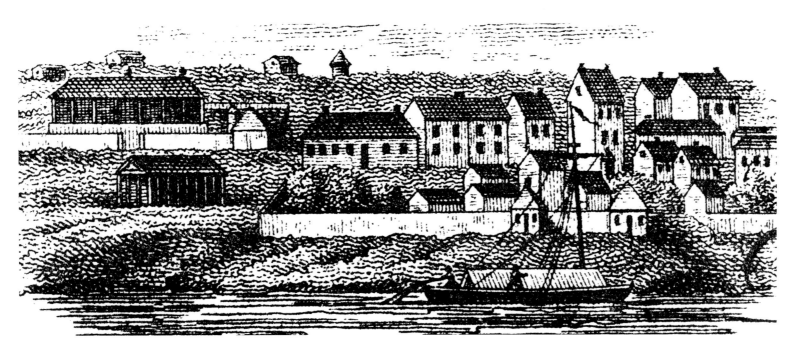

AN 1817 banknote celebrates
St. Louis, the Mississippi River
town that became the gateway
west. Lewis spent the winter of
1803-04 here, making final
preparations for the expedition.

their peers, found them guilty and sentenced Warner and Hall to 25 lashes, Collins to 50. Clark must have thought Collins was the ringleader, for he remitted Warner's and Hall's sentences; Collins's sentence was carried out.

Lewis was in St. Louis, making the arrangements for the Osage chief to go to Washington. Not until May 20 did he get away. Clark was waiting for him at St. Charles, on the north bank of the Missouri. It was a village of some 450 inhabitants, most of whom, Lewis noted, "can boast a small dash of the pure blood of the aboriginees of America." The captains hired two of the half-breeds, Pierre Cruzatte and Francis Labiche. Cruzatte, son of a French father and Omaha mother, was skilled in the sign language and spoke Omaha. Labiche spoke several native tongues. The captains attached them to the permanent party after swearing them in as privates, a sign of their high approval of the two men.

On May 21, to the cheers of a crowd on the bank, the expedition set out. They made three and a quarter miles—they measured distance by line of sight; Clark was an unusually gifted expert in this—and camped that night on the head of an island. A hard rain lasted through the night. At 6 a.m., May 22, 1804, they were on their way.

When they set off from St. Charles, they were on their own. They had no supply line. No orders from their Commander-in-Chief could reach them. As our family set off on our 1976 voyage, it gave us a thrill to to think that the captains had an independence of command that matched the independence of Columbus, Magellan, and Cook. Like those great explorers, Lewis and Clark knew not what lay ahead, but whatever it turned out to be, they would have to deal with the challenges with what they had with them.

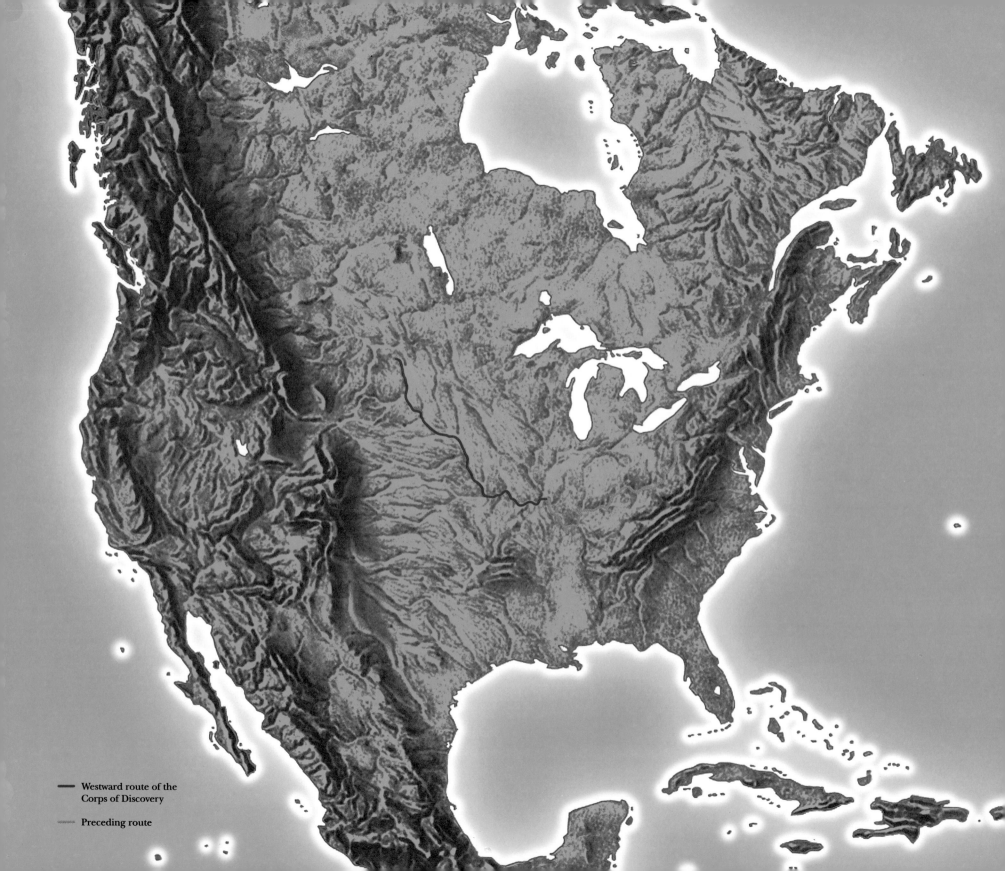

Westward route of the
Corps of Discovery

Preceding route

Up the Missouri

"The Souix is a Stout bold looking people (the young men hand Som) and well made."

WILLIAM CLARK ~ AUGUST 29, 1804

UP THE MISSOURI

ON MAY 23, THE SECOND DAY OUT, CLARK RECORD-ed in his journal, "Capt Lewis' assended the hill which has peninsulis projecting in raged pints to the river, and was near falling from a Peninsulia of rocks 300 feet, he caught at 20 foot. Saved himself by the assistance of his Knife." That was rather early in the journey to be having life-threatening accidents.

Not far from the spot, near today's village of Defiance, the man who had blazed the way into Kentucky, Daniel Boone, had his last home. On our first trip we explored the area, called then Boone's Settlement. I tried to imagine a conversation between Boone and the captains. Did he pass the torch, wish them Godspeed, warn them of dangers? Alas, we do not know if the captains even saw Boone. The site is gone now, washed away by the river, leaving it as remote and densely wooded a spot as Boone himself may have seen it. On May 25, the expedition passed La Charette, the last settlement of whites on the river.

Fighting the river was the expedition's preoccupation. The current ran at five miles per hour usually, but it sped up when it encountered encroaching bluffs, islands, sandbars, and narrow channels. Incredible to behold were the obstacles—whole trees, huge trees, oaks and maples and cottonwoods, that had been uprooted when a bank caved in, racing downriver, threatening to tear holes in the sides of the keelboat; innumerable sandbars, always shifting; swirls and whirlpools beyond counting. This was worse than the Mississippi.

If the wind was fair the men put up the sail and had it relatively easy. At all other times their labor was immense. In shallow water they used the iron-pointed setting poles and started pushing. If the bottom was deep enough they worked at the oars, rowing. If the current was too swift for either pushing or rowing, they would bend a 40-fathom length of cordelling cable to the mast and go ashore, to haul on the line. Despite everything, they made good time generally, usually about 10 miles per day but if the wind was astern they could make 20. They had to be alert at all times. Clark reported a typical incident: "Sand Collecting &c forming Bars and Bars washing a way, the boat Struck and turned. She was near oversetting. We saved her by Some extrodany exeretions of our party who are ever ready to incounture any fatigue for the premotion of the enterprise."

On May 26, Lewis issued his Detachment Orders, the rules and regulations for the Corps of Discovery. The party was in country where every Indian tribe had to be regarded as a threat until it proved otherwise, but the last thing Lewis wanted was an Indian fight. He was prepared—and was under orders—to do everything possible to avoid one.

The best way to avoid a fight was to make sure one never got started, which meant in the first instance making certain that the expedition was never caught by surprise. A camp of sleeping men with weapons carelessly scattered around could well tempt a roving band of Indians into an attack. A well-regulated camp, with guards posted and calling out challenges, would not. Instead of a fight there would be a talk, which was what Lewis wanted.

To prevent surprise, his Detachment Orders stressed alertness. There should be two sentinels on duty at all times the party was ashore. There were daily inspections of the rifles and the cannon, to be certain they were ready for action. To add to nighttime security, the party camped on islands whenever feasible. Their knowledge of the frontier and what they learned from the other voyagers told them

A PLAINS-STYLE hunting shirt, which he wore with moccasins, constituted Clark's "uniform" during the expedition. Made of buffalo hide, the shirt was painted and decorated with porcupine quills, an ornamentation often used by the Plains Indians. To make the quills pliable, the women chewed them, then dyed and bent them into ornamental patterns. In this shirt, the broad-shouldered, six-foot Clark might have mirrored his own description of the Yankton Sioux: "Stout bold looking people...," he called them, "much decorated with Paint Porcupine quils & feathers."

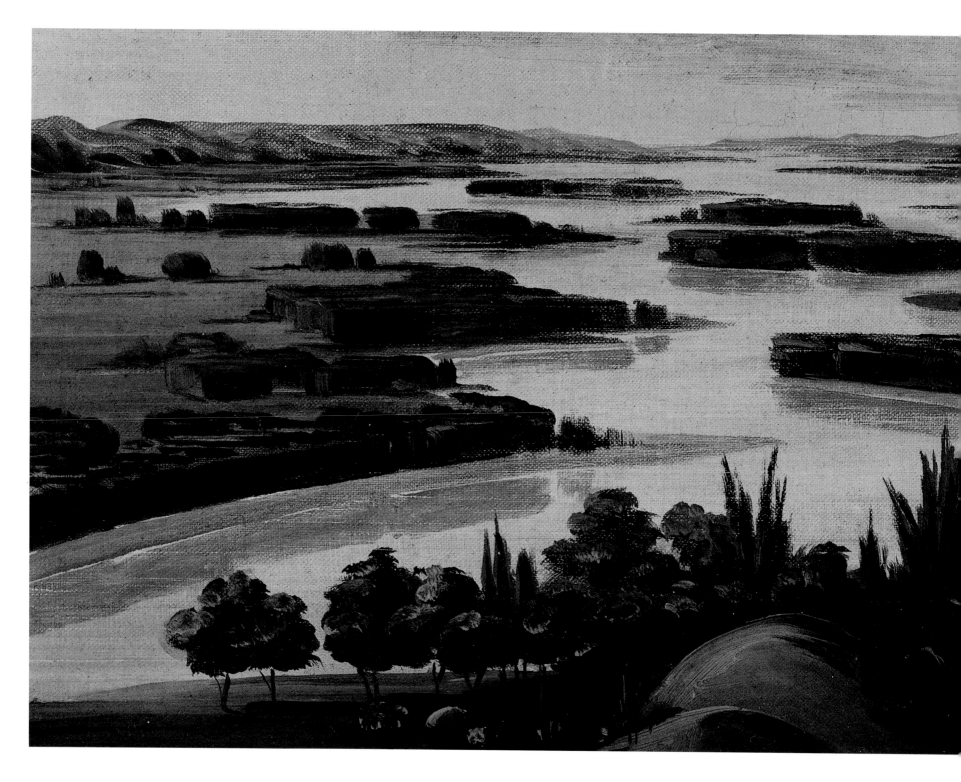

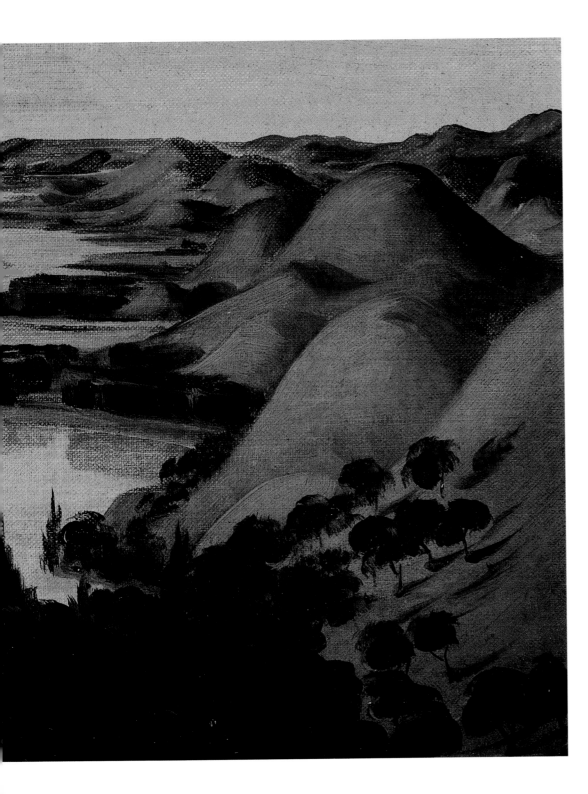

"VIEW from Floyd's Grave, 1000 miles above St. Louis," George Catlin called the painting he completed in 1832. Twenty-eight years earlier, the Corps' Sergeant Charles Floyd had died here, probably of complications from appendicitis. Burying him with the honors of war, the captains chose a knoll above the Missouri for his gravesite. On their return journey two years later, they "found the grave had been opened by nativs and left half covered." Respectfully, the Corps refilled the grave on Floyd's Bluff, now a prominent landmark in Sioux City, Iowa.

When the lashing was finished, the party set off, Collins and Hall at the oars, groaning. They got no sympathy.

On July 4, the men ushered in the day with a firing of the cannon. The captains made camp at the mouth of a creek, which they named Independence Creek. Clark wrote, "We Camped in the plain, one of the most butifull Plains I ever Saw, open & butifully diversified with hills & vallies all presenting themselves to the river covered with grass and a handsom Creek meandering thro." The captains ordered an extra gill distributed. Cruzatte played his fiddle. The men danced. Clark was quite carried away by the copses of trees "Spreding ther lofty branchs over Pools Springs or Brooks of fine water. Groops of Shrubs covered with the most delicioiuis froot is to be seen in every direction, and nature appears to have exerted herself to butify the Senery by the variety of flours Delicately and highly flavered raised above the Grass, which Strikes and profumes the Sensation and amuses the mind." At sunset, the men fired the cannon. This was the first-ever Fourth of July celebration west of the Mississippi River.

On our first trip we camped at Lewis and Clark State Park, Missouri, across the river from Atchison, Kansas. Moira and I paddled our canoe across the river to the mouth of Independence Creek. The river has been canalized, with lots of jetties, meaning it is even faster today than it was in 1804. From Sioux City, Iowa, to St. Louis, the river averages just one-third its original width. Nearly all of the river's meanders, islands, and sandbars are gone. In their place are stabilized banks and a single channel. As a result, wildlife habitat all along the lower river has nearly disappeared. The berries and meadow of flowers that so entranced Clark on July 4 are gone today; the farmers plow right up to the river. Clark's "butifull Plain" is a cultivated field.

ON THE NIGHT OF JULY 11-12, PVT. ALEXANDER Willard went to sleep on his post. Ordway found him and turned him in. The offense was one of the most serious possible—punishable by death, according to the regulations. The captains themselves constituted the court. Ordway charged Willard with "Lying down and Sleeping on his post whilst a Sentinal." Willard pled, "Guilty of Ly Down, and not Guilty, of Going to Sleep." The captains found him guilty on both counts and sentenced him to one hundred lashes, each day for four days, starting that evening at sunset. One shudders at the thought of Willard's back after the fourth day; one shudders at the thought of what might have happened had a roving band of Sioux come up while Willard was sleeping on guard duty.

On July 21, some 600 miles and 68 days upstream from Wood River, the expedition reached the mouth of the Platte River. That meant entering a new ecosystem, the Great Plains. It also meant entering Sioux territory. So far, to its surprise, the party had not seen a single Indian. All the river tribes were out on the prairie, hunting buffalo, the popular name for American bison.

We get a sense of the richness and diversity of the Plains from Clark's 34th birthday menu, August 1. "I order'd a Saddle of fat Vennison, an Elk fleece & a Bevertail to be cooked and a Desert of Cheries, Plumbs, Raspberries, Currents and grapes of a Supr. Quallity." Taking note of the wonderland around him, Clark mused "What a field for a Botents [botanist] and a natirless [naturalist]." Clark was giving the first account of a land that would become the nation's breadbasket.

The sense of being in a Garden of Eden was already strong, and growing. Fat deer, elk, beaver, and other species were present in numbers scarcely conceivable. And so much that was new! They shot their first buffalo—not new to science but new to them—and immediately decided that the tongue and hump of the buffalo beat everything, save only the tail of the beaver. To my taste, buffalo tongue is the best meat in the world, but the hump has too much fat in it— which was why the men so loved it. On August 12, Clark saw what he called a "Prarie Wolf" on the bank. The captains went ashore to bag it, but Clark sadly noted, "we could not git him." The animal was a coyote. Lewis and Clark were the first men to record seeing one. The captains set a precedent; millions of Americans who came after also failed in their attempt to kill the coyote.

The Corps was found by Indians. On August 2, at a camp

the men named Council Bluff (across and slightly downriver from present-day Council Bluffs, Iowa), a party of Otoe and a few Missouri arrived, accompanied by a French trader.

After an exchange of greetings, the captains gave the Indians some tobacco, pork, flour, and meal. "In return," Clark noted, "they Sent us Water millions [watermelons]." The captains invited the Indians to attend a council the following morning.

In 1976, we visited the Lewis and Clark Monument on the bluffs north of town, where Clark observed "the most butifull prospect of the River up and Down." The view is different today: The river has cut away from the bluffs and now flows some two or three miles to the west.

In 1997, I went back to the bluffs to pay my respects to the captains, but also to visit the nearby Lincoln monument—at the spot where Abraham Lincoln stood in 1859 and decided that it was exactly here that the transcontinental railroad should have its eastern terminus. I was struck by the thought that when Lewis and Clark reported that there was no Northwest Passage, the American people decided to build one, or its equivalent. And it was Lincoln, standing on ground that the captains had stood on, who decided that this was the place to begin the railroad.

At the Corps' arrival in 1804 the Otoe and Missouri numbered 250, having been much reduced by smallpox. They were a farming and hunting people, with semipermanent villages. Their numbers and peaceable nature precluded their playing a significant role in the politics of the nations of the Missouri River, but they were the first Lewis and Clark met, so they gave the captains an opportunity to rehearse their Indian diplomacy, which had as its guiding light the notion of bringing the Missouri River and Rocky Mountain Indians into an American trading empire. To convince the Indians that they should shift their allegiance from the British in Canada to the Americans in U.S. territory, the captains used a carrot-and-stick approach. Lewis wrote out his speech—which he delivered to every Indian tribe he met over the next two years—and he and Clark appeared for the council in full-dress uniforms, complete with cocked hats. The sergeants put the men through a dress parade and passed in review. Then Lewis spoke.

"Children," he began, "we have been sent by the great Chief of the Seventeen great nations of America to inform you" of the transfer of power from Spain and France to the United States. He told the Otoe that they were "bound to obey the commands of their great Chief the President who is now your only great father. Children, he is the only friend to whom you can now look for protection, or from whom you can ask favours, and he will take care to serve you, & not deceive you."

The President, Lewis went on, "has sent us out to clear the road, remove every obstruction, and to enquire into the nature of your wants." He promised that when Jefferson knew what the Otoe desired, he would supply the goods.

Then came the threats. The 17 great nations of America had "cities as numerous as the stars of the heavens." The Otoe must be friends with the Americans, "lest by one false step you should bring upon your nation the displeasure of your great father, who could consume you as the fire consumes the grass of the plains." The Great Father, "if you displease him," would stop all traders from coming up the river. Lewis spoke with a forked tongue, not only about America's many cities, but in promising what could not be delivered.

The Otoe liked that part about supplying their wants and wished to know when. In two or three years, Lewis said. The Otoe looked longingly at the trade goods piled into the canoes and boat. How about some presents now? The captains distributed some breech cloth, a bit of paint, a comb, and a small medal with the new father's likeness on it.

Then the Otoe chiefs spoke. Clark was not impressed. In his opinion, "They are no Oreters." Still, they managed to make their point, which was, how about some whiskey and powder? Lewis was eager to please, as he hoped one or two of the chiefs would make the trip to Washington in 1805, so he met the request. The chiefs departed with their bottle of whiskey and said they would return in the morning.

When they did, on August 19, one of the chiefs, Big Horse, showed up naked, to emphasize his poverty. He spoke first, expressing his fear that he would return home naked. The captains handed out tobacco, paint, and beads. The presents made little impression. The captains then tried handing around printed certificates proclaiming the bearer

to be a "friend and ally" of the United States. One disgusted warrior disdainfully handed back his certificate. The captains, angered by this disrespect toward an official document, rebuked the man "very roughly." The Otoe departed in a sour mood, but Chief Little Thief indicated he would make the trip to Washington in the spring, which made Lewis happy. The captains thought they had got off to a good start in their Indian diplomacy.

We met our first Indians at Indian Cave State Park, a primitive campground downstream from the Corps' campsite, where a high bluff overlooks the river. Lining the banks below are caves filled with Indian pictographs hundreds of years old—the only known example of their kind in Nebraska. We were down by one of the caves putting in a canoe, when we met Bruce Woodhull, an Apache, and his wife, Marilyn, an Oglala Sioux, working as summer employees at the park. They led us inside, where the ancient drawings of wildlife and varied scenes of nature filled the walls. We made out buffalo, fish, and deer. Now a history teacher, Bruce explained the techniques used by the artists, how they made their paints, what various symbols meant.

For all the mystery it conjures up now, this place—and the stretch of river from here north to Sioux City—was one of harsh reality for the Corps. During the council with the Otoe, Sgt. Charles Floyd had been desperately ill. Lewis diagnosed his disease as "Biliose chorlick" or bilious colic, and had nothing to treat it with—but then neither did Dr. Rush back in Philadelphia. On August 20 Floyd died, most likely from peritonitis resulting from a ruptured appendix. The men carried his body to a high round hill overlooking an unnamed river that branched off the Missouri. The captains had him buried with all the honors of war and fixed a red-cedar post over the grave. Lewis read the funeral service. Clark provided a fitting epitaph in his journal: "This Man at all times gave us proofs of his firmness and Deturmined resolution to doe Service to his Countrey and honor to himself." The captains concluded the proceedings by naming the river Floyd's River and the bluff Sergeant Floyd's Bluff. Two days and 41 miles later, the captains ordered an election for Floyd's replacement. Pvt. Patrick Gass got 19 votes.

We visited Floyd's Bluff on a rainy, miserable morning. Its concrete obelisk, a miniature Washington Monument, overlooks the river near Sioux City. The original grave was cut through in 1857 when the flooding Missouri swept away part of the bluff. By lowering a boy over the side by rope, the community rescued Sergeant Floyd's remains, then reburied them in a coffin. In 1900, the monument was built and a year later dedicated as the nation's first National Historic Landmark commemorating "The Louisiana Purchase...of Its successful exploration by the Lewis and Clark expedition... of the valor of the American soldier...." As we read Clark's description of Floyd's death aloud, our tears joined the rain streaming down our faces.

Sergeant Floyd was responsible for other firsts. A local farmer, Craig Oldson, pointed out that Floyd was the first U.S. soldier to die west of the Mississippi River and Gass's election to replace him was the first ever held west of the river. The election took place near Elk Point, one of South Dakota's oldest communities. Not far away is Spirit Mound. According to Indian legend evil spirits—little men about 18 inches tall with remarkably large heads—inhabited the mound. Armed with sharp arrows, they supposedly killed anyone who drew too near. Clark noted, "that no consideration can induce [the Indians] to approach the hill."

We joined Craig to canoe a stretch of the river that leads to his farm. We talked more Lewis and Clark, marveled at how they moved upstream, despaired over the channelization of the river, had a fantasy about re-creating the journey in 2004. Craig's land had been a campground for the expedition and he occasionally does some digging on the site, hoping to find an artifact. I told him the captains never left anything behind.

Craig invited us to canoe to his farm, some ten miles downstream, which we did, and talked some more. The paddling was so good—this is the only stretch of free-running river between Montana and St. Louis—that I made the trip a second time with Andy. Here the lower river looks more like what Lewis and Clark saw than any other stretch; here there are sandbars and islands, geese and ducks, willow banks and woods, all but gone above and below. Moira and I had the

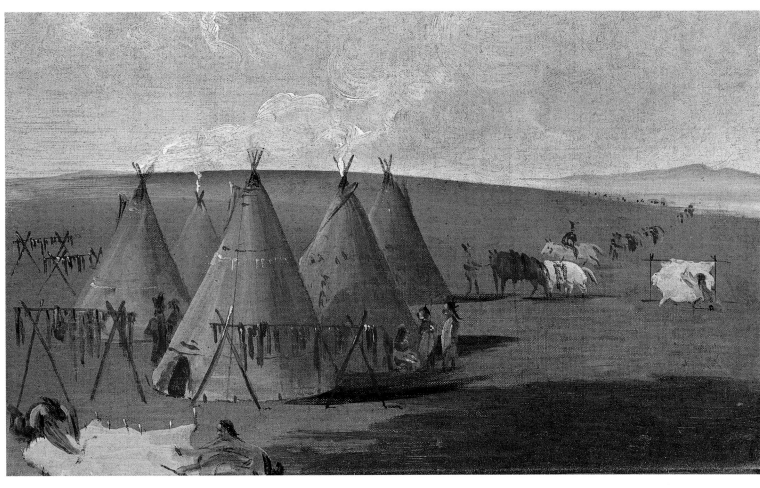

CATLIN's painting of a Sioux encampment on the upper Missouri depicts the dressing of buffalo meat and hides after a hunt. Three decades earlier, Lewis and Clark had traveled much the same ground. Striving to impress native tribes with the benevolence of the "great white father" in Washington, they handed out Jefferson's written greetings (right) and peace medals engraved with his image.

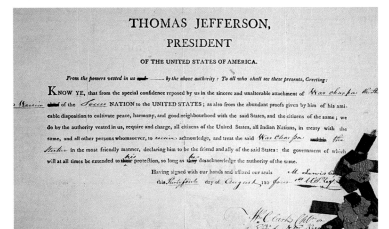

grand sight of a bank caving in, carrying a large oak with it and creating a hazard for us as such trees had for the expedition. As Craig had promised us, this was the real Missouri.

On August 27, 1804, the keelboat approached today's Yankton, South Dakota. Mr. Dorion informed the captains that they were now in Sioux country. Lewis set the prairie afire as a signal to the Yankton Sioux to come in for a council. At the mouth of the James River, a teenage Yankton boy swam out to one of the canoes and gestured that he wished to talk. The boat put ashore; more teenagers appeared. They told Mr. Dorion they were part of a large band of Yanktons camped nearby. The captains sent Sergeant Pryor and Mr. Dorion to invite those Indians to a council at Calumet Bluffs, near today's Gavins Point Dam, on the Nebraska side.

Pryor returned the following day, to report that the Yanktons were extremely friendly and that their camp "was handsum made of Buffalow Skins Painted different Colour, all compact & handSomly arranged, their Camps formed of a Conic form Containing about 12 or 15 persons each and 40 in number." Pryor had just become the first American to describe the classic Plains tepee. The Yanktons had cooked a fat dog for a feast; Pryor "thought it good & well flavored." And they agreed to come to council in the morning.

The captains made ready. They put on their dress uniforms and put up a flagstaff, running up the flag, and firing the cannon as the Yanktons approached. The Yanktons had their own sense of drama. They were in full regalia. The chiefs were preceded by four musicians, singing and playing. Lewis made his Indian speech, then distributed small presents. After the council, Indian boys showed off their skill with bows and arrows, to the delight of the soldiers, who handed out prizes of beads. At dusk, three fires burned in the center of camp. Indians in gaudy paint came leaping into the firelight, to sing of their great feats. They danced to music coming from deer-hoof rattles and a drum. Ordway recorded that the warriors began "with a woup and hollow and ended with the same." An individual would sing "of what warlike actions he had done. This they call merit. They would confess how many horses they had Stole."

Captain Clark was impressed. "The Souix," he wrote, "is a Stout bold looking people (the young men hand Som) & well made. The Warriors are Verry much deckerated with Porcupin quils & feathers, large leagins & mockersons, all with buffalow roabs of Different Colours. The Squars wore Peticoats & white Buffalow roabs."

In the morning, the chiefs gave their reply to Lewis's speech. Weuche spoke first: "We are pore and have no powder and ball, our Women has got no cloathes." Still, he said that if Mr. Dorion would accompany him, he would go to Washington in the spring. Dorion agreed, and agreed also to spend the winter with the Yanktons. This helped overcome the disappointment at the paucity of presents.

Arcawechar was the last chief to speak. "It was all very well for the Yanktons to open their ears" to Lewis's suggestion that the nations living along the Missouri make peace, run traps, and trade with the Americans, "and I think our old Friend Mr. Dorion can open the ears of the other bands of Sioux. But I fear those nations above will not open their ears, and you cannot I fear open them." He was referring to the Teton Sioux, and he spoke bluntly. The captains had given out five medals. "I wish you to give five kegs of powder with them." The captains did not, could not comply. As Arcawechar had warned them, where they were going they would need all their powder.

The Corps' next camp was at present-day Niobrara State Park, Nebraska, just west of the main route up the Missouri. The park is located on a spot described by Clark on September 4, 1804: "I went up this river [the Niobrara] three miles to a butifull Plain on the upper Side where the Panias once had a village." He noted that "the Current verry rapid, not navagable for evin Canoes without Great dificuelty owing to its Sands." Moira and I put in where Clark turned around and came close to tipping in the current. The Niobrara provides marvelous swimming—and fishing. Did Clark stop here to reflect, did he cast in a line? Probably not. I imagine his cartographer's eye shrewd and relentless, scanning every bluff and curve of the bank. Too bad. The fishing was fine. Barry caught a huge largemouth bass (seven pounds and something), which we roasted over a campfire that could not have been too different from Clark's that night.

CONFRONTATION WITH THE SIOUX

THE GREAT PLAINS OF NORTH AMERICA CAN BE hot, dusty, brown, flat, and unfit for life, or they can be delightfully cool, abundantly watered, a dozen shades of green, marvelously varied in appearance, ranging from soaring buttes to level valleys, and hospitable to all forms of life. They are relatively flat, generally semi-arid, and essentially treeless. They were covered by an endless sea of prairie grass, grass that sent roots down 24 inches or more to withstand the droughts and which offered some of the most nutritious plant food in the world. Cottonwood trees grew only along the streambeds.

The animals were there in numbers beyond imagination. In the first two weeks of September 1804, the men of the expedition were the first Americans to see such sights, now gone forever. There were herds of elk in every copse of cottonwoods along the riverbank. Deer were as plentiful as birds. On September 7, the captains took a stroll. To their astonishment, they found themselves in the middle of an extensive village of small mammals that lived in tunnels in the ground. Here, there, everywhere around them, the little mammals would pop up, sit on their hind legs, and chatter. The voyagers said they were "Petite Chien." Lewis examined the only one the men had managed to kill and gave the world the first scientific description of the prairie dog. The next day, Lewis killed his first buffalo, and the hunters brought in two buffalo, one elk, one elk fawn, three deer, three wild turkeys, and a squirrel. On September 14, Clark killed a pronghorn and Private Shields killed a jackrabbit, giving Lewis two more new species to weigh, measure, and describe. Two days later, Lewis named a small creek Corvus, "in consequence of having kiled a beautiful bird of that genus near it." That was one of the few times Lewis used

Latin; the bird was the black-billed magpie, new to science.

Adding to the pleasure, the late summer winds were southerly and the expedition sped along, making 23, then 25, then a record 33 miles in one day—through present-day Nebraska into South Dakota. The captains finally shot a coyote and added a mule deer to the list of firsts. The sizes of the buffalo herds continued to astonish them.

Today the bison are gone, hunters have driven elk off the Plains up into the mountains. Virtually gone, too, are the prairie grasses, as high as six feet when Lewis and Clark were there. The deer, pronghorns, and jackrabbits remain plentiful—still, their presence is a mere shadow of the hordes that engulfed the explorers in this Garden of Eden.

Unlike the Garden of Eden, however, the Plains had people. And the native nations could be as contradictory as the Plains weather. The Otoe were meek and submissive, the Yankton were strong, vibrant, and friendly. What the Teton Sioux would be like was to be discovered. They were known to be the largest nation on the river and were reputed to be the most warlike. It was the only nation Jefferson had named specifically in his instructions to Lewis: The President's order was to make friends with the Teton, no matter what, as they controlled the river.

The expedition met its first Teton Sioux on September 23, when three Teton teenagers swam to the expedition's camp. The only communication was through Drouillard, via sign language. The boys informed the captains that they came from two villages of 80 and 60 lodges, at the mouth of the next river upstream. The captains gave the boys some tobacco and told them to inform their chiefs that the expedition would come to them the following day for a council. They said they would.

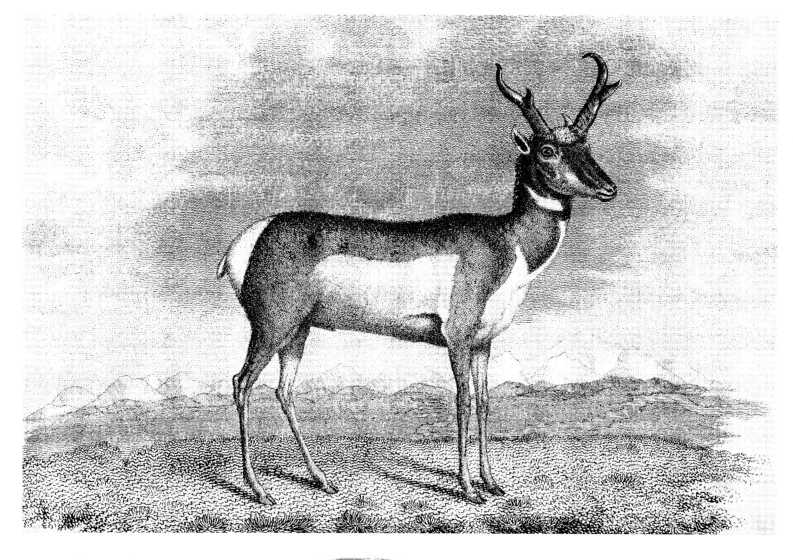

"NEVER yet known in the U.S. States," Sgt. John Ordway wrote of the pronghorn antelope the Corps first encountered on the Great Plains. Clark, who called the animal a buck goat, wrote that with "eyes like a Sheep, he is more like the Antilope or Gazelle of Africa than any other Species of Goat." Another first—prairie

dogs—captivated Clark with their industriousness. "The village of these animals covd. about 4 acres," he wrote. With characteristic optimism, Lewis included a live prairie dog in his April 1805 shipment of specimens to Jefferson. Four months and some 4,000 miles later, the animal reached Washington—alive.

My own first encounter with Teton Sioux was with a group of young Indians, at about the same place—Farm Island State Park—on the river near Pierre, South Dakota. We camped there over Memorial Day weekend of our first trip. It was packed. To get away from the crowds, I took Bib for a long, late-afternoon walk along the water's edge. We came across four Indians in their 20s, leaning on their '54 Olds, drinking beer, laughing, telling macho jokes. The best security in the world are Labs; they won't bite but they sure do make an impression. As I greeted the group, I imagined Seaman at Lewis's side approaching the Sioux settlement. In fact through the entire journey, Seaman was beside Lewis. Master praised his dog frequently, watched out for him, refused multiple offers of sale from Indians who admired Seaman's strength and intelligence. The feeling was mutual. More than once when grizzlies, and a stampeding bison, threatened, Seaman intervened. He was a Newfoundland, cousin to Bib's Labrador heritage, with the same calm patience—"active strong and docile," as Lewis put it. This was a time when Lewis needed his dog—and every one of his men—as that promising start turned sour in the morning.

Private Colter had been camping on a two-mile-long island. He had with him the expedition's last horse. He had killed four elk and hung them on trees along the shore for the party. As Lewis sent a pirogue to pick up the meat, Colter ran up the bank shouting that Indians had stolen the horse. Soon after the captains saw five Indian boys on the bank. They dropped the keelboat anchor and "Spoke to them" through Drouillard. The captains were stern. They said they came as friends, but were ready to fight if need be, and warned that "they were not afraid of any Indians." They never got the horse back but they did proceed to the Teton villages upriver and made camp. The captains put the party on full alert, with one third ashore on guard, the other two thirds staying on board the boat and pirogues.

In the morning, the captains raised the flagstaff, set up the awning, and prepared for a council, taking the precaution to leave most of the party on board, with the keelboat anchored 70 yards offshore so that its cannon commanded the site. At 11 a.m., three chiefs and many warriors came in, bearing large quantities of buffalo meat as a gift. The captains offered some pork. Then it was time to talk.

Drouillard put Lewis's standard Indian speech into the sign language; how much of what Lewis said the Indians could understand could not be told. Then Lewis had the men go through a close-order drill and fired the cannon. Finally, he handed out medals and gifts to the chiefs. He designated Black Buffalo as the leading chief and gave him a medal, a red military coat, and a cocked hat. The other two chiefs, named the Partisan and Buffalo Medicine, got medals. So far as the captains were concerned, that was the end of the ceremony.

That's all? The Teton demanded, unbelieving. Some worthless medals and a silly hat?

To mollify the chiefs, the captains invited them on board the keelboat, where they gave each a quarter-glass of whiskey. The chiefs were "exceedingly fond of it, they took up an empty bottle, Smelted it, and made maney Simple jestures and Soon began to be troublesom." Clark detailed a party of seven men to put the chiefs ashore. The chiefs resisted and had to be forced into the canoe. When it landed, three warriors seized the bowline while another hugged the mast. The Partisan "pretended drunkenness & staggered up against us, Declaring I should not go on Stateing he had not recved presents Suffient from us." The Partisan's insults became personal. He demanded a canoe load of presents before he would allow the expedition to go on.

The Partisan had picked the wrong man to challenge. Clark's blood was up, his honor at stake. He drew his sword and ordered all hands under arms. On the keelboat, Lewis ordered the men to prepare for action. The cannon was loaded with 16 musket balls; the men threw up the lockers as breastworks, loaded their rifles, and prepared to fire. Up on the bank, some warriors saw Lewis preparing the cannon and began to back away, but others strung their bows and took out their arrows from their quivers.

This was the moment Jefferson had had in mind when he told Lewis in his formal orders to exercise caution and avoid a fight if at all possible. But if Lewis recalled that order, he ignored it. He refused to back down and continued to hold

the lighted taper over the cannon. Clark kept his sword out of its scabbard. They were Virginia gentlemen who would not be insulted or bullied. They were ready to push the moment to its crisis. Luckily for them, Black Buffalo stepped forward to avert hostilities. He seized the towline from the three warriors and motioned to the warrior hugging the mast to go ashore.

As they did so, the Partisan, sulking, joined his warriors on the bank. They kept their bows strung. Lewis remained at full alert, ready to fire. Disaster had been avoided but the crisis continued. At last Black Buffalo and two warriors indicated they wanted to sleep aboard the boat. Clark agreed.

"We proceeded on about 1 mile," Clark recorded, "and anchored out off a willow Island placed a guard on Shore to protect the Cooks & a guard in the boat, fastened the Perogues to the boat, I call this Island bad humered Island as we were in a bad humer." The only good thing that could be said about the first meeting between the Teton Sioux and the Americans was that no shots had rung out, no arrows had been launched.

The next day, Black Buffalo showed Lewis the greatest courtesies, including repeated invitations to take a squaw. He made "frequent selicitations" for the expedition to remain one night longer so that the Indians could "Show their good disposition towards us." Lewis agreed. In the late afternoon, Clark and the entire party came to Black Buffalo's village at the mouth of the Bad River across from Pierre. Clark saw Omaha prisoners that had been taken in a great battle two weeks earlier and judged them "a retched and Dejected looking people. The Squars appear low & Corse but this is an unfavorable time to judge of them."

At dusk, the Teton put on a grand pageant for their guests. They opened by carrying the captains on a decorated buffalo robe, attended with much ceremony and music, into the great council lodge and sat them down in the place of honor. Fires glowed through translucent tepees as the women prepared a feast. Slabs of buffalo meat roasted over hot coals. Inside the lodge, 70 elders and prominent warriors sat in a circle, with the men of the expedition beside Black Buffalo. He conducted an elaborate smoking ceremony.

Then he spoke. The captains could not make out what he was saying, beyond that the Sioux were poor and the Americans should have pity on them and give them something. Clark answered that the Sioux should make peace with the Omaha, and as a gesture of good will release the prisoners. Black Buffalo ignored that preposterous suggestion. Instead, he signaled for the dance to begin.

It was a scalp dance, and the scalps were from the Omaha. Clark described it: "A large fire made in the Center, about 10 musitions playing on tamberins made of hoops & skin stretched, long sticks with Deer & Goats Hoofs tied So as to make a gingling noise and many others of a Similar kind, those men began to Sing & Beet on the Temboren, the women Came forward highly Deckerated in their way, with the Scalps an Trofies of war of ther father Husbands Brothers or near Connection & proceeded to Dance the war Dance."

The dance broke up at midnight. Black Buffalo offered the captains young women as bed partners. Clark noted that "a curious custom with the Sioux is to give handsom squars to those whome they wish to Show some acknowledgements to," and added that he and Lewis said no. Black Buffalo and the Partisan then accompanied the captains to the boat, to spend the night on board. At dawn, Cruzatte reported to the captains that the Omaha had told him the Teton intended to stop the expedition and rob it. The captains walked to the village. They trod cautiously, suspecting treachery, and therefore "are at all times guarded & on our guard."

In the evening another scalp dance kept the captains up until 11 p.m. They could scarcely stay awake. The Partisan and one of his warriors accompanied them down to the river. Clark got into a pirogue while Lewis stayed on shore with a guard. The current slammed Clark's pirogue broadside into the keelboat's anchor rope, which broke. The boat began to swing dangerously.

"All hands up and at their oars!" Clark shouted.

The cry and the hustle that ensued alarmed the Partisan. He hollered that the Omaha were attacking. Black Buffalo and some 200 warriors rushed to the riverbank.

Lewis, with the guard on shore, was convinced that Partisan's shouting and the sudden appearance of warriors

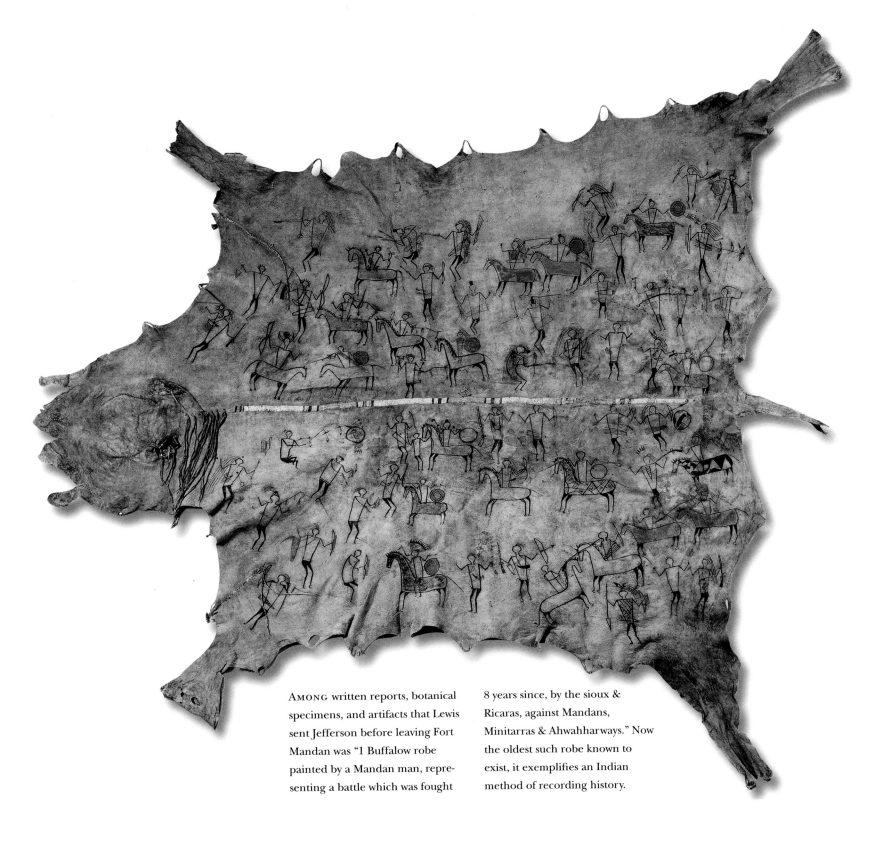

AMONG written reports, botanical specimens, and artifacts that Lewis sent Jefferson before leaving Fort Mandan was "1 Buffalow robe painted by a Mandan man, representing a battle which was fought 8 years since, by the sioux & Ricaras, against Mandans, Minitarras & Ahwahharways." Now the oldest such robe known to exist, it exemplifies an Indian method of recording history.

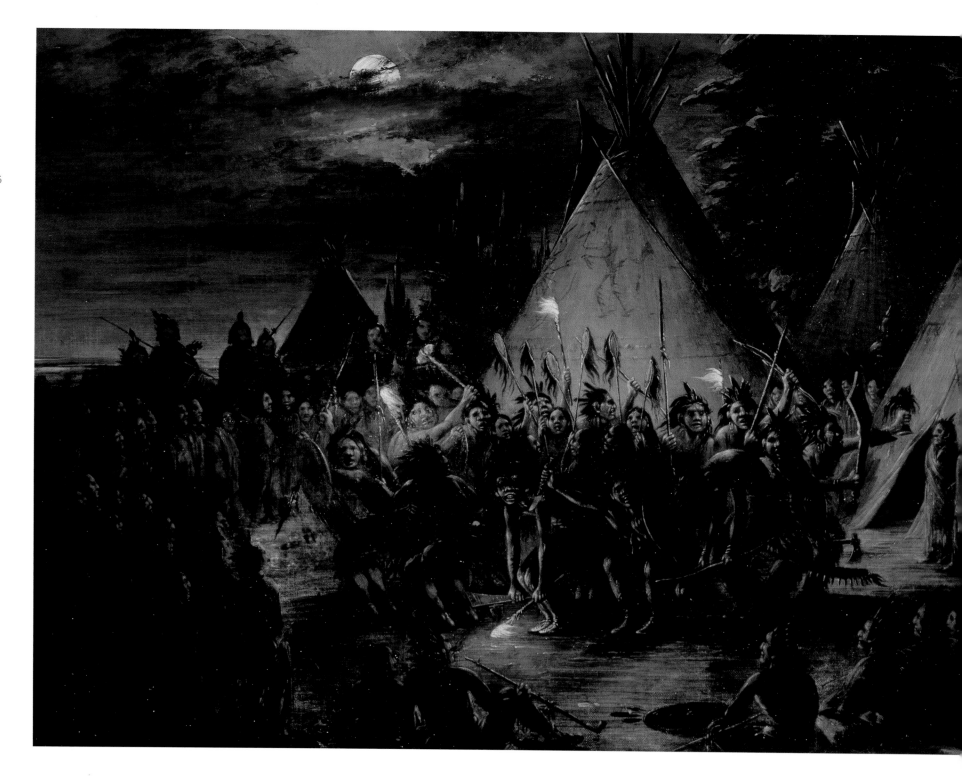

"No DESCRIPTION that can be written could ever convey more than a feeble outline of the frightful effects of these scenes," George Catlin said of the Sioux scalp dance he portrayed in his 1832 painting. Long before Catlin, the Corps of Discovery had witnessed a scalp dance, and held a different view. According to Sergeant Ordway, the dancing was done "with great Chearfullness." "Chearfull," too, were the Sioux squaws, in Clark's opinion. He described them as "fine look'g womin not handsom, High Cheeks...& I may Say perfect Slaves to the men."

was the signal for the intended treachery, just as the Omaha prisoners had said. He ordered a full alert, rifles primed.

Fortunately, nothing happened. The confusion was quickly resolved, and both parties retired. Clark concluded his journal entry for the day: "All prepared on board for any thing which might hapen, we kept a Strong guard all night in the boat. No Sleep."

In the morning, the expedition prepared to proceed. At that moment, the Teton appeared on the bank in great number, well armed. Black Buffalo came on board and asked the captains to stay one more day. As he spoke, several warriors grabbed the bowline. When Clark complained, Black Buffalo said the warriors only wanted some tobacco and then the expedition could proceed. He wasn't asking for much, a trifle merely. But as a symbol, Black Buffalo was demanding what the captains would never pay, an acknowledgment of the right of the Sioux to exact a toll from white men using their river.

Lewis lost his temper. He made clear he would not pay, ordered all hands ready for departure, had the sail hoisted, and detailed a man to untie the bow cable. As he did, several warriors again grabbed the rope.

Clark had seen enough. He wasn't going to risk all over a bit of tobacco (which was twisted into little bundles called carrots). Contemptuously he threw a carrot onto the bank, "saying to the chief you have told us you are a great man—have influence—take this tobacco and shew us your influence by taking the rope from your men and letting go without coming to hostilities." He backed his sarcasm with action—he lit the cannon's firing taper and moved toward it.

Black Buffalo demanded more tobacco. The captains refused. Lewis told him they "did not mean to be trifled with."

It was Black Buffalo's turn for a bit of sarcasm. He said that "he was mad too, to see us stand so much for one carrot of tobacco." Lewis, by now composed and eager to get moving, threw two or three carrots of tobacco to the warriors holding the bowline. With that, Black Buffalo jerked the line from their hands and the boat cast off. The Teton confrontation was over.

The captains had been exceedingly lucky. Had a fire fight broken out, they and their men would almost certainly have been wiped out. They would have taken a goodly number of Sioux with them, thus making the most powerful tribe on the Missouri River the implacable enemy of the United States. It would have been years, perhaps decades, before the United States would become strong enough to send trading parties up the river against the active opposition of the Sioux. The entire timetable of westward expansion would have been slowed.

The men left breathing hard and breathing fire. The expedition had passed the Sioux, but it had not made friends, and it would have to come this way again on the return trip. Lewis's diplomacy had failed, and with the tribe above all others Jefferson wanted to woo to the American side.

These events played through my mind as I continued my own encounter, chatting with the Indians as Bib swam out to retrieve sticks: They were in good spirits, but still there was a touch of apprehension as I imagined unpleasant possibilities, with no one else nearby and darkness coming on fast.

I looked at my watch and mumbled it was time for dinner.

"Ha!" one of the younger men laughed. "Only white men need to look at their watch to see if they are hungry. Stick around—We like that dog. Got a cigarette?"

I handed around cigarettes. These were not bad guys, I knew—I had spent a lot of time hanging around the Sioux when working on my Crazy Horse book and realized that many were unemployed, bored, restless, looking for some fun. These guys were descendants of the Partisan, and of Sitting Bull, but now they were stuck on a reservation, with no buffalo to hunt, wards of a government that had broken every promise it had made to their ancestors.

They were out of beer, and money. They asked me to accompany them into town (12 miles away on a dirt road) and buy them some beer. I shook my head no, I had to get going. They insisted; so did I. As I walked away, Bib at my side, they started chanting one of the old war songs, "Hay Ya Ya, Hay Ya Ya." I don't think it was meant as a threat, and was not taken as one—although I did keep Bib close to me—but it was a reminder of who they had been, and that the valley was once theirs. I was the intruder.

On "a verry Small Sand bar in the middle of the river" the

captains spent a sleepless night, which gave way to a fall morning with the wind from the south. The men hoisted the sail and put 20 miles between themselves and the Teton. In the evening—once again on a sandbar island, the safest place to be—the captains refreshed the party with a gill. It was a cold evening. Migrating geese flew downriver, honking, through the night. Fall was here. It was time to get on, as far north and west as possible, before winter set in.

It was a spectacular time to be on the Plains. The sun had gone past the equinox; the shadows were growing longer. The hills and bluffs, their grasses turned a golden brown, gleamed in the sunlight, or threw off long shadows up and down the valley, creating a masterpiece of light and shade. The great mammals of the Plains were gathering into herds. Elk, pronghorn, and buffalo began their mass migration to their wintering grounds. Canada geese flew overhead, along with snow geese, brants, swans, mallards, all honking and quacking as they descended the river. The days were pleasant, the nights cool—no more mosquitoes! With shorter days, the men had more time around the campfire. The fowl and mammals were in prime condition, which meant that the buffalo ribs, the venison haunches, the beaver tails, the mallard breasts all dripped fat into the fire as they were turned on the spit, causing a sizzle and a smell that sharpened already keen appetites.

On October 8, the keelboat passed a three-mile-long island, near the mouth of the Grand River, home to some 2,000 Arikara Indians. A couple of decades earlier they had numbered 30,000, but two smallpox epidemics had devastated the tribe. Today a mere 1,000 of the tribe exist in all America, mainly living on Fort Berthold Reservation north of the Grand River. In the past half a century they have been forced out of their farmlands by the damming of the Missouri to create, ironically, Lake Sakakawea.

The Arikara were farmers; their island was one large garden, growing beans, corn, and squash. Two of the voyagers with the expedition spoke the Arikara language. Lewis had them come ashore with him, along with two soldiers, to meet the Indians. Clark stayed with the boat, "all things arranged both for Peace or War."

Lewis received a warm welcome. Best of all was meeting two traders, Joseph Gravelines and Pierre-Antoine Tabeau, who lived with the Arikara, spoke their language and English and French. A major part of the problem with the Sioux was the inadequate, incomplete nature of the sign language; a competent translator was much better. Further, from Gravelines and Tabeau, Lewis learned a great deal about the nations on the middle stretch of the Missouri River.

Tabeau told Lewis about local politics. The Mandan were at war with the Sioux. The Arikara, economic dependents of the Sioux, were allied with them. Lewis made a decision to meddle in Indian politics. He thought that if he could persuade the Arikara to break free from the Sioux and ally themselves with the Mandan, then the power of the Sioux would be broken and the Mandan, friendly to whites, would become the dominant nation on the river. To that end he proposed a council the next day; the Arikara accepted.

In the morning, the waves were the highest Clark had seen so far. He was thus astonished to see bull boats brought to the bank—boats made of a single buffalo hide stretched over a bowl-shaped willow frame—and five or six men get in, with three women to paddle. The women pushed off and despite the waves and wind crossed the river "quite uncomposed." They brought with them some chiefs, some warriors, and Tabeau. The captains put on their by-now familiar routine, with much ceremony. Lewis gave his speech, with Tabeau translating. According to Clark, it provided the Indians with "good counsel," which was to embrace their new father, to make peace with the Mandan, to shun the Sioux, and to trade with American merchants only. If they did as told, they would be protected by their new father.

When Lewis finished, a detail fired three shots from the cannon. When the smoke cleared and the Indians recovered from their astonishment, the captains brought out gift bale number 15, marked and prepared for the Arikara back at Wood River. There were vermilion paint, broadcloth, pewter looking-glasses, 400 needles, beads, combs, razors, 9 pairs of scissors, knives, tomahawks, and more. They had had a similar bale marked for the Sioux, but had not brought it out because of their hostile reception. With the Arikara it was

different. Their chiefs got military coats, cocked hats, medals, and American flags. The chiefs ended the council saying they would have to consult with their constituents— the warriors—before they could reply to Lewis's proposals.

That afternoon, the men visited the Indian villages. York was a sensation. His size was impressive enough, but the Arikara had never seen a black man and couldn't make out if he was man, beast, or spirit being. York played with the children, roaring at them, chasing them between lodges, bellowing that he was a wild beast caught and tamed by Captain Clark. The captains finally told him to stop, because "he Carried on the joke and made himself more turibal than we wished him to doe."

York's blackness and curly hair set him apart from the other men. So did his size (he was probably the biggest member of the party) and so did his status as the only slave. And yet, the captains in their journals give fascinating glimpses of York on the expedition that indicate he did everything everyone else did plus looking after Clark's personal needs. York was at his post, rifle in hand, during the confrontation with the Sioux. York went out on hunting parties, carrying his rifle and killing at least one buffalo and many deer. He paddled, pushed, and pulled the keelboat, like everyone else. He sang at the campfire and danced to the fiddle.

Historian Gerard Baker, of Mandan heritage, who in 1997 was superintendent of the Little Big Horn Battlefield, says of the Indians' reaction to York, "Different wasn't wrong." That point of view prevailed with every tribe that came into contact with York. Unfortunately for him, that wasn't the white man's attitude, so no matter what he did, or how well, he would remain a slave.

The soldiers, meanwhile, enjoyed the favors of the Arikara women, encouraged to do so by the husbands, who believed that they would catch some of the power of the white men from such intercourse, transmitted to them through their wives. One warrior invited York to his lodge, offered him his wife, and guarded the entrance during the act. York was said to be "the big Medison." Sergeant Gass pronounced the Arikara women to be "the most cleanly Indians I have ever seen…handsome…the best looking Indians I have ever seen." Sergeant Ordway agreed: "Some of their women are very handsome and clean."

The following day, the chiefs returned to the expedition's camp to make their answer to Lewis's proposals. One of the chiefs, unnamed, agreed to accompany the expedition to the Mandan and talk peace. The Corps continued north.

On October 20, near present-day Bismarck, North Dakota, Private Cruzatte was the first to encounter a grizzly bear. The whites had heard the Indians talk about the grizzly, and Clark had recently seen a footprint that he pronounced the biggest he had ever seen. The men were eager to get a look and a shot at it. Cruzatte was the lucky one—except, as Lewis dryly recorded, "he wounded him, but being alarmed at the formidable apparance of the bear he left his tomahalk and gun." An hour later, Cruzatte returned for the weapons. "Soon after he shot a buffaloe cow," Lewis wrote, and "broke her thy, the cow pursued him he conceal himself in a small raviene." The little incident highlighted a major problem for the hunters—after they had fired their rifles, they were helpless until they got a chance to reload.

By October 24 the expedition was approaching the Mandan villages, where the captains intended to build winter quarters. The environs of Bismarck would be well-traveled. Seventy years later George Armstrong Custer would set out to look for Indians from Fort Abraham Lincoln built on this land. He found them at the Little Big Horn. The restored Fort Lincoln stands there today. Nearby, a village of Mandan earth lodges looking much like those Lewis and Clark approached send a thrill through the traveler. We felt it from a distance as houses materialized and we recognized stands of hardy cottonwood. The party's survival for the winter—indeed at all—depended on what greeted them there. That day in 1804, they met their first Mandan, Chief Big White and a 25-man hunting party. With Gravelines translating, Lewis introduced Big White to the Arikara chief with "great Cordiallity & Sermony." They smoked a pipe. Lewis, Gravelines, and the Arikara chief accompanied Big White to his village. Peace between the Arikara and the Mandan seemed possible. The captains were off to a good start with the Indians who would be their neighbors for the winter.

MAN of magic: York, Clark's slave
and the only nonwhite man on
the expedition, captivated the
Plains Indians, who had never
seen a black man before. Some
thought his color must give him
powerful "medicine"; others,
like the skeptical Hidatsa chief,
Le Borgne, portrayed in this
1908 painting by Charles M.
Russell, rubbed York's skin to see
if he was not a painted white
man. York playfully encouraged
his myth, telling the Arikara that
he was a wild beast caught and
tamed by Clark.

WINTER WITH THE MANDAN

THE MANDAN, AND THEIR RELATIVES AND ALLIES the Hidatsa, lived along the Missouri and Knife Rivers in five villages of about a thousand residents each. They lived in earthen lodges that answered perfectly their greatest challenge, getting through the North Dakota winter. The dome-shaped lodge held in the heat from a central fire while allowing the smoke to escape through a hole at the top. Inside, there was room for extended families and their horses. The Mandan were in two villages on the Missouri, led by Big White and Black Cat. The Hidatsa were on the Knife River, coming into the Missouri from the west. Today the descendants of these two tribes, plus the Arikara, live on Fort Berthold Indian Reservation. The community of some 8,500 residents encompasses both sides of the Missouri River northwest of Bismarck.

The Mandan hunted buffalo on horseback but did not ride out on war parties ranging to the Rocky Mountains, whereas the Hidatsa rode the whole way to the snow-covered peaks to make raids and capture horses and slaves. The Hidatsa had been where Lewis and Clark were going, where no white man had yet set foot. They were an intelligence source waiting to be tapped.

First, the captains needed to establish winter quarters. They wanted a site with plenty of wood and game. At the end of October, they picked their spot and work began on Fort Mandan. It was on the north bank of the Missouri, some seven miles below the mouth of the Knife and directly opposite Big White's village. The men went at the work with a will, as well they might; as Pvt. Joseph Whitehouse put it in his journal, "All the men at Camp Ocepied their time dilligenently in Building their huts and got them Made comfertable to live in." Those huts would be home for five

months, with lower temperatures and higher winds than any of the men had ever experienced. The fort consisted of two rows of huts, set at an angle, with a palisade on the river side, a gate and a sentry post, plus the cannon mounted. The outer walls were 18 feet high. A magnificent stand of cottonwood trees surrounded the place; it would be gone by spring, burned to feed the fires.

On our first trip in 1976, Moira and I went looking for the site. We followed the river bluffs to Washburn, where we got some vague directions to follow such and such a dirt road and we would find the little marker. We did our best picking our way through brush, got down to the river, found some fishermen, who gave us more accurate directions, drawn in the dust with a stick—just the way Lewis and Clark got directions from the Hidatsa.

We followed the fishermen's directions: a winding line for the Missouri, with another line departing from it at a northeast bend, continuing due north through circles—a copse of trees—and into a valley. There we found the marker—a stone plaque—proclaiming this was the site of Fort Mandan, although due to frequent changes in the course of the river, the actual site cannot be determined. The silence of the place sparked our imaginations.

The Corps of Discovery was on the edge of the unknown. Only two or three white men had been west of this spot and they had left no written record. Here the men would spend their first winter in the wilderness, their first among Indians. Outnumbered more than a hundred to one by their immediate neighbors, safety was the prime consideration, along with food and warmth. The fort would provide safety, the local game plus Mandan corn and squash would provide the food, cottonwoods the warmth. I don't suppose any of them

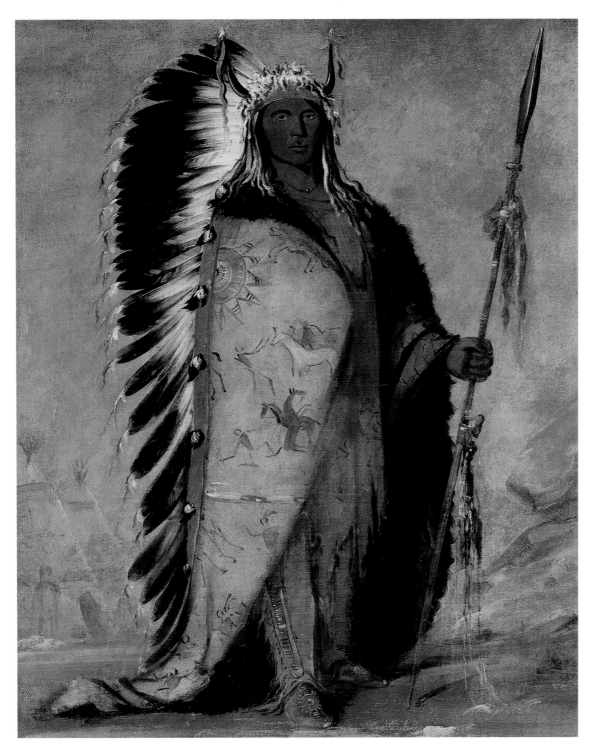

BEDECKED with the regalia of
bravery, Mandan Chief Black Rock
wears the split-horned, eagle-
feather headdress conferred on
a leader of great valor and a
buffalo robe recording his
courageous exploits. The winter
Lewis and Clark spent among the
Mandan and Hidatsa apparently
left a lasting impression on the
Indians. When George Catlin, who
painted this portrait, arrived 30
years later, an aging Hidatsa chief
asked after Long Knife (Lewis)
and Red Hair (Clark).

looked forward to it, but they were determined to make the most of it, the captains especially. They planned to use their time collecting information from the Hidatsa and writing a report to Jefferson on what they had found so far. Thus would Fort Mandan become the first research/scholarship center west of the Mississippi.

Some distance from the plaque, the McLean Historical Society of North Dakota has built a replica of Fort Mandan on the river near Washburn, where a new interpretative center opened in 1997, with excellent displays about the local Indians and life at the fort. The replica, built as the captains sketched it in their journals, appears as one Canadian trader observed in 1807, "so strong as to be almost cannonball proof." In other words it would answer for protection and safety. At the same time it is extremely compact. Each hut measures just 14 square feet, the entire fort not more than 3,300 square feet.

I visited the site in 1997 with Gerard Baker, accompanied by author-historians and filmmakers Ken Burns and Dayton Duncan, who were doing a television documentary on the expedition. To our modern eyes, it seemed impossible that more than 30 men could live in such confinement through a North Dakota winter, with not much more than eight hours of daylight and nothing but candles for light. We swapped favorite lines from the journals and stories about the rigors of winter in Dakota.

Gerard is huge—the size of a National Football League lineman—with the most marvelously rugged good looks and the physical grace of a dancer. He is a Mandan-Hidatsa and always reminds me of Big White. You expect him to roar like a grizzly, but he is in fact a soft-spoken man, full of good humor and subtle jokes. He is a scholar who learns from books, from the elders, and from practicing old ways, which includes dealing with the frigid winters.

He likes to tell about the time Dayton was working on his 1987 book *Out West*. Dayton wanted to find out what it was like sleeping in a Mandan earth lodge in January. Gerard agreed to join him at the Knife River Indian Village across the Missouri from Fort Mandan. They got to the lodge there and built a fire. Gerard burned a twined rope of sweetgrass

and blew the smoke in the four directons. "For the spirits," he explained. Then he cooked—potatoes, onions, red peppers, and buffalo tripe. "Hidatsa lobster," he called it.

Gerard warned Dayton that if he had to do his business during the night he should be quick about it, else he would get frostbitten. Then he spread out a buffalo robe on the floor for Dayton, and gave him another four to use for covers. As Dayton arranged himself, he asked Gerard what he was going to use. Gerard shook out his "good ol' Eddie Bauer," a goose-down sleeping bag "guaranteed to 20 below." He had only a hint of a smile.

When he finished the story, Gerard explained, "Teasing is a big part of Indian life."

On October 29, 1804, Lewis and Clark held their first formal council with the Mandan. Lewis gave his basic Indian speech; to Clark's dismay "The old Chief was restless before the Speech was half ended." Another chief "rebuked him for his uneasiness at Such a time." Clark complained that the Mandan "known nothing of regular Counciles, and know not how to proceed in them, they are restless &c." When Lewis finished, Clark introduced the Arikara chief, who smoked with the Mandan and talked peace. Big White and the Arikara agreed to a truce.

On November 4, Clark recorded that "a french man by Name Chabonah visit us, he wished to hire & informed us his 2 Squars were Snake Indians." The man's name was Toussaint Charbonneau. A French Canadian, about 45 years old, he was living among the Hidatsa as an independent trader. His squaws were teenage Shoshone (or Snakes) who had been captured by a Hidatsa raiding party four years earlier at the place where three rivers came together to form the Missouri, called Three Forks. Charbonneau had won them in a bet with the warriors who had captured them.

Here was opportunity. The captains had learned from the Hidatsa that the Rocky Mountains were snow-covered even in August, meaning the party was going to need horses to get over them. The Hidatsa had further informed them that the Shoshone lived at the headwaters of the Missouri and were rich in horses. Now here was the French-speaking Charbonneau with Shoshone-speaking squaws (who could

speak to Charbonneau in Hidatsa), offering his services. They signed him up at once, and told him to pick one of his wives: he chose Sacagawea, who was about 15 years old and 6 months pregnant. The couple moved into the fort, apparently leaving Charbonneau's other wife to fend for herself.

Sitting in front of a fire of crackling cottonwood limbs, neither one could understand the stories the men told—although Charbonneau could communicate with Private Labiche and a few others who spoke French. We know—from the journals—that Charbonneau was small, dark, feisty. Stephenie and Grace asked me if we know anything about Sacagawea's looks. Not one of the journal keepers ever thought to describe her, but she can be imagined: A young mountain girl who had been brought to the Plains, traded among red and white men like a piece of property, surrounded by strangers (except for a while her sister, which must have helped considerably), few to talk to except her husband, who treated her with indifference. And six months pregnant, with no older woman around to provide advice or help. Within the fort, where she spent most of her time, no other woman at all. Only men.

At Fort Mandan, Lewis continued to practice Indian diplomacy. Having arranged a peace between the Mandan and Arikara, he wanted to bring the Hidatsa into the accord. But he met resistance. War was necessary so that the Hidatsa could witness the achievements of their warriors, and thus choose their chiefs. That the captains were meddling in affairs they didn't understand became even more obvious on November 30, when a raiding party of Sioux and Arikara attacked five Mandan hunters, killing two and stealing nine horses. The peace had not lasted a month. The Mandan blamed the captains, who had said there was a peace and caused the Mandan to let down their guard. One chief said he had always known that the Arikara were "liers, they were liers."

Within a week, the Mandan had forgiven the Americans, who after all promised to be good customers for Mandan corn, beans, and squash through the winter. One of the Mandan chiefs offered horses for any soldiers who wished to join the Mandan on a buffalo hunt. Lewis gathered a party of 15 men. To his astonishment, the Indians as riders put the Americans in the shade, even Americans from Virginia. Riding bareback at breakneck speed chasing the fleeing buffalo, they could guide their horses with their knees, leaving their hands free to shoot their arrows, which they did with such force that often an arrow would go right through the buffalo. Squaws came after, to butcher the animals before the wolves could get to the carcasses. With their rifles, Lewis and his men killed 11 buffalo that day. They enjoyed the experience so much they stayed out all night, sleeping in a buffalo robe in below-zero weather. The next day, they killed 9 more buffalo. They ate only the tongues; the wolves got the rest. "We lived on the fat of the land," one of the party reported. "Hunting and eating were the order of the day." That night, the temperature went down to 45° below zero F —and winter was still 13 days away.

How cold did it get? Some nights $-20°F$. Some nights worse. Lewis kept a weather diary—the first collection of weather data from west of the Mississippi River—and reported the average temperature in December was 4° above 0; in January 3° below zero; and 11° above for February. The Indians were accustomed to it; as Clark put it, "Customs & the habits of those people has ancered to beare more Cold than I thought it possible for man to indure."

For our part, we were amazed at the cold the Corps of Discovery endured. This was the coldest any of them had ever been, and in place of the longjohns, down-filled parkas guaranteed to 20° below, fur-lined boots, and gloves that Barry and I use when we go winter hunting, they had buckskins and handmade moccasins (with the fur turned in), along with heavy, cumbersome buffalo robes for overcoats. In their huts, they were either too hot—when near the fire—or too cold. The rooms were smoke-filled, the split-log floors were cold, the light from the candles dim at best.

The captains kept the men busy, both because there was real work to be done, beginning with wood-gathering and meat-hunting, and because they knew for a certainty that an idle soldier is a bored soldier headed for trouble. The garrison maintained regular military security, with drills and sentry-posting (30 minutes on duty when the temperature

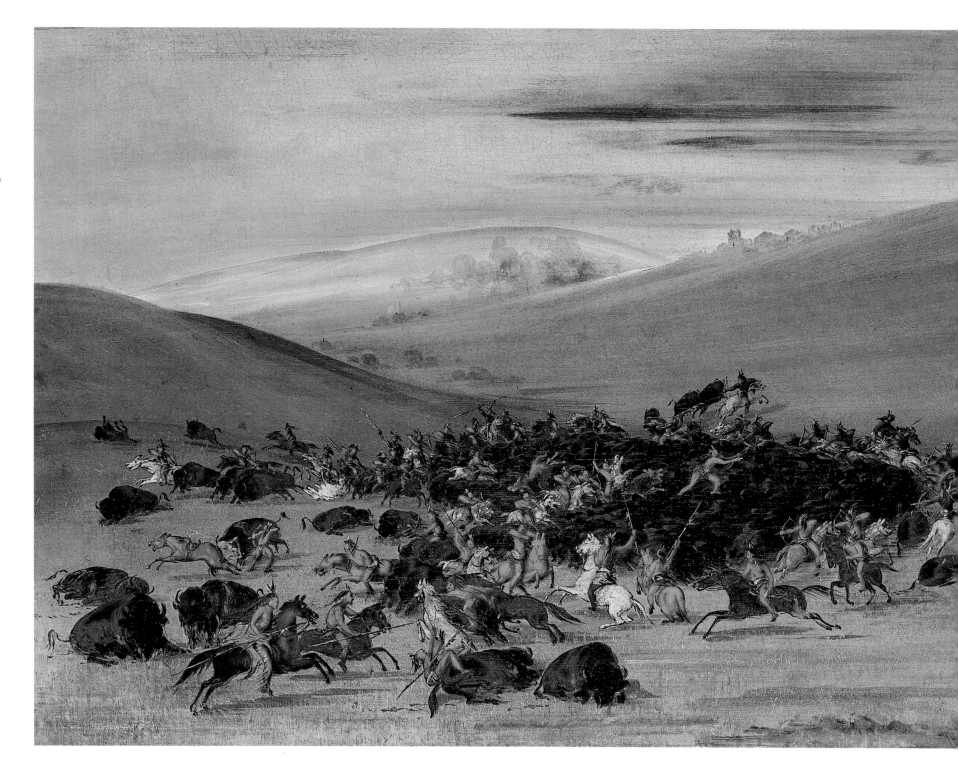

THE HUNT is on: Encircling a herd of bison, called buffalo by the Corps, Hidatsa warriors (opposite) charge in for the kill, aiming for a spot just behind the last rib. The survival of the Plains Indians hinged on successful hunts, as the bison provided them with food and clothing through the raw Plains winters. In the painting above, Hidatsa elders huddle into their buffalo robes as they watch two young braves play hoop-and-pole over the frozen ground. Hidatsa dome-shaped earth lodges were hubs of indoor activity, and heat efficient. A thick matting of grass and mud spread over a frame of branches provided insulation; a hole in the ceiling let out smoke from a central fire.

fell below 0°F, 30 minutes to warm up at a fire) replaced every half hour.

At Wood River the previous winter, the captains had faced some severe discipline problems. But at Fort Mandan, there were no fights, no desertions, no dereliction of duty. The Corps of Discovery was an elite unit now, in which discipline was perfect and obedience was instant.

Relations with the Mandan improved from acceptance to friendliness. There was no clash of cultures, but rather a mingling of customs.

That winter the Mandan's earthen lodges turned into hubs of activity that ranged from dancing and feasting to storytelling. Entering a replica of one of these lodges gets your imagination going, picturing the festivity Lewis recorded: Private Cruzatte with his fiddle joined Indian musicians with tambourines, drums, and sounding horns to play for a dance. York danced, "which amused the croud verry much, and Some what astonished them, that So large a man Should be so active." What a spectacle it must have been: a fire blazing at the center of the dirt floor, lighting the disparate forms of the spritely Cruzatte and the mighty York, spectators hanging on every movement.

In 1997, Ken, Dayton, Gerard, and I sat around a fire in one of the lodges at the replica of On-A-Slant Village next to Fort Abraham Lincoln, near Mandan, North Dakota. Gerard told us about his grandfather passing on a story of one of the Mandan chiefs rubbing York's face with dirt and spittle in an attempt to rub off the black—a scene immortalized by Charles M. Russell in one of his most famous paintings.

This happened during a dance held in the largest of the earth lodges. The dancers entered first, then the musicians. To the rattle and drumbeat, the old men of the village entered, gathered into a circle, sat down, and waited. Soon the young men and their wives filed in, to take their places at the back of the circle. There was a smoking ceremony. Then the drumbeat became more insistent and the chanting swelled, and one of the youngsters would approach an old man and beg him to take his wife, who in her turn stood naked before the elder. The girl would lead him by the hand and—but let Clark tell it, as only he can: "The Girl then takes the Old man (who verry often can Screcely walk) and leades him to a Convenient place for the business, after which they return to the lodge."

The Mandan believed that power could be transferred from one man to another through sexual relations with the same woman. To the great good luck of the enlisted men, the Mandan attributed to the whites great powers. So, throughout the three-day buffalo dance, the Americans were "untiringly zealous in attracting the cow" and in transferring power. One unnamed private made four contributions. A direct consequence was syphilis. Nearly every man suffered from the disease. The captains treated it by having the patient ingest mercury in the form of a pill called calomel (mercurous chloride).

Lewis's most unusual experience as a doctor came on February 11, when he was present for Sacagawea's labor. Lewis noted that "this was the first child which this woman had boarn and as is common in such cases her labour was tedious and the pain violent." He had heard from a trader that a small portion of a rattlesnake's rattle was sovereign in such cases. Lewis was always ready to undertake a medical experiment. "Having the rattle of a snake by me," he wrote in his journal, he broke the rattles into small pieces and mixed them with some water, which Sacagawea then drank. "Whether this medicine was truly the cause or not I shall not undertake to determine," Lewis wrote, "but she had not taken it more than ten minutes before she brought forth."

The baby, a boy named Jean Baptiste Charbonneau, was healthy and active. The family had its own hut inside Fort Mandan, so the cries of a hungry infant rang through the parade ground and surely caused a least some pangs of homesickness among at least a few of the man, as they remembered their own families. With the birth, the roster for the expedition was complete. The permanent party that would head west in the spring consisted of the three squads of enlisted men, each with its sergeant, plus the two captains, and five persons from outside the military establishment: Drouillard, York, Charbonneau, Sacagawea, and Jean Baptiste (nicknamed "Pomp" by Clark).

By February the pickings were slim. There were fewer and

leaner animals around. The men needed their calories to live in the cold. On many days, only Mandan corn and beans could provide those calories in sufficient quantity. But the captains needed to hoard their trade goods, for whatever lay ahead. Pvt. John Shields solved the problem. He was a skilled blacksmith. He had set up for business at the expeditions' forge and bellows inside the fort. When the market for mending hoes and sharpening axes had been satisfied, he began making battle-axes, a weapon that was highly prized by the Mandan and easily made by Shields.

Lewis disapproved of the design, writing that it was "formed in a very unconvenient manner in my opinion." The blade was too thin and too long, the handle too short, the overall weight too little. A replica I studied at Mandan attests to its asymmetry—medieval in appearance, the tool is badly balanced and too light to serve as a weapon. But Shields couldn't turn out battle-axes fast enough. How popular those axes were among the Indians, Shields found out some 14 months later, when he discovered axes he had made at Fort Mandan among the Nez Perce on the other side of the Rocky Mountains. This was dramatic example of the extent of the Plains Indians trading area—it ranged from the Missouri to the Columbia.

Shields earned dozens of bushels of corn for his axes, and it was Mandan corn that got the expedition through the winter. Had the Mandan not been there, or had they had no corn to spare, or had they been hostile, the expedition would not have survived the winter.

The winter involved hunting, trading, keeping fit, dealing with the cold, doing extensive repairs to old equipment and building new canoes, visiting the Indians, and more. But for Lewis and Clark it was primarily a winter of scholarship, of research and writing. Their subject was America west of the Mississippi River. They wrote about what they had seen and learned. The end result, a report to Jefferson, ran to 45,000 words—book-length—and constituted the first systematic survey of the trans-Mississippi West. It provided an invaluable contribution to the world's knowledge. The subjects were the flora and fauna of the Missouri River country, its climate and fertility, its peoples and their wars and economies.

The captains collected information in two basic ways. First, from their own observations. Second, by making local inquiry. They asked questions about the surrounding country of every Indian and white trader they met.

Altogether the amount of information they gathered, organized, and presented to Jefferson—and beyond him to the scientific world—was enough to justify the expedition. The ethnography alone was priceless. They described the Sioux, Mandan, Hidatsa, and other tribes. They did not hesitate to make judgments. They wrote of their friends the Mandan, "These are the most friendly, well disposed Indians inhabiting the Missouri." Of the Teton Sioux, the opposite: "These are the vilest miscreants of the savage race, and must ever remain the pirates of the Missouri."

Gerard Baker, and other modern Indians who have sought out their people's oral traditions, can give a Mandan and Hidatsa view of the Corps of Discovery. These were sophisticated Indians. French trappers and British traders had lived among them for decades before the Corps arrived. They knew about white men, and their products. What amazed them was the captains' determination to go not just to but over the Rocky Mountains, then descend to the great lake whose waters were "illy taisted." And they weren't all that happy with Shields's prices for their axes, not to mention the captains' stingy ways when it came to handing out presents. But overall they were delighted to have so large a party spend the winter with them, and they found the white man's ways were as delightful and odd as the white men found their practices. As Dayton remarked, sometimes it is hard to tell who was studying whom. Both sides learned: the white men how to hunt buffalo from horseback, or build bull boats; the red men how to repair muskets or dance to a fiddle. They were teachers, students, and friends. The winter they had dreaded turned out to be a joy. This was shown by the health of the men: There was not an illness through the winter worth recording in the journals.

Along with the written report, the captains sent back to Jefferson 108 botanical specimens, all properly labeled as to where and when collected, and described. These were pressed plants. They also sent minerals. These were part of a

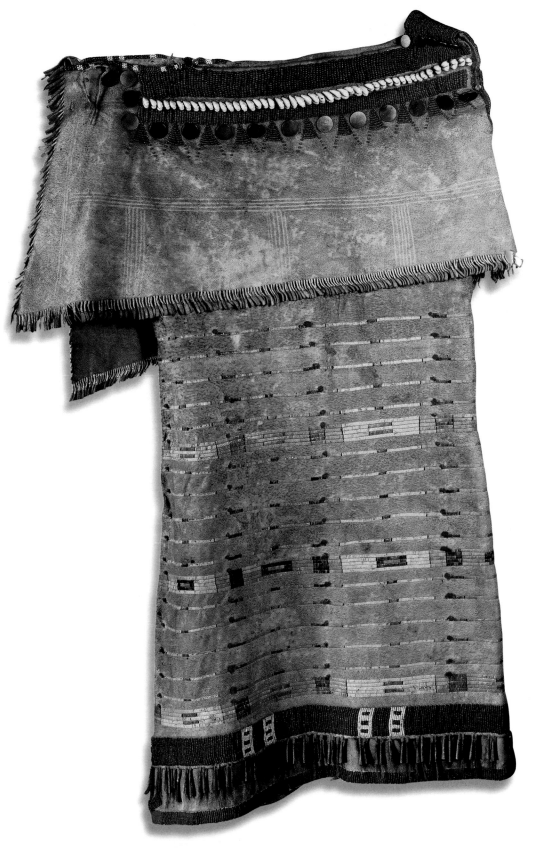

Beads, buttons, tin pendants, and deer-hair fringes adorn a Cree dress that Lewis sent back to Jefferson. Now the oldest existing piece of Plains Indian beadwork, the dress was traded to the captains by a group of Cree who stopped at the Corps' winter quarters, Fort Mandan, in November 1804. Trading networks among tribes extended across the western lands. A battle-ax that Private Shields designed and made proved so popular as a trade item that Shields found his handiwork among the Nez Perce, on the far side of the Rockies. Though Lewis sketched the ax (top) in his journal, he noted that in his opinion it was "formed in a very inconvenient manner."

larger shipment that included skeletons of a male and female pronghorn, the horns of two mule deer, insects and mice, skins of various animals, and more, including live animals new to science: four magpies, a prairie dog, and a prairie grouse hen. (Only one magpie and the prairie dog reached Jefferson alive.)

Clark's major contribution was his map of the United States west of the Mississippi River. It was a masterpiece of the cartographer's art and an invaluable contribution to knowledge. His depictions of the various tributaries were based on hearsay, of course, and of course were sketchy the farther away from the Missouri they got. Still, Clark did well; he would talk to every Indian he could find and compare one description with another, questioning them separately and together. Only when there was agreement on placement, distance, mountain passes, and so forth was the information put on Clark's map and into Lewis's report.

Much of what Lewis and Clark sent back in the spring of 1805 is on display today. The Great Hall at Monticello has horns, heads, painted buffalo robes, and Indian artifacts. Jefferson successfully cultivated the various seeds Lewis had shipped; many of those plants are growing in the Monticello garden today. Jefferson, pleased and proud, shared the plants and seeds with his scientific friends in Philadelphia and Paris. At the Academy of Natural Sciences in Philadelphia, in 1997, Moira and I had the never-to-be-forgotten thrill of holding in our hands plants that Meriwether Lewis had collected and pressed. We were especially taken with the bear grass, a member of the lily or agave family that grows across the West, with a foliage resembling coarse blades of grass. It was commonly used by Indians of the Northwest for making clothing and fine baskets. Lewis and Clark collected it at a site in the Idaho mountains, a site where we have camped. Bear grass still grows there.

In the five months between May and October 1804, the captains and their men had traveled more miles than many of their contemporaries would in a lifetime. In the five months between November 1804 and April 1805, they had stayed in one place. The anticipation of getting going again was so keen it was almost unbearable.

On the last day of March, Clark wrote, "All the party in high Spirits, but fiew nights pass without a Dance."

By April 6, they had the packing complete. The following day Corporal Warfington would head downstream for St. Louis on the keelboat, carrying the reports, maps, specimens, and the rest. The captains and the other members of the permanent party would head upstream in six new canoes and the two pirogues. Once the party reached the mountains, "any calculation with rispect to our daily progress, can be little more than bare conjecture." But Lewis's hopes were high: "The circumstance of the Snake Indians possessing large quantites of horses, is much in our favour, as by means of horses, the transportation of our baggage will be rendered easy and expeditious over land, from the Missouri to the Columbia River." In the conclusion of his report to Jefferson, Lewis wrote: "I can foresee no material or probable obstruction to our progress, and entertain therefore the most sanguine hopes of complete success. I have never enjoyed a more perfect state of good health. Capt. Clark and every individual of the party are in good health, and excellent sperits; zealously attached to the enterprise, and anxious to proceed; not a whisper of discontent or murmur is to be heard among them; but all in unison, act with the most perfect harmoney. With such men I have everything to hope, and but little to fear."

I wish I could have said something similar as we prepared in the late spring of 1976 to penetrate Montana, but in fact my journal entries indicate considerable trepidation. June 10: "Of all the things I envy Meriwether Lewis for, at the top of the list is his military authority. I announce that we will be packed and ready to roll at 7 a.m.; at 8 a.m. I'm pleading with the kids to get moving. Moira chastises me when I yell at them; there is no way to enforce my will. Plus there is more than a whisper of discontent; there is daily whining about inconsequential matters. There is concern: So far, all our camping has been in state parks, next to our vehicles, so we have not been tested yet; canoe camping and backpacking will be more demanding. Otherwise, we are in good health and spirits, and anxious to proceed, fully attached to the enterprise and determined to make it to the Pacific."

"This Day we passed Several Islands, and Some high lands on the Starboard Side, Verry hard water."

WILLIAM CLARK ~ MAY 22, 1804

FOG follows the broad course of the Missouri above St. Louis. Now dredged and tamed, the once wild river no longer challenges modern boatsmen as it did the Corps of Discovery.

FORESTED sandstone palisades pocked by caves still line the lower Missouri. On its second day out, the expedition stopped to reconnoiter a large cave (left) "Called by the french the *Tavern*— about 120 feet wide 40 feet Deep & 20 feet high," Lewis recorded, "many different immages are Painted on the Rock at this place the Inds. & French pay omage." Climbing the sheer cliffs (opposite) above it, Lewis—and the fledgling expedition—met with near disaster when the captain lost his footing. "He caught at 20 foot," Clark calmly recorded. "Saved himself by the assistance of his Knife."

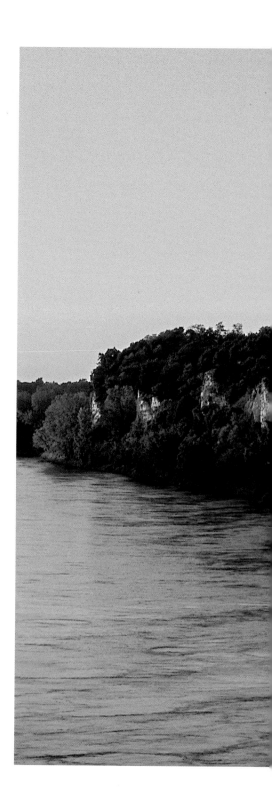

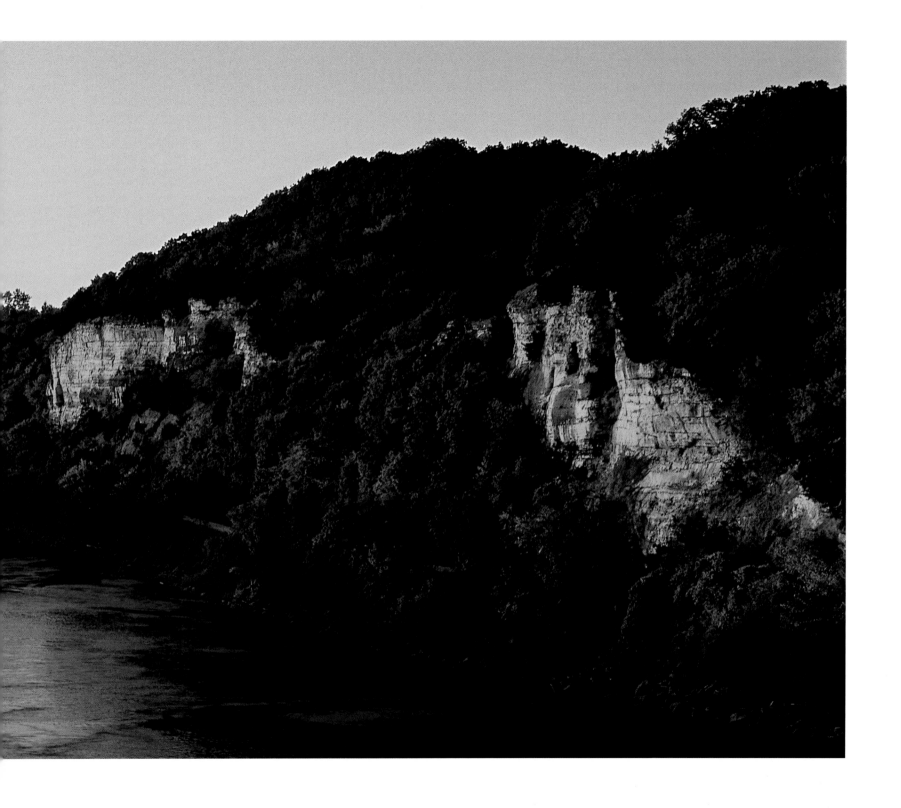

STONE obelisk in Sioux City, Iowa, memorializes the first and only casualty among the Corps of Discovery. "Serj. Floyd Died with a great deal of Composure," Clark wrote on August 20, 1804, attributing the cause to "Biliose Chorlick." Near present-day Vermillion, South Dakota, the expedition came upon a "*Mound* which the Indians Call Mountain of *little people* or Spirits." So much did the Indians fear the evil 18-inch-tall "Deavels" said to inhabit Spirit Mound (opposite) that "no Consideration is Suffecient to induce them to approach the hill."

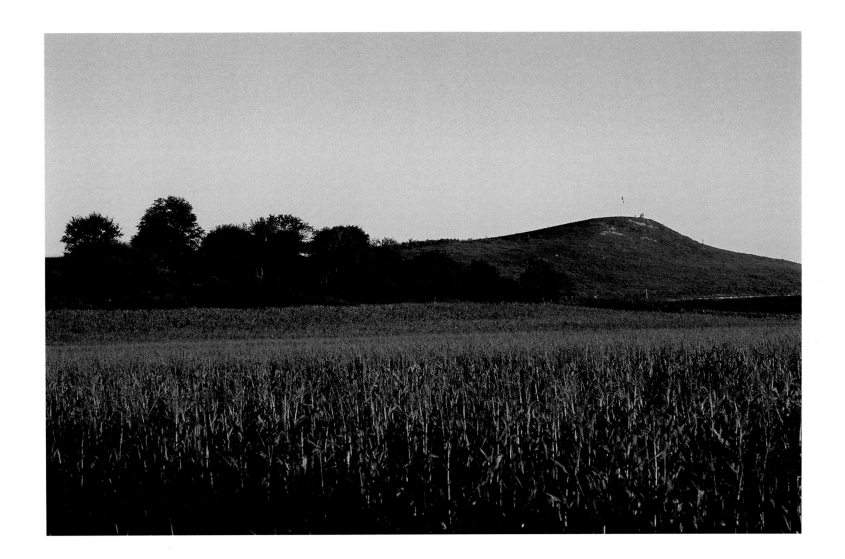

ISLANDS in a racing river: A rare, free-running stretch of the lower Missouri evokes the unruly river course that the captains encountered almost 200 years ago. Struggling upriver, they had to battle whirlpools, sandbars, shifting currents, and floating logs that perpetually threatened to capsize them.

ADDING a grace note to the riverscape, a skein of American white pelicans wings its way along the Missouri. Early in his journey, Lewis reported floating through three miles of feathers "in such quantities as to cover prettey generally sixty or seventy yards of the breadth of the river." Farther upriver, the expedition came upon the source of the feathers: a flock of pelicans so numerous "they appeared to cover several acres of ground." Dutifully, Lewis recorded their breeding habits and their "Discription of Colour &c." in his journal, now considered one of the best natural history records ever kept.

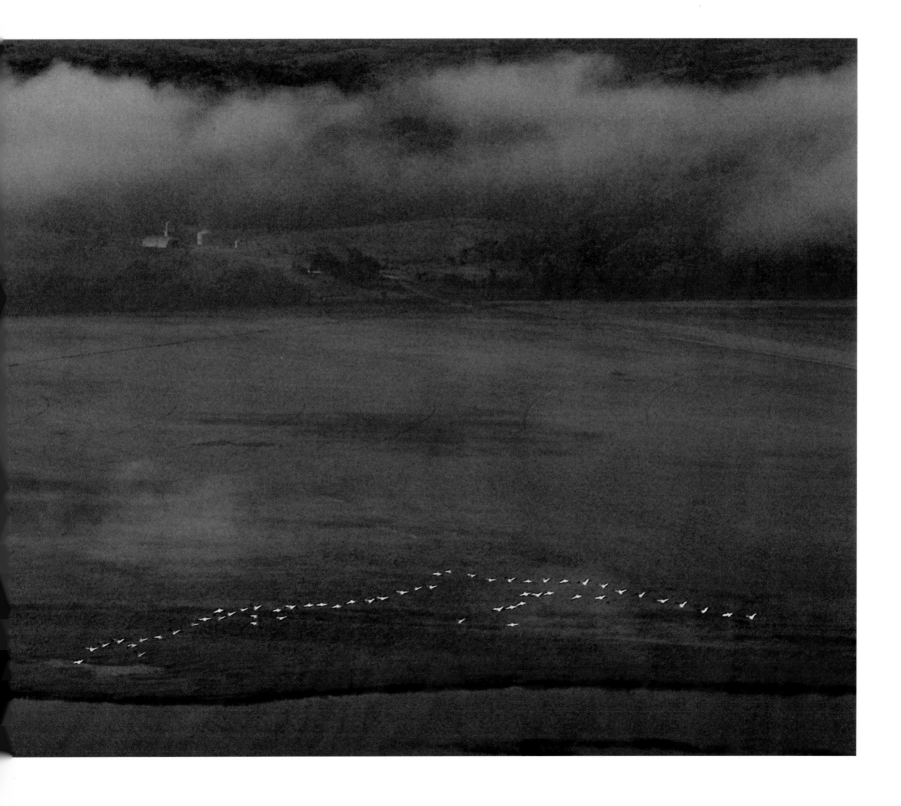

"A BUTIFULL Countrey on both Sides of the river. the bottoms Covd. with wood, we have Seen no game on the river to day, a pro[o]f of the Indians hunting in the neighbourhood," Clark wrote on October 24. Here on the northern plains of present-day North Dakota, the captains planned to winter over with the Mandan, "the most friendly and well disposed savages that we have yet met," Lewis wrote reassuringly to his mother in Virginia.

RECONSTRUCTED Fort Mandan depicts the secure if remote outpost the expedition occupied during the often sub-zero winter of 1804-05. "Our Rooms are verry close and warm," Sergeant Ordway wrote. Close and warm, too, were the earthen lodges of the Mandan, replicated nearby today at On-A-Slant Village (opposite). When game grew scarce, the Corps traded with the Mandan for beans, corn, and squash. "We gave to the whites the name *Maci*, meaning...pretty people," a Mandan chief recalled. "We said also, 'We will call these people our friends.'"

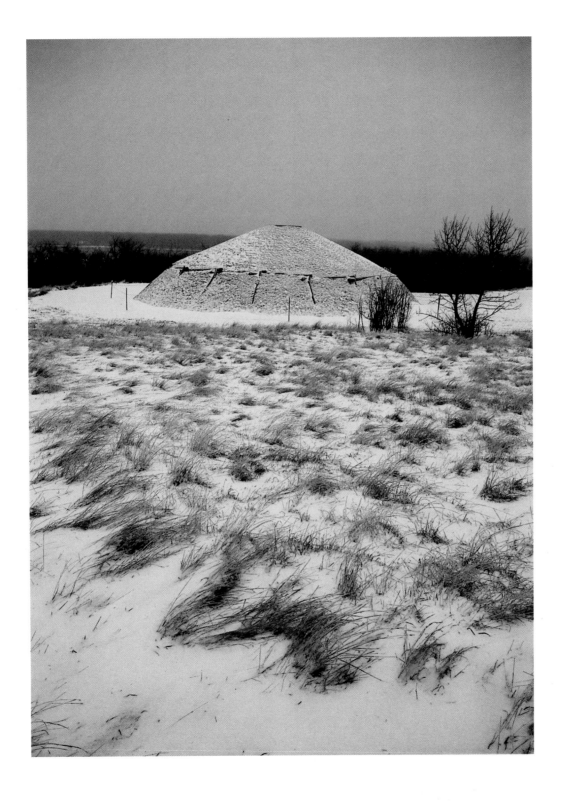

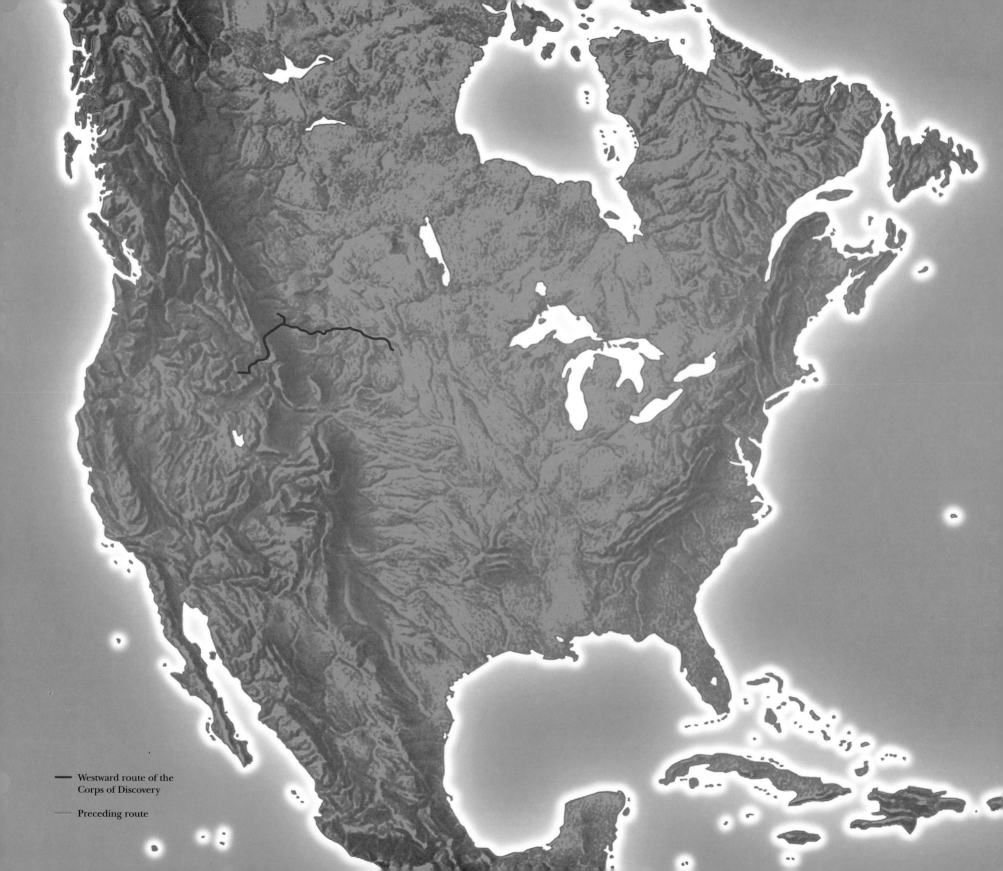

— Westward route of the
 Corps of Discovery

— Preceding route

Uncharted Territory

"We were now about to penetrate a country at least two thousand miles in width, on which the foot of civilized man had never trodden...."

MERIWETHER LEWIS ~ APRIL 7, 1805

TO THE GREAT FALLS

AT 4 P.M., APRIL 7, 1805, THE CREWS WERE READY to shove off into the Missouri. The keelboat headed downriver, Corporal Warfington in command, while the permanent party of the Corps of Discovery pushed their heavily laden canoes and pirogues into the current. They climbed in, took up their paddles, and began pulling upstream. They made seven miles before putting ashore to make camp. There wasn't much to the camp. The only shelter was a tepee—the tents had long since given out—made by Sacagawea, and therefore belonging to Charbonneau (who was paid for its use), put up by Sacagawea and York; in it slept the captains, the Charbonneau family, and Drouillard. The fires were small ones for cooking, not big blazes for dancing and singing. Sentries took up their posts. The men slept on the ground, with a buffalo robe below and another above. The captains had a writing table and candles in their tepee.

That evening, Clark listed the names of the members of the party, with his own delightful spellings. Lewis was also in a "This Is History" mood. He wrote: "Our vessels consisted of six small canoes, and two large perogues. This little fleet altho' not quite so rispectable as those of Columbus or Capt. Cook, were still viewed by us with as much pleasure as those deservedly famed adventurers ever beheld theirs; and I dare say with quite as much anxiety for their safety and preservation. we were now about to penetrate a country at least two thousand miles in width, on which the foot of civillized man had never trodden; the good or evil it had in short for us was for experiment yet to determine. [Yet] the picture which now presented itself to me was a most pleasing one, entertaining as I do, the most confident hope of succeading in a voyage which had formed a darling project of mine for the

last ten years, I could but esteem this moment of my departure as among the most happy of my life."

They were stepping off into the unknown. Their sole source of information as to what lay ahead was from Indians with whom they could scarcely converse. Only two white men had journeyed beyond the Mandan villages; they were French trappers and one of them was a member of the expedition, Pvt. Baptiste Lepage. The Corps of Discovery was as close to entering a completely unknown territory, nearly a half-continent wide, as any expedition ever was. Lewis's half-humorous comparison of his fleet to those of Columbus and Cook was on the mark. What lay ahead—deserts, mountains, great cataracts, warlike Indian tribes—the men could not imagine, because no American had ever seen them. But they all knew that from now on they would be making history. And they were all as determined as the captains to succeed. They could not, would not contemplate failure. They had turned their faces west. They would not turn around until they reached the Pacific Ocean.

During the first four days the expedition covered 93 miles, to the mouth of the Little Missouri. Now the river had made its Great Bend and the expedition was headed nearly straight west. It was entering one of the great grasslands in the world, a paradise of high-protein prairie grass (six feet tall and taller) that sustained countless animals. Lewis was lyrical in his descriptions:

April 22: "I asscended to the top of the cutt bluff this morning, from whence I had a most delightfull view of the country, the whole of which except the valley formed by the Missouri is void of timber or underbrush, exposing to the first glance of the spectator immence herds of Buffaloe, Elk, deer, & Antelopes feeding in one common and boundless

pasture. Walking on shore this evening I met with a buffaloe calf which attached itself to me and continued to follow close at my heels untill I embarked and left it."

May 6: "It is now only amusement for Capt. C. and myself to kill as much meat as the party can consum." The party consumed 300 pounds of meat per day, or about 10 pounds per man, which meant the captains had to bring in four deer or an elk to feed the party. Despite the amount, the meat's fat content was very low, so the men were still hungry.

There were new discoveries daily. The creeping juniper, the American avocet, the snow goose, the cackling goose. On May 5, it was the gray wolf. Lewis described it, including the pack's hunting technique—some wolves pursuing while others rested before taking up the chase in their turn. Lewis noted, "We scarcely see a gang of buffaloe without observing a parsel of those faithfull shepherds on their skirts in readiness to take care of the mamed & wounded." As with a number of his passages, I find Lewis's sentence an exemplary use of imagery.

Lewis was observing a process that is heavily debated today by ranchers and environmentalists. Wolves, once hunted or poisoned to the point they were all but gone in the lower 48 by the 1950s, are being reintroduced from Canada into Montana, Idaho, Wyoming, and elsewhere. The wolves still travel and hunt in packs, but now sheep and cattle are often their prey; their protected status infuriates the ranchers who lose their livestock. Yellowstone National Park is at the center of the controversy; as with the buffalo and elk, the wolves won't stay within the park's boundary. The balance is delicate. "Reintroducing the wolves into Yellowstone has been like dropping a pebble into a pond that had not been disturbed for more than 60 years," says supporter James N. Barber of the Wolfstock Foundation. "The ripples will travel far into the future."

The quintessential beast of the grasslands was the grizzly bear. (Today they are found largely in the mountains, as the Plains grizzlies were killed off by 19th-century ranchers. Gradually, however, the mountain bears are now finding their way to the Plains, in search of food.) Lewis wrote on April 13, "The men as well as ourselves are anxious to meet with some of these bear." The Indians had given the white men "a very formidable account of the strength and ferocity of this anamal," Lewis noted, but he discounted the information because of the Indians' inferior weapons. Two weeks later, Lewis and a private were walking on shore and spotted a young grizzly. They fired; the wounded bear charged; Lewis ran as the private reloaded and shot again; that slowed the bear, giving Lewis time to reload and fire; finally the bear was dead. Though not full grown, it weighed 300 pounds. Lewis described it as a "much more furious and formidable anamal" than the black bear. "It is asstonishing to see the wounds they will bear before they can be put to death." Still he remained cocky: "The Indians may well fear this anamal but in the hands of skillfull riflemen the bears are by no means as formidable or dangerous" as the Indians said.

On May 5, the cockiness began to fade. Clark and Drouillard killed a grizzly, "a most tremendious looking anamal, and extreemly hard to kill notwithstanding he had five balls through his lungs and five others in various parts he swam more than half the distance across the river to a sandbar & it was at least twenty minutes before he died; he made the most tremendous roaring from the moment he was shot." A week later, the party saw a grizzly swim the river. No one chased him. Lewis wrote, "I find that the curiossity of our party is pretty well satisfyed with rispect to this anamal."

On April 25, the expedition came to the mouth of the Yellowstone. Lewis wrote of the wide and fertile valleys and the incredible animal life: "The whol face of the country was covered with herds of Buffaloe, Elk & Antelopes, so gentle that we pass near them while feeding."

The river, however, could be dangerous, even for craft that never moved as fast as a man's walking pace. On May 14, the wind was behind, so the sails were up on the pirogues. A crosswind struck; one pirogue, having no keel, turned on her side, and according to Lewis would have gone "topsaturva had it not been from the resistance made by the oarning [sail] against the water." Private Cruzatte, at the bow, was shouting at Charbonneau, at the rudder, to turn the boat into the wind, but Charbonneau was crying to God for mercy and could not hear. Meanwhile articles began drifting

THE GRIZZLY bear "took after them and chased 2 men in to a cannoe," Pvt. Joseph Whitehouse wrote in his journal. "They Shoved off in the River and fired at him." It took nine bullets to bring down the great animal, whose "feet was nine Inches across the ball" with "nales Seven Inches long." Warned by the Mandan and Hidatsa of the grizzly's strength and ferocity, Lewis at first discounted their tales, but after a few close encounters with *Ursus horribilis,* he confessed that he did "not like the gentlemen and had reather fight two Indians than one bear." A much gentler denizen of the West, the sage grouse (left)—called by the captains the "cock of the plains"—was first encountered by Lewis along the Marias River; Clark made this sketch of it in his journal. One of America's largest wild fowl, it proved a convenient food source for the expedition.

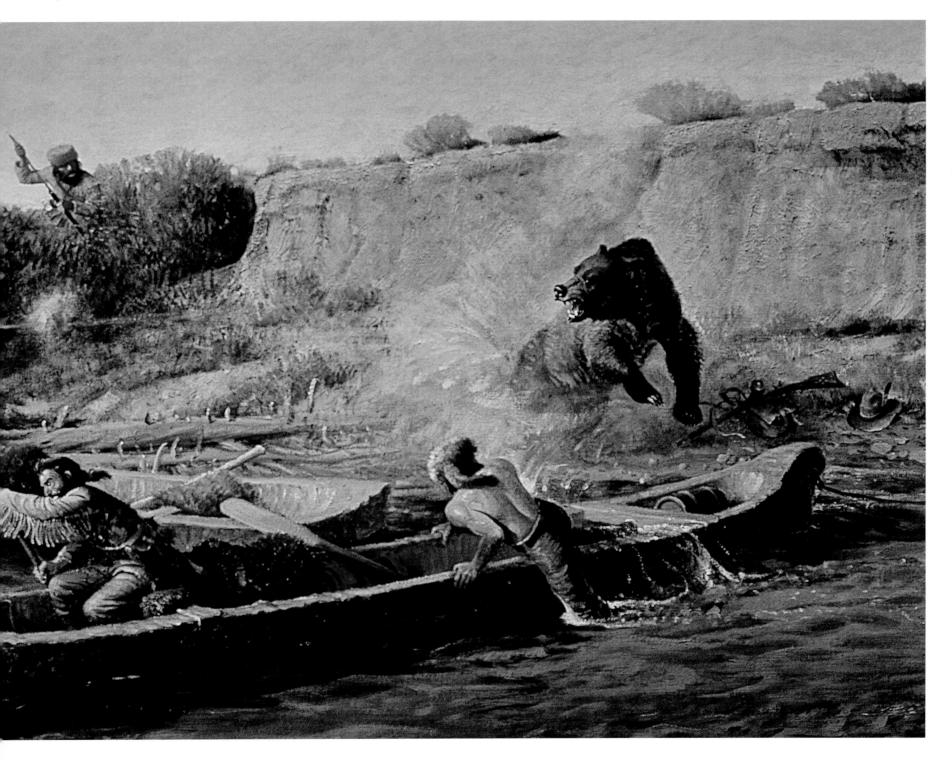

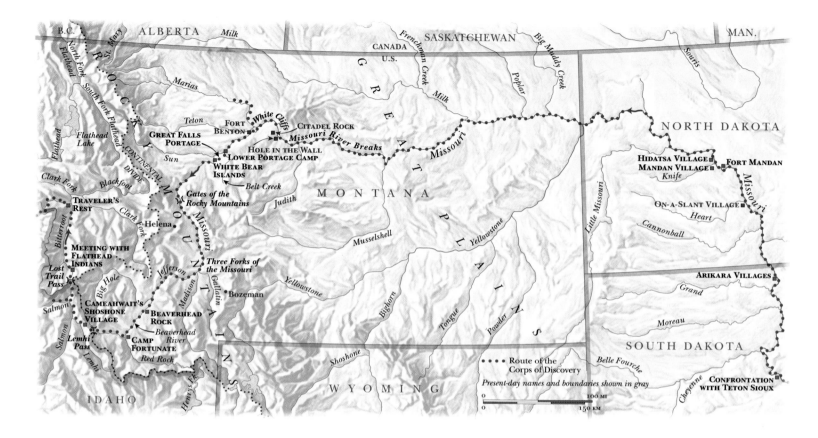

downstream from the capsized pirogue, including scientific instruments and the captains' journals. Sacagawea, her baby boy Pomp strapped to her back, sitting in the floundering craft, calmly reached out and gathered them in, one by one.

She saved the journals of Lewis and Clark. Those journals are a national treasure, our epic poem. We all owe her a debt that could never be paid.

The section of the upper Missouri River the expedition entered in the third week of May is one of the most isolated parts of the lower 48 today, as it was in 1805. The remarkable tameness of the game was a sure indication that the Indians didn't hunt these river bottoms. They hardly could do so, as the game-rich bottoms are closed in almost everywhere by the most rugged bluffs, making it near impossible to get down to the river in most places. Generally, you can only enter and exit by canoe or boat. Lewis and Clark saw

no Indians or Indian sign throughout the area.

There is a 160-mile stretch of the Missouri River that has been designated by Congress Wild and Scenic, from Fort Benton to Fort Peck Lake. On that stretch, you can make the canoe trip today and, with luck, not see anyone. The river is dominated by the bluffs, which are composed of all shades of brown and sandstone, on a clear summer day set off by a pure blue sky and a blazing sun. The eastern half, from Fort Peck Lake west to Judith Landing, is called the Missouri River Breaks; the western half is designated the White Cliffs Area.

Since the summer of 1976, Moira and I have continued to make canoe trips through the White Cliffs. In 1980, we started going with Bob Singer, founder of Missouri River Outfitters at Fort Benton, Montana, the grand old man of the upper Missouri. He knew the river as Mark Twain knew the Mississippi, and loved her, whether in full flood or low

water, and her many moods. Each year, as we were taking out, Bob would tell us we ought to go past Judith Landing and canoe through the Breaks. He insisted that was the best part. But we didn't follow his advice, mainly because of the distances and time involved, but frankly also because Clark called the Breaks "the Deserts of America" and Lewis spoke of "a desert, barren country," which wasn't very tempting.

Finally, in July 1993, with Bob's successors Larry and Bonnie Cook doing the outfitting, we took some of our kids, our three grandchildren, and some family friends and made the trip through the Breaks. There were 16 of us, all experienced on the river. From our canoes, we saw magnificent cliffs on both sides, their color ever changing with the sun's angle. Larry led us on a hike to one bluff that gave a sweeping view up- and downriver—plus four mountain sheep, a half dozen mule deer, a coyote, and an elk. On the river, geese, ducks, swallows, and white pelicans were everywhere. For three days, we didn't see another human being. The senses I felt were of wildness, isolation, wonder, the insignificance of mankind, and frustration at my inability to describe what I was seeing. We agreed with Lewis that it was "a desert, barren country." We also agreed that Bob Singer had it right: This was the best part.

From this barren stretch of the Missouri Lewis reaped a significant reward. On the afternoon of May 26, he climbed the surrounding bluffs, a "fortiegueing" task, but he thought himself "well repaid for any labour" because "from this point I beheld the Rocky Mountains for the first time." Clark thought he had seen distant mountains the previous day; Lewis's confirmation made them the first two United States citizens to see the Rockies.

On May 31, in the White Cliffs section that our family so loves, Lewis wrote a classic piece of travel literature: "The hills and river Clifts which we passed today exhibit a most romantic appearance," he began. They were two- to three hundred feet high, nearly perpendicular, glaring chalky white in the sun. "The water in the course of time in decending from those hills has trickled down the soft sand clifts and woarn it into a thousand grotesque figures, which with the help of a little immagination and an oblique view are made

to represent eligant ranges of lofty freestone buildings.... Statuary.... Long galleries.... ruins of eligant buildings.... nitches and alcoves.... As we passed on it seemed as if those seens of visionary inchantment would never had an end...."

My journal, June 23, 1976: "Cloudy, windy, cold, canoed 35 miles, a day of grit—25-mile-per-hour wind in our face much of the day. The Missouri was in an angry mood. Moira was just great—never complained once. We stopped at Hole in the Wall (a knife-edged bluff of sandstone jutting out over the Missouri). The rain quit, sun came out, up into the White Cliffs we climbed. A wonderland, as Lewis had first noted. Gigantic walls, pyramids, sacrificial altars, statues of gods and goddesses, they are products of wind, sun, and rain, the master carvers of nature. Around us glistened turrets, spires, arches, an enchanted world startling in its whiteness."

Against this backdrop were signs that forces beneath our feet had been at work as well. We marveled at black basaltic domes thrust up from the earth and at dikes of igneous rock along the fault planes, cooled from molten magma and lined up like stone walls so symmetrical they might have been put in place by a metal crane.

Continuing upriver from the White Cliffs area, on June 3, 1805, the expedition set up a camp on the point formed by the junction of two large rivers. They were near present-day Fort Benton, the first town in Montana, an oasis on the High Plains, wonderfully shaded by cottonwoods. It has an excellent larger-than-life-size statue of Lewis and Clark and Sacagawea by the famous Western artist from Browning, Montana, Bob Scriver. He spent a year researching the expedition, and our family marveled at the utmost accuracy with which he depicted faces, clothing, and equipment. Pomp, for instance, is carried in a blanket because his cradleboard had been lost when the pirogue capsized on May 14.

As Lewis anticipated, the Missouri would foster an enormous river trade, first for furs, then supplies for miners and ranchers. Founded in 1846, Fort Benton became a teeming port, with sometimes ten steamboats a day tying up at its waterfront. For the expedition the site was important for the decision that had to be made there.

"An interesting question was now to be determined,"

Lewis wrote soon after pitching camp at the river fork. His orders were explicit: to follow the Missouri to its source. But, "Which of these rivers was the Missouri?" The Hidatsa Indians had told them of a Great Falls on the Missouri, and that it came out of the mountains south of the Three Forks, but had said nothing about a river coming in from the northwest equal in size to the one coming from the south. It was later determined that this was because the Hidatsa cut the bend of the river and rode cross-country to the falls—thus they had never seen the forks. Yet here was another river. Which one to follow? A mistake this far along in the traveling season would mean not getting over the mountains in 1805.

The men were convinced by the cloudy, turbid nature of the right fork, which was exactly like the Missouri from St. Louis to this point. The captains were convinced by the clear water of the left fork, and its bed of smooth stones, "like most rivers issuing from a mountainous country."

They decided to explore, with Clark leading one group up the left, or south, fork for a day and a half, while Lewis did the same on the right, or north, fork. When they returned to base camp, Lewis attempted to convince the men that the south fork was the Missouri, without success. But the captains would not change their minds, and so informed the men. In a magnificent tribute to the captains' leadership qualities, "the men said very cheerfully that they were ready to follow us any wher we thought proper to direct but that they still thought that the other was the river."

The captains named the north fork Marias River, in honor of Lewis's cousin Maria Wood. They agreed that in the morning, Lewis would go ahead on foot, with a party of four men, to discover the Great Falls, "which should determine this question prety accurately." Clark would prepare caches at the junction of the Marias and Missouri, to lighten the load for mountain water and to have a supply depot on the return journey.

Lewis and his party, meanwhile, hiked upstream, on the west bank. There he struck out for the river. "I had proceded on this course about two miles when my ears were saluted with the agreeable sound of a fall of water and advancing a little further I saw the spray arrise above the plain like a coll-umn of smoke. It soon began to make a roaring too tremendious to be mistaken for any cause short of the great falls of the Missouri."

He hurried down the 200-foot bluff to a point on top of some rocks on an island, opposite the center of the falls, "to gaze on this sublimely grand spectical…the grandest sight I ever beheld." It filled him with "pleasure and astonishment." The falls dropped some 40 feet. The men met him at the foot of the falls. Private Goodrich caught some trout, unknown to science, described by Lewis that night, delicious to eat—they were cutthroats.

The next day, Lewis continued upstream. To his surprise, he discovered a second falls, of some 19 feet. He named it Crooked Falls and pushed on. "Hearing a tremendous roaring above me I continued my rout and was again presented by one of the most beautifull objects in nature, a cascade of about 50 feet perpendicular stretching at right angles across the river. I now thought that if a skillfull painter had been asked to make a beautifull cascade that he would most probably have presented the precise immage of this one."

The falls are not as spectacular today, insofar as the human eye sees just above them a modern dam, stretching across the river, generating hydroelectric power. But with the magic of a camera, an expert can cut out the dam so that you see only the falls themselves. I've watched Sam Abell do this, and Ken Burns, and can only wish I had their eyes. Once I joined Sam for a hike along the top of the dam above Rainbow Falls. No one not employed by Montana Power has been up there in decades, but Sam wanted to shoot the falls from above, and Montana Power gave him permission. I never let go of the rail—the falls were immediately below us, the flooring was steel, always wet—while Sam leaned over it, holding on I couldn't tell how, to get the shots he wanted.

For Lewis, more discoveries. There was another falls of 14 feet, then another of 26 feet. Altogether, five separate falls made up the Great Falls of the Missouri. The Hidatsa had never mentioned more than one. It suddenly looked like a much longer and more difficult portage than the captains had anticipated.

Finally, there was an end to the 12-mile stretch of falls.

"FROM this point, I beheld the Rocky Mountains for the first time," Lewis recorded on May 26, 1805, of his view from a cliff above the present-day Missouri Breaks. Artist Olaf Seltzer's vision of that moment is reflected in a painting he executed in 1934. The spyglass Lewis holds remains a cherished artifact (above) of the expedition. With the passage of time, the exploits of the Corps of Discovery became larger than legend— and a subject of endless fascination for western artists.

Lewis arrived at a point where the Missouri "lies a smooth even and unruffled sheet of water of nearly a mile in width bearing on it's watry bosome vast flocks of geese which feed at pleasure in the delightfull pasture on either border." He explored. His walk took him past the biggest buffalo herd he ever saw. He shot one. Before he could reload, a grizzly charged him. He ran into the river, turned on the bear, and presented the iron spike point of his espontoon. The bear took one look and "sudonly wheeled about as if frightened, declined the combat on such unequal ground, and retreated with quite as great precipiation as he had just pursued me."

The following day, Lewis rejoined Clark, who had established camp at the mouth of today's Belt Creek. In the second half of the 1990s, archaeologist Ken Karsmizki of the Museum of the Rockies in Bozeman, Montana, has been digging at the Belt Creek camp. He has so far found three fire rings that date to the beginning of the 19th century, and are almost surely the Corps of Discovery's campfires. At this site, Clark had moved the canoes upriver to the rapids below the foot of the first falls. The captains talked about the portage, but there was an even more urgent matter.

Sacagawea was ill and had been for almost a week. Clark had tried bleeding her, which hadn't worked, and applying to her pelvic region a poultice of Peruvian bark and laudanum, also without success. "The Indian woman verry bad," he wrote in his journal.

Lewis examined Sacagawea and concluded that "her disorder originated principally from an obstruction of the mensis in consequence of taking could." His therapy was "two dozes of barks and opium," which soon produced an improvement in her pulse. She was thirsty. Lewis recalled a sulfur spring on the opposite bank of the river; he sent a man to bring him some. He thought minerals were just what she needed; he was probably right as such symptoms as the twitching of the fingers and arms could have been due to the loss of minerals resulting from Clark's bleeding her. For sure all that bleeding had left her thirsty. Lewis would allow her to drink the sulfur water only. He continued the application of poultices to her pelvic region. That evening, he was delighted with her progress. She had recovered from near-death and was alert and hungry.

"A ROARING too tremendious to be mistaken for any cause short of the great falls of the Missouri," Lewis wrote of the sound that heralded "the grandest sight" he ever beheld. Though inspiring, the extensive stretch of cataracts and rapids forced the Corps into a backbreaking 16-mile, 11-day portage. Clark's detailed map of the falls (above) charts portage sites, islands, current flow, and the heights of various cascades.

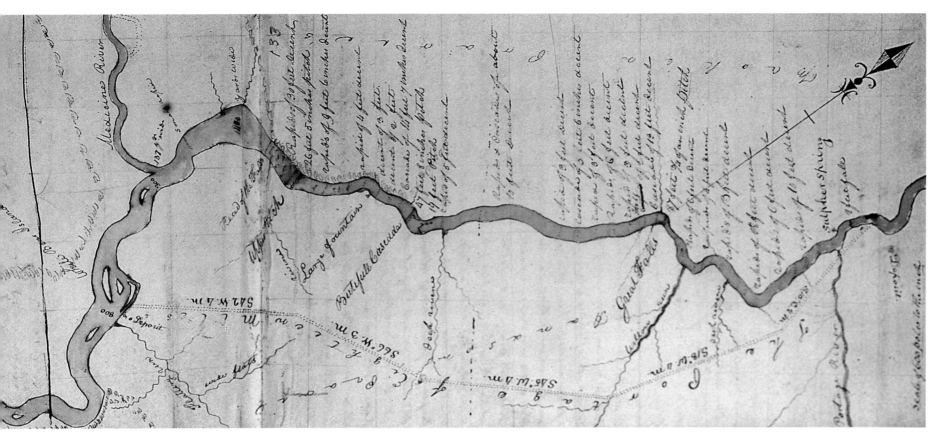

LEWIS made his own rough sketch of the falls, hoping that "some abler pencil" would later elaborate on his drawing. In fact, his image may have inspired this 1867 engraving by A. E. Mathews. As deadly as they were beautiful, the cataracts took the lives of countless buffalo, who, while drinking from the fast-moving river, would find themselves "out of their debth," Lewis reported. "The water insta[n]tly takes them over the cataracts...their mangled carcases ly along the shores below the falls in considerable quantities...."

Although there was a brief relapse, Sacagawea was cured.

On our first trip, Moira and I visited the sulfur spring. It is easy enough to find—it is directly across the river from the mouth of Belt Creek. It is not so easy to get to—it takes a couple of miles of hiking over and among the bluffs on the northwest bank. Foolishly, we were in tennis shoes. The thorns of the prickly pears cut through the sides and even the bottoms of the shoes. The spring itself is a small pool of perhaps 10 yards across. The water bubbles over the edge and drops in a small rivulet the 30 yards or so to the river. The sulfur content is high, the smell bad, the taste terrible.

Lewis was delighted by Sacagawea's recovery, of course, not only for her sake—and Pomp's—but even more for the sake of the expedition. His mind was always leaping ahead to the next problem, even while solving the one at hand. Once the portage was complete, the expedition would be penetrating the mountains. Those mountains were always in the back of his mind, those tremendous mountains looming to the west, standing between him and his goal—greater, higher, deeper than anything he had seen in Virginia, or anywhere else. He was eager to vault his energy over those mountains, but to do that the expedition would have to have horses. And Sacagawea was the key.

But to get to the Shoshone the expedition had to get past the Great Falls. It was going to be a difficult 16 miles. Lewis took it in stride. "Good or bad we must make the portage," he wrote. The captains had the largest cottonwood tree in the vicinity cut down, then put six men to work sawing it crosswise to make wheels. They directed that the hardwood mast of the pirogue be cut to make axles. Cottonwood served for tongues, couplings, and bodies of two wagons—or "trucks," as Lewis called them—which would transport the canoes and baggage. He had other men hunting elk, not for the meat but for the skins, which he thought superior to buffalo skins as cover for his iron-frame. He had hauled the boat all the way from Harpers Ferry to put together on the far side of the falls. Clark would oversee the portage while Lewis would go to the termination point upstream, a group of islands that Clark named White Bear Islands from the presence of so many grizzlies. There Lewis would oversee the preparation of his boat. He would take the first load over the portage route, in a canoe carried on a wagon; the load would include the iron-frame and the necessary tools. Clark, who had scouted the route, informed Lewis that there were no pine trees anywhere near the termination point. That meant no pine pitch to pay the seams of the leather covering the frame. Something else for Lewis to worry about.

The portage began shortly after sunrise on June 22. All the men joined the captains in moving the canoe over the Plains. They had a multitude of problems, beginning with prickly pear thorns cutting through their moccasins. There were numerous breakdowns. The axles broke. The tongues broke. Lewis renewed them with sweet-willow branches. Just after dark, they had reached the termination point. Along the way, Lewis discovered and described one of the best-loved birds of the Great Plains, the western meadowlark.

As Lewis went to work on his boat, Clark returned to base camp at the foot of the falls to continue the portage. Clark described it: "The men has to haul with all their Strength wate & art...maney limping from the Soreness of their feet Some become fant for a fiew moments, but no man Complains all go Chearfully on...."

They were assaulted by hail as big as apples, by "musquetoes," by hot sun and cold rain. The winds could be awesome. On June 25 Lewis noted in his journal, "The men informed me that they hoisted a sail in the canoe and the wind had driven her along on the truck wheels, this is really sailing on dry land."

For the past decade or so, the Guard of Honor of the Great Falls Chapter of the Lewis and Clark Trail Heritage Foundation have had an encampment, near the new interpretative center, opened on July 4, 1998. The reenactors are faithful to their models to the smallest detail. They put on displays of cooking, constructing the iron-frame boat, handling weapons, preparing furs, and more. They even recruit a Newfoundland to play Seaman. What we find most fascinating is their "truck" and their methods of push-pulling-sailing it across the portage route. The most memorable sight came on a hot day in August 1996, when Dayton and Ken were shooting for their television documentary of the

expedition. They persuaded the reenactors to put on their outfits and pull their truck and canoe across a ridgeline, with the sun setting behind them. It made a glorious shot.

For the Corps of Discovery the slowness of the portage was agonizing. Lewis confessed in his journal, "I begin to be extremely impatient to be off as the season is now waisting a pace nearly three months have now elapsed since we left Fort Mandan and not yet reached the Rocky Mountains." The anxiety over the iron-frame boat, which the men had taken to calling "Experiment," was intense. He had failed to turn up any substitute for pine pitch. By July 3, the portage was complete. Clark and the men wanted to get going: "The current of the river looks so gentle and inviting that the men all seem anxious to be moving upward." But Lewis said, Wait, the boat isn't ready. On July 4, he had the men turn the boat and put her on a scaffold, then had small fires built underneath the craft to dry the leather.

That evening, the first white men ever to enter today's Montana, the first ever to see the Yellowstone, the Milk, the Marias, and the Great Falls, the first U. S. citizens ever to kill a grizzly, celebrated their nation's 29th birthday. The captains gave the men a gill of whiskey—the last of the stock— "and some of them appeared a little sensible of it's effects."

For five more days, Lewis tried various compositions of charcoal, beeswax, tallow, and soot. On July 9 he finally decided Experiment was ready to be tried. "We launched the boat, she lay like a perfect cork on the water. Five men would carry her with the greatest ease." He ordered her loaded. This was done and all was prepared for shoving off when a thunderstorm came up. The men took cover. When the storm passed, Lewis discovered that the composition had separated from the skins and left the seams exposed. "She leaked in such manner that she would not answer." He described himself: "mortifyed." He added, "I relinquish all further hope of my favorite boat." He never mentioned her again. He had her put in a cache but apparently did not dig her up on the return journey. Presumably she is still there, waiting for someone to find her—it is an awfully dry climate.

Clark, who had less at stake and less faith in Experiment, had already found some cottonwood trees some 20 miles upstream and put men to work at making the two largest into canoes. This was neither the first nor the last time the cottonwoods had saved the expedition. It is virtually the only tree that grows along the banks of the Missouri; it provided shelter, fuel, and canoes. Pioneering Lewis and Clark scholar Paul Russell Cutright pays the cottonwood an appropriate tribute: "Of all the western trees it contributed more to the success of the Expedition than any other. Lewis and Clark were men of great talent and resourcefulness, masters of ingenuity and improvisation. Though we think it probable that they would have successfully crossed the continent without the cottonwood, don't ask us how!"

Copses of cottonwood trees still stand along the Missouri, but their numbers are dwindling fast. This is due mainly to the damming of the Missouri. To survive and flourish, cottonwoods require natural periodic flooding, which no longer occurs. Some damage is also caused by the unrestricted grazing of cattle; they trample down the young trees, and cottonwood is fairly short-lived—50 to 80 years; therefore the old trees are not being replaced. It wouldn't take a lot of money to fence off the groves and copses, but it is an expense the ranchers resist and the government has not required, even in the section designated Wild and Scenic.

When Clark finished the canoes—it took five days to hollow out the trunks—it had been a month since the Corps discovered the Great Falls, a month in which the total progress was about 25 miles, or less than a mile a day. On July 12, Lewis confessed, "I feel excessively anxioius to be moving on." On July 14, he was. With two large and six smaller canoes, and greatly reduced baggage, the Corps set out for the mountains. If the Hidatsa were right, the river would penetrate up to the Continental Divide, where the Americans would meet the Shoshone Indians, and where a half-day's portage would take them over the Divide and into the Columbia River drainage. Whatever lay ahead, and no one expected it to be easy, the captains and the men must have felt that it could not possibly be more arduous than the portage they had just completed. And for Lewis personally, nothing could be more heartbreaking than seeing his beloved boat go down. The worst had to be behind them.

GATES OF THE MOUNTAINS, THREE FORKS, AND LEMHI PASS

Lewis had many worries as his little fleet worked its way upstream, but even so he was well aware of entering a new ecological zone. He was penetrating the eastern edge of the northern Rocky Mountains and was enchanted by the sights and sounds of new birds and animals, and the majesty of the western mountains and valleys. As the mountains began to crowd in on the river, Lewis noted "a large herd of the Bighorned anamals on the immencely high and nearly perpendicular clift opposite to us; on the fase of this clift they walked about and bounded from rock to rock with apparent unconcern where it appared to me that no quadruped could have stood, and from which had they made one false step they must have been precipitated at least a 500 feet." In following years bighorn sheep were hunted to the point of extermination in these cliffs, but since the 1970s they have been successfully reintroduced and are now a common sight. The herd numbers a hundred or so.

Bighorns and other wonders, however, had to give place to the immediate problem of finding Indians. To do this, it was decided that Clark and a small party would proceed by land upriver, to get well ahead of the canoes. Their idea was that the daily firing of the rifles by the hunters would frighten away the Shoshone, who would assume their enemy the Blackfeet were around. Clark set off at dawn on July 19.

Lewis led the canoes upriver. Whenever the mountains broke back to give a view, there was to the right the disheartening sight of distant, lofty summits all covered with snow, standing between the expedition and its goal.

That evening, "we entered much the most remarkable clifts that we have yet seen. These clifts rise from the waters edge on either side perpendicular rocks in many places

seem ready to tumble on us. From the singular appearance of this place I called it the Gates of the rocky mountains."

We first saw the Gates of the Mountains on June 27, 1976, marveled at the cliffs, the folds of solid rock, the outcroppings, the deer, and other animals. Stephenie's journal entry for June 27: "Took a tour boat ride through weird formations along with Indian drawings, osprey nests, mountain goats, sheep, and more." The goats are another introduction success story; from zero in 1969 they now number over 50—Lewis didn't see any as they are not native to the area. Paddling by canoe, Moira and I were intrigued by the Indian pictographs so we pulled ashore to inspect them. They are about 200 years old, made, in all probability, by Blackfeet; they consist of sketches of deer and buffalo.

At the landing, we had a good talk with the manager, Bob Tubbs, who is as obsessed with Lewis and Clark as we are. "They did almost everything right," he said.

"Ah," I replied, "they didn't pack all that well. They ran out of whiskey, salt, trade goods...."

He cut me off: "They never ran out of lead and powder. They knew what was critical, what was peripheral."

Within an hour we were fast friends. My journal for that day includes this: "Bob urged us to move up here—great place to raise kids, he says—he has five sons, one out hang gliding right now, the others fishing or backpacking. In the winter, they all ski. 'Mighty hard winter,' says I. 'Winter never lasts long enough,' says he."

That night Stephenie informed Moira and me that our grandchildren would be bred, born, and raised in Montana.

As much as we were tempted to stay (we live half the year today within 15 miles of the Gates) the captains were anxious to move on. On the morning of July 20, 1805, as the flotilla

MARVELS of surefootedness, bighorn sheep amazed the Corps with their agility. On a nearly perpendicular cliff, the men watched as the sheep "bounded from rock to rock with apparent unconcern...this anamal appears to frequent such precepices and clifts where...they are perfectly

secure from...wolf, bear or even man himself." Clark sketched a bighorn (left), and the captains sent a specimen east, which is now mounted in Philadelphia's Peale Museum, where most of the Corps' collection resides; it probably inspired this later engraving by Alexander Lawson.

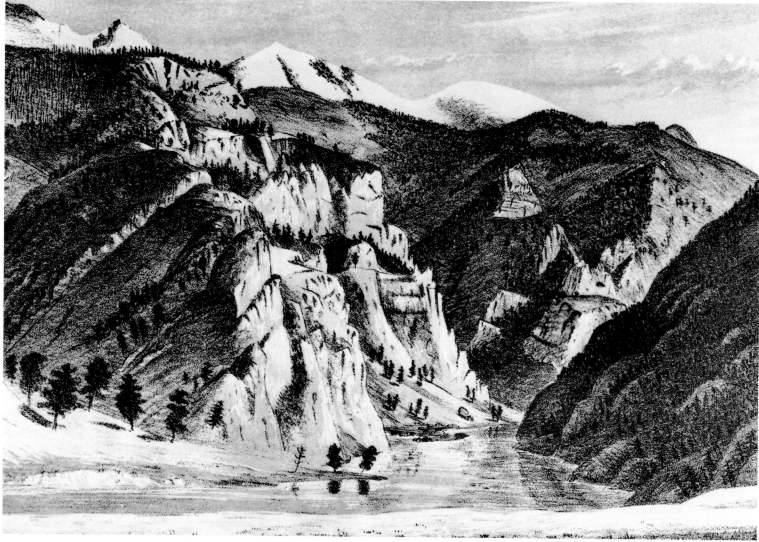

"THE RIVER appears to have forced it's way through this immence body of solid rock," wrote Lewis of this gorge chiseled by the Missouri into 1,200-foot-high cliffs. The "Gates of the rocky mountains," he called the spectacle. After five miles of rapids, the river spilled out onto a broad plain. "The Indian woman recognizes the country," Lewis wrote, referring to Sacagawea, "and assures us that...the three forks are at no great distance." Soon, Lewis concluded, the Corps would reach "the head of the missouri, yet unknown to the civilized world."

paddled out of the canyon, the mountains receded and a beautiful intermountain valley presented itself. But the men with the canoes were laboring mightily, and unhappily: The river apparently had no end, the mountains were crowding in, the buffalo herds had been left behind on the Plains, the whiskey was gone. Clark was nowhere in sight. On the afternoon of July 22, Sacagawea recognized the section of river. She had been here as a girl. She said the Three Forks were at no great distance ahead. "This peice of information has cheered the sperits of the party," Lewis noted.

An hour or so later, spirits sank again, as the flotilla came upon Captain Clark and his party. Clark had found no Indians. And his feet were raw and bleeding, torn apart by prickly pear thorns. Lewis bathed his feet, and the captains talked. They agreed another overland search was necessary. Clark insisted on leading it and set out the next morning. Lewis headed upriver. Conditions were awful. "Our trio of pests still invade and obstruct us on all occasions, these are the Musquetoes eye knats and prickley pears." It was hot. Progress was slow. Clark so far had found no sign of Indians.

Lewis, July 27: "We set out at an early hour and proceeded on but slowly the current still so rapid that the men are in a continual state of their utmost exertion to get on, and they begin to weaken fast from this continual state of violent exertion." They had reached the breaking point.

Then fortune smiled. Just around the bend, Lewis in the lead canoe came to a junction with a river from the southeast. A few hundred yards upstream, a southwest fork and a middle fork also came together, making the Three Forks. As Lewis described it, "The country opens suddonly to extensive and beatifull plains and meadows which appear to be surrounded in every direction with distant and lofty mountains." He climbed a nearby high limestone cliff above the bank of the river coming from the southeast. At the top, "I commanded a most perfect view of the neighbouring country.... smoth extensive green meadows.... a distant range of lofty mountains rose their snow-clad tops above the irregular and broken mountains which lie adjacent to this beautifull spot."

On our first visit to Three Forks, we climbed Lewis's cliff and I read aloud his journal entry. We gazed in a kind of rev-

erence on what he'd described. The view is still spectacular despite modern intrusions—roads, the town of Three Forks, power lines. There is a tremendous bowl, containing the linked valleys of the two rivers coming out of today's Yellowstone Park to the south and east, and the valley of the river to the southwest that flows down from the Madison Mountains. The mountains surround the bowl in a nearly complete circle of up to a hundred miles in diameter, and are just as Lewis saw them, lofty and snow-covered.

After admiring the view, we prepared to descend. We heard a rattle. Then another. Another. We were surrounded by rattlesnakes that had been basking in the sun and were now disturbed. We gathered together. There wasn't a stick in sight on this treeless cliff top. We couldn't go down the way we had come up—too many snakes. I had Moira and the kids line up behind me, then put Bib and our other dog, LC, in front, figuring better the dogs than the kids. We managed to get down without incident, but surely breathing hard.

Down at river level, railroad tracks circled the cliff. We walked between the rails, feeling secure, no snakes in sight. The wind blew strong, in our faces. We rounded the bend, the kids out front, singing, the dogs ahead of them. From not a hundred feet behind us, we heard a train whistle. We glanced back to see a diesel locomotive bearing down. I caught a glimpse of the engineer's face, white with fear. He was pulling the whistle cord for all he was worth, applying the brakes with the other hand. He had not seen us because of the bend, we had not heard him because of the wind.

Seconds ahead of the train, Moira and I stepped off the track. Then we watched in the greatest trepidation as each of the kids did the same. Hugh slipped slightly. Our hearts stopped. He stepped off. LC darted off. Bib got off without losing his customary dignity, only just in time. Slowly the adrenaline receded. Lewis and Clark had many experiences that caused their adrenaline to pump—and in no way could we compare with them—but in this instance, with our children's lives at stake twice within a half hour, we figured the captains couldn't have been more anxious than we were.

After coming down the same cliff in July 1805 (without any recorded incident), Lewis explored the area on foot.

Comparing the middle fork with the southwest fork, he could see no difference in character or size. "Therefore to call either of these streams the Missouri would be giving it a preference which it's size does not warrant as it is not larger than the other." So he named the southeast fork "Gallitin's river," in honor of Albert Gallatin, Secretary of the Treasury; the middle fork he called "Maddison's river," in honor of James Madison, Secretary of State; the southwest fork he called "Jefferson's River in honor of that illustrious personage Thomas Jefferson President of the United States."

That afternoon, Clark joined Lewis at the Three Forks. He was extremely sick, completely exhausted, his search for the Shoshone fruitless. Clark closed his short journal entry for the day, "I continue to be verry unwell fever verry high." Lewis closed his journal with a worry. "We begin to feel considerable anxiety with rispect to the Snake Indians. If we do not find them I fear the successfull issue of our voyage."

The expedition spent two days at the Three Forks. Sacagawea informed Lewis that the expedition's camp was precisely on the spot where the Shoshone had been camped five years ago when a Hidatsa raiding party discovered them. Sacagawea was made prisoner. "I cannot discover that she shews any immotion of sorrow in recollecting this event," Lewis wrote, "or of joy in being again restored to her native country; if she has enough to eat and a few trinkets to wear I believe she would be perfectly content anywhere."

It apparently never occurred to Lewis that Sacagawea was the only teenager on the expedition, the only woman, the only mother, the only Indian and a slave, and thus that it was no wonder she kept a low profile. She was obviously eager to help, however. As the party approached the point where the Big Hole and Beaverhead Rivers join to form the Jefferson, she pointed to a series of rolling hills sharply ending in a knobby protrusion. She called the rock the "Beaver's Head," so named by her people from its supposed resemblance to the head of a swimming beaver. For our family it was a stretch to find in the rock the beaver's head, and no wonder: Sacagawea was so eager to provide encouraging news, that she mistook this formation (today's Point of Rocks) for the real "Beaver's Head," still some 20 miles upstream.

The captains agreed that the Beaverhead was the river to follow. Over the next two weeks, Clark stayed with the canoes while Lewis, with small parties marched ahead, searching for Indians, returning to the camp in the evening—always without making contact. The labor for the men in the canoes against the swift-flowing Beaverhead was tremendous.

The captains agreed that "as it is now all important with us to meet with those people [the Shoshone] as soon as possible," a land party should stay out until it located Indians. Clark wanted to lead it, but "the rageing fury of a tumer on my anckle musle" made it impossible for him to walk. Lewis's determination was absolute. His intention was "to proceed tomorrow with a small party to the source of the principal stream of this river and pass the mountains to the Columbia; and down that river untill I found the Indians." Clark would continue with the main party up the Beaverhead.

The first day out, accompanied by Drouillard and Privates Shields and McNeal, Lewis covered 16 miles. The second day it was 30 miles, ending up in "one of the handsomest coves I ever saw, of about 16 or 18 miles in diameter." He struck and followed an old Indian road, but it gave out on him. The third morning, he spread out, with Drouillard on the right, Shields to the left, himself and McNeal in the middle, and advanced through the valley. Suddenly Lewis squinted, looked again, took out his telescope, and saw for sure "an Indian on horse back about two miles distant coming toward us." His dress was Shoshone. "His arms were a bow and quiver of arrows, and was mounted on an eligant horse without a saddle."

"I was overjoyed at the sight of this stranger," Lewis wrote. He didn't want to arouse suspicion or fear, so he hiked on at his usual pace. When they were about a mile apart, the Indian halted. Lewis pulled his blanket from his pack, threw it into the air, and spread it on the ground, a signal of friendship. The Indian did not come on. Lewis spread out the pitiful supply of trade goods he had brought with him—some beads, a looking glass, a few trinkets. Leaving his rifle and pouch with McNeal, he advanced toward the Indian, who sat his horse, watching, until Lewis was within 200 yards, when he turned his horse and began to move off slowly.

Lewis called out loudly, *"tab-ba-bone,"* which Sacagawea had said was the Shoshone word for "white man." Actually, the Shoshone had no word for white man, never having seen one; *tab-ba-bone* meant "stranger" or "enemy." Lewis kept shouting the word, meanwhile rolling up his sleeve to show that he was a white man—his face and hands were so tanned he looked like an Indian. He advanced, but at one hundred yards the Indian "suddonly turned his horse about, gave him the whip, leaped the creek and disapeared in the willow brush in an instant with him vanished all my hopes of obtaining horses for the present. I now felt quite as much mortification and disappointment as I had pleasure and expectation at the first sight of this Indian."

Lewis tried to follow the Indian trail, but it rained and raised the grass. He made camp. Clark and the main party, meanwhile, continued to struggle against the swift-flowing Beaverhead. In the morning, August 12, Lewis and his three men came on a large and plain Indian road, which they followed, headed west, toward a pass in the mountains, the stream growing small as the men ascended the gentle slope. "At a distance of 4 miles further the road took us to the most distant fountain of the waters of the mighty Missouri in search of which we have spent so many toilsome days and wristless nights." Lewis assessed the impact on himself: "Thus far I had accomplished one of those great objects on which my mind has been unalterably fixed for many years, judge then of the pleasure I felt in allying my thirst with this pure and ice cold water." The spring is there today; on our dozen or so trips to the site, we always drink from it.

Lewis was not alone in his rejoicing: "Two miles below McNeal had exultingly stood with a foot on each side of this little rivulet and thanked his god that he had lived to bestride the mighty & heretofore deemed endless Missouri."

It was time to scale the pass, to become the first American to look on Idaho and the great Northwestern empire. Lewis described the moment: "We proceeded on to the top of the dividing ridge from which I discovered immence ranges of high mountains still to the West of us with their tops partially covered with snow." The sight shattered Lewis's hopes for an easy portage to a major branch of the Columbia.

The scene today is as Lewis saw it, save for a cattleguard and a barbwire fence that stretches north and south along the Continental Divide. Not until you have taken that last step to the Divide do you have any inkling of what is out there to the west. To the contrary; you expect to see something like what you have just left behind you, a long, relatively gentle slope through a broad valley all the way to Three Forks. But what you see to the west from the top is the Bitterroot Range, 60 miles and more broad, covered with snow in August, cut by narrow little streambeds with precipitous sides, and no hint of an east-west pass anywhere.

Lemhi Pass is one of our three favorite Lewis and Clark sites. The others are the Missouri River Breaks-White Cliffs run, and Idaho's Lolo Trail. In these places you can camp where the expedition camped, drink from the spring that refreshed the men, walk in their footsteps, see what they saw.

On our first trip to Lemhi Pass, we camped there on the Fourth of July 1976, along with a dozen of my students. My journal, July 4: "Around the campfire I read from the Journals. I quit when Lewis was still a few miles below us, frustrated at the failure of his meeting with the Shoshone boy, Clark still struggling against the Beaverhead. The kids wanted me to read on but I figure a little suspense helps keep the interest up, so I suggested, 'Lets climb yon mountain.' The nearly full moon was illuminating the treeless slope—an opportunity for them to see what Lewis saw in high drama. So up we went. To the west, the Bitterroots gleamed in the moonlight. To the east, we could see various mountain creeks coming together to form the Beaverhead, the beginnings of the Missouri River. To the west, Idaho and the entry to a new land of opportunity. Lewis was seeing territory never before seen by a white man, an empire inhabited by Indians, not yet claimed by a white nation."

What emotions the unexpected and unwelcome sight of the Bitterroots brought to Lewis, he never said. He was a man of the Enlightenment. Facing facts was his creed. He descended the mountain, which was much steeper than the approach on the eastern side, about three-quarters of a mile, "to a handsome bold running Creek of cold Clear water. Here I first tasted the water of the great Columbia river."

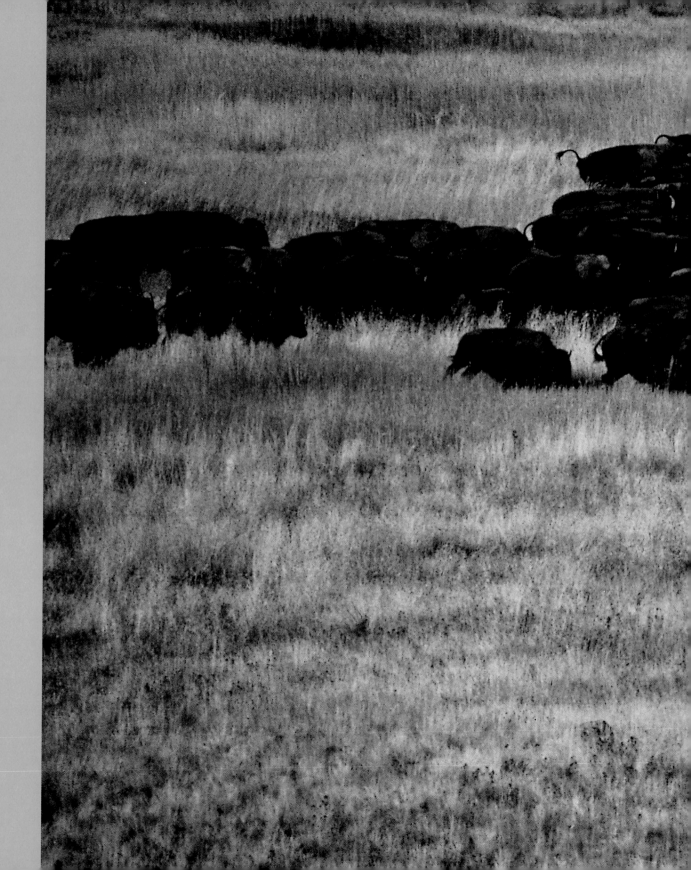

"The buffaloe, Elk and Antelope are so gentle that we pass near them...they frequently approach us more nearly to discover what we are."

MERIWETHER LEWIS ~ APRIL 25, 1805

ON THE National Bison Range in central Montana, one of the prairie's few remaining herds grazes on protected grasslands.

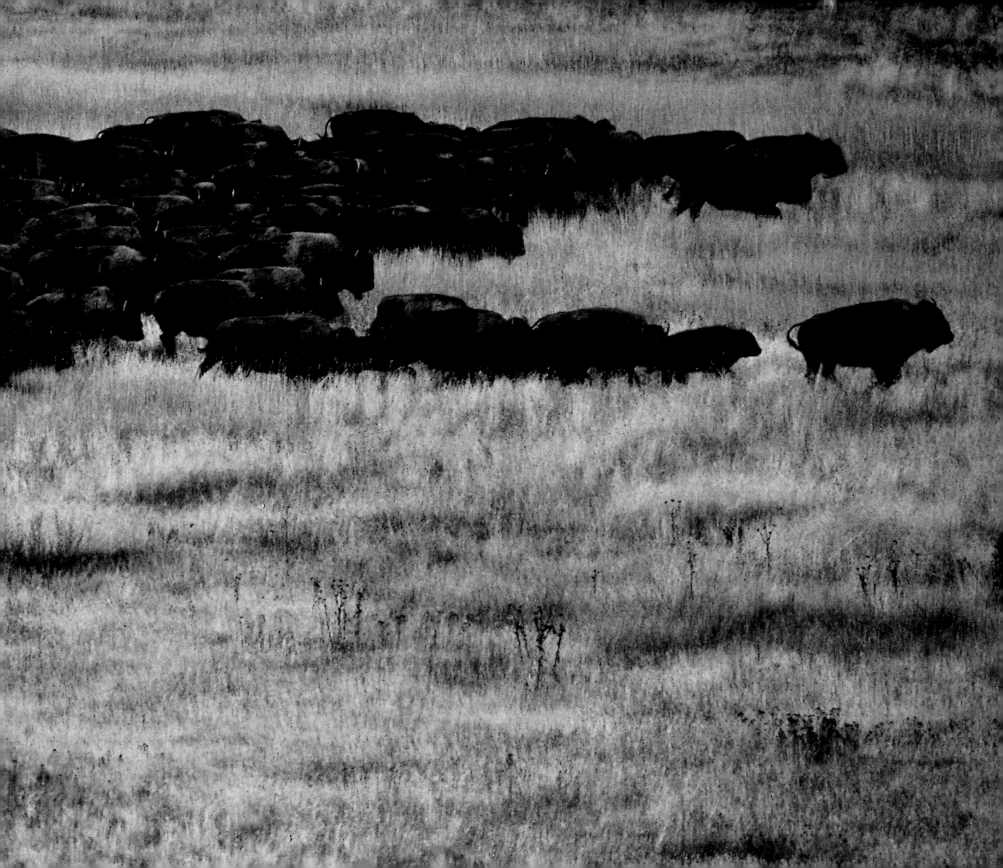

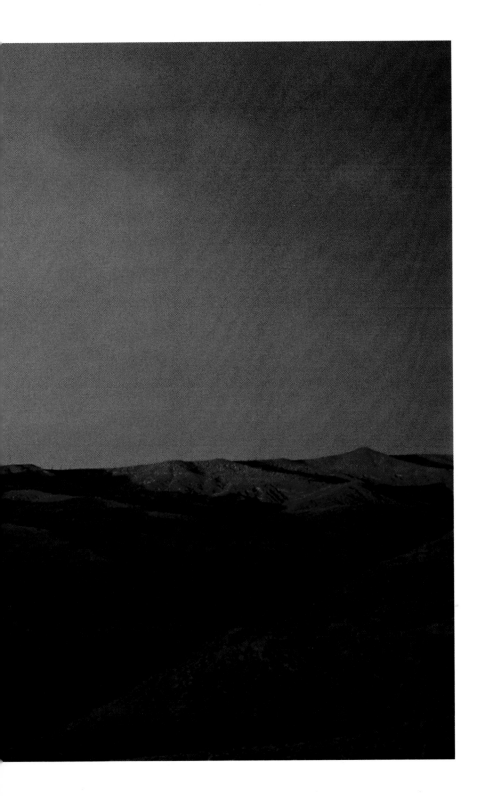

RAINBOW-ARCHED Montana prairie settles into dusky silence after an evening thunderstorm. "The country on both sides of the missouri from the tops of the river hills, is one continued level fertile plain as far as the eye can reach," Lewis wrote. Spring fires set by the Indians kept the plains treeless but luxuriant with tall, protein-rich grasses that supported buffalo and other game.

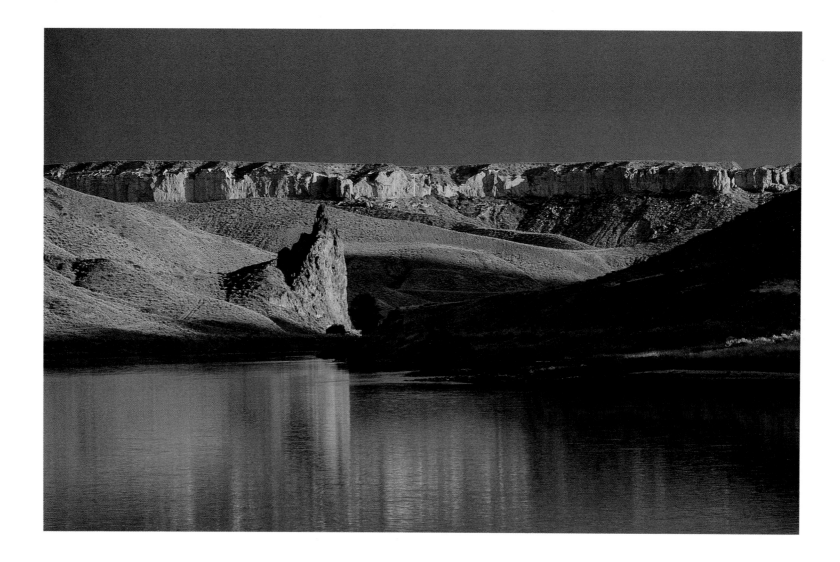

LANDMARK on the upper Missouri, Citadel Rock became a prominent pinnacle for the steamboat traffic that eventually followed in the wake of Lewis and Clark. Jefferson had instructed Lewis to "take careful observations of latitude & longitude, at all remarkable points on the river... that they may with certainty be recognized hereafter." Protected now by Congress as a Wild and Scenic River, the upper Missouri and its eroded bluffs still hold a wealth of natural marvels like this weather-sculpted arch (opposite).

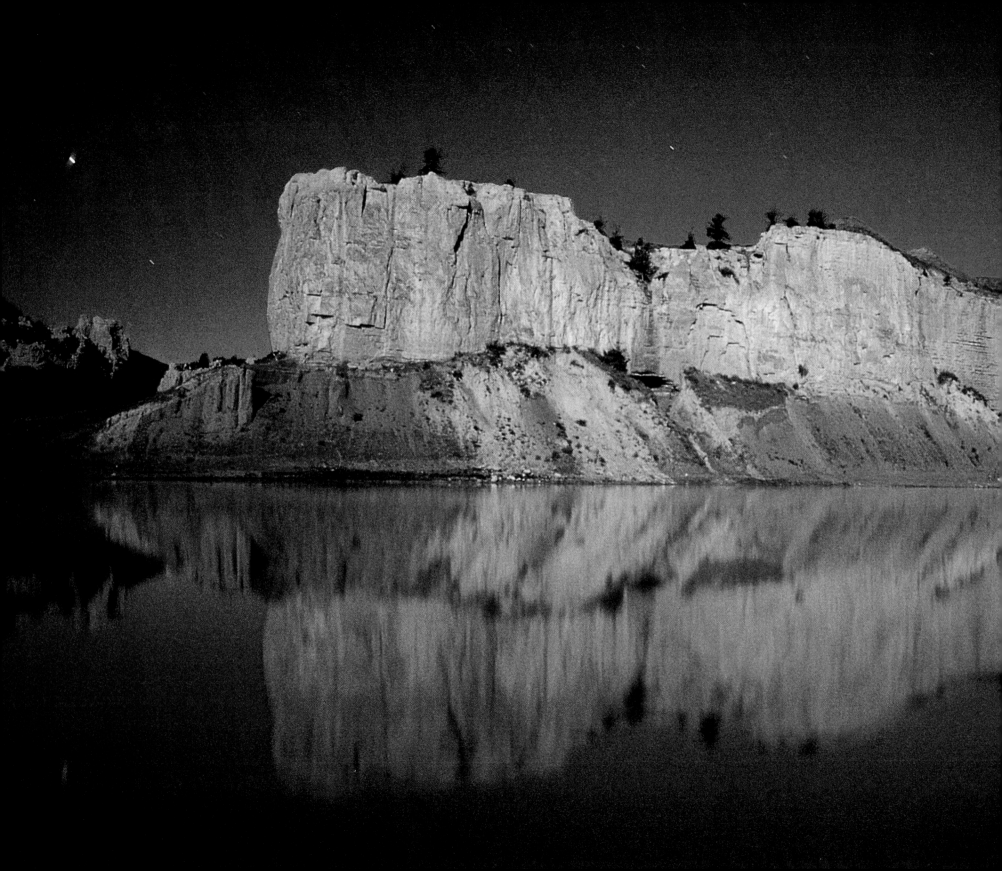

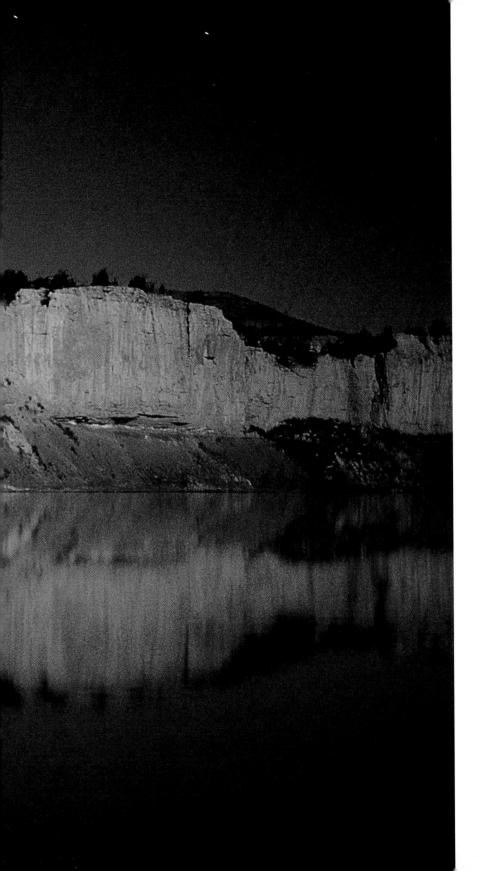

"Seens of Visionary inchantment" greeted the explorers as they floated past the White Cliffs of the upper Missouri. "They are formed of remarkable white sandstone which is sufficiently soft to give way readily to the impression of water," Lewis observed. Eroded into spires, hoodoos, and ramparts, the sandstone bluffs still "exhibit a most romantic appearance," especially by starlight.

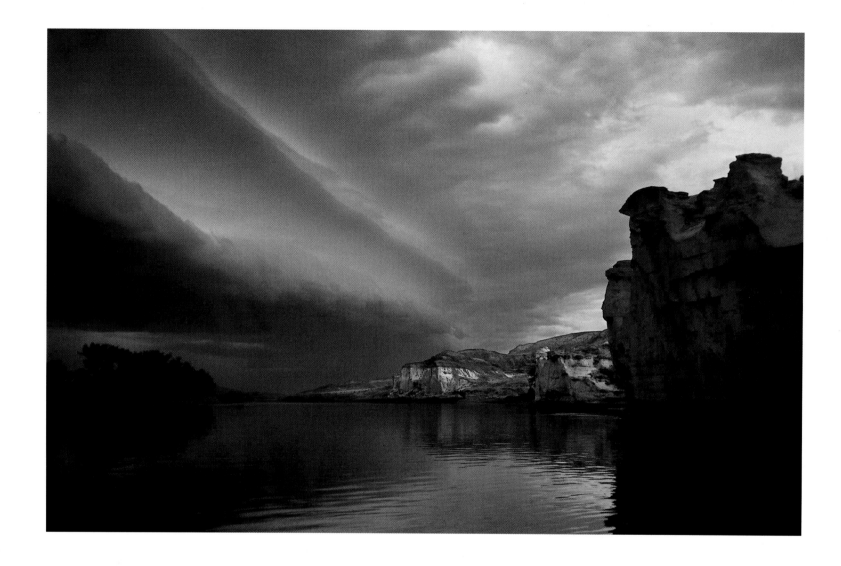

THREATENED by an approaching storm, the White Cliffs turn an ominous gray. "It continued to rain almost without intermission last night and...our camp possessing no allurements, we left our watery beds at an early hour and continued our rout down the river," Lewis recorded of one of his own nights spent in this area. Upriver from the White Cliffs, the expedition finally arrived at a sight they had long anticipated—the Great Falls of the Missouri. Though damming has reduced the falls to one roaring rapid (opposite), it remains a "sublimely grand specticle."

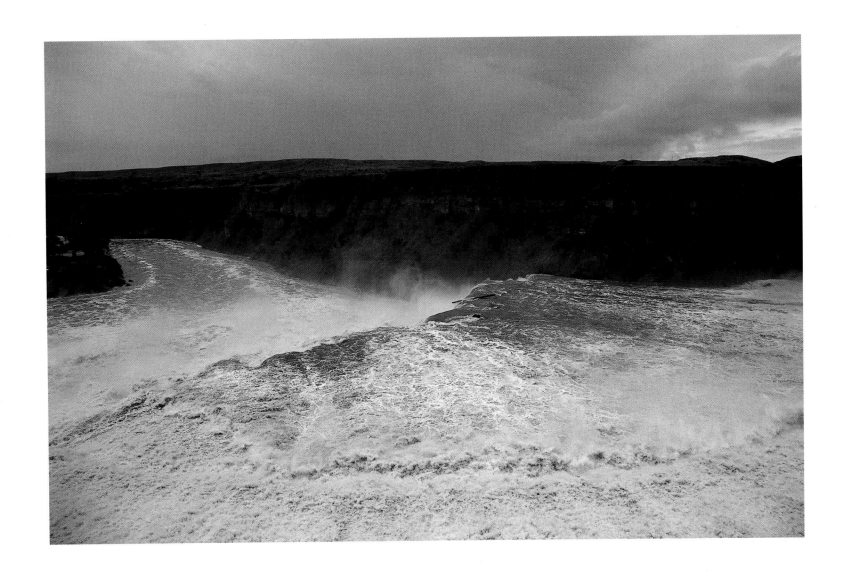

"THE MOST remarkable clifts that we have yet seen," Lewis said of the river canyon he called the Gates of the Rocky Mountains. Near present-day Helena, Montana, the canyon still mirrors Lewis's careful description of it: "The pine cedar and balsum fir grow on the mountains in irregular assemb[l]ages or spots mostly high up on their sides and summits," and the "projecting rocks in many places seem ready to tumble on us."

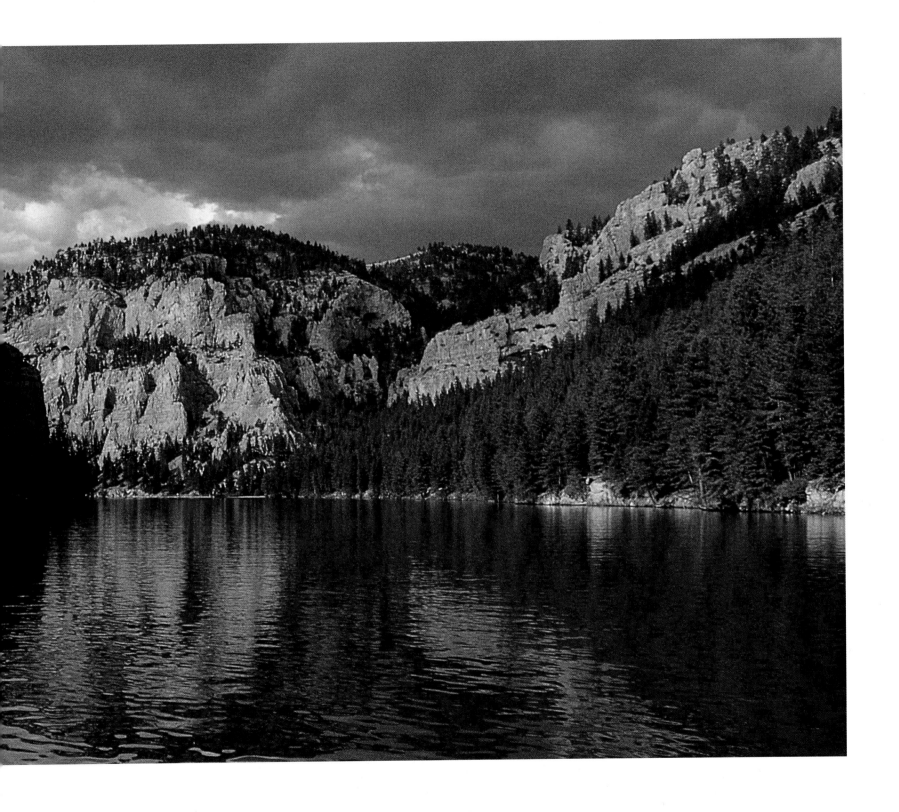

ENTWINED in history, the Three Forks confluence forever bears the mark of the Corps of Discovery. With political astuteness, Lewis named its three rivers after prominent national figures of the day—Secretary of the Treasury Albert Gallatin, Secretary of State James Madison, and President Jefferson, the expedition's most ardent supporter. The river surroundings gave rise to more than political inspiration. "Our trio of pests still invade and obstruct us on all occasion," Lewis wrote while in the area, "these are the Musquetoes eye knats and prickley pear, equal to any three curses that ever poor Egypt laiboured under."

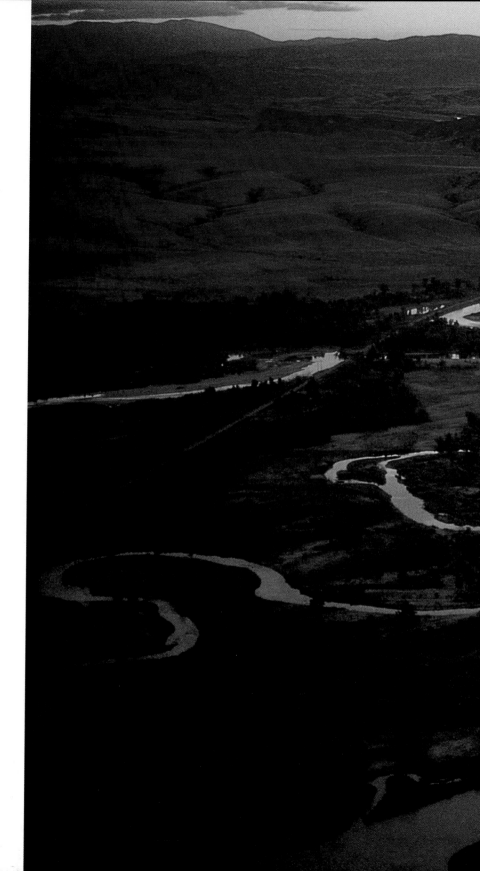

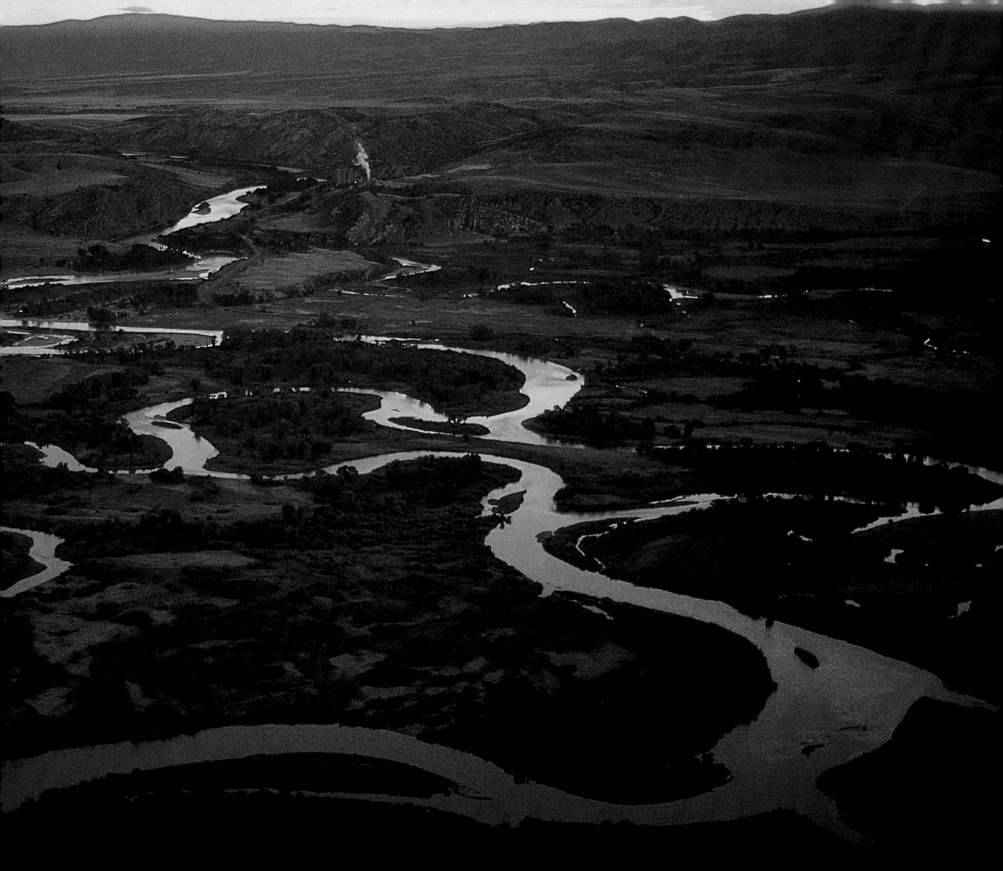

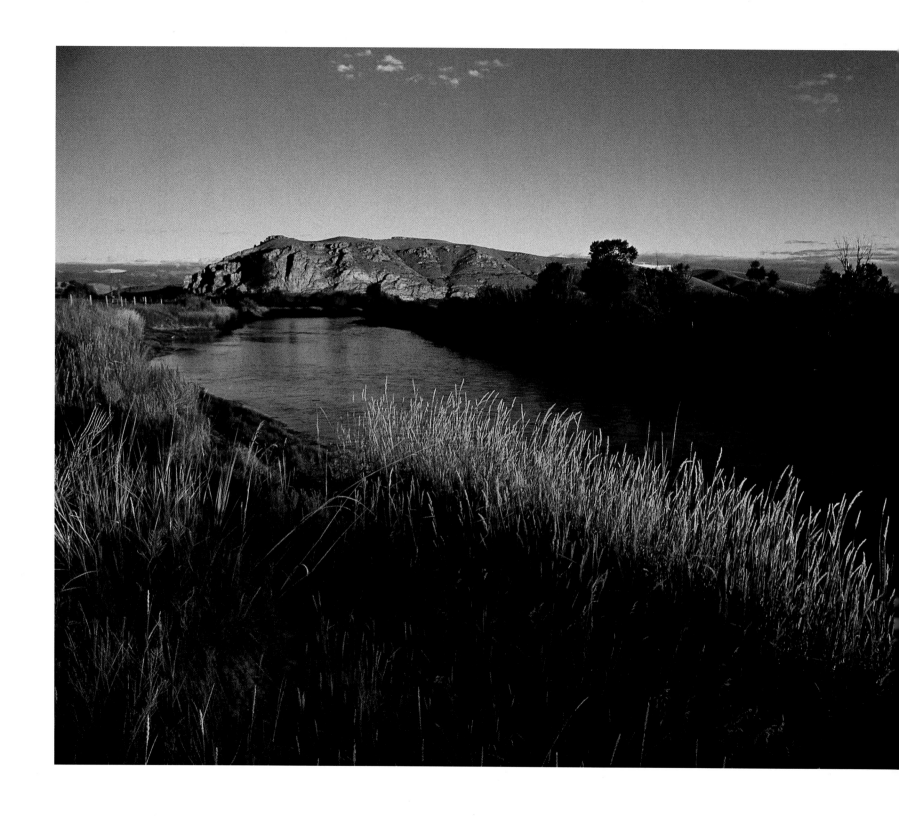

LANDMARK bluff, the rock called Beaverhead Rock looms above the river of the same name (opposite). Sacagawea, a native of this area, misidentified an earlier peak the expedition encountered as the "Beaver's Head," and assured the captains that the formation "was not very distant from the summer retreat of her nation"—the Lemhi Shoshone. The Corps searched for days before making contact with the Indians, but during that search Lewis and his small party climbed grassy Lemhi Pass (right) and there discovered a small spring. Lewis at once proclaimed it as "the most distant fountain of the waters of the Mighty Missouri."

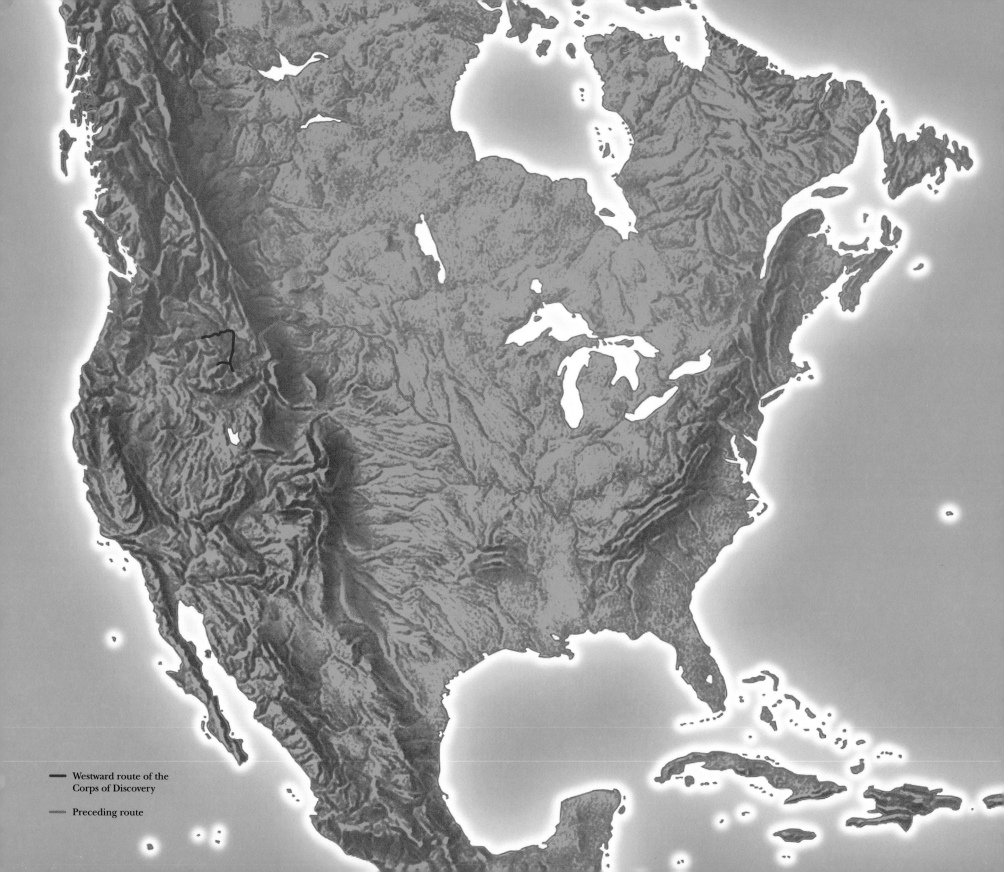

Westward route of the
Corps of Discovery

Preceding route

Most Terrible Mountains

"I have been wet and
as cold in every part as
I ever was in my life."

WILLIAM CLARK ~ SEPTEMBER 16, 1805

OVER THE CONTINENTAL DIVIDE

WHAT AN EYE MERIWETHER LEWIS HAD, AND what curiosity. Tuesday morning, August 13, 1805, he knew he was waking to the most important day of his life. Either he would make a friendly contact with the Shoshone this day or almost certainly fail in his quest for the Pacific Ocean. Yet as he hiked down the west slope of the Continental Divide, the first white man to do so, along a heavily and recently used Indian trail, his eye caught the Rocky Mountain maple, the skunkbush sumac, and the common snowberry, and he took the time to collect samples and describe the plants. The seeds of the snowberry Mr. Jefferson later introduced into Philadelphia gardens and the horticultural trade. Lewis compared the shrub to the honeysuckle of the Missouri, or wolfberry.

Clark, meanwhile, continued to ascend the Beaverhead, making only four or five miles a day against the swift stream. The men were close to giving up and complained much of their labor. "I passify them," Clark noted in his usual laconic style, without bothering to tell us how. His strength of character and leadership ability were invaluable, but it was Lewis's "remarkable botanical powers of observation," in the words of Lewis and Clark scholar Gary Moulton, that made possible the naturalist's record we have today.

At nine miles down the mountain, Lewis saw some Indians digging roots. They ran off. Lewis followed. He topped a steep rise and saw three Indians: an elderly woman, a teenage girl, and a child. The teen ran off; the old woman and child, seeing no hope of escape, sat on the ground and held their heads down; to Lewis it looked as though they had reconciled themselves to die. He called out, "tab-ba-bone," and rolled up his sleeve, showed his white skin, handed out small presents—some beads, a moccasin awl, a mirror, some

paint. Through Drouillard's sign language, Lewis persuaded the woman to lead the white men to the Shoshone village.

After two miles, the long-anticipated and eagerly sought contact took place. Sixty Shoshone warriors, mounted on excellent horses and armed with bows and arrows plus three inferior rifles, came on at full speed. When they saw Lewis's party, they halted. This was the first time an American had ever seen a Shoshone war party, and the first time this band of Shoshone had ever seen a white man.

The Indians were overwhelmingly superior. Knowing that he was doomed anyway if the Shoshone decided to fight, Lewis boldly laid down his rifle, told Drouillard and the privates to do the same, picked up his flag, and following the old woman advanced toward the Indians. The chief, in the lead, spoke to the woman. She told him that these were white men "and exultingly shewed the presents which had been given." The tension broke. The Indians dismounted. The chief advanced toward Lewis, saying *"ah-hi-e, ah-hi-e,"* which Lewis later learned meant, "I am much pleased, I am much rejoiced." The chief put his left arm over Lewis's right shoulder and applied his left cheek to Lewis's right cheek, continuing "to frequently vociforate the word *ah-hi-e."* The warriors and Lewis's men then came on "and we wer all carresed and besmeared with their grease and paint till I was heartily tired of the national hug."

Lewis brought out his pipe and all sat for a smoke. He learned that the chief's name was "Ca-me-ah-wait." Lewis said that "the object of our visit was a friendly one," and that when they got to Cameahwait's village he would explain "who we wer, from whence we had come and wither we were going." Off they went, Lewis and his men on Indian ponies, the first time they had ridden since leaving the Mandan

four months ago. The camp was located on the east bank of the Lemhi River, about seven miles north of today's Tendoy, Idaho. Lewis was ushered into an old leather tepee (the only one the band had left after a recent Blackfeet raid) and seated ceremoniously on green boughs and pronghorn skins. There was a smoke. Then Lewis passed out presents, such trifles as he had. It grew dark. Lewis mentioned to Cameahwait that neither he nor his men had eaten that day. Cameahwait could produce only some serviceberries and chokecherries. "Of these we made a harty meal," Lewis wrote.

After dinner, Lewis, Drouillard, and Cameahwait strolled down to the Lemhi River. It was a rapid, clear stream about 40 yards wide and 3 feet deep. Where does it go? Lewis asked. Cameahwait said that a half-day's march north it joined with another stream, twice as large, to form a river—today's Salmon River—that flowed west. There was but little timber along it, the chief said, and the river "was confined between inacessable mountains, was very rapid and rocky insomuch that it was impossible for us to pass either by land or water down this river to the great lake." That confirmed the impression Lewis had when he first got to the top of Lemhi Pass and looked on the Bitterroots—there was no all-water route across the continent. The distressing information about the Salmon was somewhat balanced for Lewis by the sight of "a great number of horses feeding in every direction around their camp." Drouillard counted 400. Assuming he could trade for the horses he needed, Lewis had "little doubt but we shall be enable to transport our stores even if we are compelled to travel by land over these mountains."

But how? Cameahwait said he had never crossed the mountains, but there was an old man in his band "who could probably give me some information of the country." The chief added that "he had understood from the persed nosed Indians [the Nez Perce] who inhabit this river below the rocky mountains that it ran a great way toward the seting sun and finally lost itself in a great lake of water which was illy taisted."

That sentence gave Lewis his first positive information about the drainage west of the mountains. In his mind, he now had a map, however imprecise, to connect the great rivers of the western two-thirds of the continent. Also for the first time, a white man heard of the Nez Perce, the major tribe living west of the Rockies and east of the Cascades.

Lewis was encouraged, too, when Cameahwait said the Nez Perce crossed the mountains each year to get to the Missouri River buffalo country. Their route was to the north, Cameahwait said, "but added that the road was a very bad one as he had been informed by them and that they had suffered excessively with hunger on the rout being obliged to subsist for many days on berries alone as there was no game in that part of the mountains which were broken rockey and so thickly covered with timber that they could scarcely pass."

Lewis hardly heard the words about the difficulties in store; what stood out for him was positive. "My rout was instantly settled in my own mind," he wrote. "I felt perfectly satisfyed, that if the Indians could pass these mountains with their women and Children, that we could also pass them."

Cameahwait added that there were no buffalo west of the Continental Divide that the Indians who lived there subsisted on salmon and roots. He complained that his enemies the Blackfeet and Hidatsa traded with the British for rifles, while the Shoshone had none, so they had to hide in the mountains most of the year. But, the chief continued, "with his ferce eyes and lank jaws grown meager for the want of food, such would not be the case if we had guns, we could then live in the country of buffaloe and eat as our enimies do."

Here was the opening Lewis sought. He told Cameahwait that he had come to make peace between the tribes (he did not mention the new great Father because he was now out of the Louisiana Purchase territory), and that when the expedition got back to the United States, "whitemen would come to the Shoshone with an abundance of guns and every other article necessary to their defence and comfort." In return for that promise, which could not be fulfilled for many years, Lewis asked immediate help. He explained that Captain Clark and the main body of soldiers was coming up the Beaverhead River. He wanted Cameahwait and his people to cross Lemhi Pass with him in the morning to help Clark's party carry the baggage back over the pass, to the Shoshone village, where "we would then remain sometime...and trade with them for horses." Cameahwait agreed.

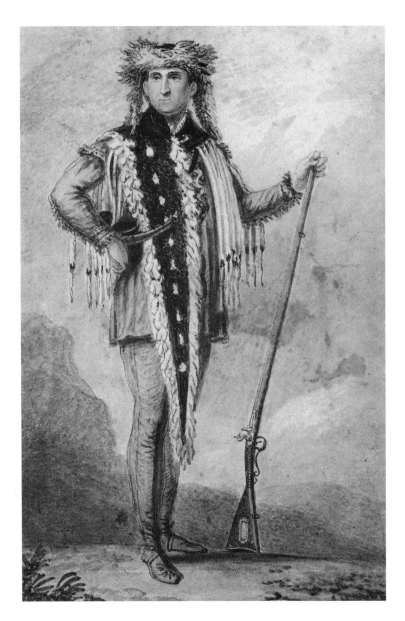

CONQUERING hero: Wearing full expedition regalia, including an elaborate fur cape he called "the most eligant peice of Indian dress I ever saw," Lewis posed for portraitist Charles de Saint-Mémin after returning to civilization. The cape, a fur tippet made of otter fur and some 100 white weasel skins, was probably a gift from the Shoshone chief Cameahwait during the Corps' stay near the Great Divide. Though Lewis met a tragic early death, which cast a pall on his achievements, many artists still chose to celebrate his accomplishments. This 1918 canvas by Montana master Charles Russell (right) memorializes the captain's courageous first meeting with Cameahwait's war party. Leaving his gun behind with two Corps members, Lewis advanced with only the American flag. His ploy worked: "We wer all carresed and besmeared with their grease and paint till I was heartily tired of the national hug," he wrote.

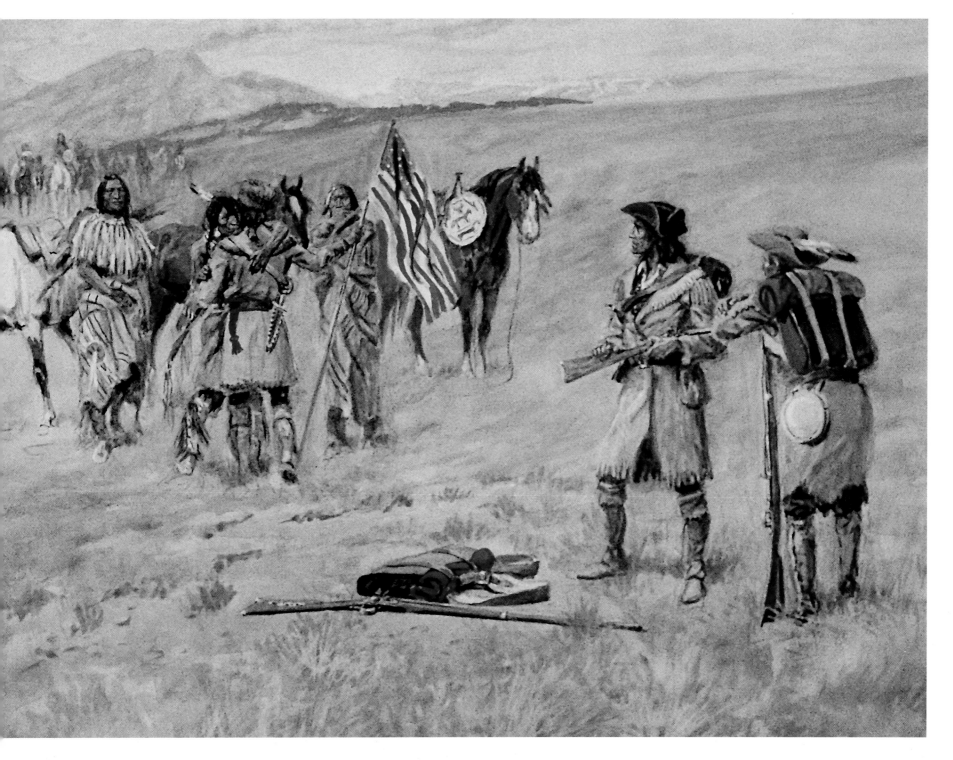

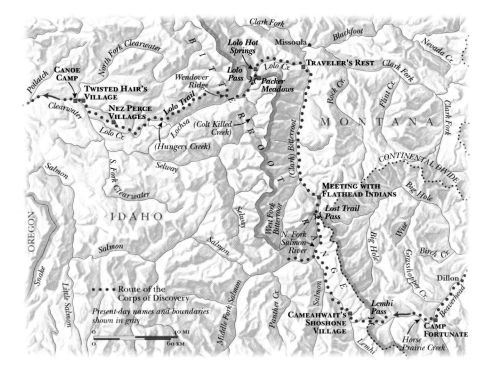

Early on August 15, a crisis. The warriors would not move. Cameahwait explained "that some foolish persons among them had suggested the idea that we were in league with their enemies and had come on in order to decoy them into an ambuscade." After words of persuasion, which included refusing them arms and ammunition if they did not go and, worst of all, challenging their bravery, Lewis watched as Cameahwait headed his horse toward the pass. Some two dozen warriors joined him, as did Lewis and his party.

They crossed Lemhi Pass, descended to the cove, and camped on today's Horse Prairie Creek. Lewis concluded his journal entry, "I now cooked and among six of us eat the remaining pound of flour stired in a little boiling water." Among the Shoshone only Cameahwait and an unnamed warrior had eaten that day. The party was out of food.

In the morning, Drouillard killed a deer. An Indian who'd been with him came racing back to camp with the news. "In an instant they all gave their horses the whip," Lewis wrote.

At the site of the kill, "the seen when I arrived was such

that had I not have had a pretty keen appetite myself I am confident I should not have taisted any part of the vension. Each Indian had a peice of some discription and all eating most ravenously. Some were eating the kidnies, the melt [the spleen] and liver and blood running from the corners of their mouths...." They devoured it without bothering to start a fire to cook it. The party then moved on.

The group descended the valley and arrived at what Lewis and Clark later named Camp Fortunate. It is today under the water of Clark Canyon Reservoir, just beside Interstate 15, 20 miles south of Dillon, Montana. We camped there in July 1976. My journal: "Barry caught a bunch of brown trout for dinner, on a stream where Private Goodrich, the Corps' best fisherman, caught trout 171 years ago. Our party grows. Our dear friend John Homer Hoffman, who has traveled with us before, drove up. He is a high school history teacher in Baltimore, nuts about Indians and the West."

John has a lively imagination. As we looked out on the reservoir, he got going on the drama that had unfolded here in 1805. "Lewis and Cameahwait would have come down from there," he said, pointing up Horse Prairie Creek. "Behind them Drouillard and the enlisted men, plus the Shoshone warriors, bedecked in leather jackets covered with beads, shells, and quills. Lewis's eyes would have been searching, every fiber in his being hoping, praying to see Clark and the rest of the party. Cameahwait and his warriors' eyes would have been searching, too, looking for their enemies, convinced they were being led into an ambush." John waved his hand across the horizon, with snow-covered mountains in every direction. "Lord, what a scene," he exclaimed.

In August 1805, Lewis had no time to notice the scenery. He had promised the Indians that Clark would be there, but there was no sign of Clark. The Shoshone grew even more restless. To restore confidence, Lewis gave his rifle to Cameahwait to hold, and had the men give theirs to warriors. Then he aroused their curiosity; he told the Shoshone that one of their people, a teenage woman, was with Clark. So was a man "who was black and had short curling hair." The Indians expressed great eagerness to see such a man.

Clark's struggles with the mountain stream continued. He

pushed on, extracting every bit of energy he and the men could muster. He was getting close.

But Lewis didn't know that. In the evening, he wrote in his journal, "my mind was in reality quite as gloomy as the most affrighted indian but I affected cheerfullness." He lay down to sleep, Cameahwait beside him, but "I slept but little...."

In the morning, the best possible sight—Clark coming on foot, ahead of the canoes, with Charbonneau and Sacagawea. Lewis saw that the Shoshone "all appeared transported with joy," and admitted, "I felt quite as much gratifyed as they." Sacagawea, meanwhile, turned to Clark, stuck two fingers in her mouth, and sucked them. Clark knew enough of the sign language to recognize that the gesture meant these were her people. He stepped forward confidently. Lewis introduced him to Cameahwait and they all used their hands to flash the sign for welcome—two open palms. Cameahwait gave Clark the national hug and festooned his hair with shells. The hugging surprised Clark, who figured the Shoshone were all as undemonstrative as Sacagawea had been so far.

He—and Lewis—were in for another surprise. In the midst of the excitement, one of the Shoshone women recognized Sacagawea. Her name, Jumping Fish, had been acquired on the day Sacagawea was taken prisoner, because of the way she had jumped through a stream in escaping the Hidatsa. The reunited teens hugged and cried and talked, all at once, in an outburst of emotion.

As John gave a verbal sketch of the scene, Stephenie and Grace—who have adopted the Indian girls' names—listened closely. When he finished, Stephenie commented, "Just think about Sacagawea being the only female on the expedition, and the joy she must have felt at being reunited with her friend. Her spirit must have soared! And think of the talk. Here was Jumping Fish, still a child, not yet married, living in the same place she had been born. Sacagawea had crossed a third of the continent, out and back, been taken as wife by a Hidatsa, been lost in the bet to Charbonneau, given birth, and had an infant. The words must have poured out."

Meanwhile, the white and red men, and the black man, examined one another. "Every article about us appeared to excite [their] astonishment," Lewis noted: the appearance

of the men, their firearms, the canoes, York, "the segacity of my dog"—all were objects of admiration. Lewis shot his air gun, which the Shoshone pronounced "great medicine."

There was work to do. Lewis gathered everyone for a conference, looking forward to being able to converse through translators rather than through the sign language. The chain would run from Sacagawea, speaking Shoshone to the Indians and translating it into Hidatsa, to Charbonneau, who translated her Hidatsa into French, to Private Labiche, who translated from French to English. But scarcely had they begun the cumbersome process when Sacagawea began to stare at Cameahwait. Suddenly recognizing him as her brother—in the excitement of seeing Jumping Fish, she had not noticed—"she jumped up, ran & embraced him, & threw her blanket over him and cried profusely." Lewis wrote that the reunion was "realy affecting." He wrote not a word to indicate that he was surprised by such a show of emotion from the girl he had characterized a couple of weeks earlier as someone who never showed the slightest emotion.

When Sacagawea recovered her composure, the talk began. Lewis and Clark said that they had come in order to find a way to bring the Shoshone firearms, but that this could not be done until the expedition got over the mountains and to the Pacific, and that could not be done without Shoshone horses and a guide. Cameahwait replied "that he was sorry to find that it must yet be some time before they could be furnished with firearms but said they could live as they had done heretofore untill we brought them as we had promised." In the morning, he said he would go back to his village and bring on enough horses to make the portage.

Clark would go with him. Clark wanted to see for himself before accepting Cameahwait's alarming description of the Salmon River route. If he found the river to be navigable, he would set to making canoes. Before he left, Clark purchased three horses for a uniform coat, a pair of leggings, a few handkerchiefs, three knives, and some trinkets "the whole of which did not cost more than about 20$ in the U'States." At such prices, the expedition could expect to obtain quite a herd. Camp Fortunate had earned its name.

Accompanied by a Shoshone guide named by the captains

Old Toby, Clark set off. Lewis stayed to prepare for the portage. Drouillard brought in a deer. Another man caught a beaver. Lewis had a net arranged and set to catch trout. It yielded 528 fish, most of which Lewis gave to the Shoshone.

John Hoffman asked me, "How come the Shoshone were starving with all these fish around?"

"Beats me," was all I could reply, and added, "Not to mention the salmon on the other side. But here is another mystery; during their winter on the Pacific Coast the captains paid outrageous prices to the local Indians for fish, yet never went fishing themselves. Not even Goodrich. Beats me why."

Lewis concluded his August 18 journal entry with an oft-quoted passage. "This day I completed my thirty first year," he began. He figured he was halfway through his life's journey. "I reflected that I had as yet done but little, very little indeed, to further the hapiness of the human race, or to advance the information of the succeeding generation. I viewed with regret the many hours I have spent in indolence." Then he shook the mood, writing that, since the past could not be recalled, "I dash from me the gloomy thought and resolved in future, to redouble my exertions.... to live for *mankind,* as I have heretofore lived *for myself.*"

Among other things, the passage is a reminder of how young he was, and how physically tired and emotionally exhausted after the tension of the last few days. And of how far he had come, and how far he had to go.

He was in what remains today one of the more undeveloped places on the continent. To the north, the nearest town is Dillon, Montana, 20 miles from Camp Fortunate; to the south, Idaho Falls is 160 miles away; to the east it is the town of West Yellowstone, 100 miles distant; Salmon, Idaho, is 60 miles to the west as the crow flies, over 100 on the ground. In this vast area there are but a handful of ranches and virtually no paved roads. The spectacular scenery is complemented by the grazing herds of sleek cattle and spirited horses grown fat and healthy on the magnificent Montana grass (which has one of the highest protein contents of any in the world).

Lewis spent six days at Camp Fortunate. Cameahwait showed up with the horses on August 22.

Clark, meanwhile, had gone down the Salmon far enough to convince himself that Cameahwait had given an accurate description of the river. "The water runs with great violence from one rock to the other on each Side foaming & roreing thro rocks in every direction," he wrote, in considerable awe, "So as to render the passage of any thing impossible."

Three times I have followed Clark down the Salmon, finding his description as accurate as ever. He said it could not be passed, but he meant by horse or dugout canoe. We did it in large rubber rafts, with professional guides at the tillers. The some 40 miles he traveled still foams and roars—a thrill and delight in a big rubber raft, but impossible for a canoe. Our view of the shore revealed that Clark's land trek could not have been easy either, over sharp, rocky bluffs that came straight down onto the riverbed. Clark hated to give up. He hated to turn back, ever. On the Salmon River, he had to.

We ran past the point where Clark turned back, and Old Toby was right, the rapids below were much bigger. The Salmon is justly famous among floaters. We took out at the end of road; if you go beyond that point (some ten miles beyond the place where Clark gave up) you are then on what they call in Idaho "the River of No Return."

Over the last week of August 1805, the captains traded with the Shoshone for their horses, purchasing 29. And Old Toby had agreed to be the guide.

On September 1, the party set out, traveling cross-country over high, rugged hills, to today's North Fork of the Salmon River. The men were headed almost due north in rough, seldom-traveled country, with no Indian road or any other sign of human presence. They were entering mountains far more difficult to pass than any American had ever attempted—steep and massive peaks thrust up by tectonic forces deep within the earth, thickly timbered in pine. Nearly two full centuries later this remote country retains its natural status and is still basically uninhabited due in large part to its rank as federal land. The confusion of creeks and ravines cutting through the steep mountainsides has made the route the expedition used the most disputed of the entire journey.

Clark described the route: "Thro' thickets in which we were obliged to Cut a road, over rockey hill Sides where our

horses were in perpetual danger of Slipping to Ther certain distruction & up & Down Steep hills....with the greatest dificuelty risque & c. We made 7 1/2 miles."

The next day was worse. On September 3 it snowed. Clark summed up the misery of the day: "We passed over emence hils and Some of the worst roade that ever horses passed our horses frequently fell." There was no game. The men had eaten the last of the salt pork. That night there was a hard freeze. The following day, the party fell down a steep descent to a north-flowing river that Lewis named for Clark (but which is today known as the Bitterroot River). There, at today's Ross's Hole, a wide and gently sloping valley later named for Alexander Ross of the Hudson Bay Company who came there in 1824, the captains encountered a band of some 400 Flathead Indians, with some 500 horses. Charles M. Russell immortalized the scene in a floor-to-ceiling wall painting behind the Speaker's podium in the House of Representatives chamber in the capitol building in Helena.

The Flathead were friendly, thanks to Old Toby, who had relatives among them. The captains bought 13 horses for a total of 39 horses for packing, riding, or food in the extreme.

Over the next four days, the expedition rode along the west bank of the wide and beautiful Bitterroot River. They made good time, 20 miles a day or more, but as they marched, the men kept looking to the west at the snow-covered Bitterroot Mountains, described by Sergeant Gass as "the most terrible mountains I ever beheld."

The first time we saw them, we had to agree. Like Gass, all of us knew the Appalachian chain and the front range of the Rockies, but they were nothing in comparison with the Bitterroots. Here was a mile-high sheer mass of rock, its jagged, snowbound peaks and angled drainages presenting a formidable barrier. But the barrier would have to be crossed. The men put their fate in the hands of Old Toby.

The party camped the night of September 9 at the junction of a stream coming in from the west, today's Lolo Creek, some ten miles southwest of Missoula. Old Toby informed Lewis that at this place the party would leave the Bitterroot River and head almost straight west, up Lolo Creek, then over the mountains. The ordeal that every man had dreaded

was about to begin. Lewis wrote of "those unknown formidable snow clad Mountains" then concluded, "The weather appearing settled and fair, I determined to halt the next day rest our horses and take some scelestial Observations." He called the campground "Travellers rest."

On our first trip, we camped about 20 miles west of a plaque marked "Traveler's Rest," in today's town of Lolo. But like most such signs, it was a guess, the exact site unknown. That changed in 1996 when geologist Bob Bergantino of the Bureau of Mines and Geology in Montana pinpointed the spot on a nearby bench of land, partly through the use of infrared aerial photographs that revealed a tepee ring and campfire, partly through Clark's map and the descriptions in the journals. For 25 years Bob has been tracking down every one of the Corps' campsites, from St. Louis to the Pacific, and he knows what he is doing.

Moira and I prepared for our own first trek by walking from our campsite, which the expedition had walked through, to the original Lolo Trail, which climbed the ridge behind us. We hiked a couple of hours along it. Moira said being in Lewis's footsteps made her feet tingle. The Trail is indistinct and crisscrossed by deadfalls, difficult going.

At the Visitor's Center on Lolo Pass, we got some help from Smokey Shultz, the ranger. Together we pored over maps as he pointed out the Corps' campsites and the places where today's Forest Service Road 500 follows the original Lolo Trail. He gives excellent advice.

Before starting out, I read the journals, following the captains over the Lolo Trail. In my journal I wrote, "Hiking the Trail is the summit of our ambitions, the place where we will get closest to Lewis and Clark, and we are all full of apprehension. The first day we will climb 4,000 ft. In eight miles. All are determined to give it their best shot."

Standing at the captains' starting point, Traveler's Rest, Bob Bergantino describes what it was like for them: "I can see a party of people camped here, preparing for the push over the mountains. I feel the first cold of winter coming down off the hillsides and the fear of what might lie ahead, not knowing if there will even be food, knowing that I would rather die than see the expedition fail."

THE LOLO TRAIL

LATE IN THE AFTERNOON OF SEPTEMBER 11, THE expedition began its assault on the Nez Perce Trail over the Bitterroots, today's Lolo Trail. It made seven miles. On the second day, the Corps passed a hot springs that "Sprouted from the rocks." The Nez Perce had built a rock-enclosed pool, where Clark took a soak, pronouncing it "nearly boiling hot." Today called Lolo Hot Springs, it is a commercial swimming pool, outdoors, in a natural, bowl-shaped depression in the mountainside that collects hot water from a thermal springs. The temperature of the pool is 100°F.

From there the Corps followed what Clark called a "tolerabl rout" over the divide that separated the Bitterroot River drainage from the waters flowing west. A mile or so south of today's Lolo Pass, it came to a beautiful open glade (today's Packer Meadows). Then it fell down today's Pack Creek and camped. All well so far. But September 14 opened with rain, followed by hail and then snow. Worse, Old Toby got lost. The Nez Perce trail followed the ridgeline, north of the river the Nez Perce called the Kooskooskee (today's Lochsa), but Old Toby led the party down the drainage to a fishing camp on the Kooskooskee. Indians had recently been there and their ponies had eaten all the grass—more bad luck for the expedition. The road was "much worst than yesterday…Excessively bad & Thickly Strowed with falling timber…. Steep & Stoney."

By the time the men made camp (near today's Powell Ranger Station on the Lochsa), they and the horses were "much fatigued" and famished. Since the hunters had been unsuccessful, "we wer compelled to kill a Colt…to eat and named the South fork Colt killed Creek." In the morning, Old Toby led the men up today's Wendover Ridge, in order to regain the ridgeline and the Nez Perce Trail. The going was incredibly difficult. It was a steep ascent made worse by "the emence quantity of falling timber." Several of the horses slipped and crashed down the hills. The horse carrying Clark's field desk rolled down the mountain for 40 yards until it lodged against a tree. The desk was smashed, but the horse was unhurt. When the party reached the ridgeline, at some 7,000 feet of elevation, there was no water. Using snow, the men made a soup out of the remains of the colt killed the previous day.

The expedition had made only 12 miles, despite "the greatest exertion." Even more discouraging, Clark wrote that "from this mountain I could observe high ruged mountains in every direction as far as I could See."

For us, the climb to the ridgeline was relatively easy. Our party was 20 people strong with friends and students. By noon we had made four miles, even the little kids, and had seen some fine scenery: Thickets of mountain heather woven through with the trunks of fallen trees; streams filigreed with ice; ponderosa pines intermixed with cedars and firs so tall you lose sight of them at the tips; crystalline peaks where the snow never melts.

This was tough country for the expedition, but not so bad for us, as the Forest Service maintains a logging road that runs up to Forest Service Road 500 and keeps the deadfall out of the way. On the other hand, the expedition had horses to haul the gear; we packed ours on our backs. We got to a Lewis and Clark campsite best described by Pvt. Joseph Whitehouse in his journal: "Camped at a Small branch of the mountain near a round deep Sinque hole full of water. we being hungry obledged us to kill the other sucking colt to eat."

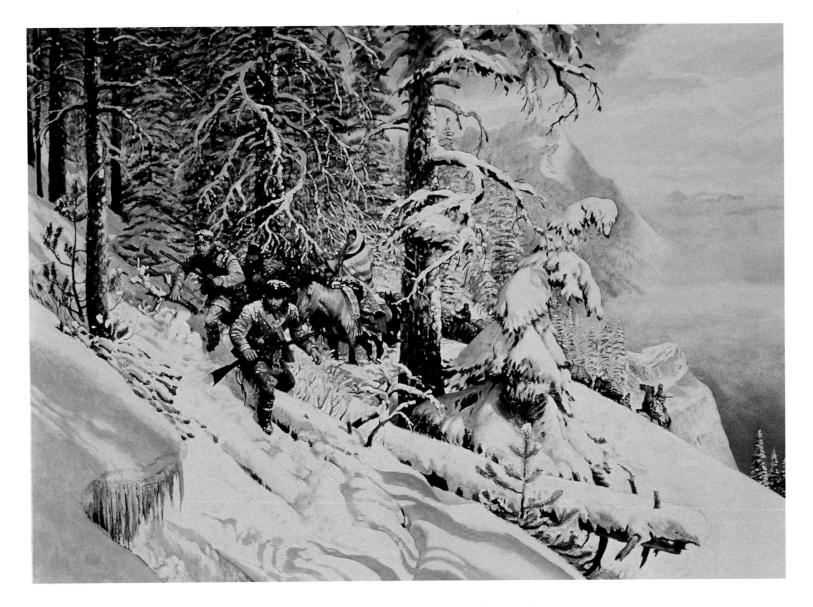

CROSSING the Bitteroot Mountains after an early September snowfall, the Corps battled hellishly steep terrain made more difficult by the wet and cold. With no food for themselves or their horses, they were forced to kill and eat three colts. "We suffered everything Cold, Hunger & Fatigue could impart," Lewis later recalled of the torturous 11-day-long forced march across this remote range of the Rocky Mountains.

All the campsites along the Trail have been named by Ralph Space, a legendary Forest Service employee who knew the Trail better than anyone else in the 20th century. He had signs put up at the Lewis and Clark sites, with names taken from the journals, such as "Salmon Trout Camp," "Spirit Revival Ridge," and "Bears Oil and Roots Camp," and was responsible for putting together the Forest Service map (in supply at the Lolo Pass ranger station) that is the best available for following the expedition through the Bitterroots.

Our campsite that first night was completely enclosed by mountains. We had made nine miles and gained 4,000 feet. With eight tents on this couple of acres of flat ground, it looked like a regular campground. Supper was a feast, as everyone cooked whatever meat they had brought with them, to lighten the load for the next day. It ranged from venison jerky to beef steaks, elegant compared with the colt the Corps of Discovery ate. A cow moose and calf wandered into the sinque hole; Bib barked and drove them off.

For the Corps of Discovery, September 16, 1805, was the worst day ever. It began to snow three hours before dawn and continued all day, piling up as high as six to eight inches. Clark walked in front to find the trail "and found great dificuelty in keeping it" because of the snow. He wrote in his journal, "I have been wet and as cold in every part as I ever was in my life." The party made but 13 miles, "passing emince Dificuelt Knobs Stones much falling timber and emencely Steep."

My journal of our second day on the Trail: "A stunning sunrise, 20 cheery people to share it with. Hearty breakfast. Everyone wanders around the three or four cooking fires, making trades, a bite of this for a bite of that. We got into deep snow right away—from that point on we were the first people on the Trail this year. Bear, elk, moose, and deer tracks in the snow, but no human. Many deadfalls over the road, which the Forest Service will clear out when the snow melts. For us, a delight—there is no way in and no way out, other than by hiking for two days.

It is ironic that we were inundated with big-game tracks and an occasional sighting, not needing to hunt to survive, while the captains found no big game despite the efforts of their most skilled hunters. This was a sharp reminder that the animals are not native to the mountains, but have been driven up here from the valleys and grasslands by hunting and ranching pressure. Where Lewis and Clark never saw an elk, out-of-state hunters today pay Idaho Fish and Game and Idaho outfitters thousands of dollars to hunt elk.

"We nooned at Wendover Ridge," my journal continued, "where Lewis and Clark camped on June 28, 1806, on the return trip. Built a fire so we could have hot soup, dried soup, in honor of the captains, almost inedible, but like Lewis's similar portable soup it sustains human life. The expedition could find no running water up on top of the mountain and neither could we, so like them we melted snow. The afternoon hike took us to a hollow with a lovely lake of clear blue water, where we camped. Ralph Space calls this 'Greensward Camp.'"

To a point, our 20th-century party reveled in the isolation, the snow, the experience. But we were getting a taste of the Corps' misery, too. Wrote Stephenie in her journal for the second day on the Lolo: "Dad had us up at six and hitting the road at seven. We hiked a ton and my muscles ache tremendously. Hiking behind my father is an experience if one lives through it. Never mind, we all trudge faithfully behind. Snow is a real lifesaver on the Trail particularly when the last stream was three miles back." She concluded, "This morning I could hardly believe Grace, standing there blue lipped, saying 'I'm not cold,' wearing only one sweater."

By September 17, 1805, the Corps had become desperate. The men's spirits were low, they were approaching the uttermost limits of physical endurance, the food supply was down to a little bear's oil and 20 pounds of candles, with no hope of finding game. They had reached the breaking point.

The captains conferred around the campfire. They agreed that in the morning Clark and six hunters would go ahead "to hurry on to the leavel country a head and there hunt and provide some provision" to send back to the main party, which would be following under Lewis's leadership. Clark set out the morning of September 18. The advance party made almost 30 miles, but shot no game. Clark made camp beside a creek that he named

"Hungery Creek as at that place we had nothing to eate."

Lewis and the main party made 18 miles. He wrote that evening that the situation was critical, as the expedition's only resources were the rifles and the packhorses. The rifles were "but a poor dependance in a country where there is nothing upon earth except ourselves and a few small birds," and killing the packhorses would mean abandoning most of the baggage, unthinkable with the Pacific still so far away. There was nothing for it but to proceed.

My journal for our third day on the Trail: "Some little rain last night, took us until 10 a.m. to dry out and pack up. A long, hard hike, mostly climbing. How they made 18 miles in a day we can't imagine. No matter how hard we push, we can't average better than one mile per hour on the ascents, two on the descents—and neither could they, but they could keep at it for 14 hours. Incomprehensible.

"As for scenery, there are snow-covered mountains in every direction, deep valleys and canyons, gigantic cedars, firs, spruce, flowers of every hue, birds, animals—we saw another moose cow and calf, an elk and a number of deer."

In 1997, Ken Burns, Dayton Duncan, Moira, and I, plus a dozen cameramen and reporters, camped on the Trail with Harlan and Barb Opdahl of Triple O Outfitters, Weippe, Idaho. We rode horses to The Smoking Place, where the Nez Perce would stop while crossing the Trail to smoke. "It was just about here," Ken commented, gazing out over the Bitterroots from this superb vantage point (the mountain drops off sheer from The Smoking Place for 2,000 feet and more), "that Drouillard said he could never find his way out of here and hoped to hell Old Toby knew where he was going. Drouillard was perhaps the best woodsman America ever produced, and he was lost. Think of it! But looking out here, I'm not surprised. It's impossible to follow the drainages with your eyes."

The morning of September 19, 1805, the captains pushed on. Clark met a stray horse, killed and butchered it, and after breakfasting on it hung the remainder on a tree for Lewis and the main party. Lewis got going just after sunrise. At 6 miles, "the ridge terminated [at today's Sherman Peak] and we to our inexpressable joy discovered a large tract of Prairie country lying to the S.W." There was an end to the mountains. The plain appeared to be about 60 miles distant. Lewis pushed on. "The road was excessively dangerous . . . being a narrow rockey path generally on the side of steep precipices." One horse fell, "and roled with his load near a hundred yards into the Creek. We all expected that the horse was killed but to our astonishment when the load was taken off him he arose to his feet & appeared to be but little injured. This was the most wonderfull escape I ever witnessed." The expedition's luck was changing.

In 1976, where the expedition got snow, we got rain. Moira's journal, July 16: "A real Rocky Mountain thunderstorm rocked and rolled us all night long. Powerful, brilliant, loud and scary, it thundered up and over our camp, and returned an hour later to roll back where it came from."

My journal: "By first light, about 4:30 a.m. on the eastern edge of the Pacific time zone, we got a fire going and 18 miserable people huddling around it. At 7:30, more rain. As we were engulfed in a cloud, it seemed to be raining up. Most feet in bad shape. Spirits gone. The group decides it is time to retreat down the mountain. Back to cars, civilization."

Something about this place commands poetry even in the midst of pain. On our 4,000-foot descent to the Lochsa River and Highway 12, Moira, blistered and tired, was compelled to write, "Deep green and leafy flowering underbrush walking right through the dripping clouds. Tall pines giving way to cedars a hundred feet tall. More rain. My toes hurt from the steady pounding. Beautiful rivulets cluttered with flowers appear at each turn in the switchbacks." We hated to quit—but being able to choose to leave was nice.

Of course the captains didn't have the option of quitting. On September 20, 1805, Clark finally got out of the mountains and had a friendly meeting with the Nez Perce at Weippe Prairie. The Indians fed his advance party with their two staples, dried salmon and boiled camas roots. He purchased a pack load of the fish and roots and sent Reuben Field back up the Trail to give it to Lewis and the party. Then he continued on to the Clearwater River, where a large village of Nez Perce greeted him. Their chief, Twisted Hair, struck Clark as "a Chearfull man with apparant Siencerity."

Clark and his men spent the night in various tepees, all of them suffering severe gastrointestinal stress.

The Nez Perce were by far the largest tribe between the Missouri River and the Pacific Coast. They ranged across today's central Idaho, from the western base of the Rockies to the falls of the Columbia. A nomadic, hunting-and-gathering tribe, they had few enemies and had never seen a white man. They had a magnificent horse herd and were the only Indians to practice selective breeding—which produced the Appaloosa. They quickly became the Corps of Discovery's favorite Indian tribe.

As Clark made contact with the Nez Perce, Lewis got off to an early start. After proceeding two miles, he saw a most welcome sight, the horse that Clark had killed and left hanging for him. The party "made a hearty meal on our horse beef much to the comfort of our hungry stomachs." The party made another dozen miles before making camp, where the men finished what was left of the horse.

That night, sitting around the campfire, cold, hungry, exhausted, miserable, and anxious, Lewis summoned the energy to make significant additions to scientific knowledge as he described the discoveries he had made over the past few days in the mountains: the varied thrush, Steller's jay, the gray jay, the black woodpecker (known today as Lewis's woodpecker), the blue grouse, the spruce grouse, and the Oregon ruffed grouse, as well as the mountain huckleberry, the Sitka alder, and the western red cedar. They are all still there, and we have seen all of them—although you need a serious bird-watcher to distinguish the grouse, a role John Hoffman filled for us.

Lewis wasn't quite out of the mountains yet. The hunters killed three grouse, Lewis killed a coyote, one private found crayfish in the creek, providing "one more hearty meal, not knowing where the next was to be found. I find myself growing weak for the want of food and most of the men complain of a similar deficiency and have fallen off very much."

We try to emulate the captains in every way possible, but as to eating coyote it is like paddling upstream on the Jefferson and Beaverhead Rivers—we pass.

On the morning of September 22, Lewis's party had proceeded some three miles on foot down the creek when it met Private Field and his packhorse coming upstream, carrying salmon and roots. The load was sufficient "to satisfy compoleatly all our appetits." After eating, the party proceeded to a small village of Nez Perce.

The expedition had made 160 miles since it left Traveler's Rest 11 days before. It was one of the great forced marches in American history. Lewis tried to describe his emotions: "The pleasure I now felt in having tryumphed over the rocky Mountains and decending once more to a level and fertile country can be more readily conceived than expressed, nor was the flattering prospect of the final success of the expedition less pleasing."

Clark had been down at Twisted Hair's village when the expedition got out of the mountains. He joined Lewis that evening, bringing plenty of information, and a warning. "I found Capt. Lewis & the party Encamped, much fatigued, & hungery, much rejoiced to find something to eate of which They appeared to partake plentifully. I cautioned them of the Consequences of eateing too much &c."

The information came from Twisted Hair, who was with Clark and who drew a map on white elk skin of the country to the west. He showed the creek they were on emptying into the Clearwater River, which was soon joined by a river coming in from the northeast (the North Fork of the Clearwater) and then flowing west to join with the Columbia. It was a five-sleep journey to the Columbia, then another five sleeps to the falls of the Columbia. "At the falls," Clark recorded, Twisted Hair "places Establishments of white people &c. And informs that great numbers of Indians reside on all those forks as well as the main river."

If Twisted Hair was right, the expedition was within ten days of the falls, and a couple of weeks from the ocean. This was wonderful news, made even better by the presence in the area of Ponderosa pines of sufficient size to make canoes.

First the canoes would have to be made, but because no one had heeded Clark's warning about overeating, all the men were sick. Most of them were violently ill for a week, their dysentery producing acute diarrhea and vomiting. The sickness was presumably the result of the change of diet from all meat

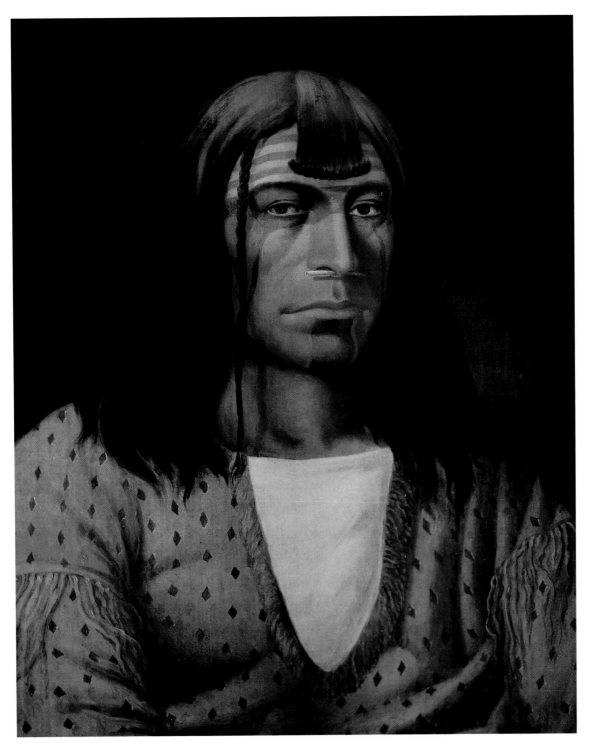

PERPETUATING a myth, Canadian artist Paul Kane executed his 1840s painting of a Nez Perce with the pierced nose that presumably earned the tribe its name. In fact, these Indians of the Great Basin, in present-day Idaho, did not routinely practice body piercing. Clark may have misinterpreted an Indian sign to mean "pierced nose." Like many other tribes, the Nez Perce call themselves "the people"—"Nimiipu."

Incomparable Eden: A wealth of new species enthralled Lewis and Clark on their way west. In the Beaverhead Valley, Lewis spotted a woodpecker "as black as a crow.... it has a long tail," he wrote of the bird now named for him, "and flys a good deel like the jay bird." Lewis reported that the Clatsop Indians caught the eulachon, or candlefish, "in great quantities in the Columbia" with "skiming or scooping nets...."

to all roots and dried fish, along with bacteria on the salmon.

For almost a week, the expedition resembled a hospital ward for the critically ill more than it did a platoon of fighting men. That gave the Nez Perce a once-only opportunity. Killing the whites would have been the work of a few moments, and would have put the Nez Perce in possession of the biggest arsenal west of the Mississippi River, plus trade goods, iron kettles, knives, axes, saws in quantities greater than any of them would ever see in their lifetimes. The warriors were not unaware of the opportunity; indeed they discussed killing the whites.

But there was among them a woman named Watkuweis (meaning "Returned from a Far Country") who had been captured by Blackfeet some years earlier, taken into Canada, and sold to a white trader. She lived with him for several years before somehow finding her way home. The white man had treated her much better than the Blackfeet had done, so when the warriors talked about a first strike, she said, "These are the people who helped me. Do them no hurt."

If Sacagawea and Watkuweis developed a relationship, based on their somewhat similar experiences, the captains never thought to mention it. They could not have talked, as Sacagawea did not know the Nez Perce language, but they could have used the sign language.

First Sacagawea, now Watkuweis. The expedition owed more to Indian women than either captain ever acknowledged. And the United States owed more to the Nez Perce for their restraint than it ever acknowledged. When, in 1877, the Army drove Chief Joseph and the Nez Perce from their Idaho home, there were in the band old men and women who had as children been in Twisted Hair's village.

During the week of illness, Clark moved camp some ten miles to the junction of the North Fork with the main stream, and got to work making canoes using the Indian method. Twisted Hair had shown him how to put logs over a slow-burning fire trench and burn them out. It took ten days to complete one small and four large canoes. Twisted Hair promised to care for the Corps' herd of 38 horses until the Americans came back in the spring on their return journey. Clark had the horses branded with Lewis's branding iron.

ALMOST a century after the expedition, the Columbia River yielded a rare treasure: a branding iron marked "U.S., Capt. M. Lewis." A local tribe may have stolen it. When used, its "brand" would appear reversed.

The branding iron bore the legend "U.S. Capt. M. Lewis." It is today in the Oregon Historical Society Museum, one of the few surviving authenticated artifacts associated with the expedition. It was found near Hood River, Oregon, in 1892; it had probably been stolen from Lewis by one of the tribes living along the Columbia River—Lewis never left anything behind. If an Indian stole it, he would have found no use for it and at some point tossed it aside.

By October 6, all was ready. "I am verry Sick all night, Clark recorded. But I am obliged to attend everything," because Lewis was immobile. Lewis later wrote of being "...for 10 or 12 days, sick, feeble & emaciated." Clark had the canoes put into the water and loaded. At 3 p.m. the party set out. The river was swift, with many rapids. Nevertheless, the men made 20 miles in under three hours. The expedition was once again waterborne, going downstream for the first time since the captains had turned the keelboat from the Ohio into the Mississippi River, two years earlier. Seven miles an hour felt like flying. Ahead lay the Pacific.

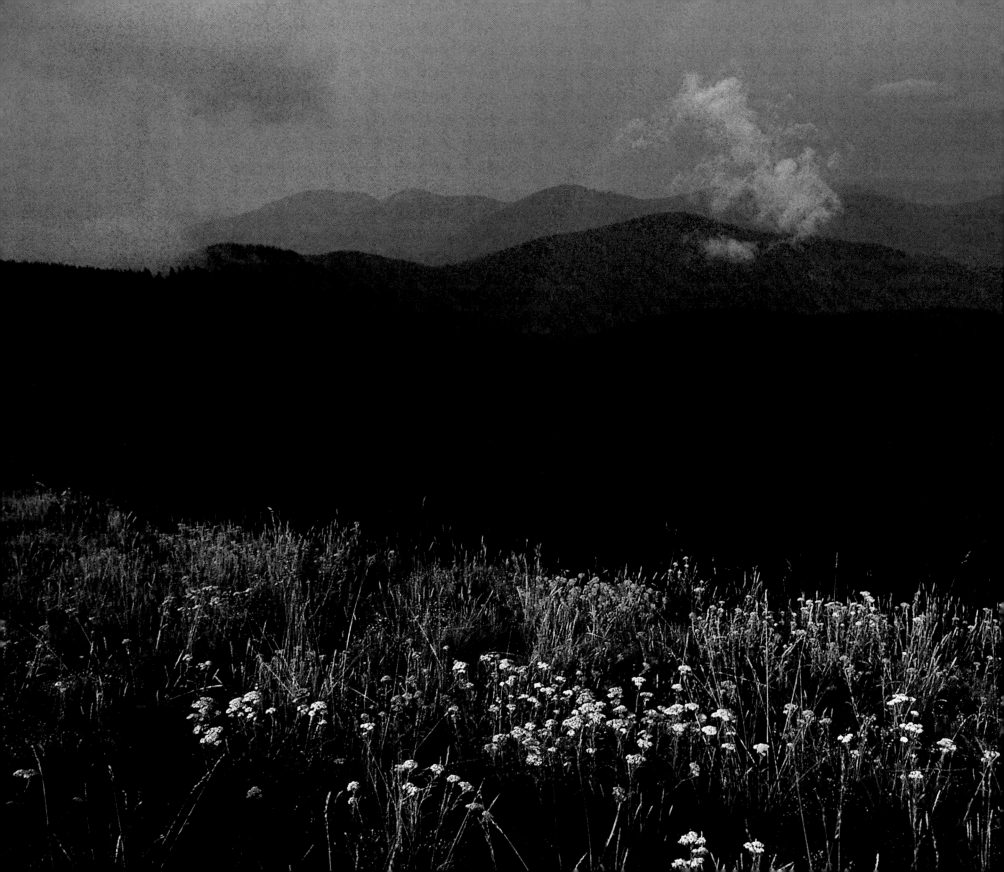

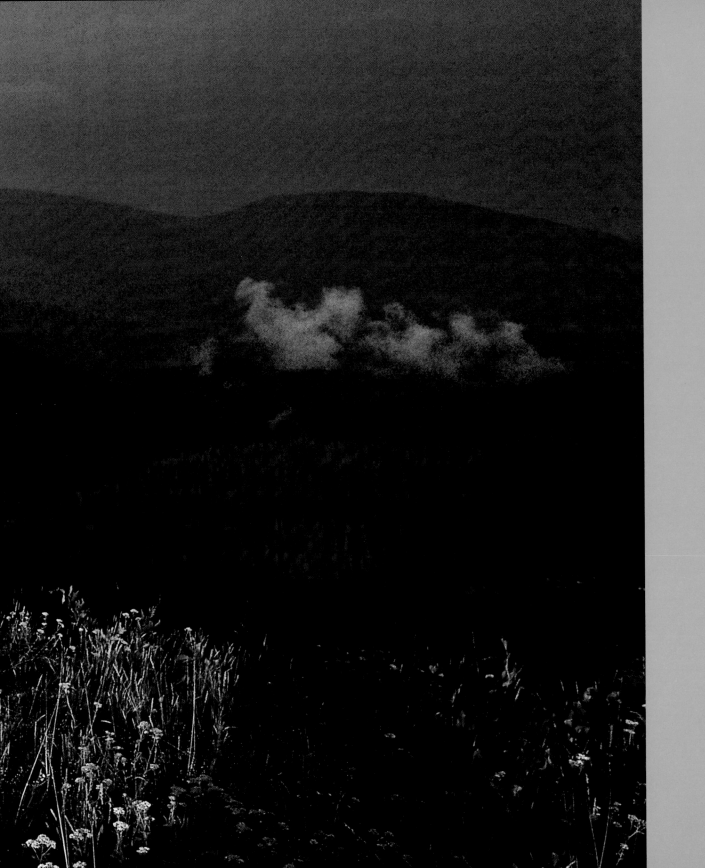

"The Mountains
continue
as far as our
eyes could
extend...
much further
than we
expected."

JOHN ORDWAY ~ SEPTEMBER 18, 1805

IN THE vicinity of this
wildflower-filled meadow,
Lewis may have gazed with
the Shoshone on the Rockies'
Bitterroot Range, "vast mountains
of rock," they warned him,
"eternally covered with snow."

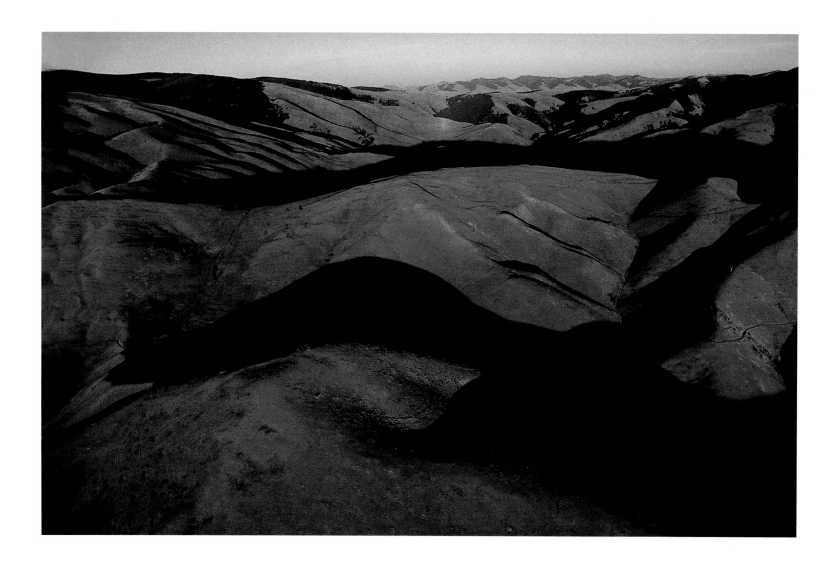

CROSSING the Continental Divide at Lemhi Pass (opposite), the Corps entered the arid landscape of the Far West. "The next part of the rout was about 10 days through a dry and parched sandy desert in which no food at this season for either man or horse, and in which we must suffer if not perish for the want of water," Lewis wrote on August 20. No longer in lands gained through the Louisiana Purchase, the expedition was venturing onto foreign turf. Not until 1848 would the Rocky Mountains they sighted in the distance (above) become part of U.S. Oregon Territory.

MOUNTAINS "as steep as the roof of a house," one of the men wrote of the Bitterroots. Buttressing the boundary between present-day Montana and Idaho, they created an unexpected, 300-mile-long barrier that rose to heights of 11,000 feet and more. Spotting the Rockies from Lemhi Pass, Lewis was nonplussed but stoic. "I discovered immence ranges of high mountains still to the West of us," he recorded, "with their tops partially covered with snow."

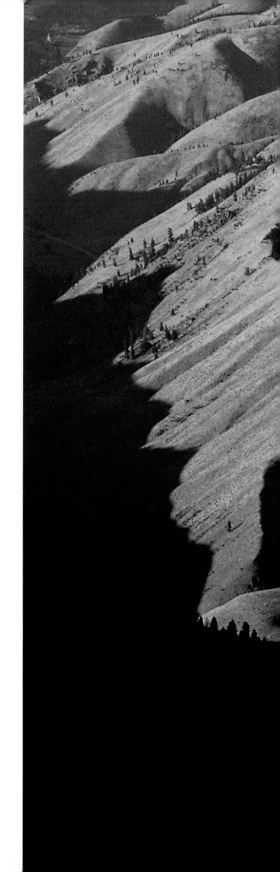

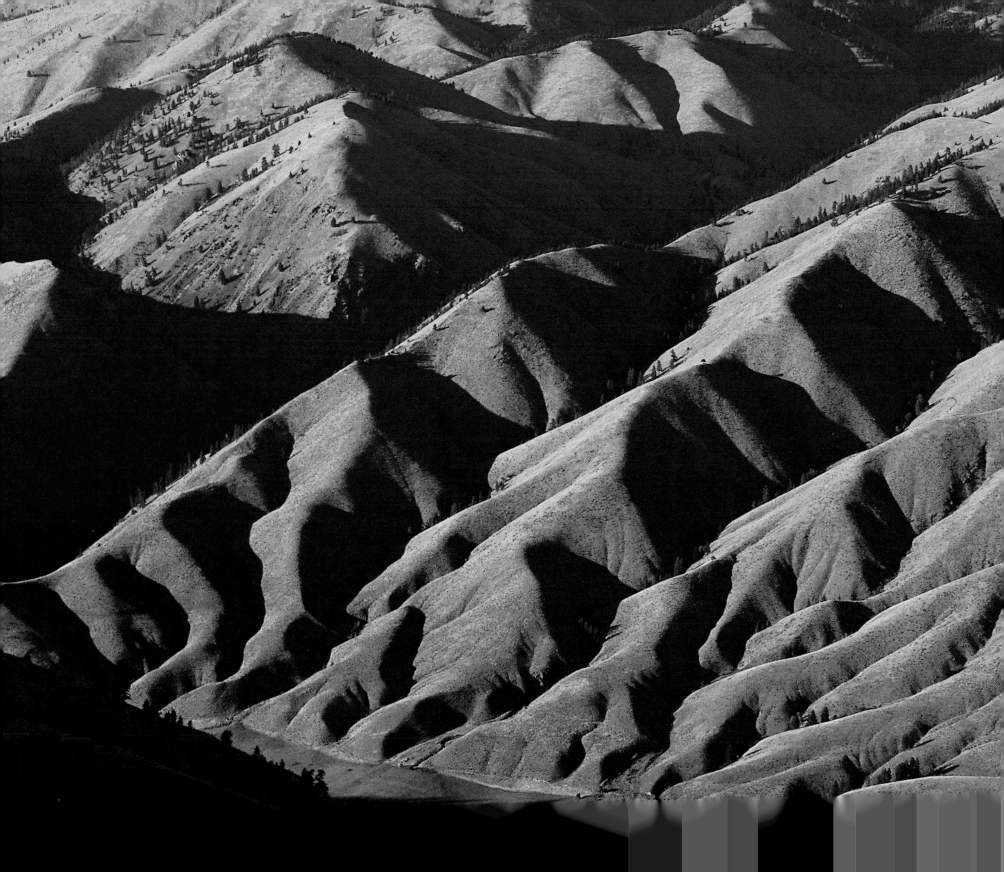

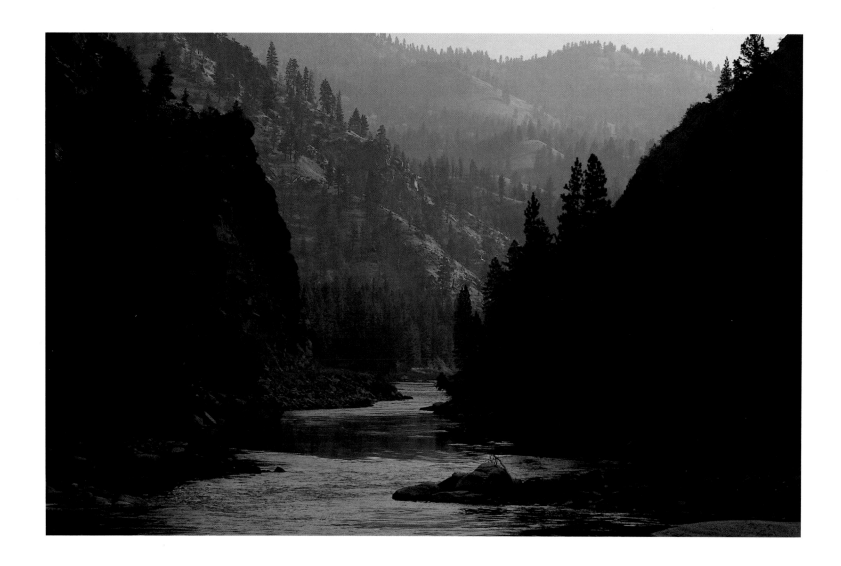

"THE WATER runs with great
violence from one rock to the
other, so as to render the passage
of any thing impossible," Clark
wrote of the river he named for
Lewis. Now known as the North
Fork of the Salmon, or the River
of No Return, it still plows a
daunting course through the
mountains. Clark's reconnoiter of
the river was halted by a boulder
field (opposite), and he was forced
to turn back. With no river route
open to them, the captains readied
themselves for the treacherous ter-
rain of the Bitteroots.

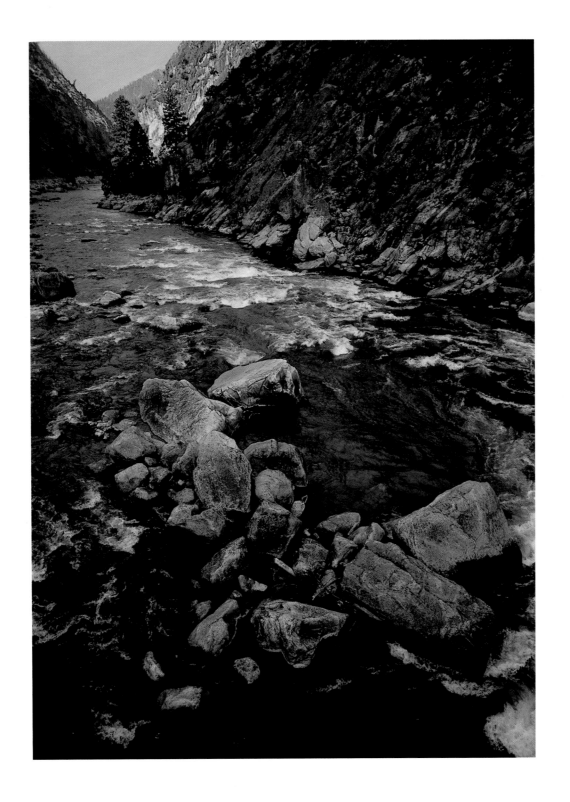

TANGLED understory, like these wind-stunted trees, often forced the expedition to hack a trail in the thick vegetation growing on Bitterroot slopes. The Shoshone had warned Lewis against taking on the Bitterroots, but he had written confidently, "I felt perfectly satisfyed, that if the Indians could pass these mountains with their women and Children, that we could also pass them."

ON SEPTEMBER 17, 1805, the men crested the highest point on the mountain trail—7,033 feet—near a spot called Indian Post Office (above), so named because local tribes may have used it as a message drop. The day before, Clark had made his now-famous journal entry: "I have been wet and as cold in every part as I ever was in my life....the men all wet, cold and hungary." Both men and horses were near starvation by the time they reached an open bottomland (opposite), "where there was tolerable food for our horses."

Fog banked into crevices amid the Bitterroots softens the edges of these "most terrible mountains." The scant Indian path through this range filled with snow as the Corps of Discovery struggled through the treacherous terrain, and small avalanches fell on the men as they brushed against snow-laden pines. The men's abbreviated journal entries only hint at the Corps' desperate, week-and-a-half trek over the mountains: "The Mountains which we passed to day much worst than yesterday...."; "verry cold Snow Storm...."; "nothing to eate."

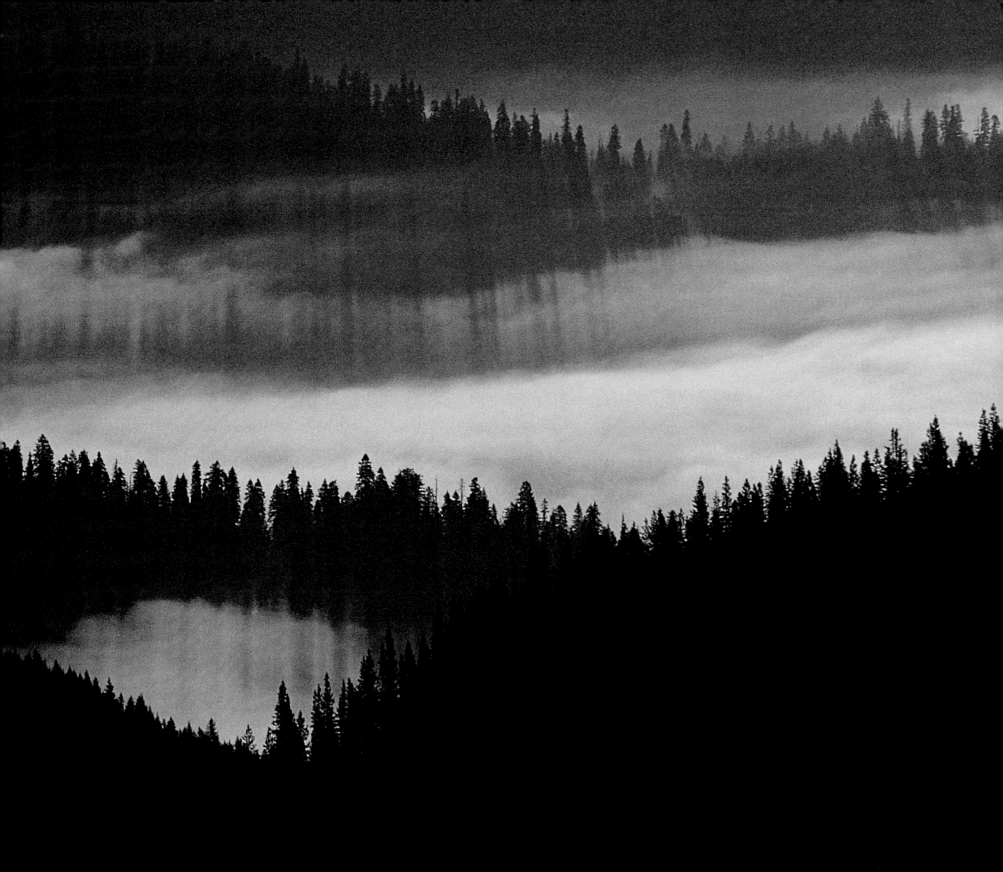

DESCENDING the Bitterroots to a "leavel pine Countrey," Clark led an advance party "to a Small Plain in which I found maney Indian lodges." Here at Weippe Prairie (opposite), the ravenous Corps bargained with the Nez Perce for dried salmon, berries, and camas root. Violent dysentery followed the feasting, and while Lewis and others recovered, the ever robust Clark moved downriver on the Clearwater (above), where he had discovered "fine timber for Canoes." Hollowing Ponderosa pine trunks by burning them over a slow fire, Indian style, Clark prepared for the next leg of the journey—the race to the Pacific.

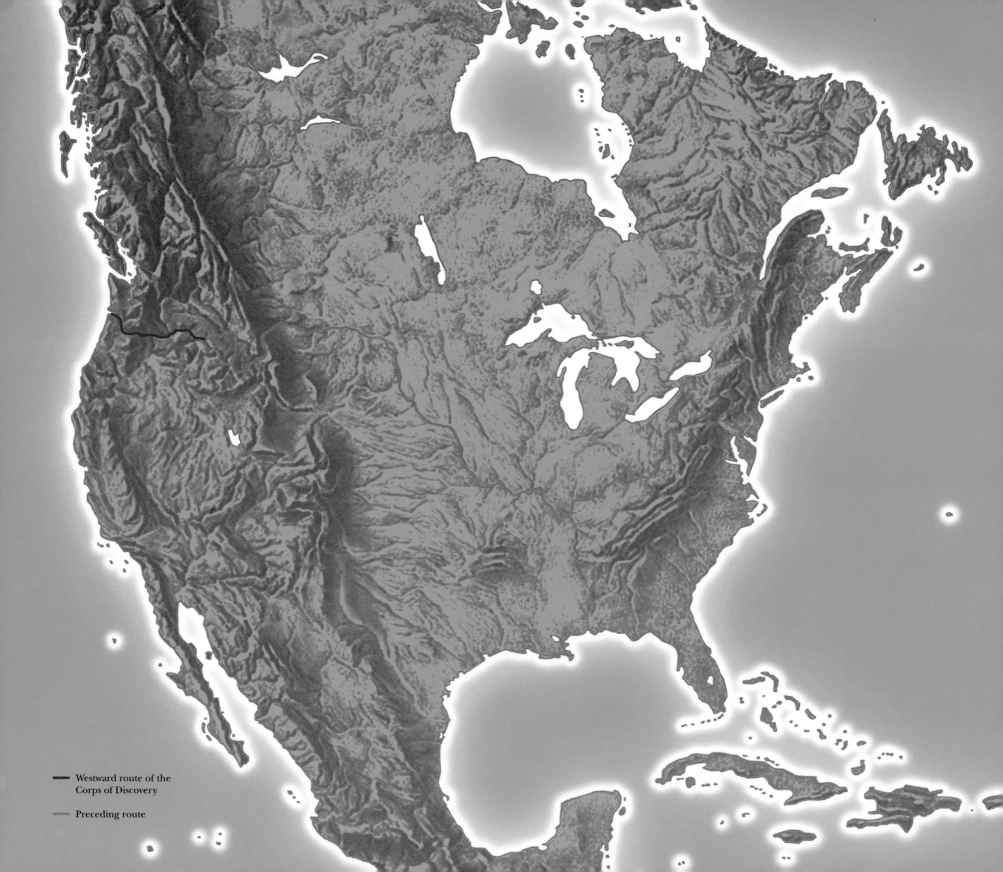

Westward route of the
Corps of Discovery

Preceding route

To the Pacific

"*Ocian in view! O! the joy.*"

WILLIAM CLARK ~ NOVEMBER 7, 1805

TO THE OCEAN

THE DUGOUT CANOES WERE CUMBERSOME. THEY overturned or grounded on rocks. They swamped. They sprang leaks. Supplies were damaged, trade goods lost. Men's lives were endangered. Still they made good progress. On October 10, the expedition reached the Snake River, joining with the Clearwater, and camped that night near the site of present-day Lewiston, Idaho.

In 1997, Ken, Dayton, and I had the fun of making a run down the Clearwater to Lewiston, in dugout canoes made by reenactors in Lewiston and Clarkston, Washington. They have made more than a dozen, ranging in size from about 14 feet to 20 feet. Ken took the bow of our dugout, followed by me and Dayton, then six reenactors. The hardest part was cramping into the small available space; we quickly learned how tender our knees were. But we made it, more or less okay. We found the canoe to be surprisingly stable. It looked like it would tip over at the first opportunity, but actually it rode quite well. Its maneuverability, on the other hand, left a lot to be desired. With nine men paddling, we moved right along (of course we were going downstream and had no rapids to deal with). We were greeted by large crowds of local residents on the riverbanks, just as Lewis and Clark had been. The Indians who met the expedition—they were Nez Perce—had dried fish and dogs for sale; the folks who met us offered beer and burgers. The men of the Corps thought dog meat almost as good as buffalo tongue or beaver tail, but Clark reported that as for himself, "All the Party have greatly the advantage of me in as much as they all relish the flesh of the dogs," which he couldn't bring himself to eat.

On October 13, the expedition came to a "verry bad place...a long bad rapid in which the water is Confined in a Channel of about 20 yards betwen rugid rocks for the distance of a mile." It cried out for portaging, but the captains and the men were straining every fiber to get on, to get to the ocean, and where they should have portaged, they ran the rapids. They made it safe, but Old Toby was so frightened by the experience that he ran off that night. He took two horses, in lieu of any pay, and rode back over the Lolo Trail and then to Cameahwait's village on the Lemhi River. With that he rode out of history, but he will be remembered as the man who guided Lewis and Clark over the mountains.

The following day, the unhappy Clark shot some ducks and was able to record, "for the first time for three weeks past I had a good dinner of Blue wing Teel."

The dugouts swept on toward the junction of the Snake and the Columbia, passing through the canyon-lined Snake on into present-day Washington State, where the Great Columbian Plain offered a barren landscape in stark contrast to the wooded mountains the party was leaving behind. Along the way, the expedition passed innumerable Indian villages. The Columbia and Snake River system, on which they lived, produced more salmon than any other river in the world. Their catches were incredible; one man could kill a hundred salmon on a good day, a full ton of fish.

These Indians gave the expedition a warm reception, partly because Twisted Hair and another Nez Perce chief, named Tetoharsky, went ahead of the party to reassure their relatives that the white men were friendly, and partly because—in Clark's words—"the wife of Shabono our interpetr we find reconsiles all the Indians, as to our friendly intentions, a woman with a party of men is a token of peace."

Spirits were soaring. On October 16, the party reached the junction with the Columbia, the nation's second largest river. Today's Sacagawea State Park marks the point where

the rivers join, though dams have tamed the flow. There they camped for two days. Clark investigated the Columbia for about ten miles upstream. The men were astonished at the numbers of salmon in the river, mostly dying after the spawn and therefore inedible. The water was so clear that, no matter how deep the river, the bottom was plainly visible. We were first there in 1976, and have returned a number of times since: The water was no longer clear and we saw no salmon. Though they still exist, you won't see them jumping in the numbers the Corps did. This is testimony to the steady decline in the environment since their time. Human influence has steadily led to pollution and deterioration of spawning grounds. Today, groups are working to protect and nurture the grounds by advocating waste control along the rivers, as well as development control.

Among the Indians the expedition spotted sure signs of their nearness to the Pacific Ocean, such as scarlet-and-blue cloth blankets and a sailor's jacket. On October 19, Clark climbed a cliff and saw a snow-covered mountain that he deduced "must be one of the mountains laid down by Vancouver, as Seen from the mouth of the Columbia River." He thought it was Mount St. Helens; actually it was Mount Adams. But his essential point was right. Lewis's and Clark's sightings of the Cascades made the first transcontinental linking of what would become the United States.

Unknown to them, they were also entering a section of the extensive volcanic zone that would later be called the Ring of Fire, extending around the rim of the Pacific and responsible for three-quarters of the world's active volcanoes, including Mount St. Helens. Silent and majestic when the Corps saw it, the mountain had built up on a foundation of ancient lava flows. It erupted in 1980, scattering lava and ash over much of Washington, Idaho, and Montana.

On October 23, 1805, the expedition came to the beginning of a spectacular but dangerous stretch of the river that extended some 55 miles. It contained four major barriers, all inundated today by reservoirs behind hydroelectric dams, beginning with the Celilo, or Great Falls. In one short stretch of violent, roaring cataracts, the river dropped 38 feet through several narrow channels between cliffs as high

as 3,000 feet. The captains did a reconnaissance, then agreed that only one drop, of some 20 feet, had to be portaged. They were able to hire local Indians and their horses to help with the heavier articles. At another place, they lowered the canoes through the rapids, using strong ropes of elk skin, while packing the baggage on a portage. Indians were gathered along the riverbanks. They were a blessing, for they provided information on the state of the river below and had dogs and fish to sell.

The Indians were of the Chinook family. They were at war with the Nez Perce. For that reason, Twisted Hair told the captains that it was time for him to return to his village.

The captains were greatly impressed by the Chinookan canoe. Made of pine, it was remarkably light, wide in the middle and tapering at each end, with crosspieces at the gunnels that made the craft surprisingly strong. There were skillfully carved animal figures on the bow and stern. Clark wrote that "these Canoes are neeter made than any I have ever Seen and Calculated to ride the waves, and carry emence burthens."

The white men were remarkably skillful in a canoe, even when it was a dugout. At the next set of falls the expedition faced, called The Dalles, Clark was appalled by "the horrid appearance of this agitated gut Swelling water, boiling & whorling in every direction." The captains agreed that no portage was possible over the rocky ledges, so they would send by land the men who could not swim, while they and the swimmers ran the rapids in the canoes.

By the standards of today's canoeist, this was a Class V rapid, meaning it could not be run even in a modern canoe specially designed for white water. The natives, obviously expert canoeists, did not believe the Corps could make it in their big heavy dugouts. They gathered by the hundreds on the banks to watch the white men drown themselves, and to be ready to help themselves to the equipment afterward. To their astonishment, the party made the run without incident.

On the evening of October 26, two chiefs and 15 men came calling, bringing gifts of deer meat and cakes of bread made of roots. The captains gave medals to the chiefs, trinkets to the men. Private Cruzatte brought out his fiddle, and

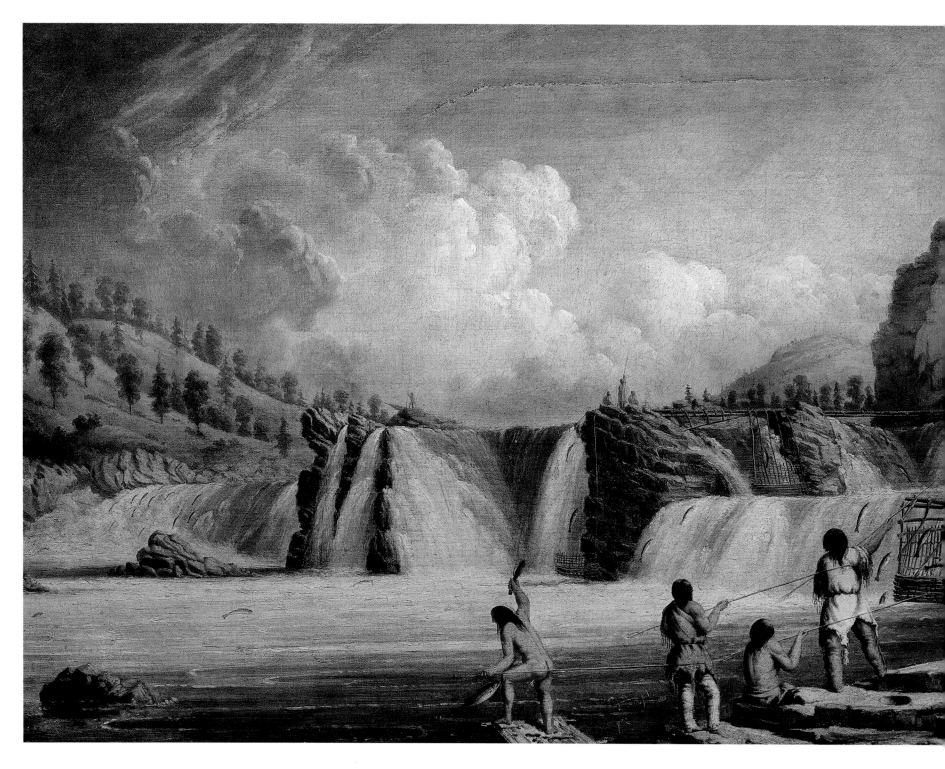

ARRIVING on the Columbia at the end of the fall salmon run, the Corps found the river "crouded with salmon," some "jumping very thick" and many others already dead. According to Clark, the Indians had "only to collect the fish Split them open and dry them on their Scaffolds." Beyond merely collecting dead salmon, the Indians also gigged, clubbed, and trapped live ones in their weirs, as this painting of a local tribe at the Columbia's Kettle Falls shows. The dried fish provided the peoples of the Northwest with a "great mart of trade," according to Clark, who made a sketch (right) of the Great Falls of the Columbia.

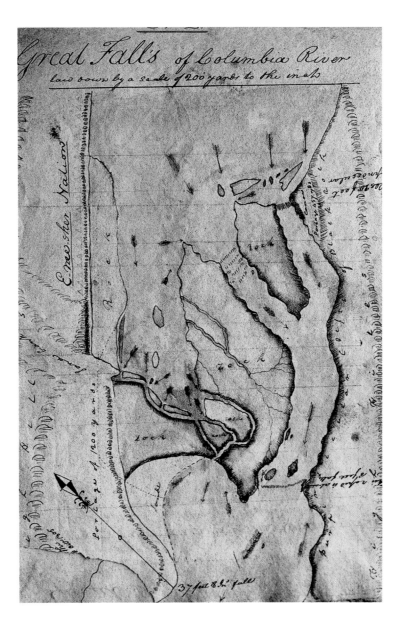

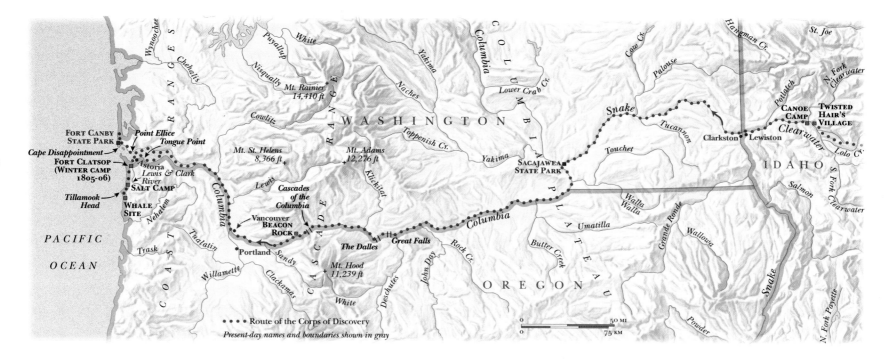

• • • Route of the Corps of Discovery
Present-day names and boundaries shown in gray

York danced to the Indians' delight. The hunters brought in five deer, and one of the men had gigged a steelhead trout, which Clark fried in some bear's oil given him by one of the Indians. Clark pronounced it "one of the most delicious fish I have ever tasted." The Indians spent the night. American-Chinookan relations were off to a good start.

The next day, Clark saw great numbers of sea otters ("orters" as he spelled it)—a welcome sight, as it meant the ocean wasn't far—as "we proceeded on down—the water fine, rocks in every derection for a fiew miles when the river widens and becoms a butifull jentle Stream of about half a mile wide." When Moira and I were there on a cruise ship in 1996, we noticed but one change from what Clark described: Today, the benches in the river valley, along the banks, are irrigated by water pumped from the river, and support magnificent groves of fruit trees. Otherwise, the land back of the banks is almost unbelievably scorched, a stranger to rain.

On October 30, the party arrived at a point two miles above the last great drop, the Cascades of the Columbia (the "Great Shute" to Lewis and Clark), where it made camp.

Reconnaissance revealed that beyond the Great Shute—four miles of rapids, chutes, and falls—the river widened "and had everry appearance of being effected by the tide," which was great news. On November 1-2, the party made its way through this final barrier. The following day the expedition came to Beacon Rock, the beginning of tidewater.

And the beginning of a whole new world. Lewis and Clark were leaving behind them a treeless desert, all but devoid of life except along the riverbanks, and entering a rain forest. It is one of the most dramatic and extreme changes in environment in North America. It happens so suddenly it snaps your head back. Clark described the new situation: "The countary a high mountain on each side thickly covered with timber, such as Spruce, Pine, Cedar, Oake & c. & c.," and—as a welcome to the Pacific Northwest—"the day proved cloudy and disagreeable with some rain all day which kept us wet." From scorched hills to tree-covered, dripping-wet mountains in almost the wink of an eye. Here the moist winds of the Pacific, driven up the Cascades, condense in the cold air to produce rain and fog. This is disagreeable for vacationers,

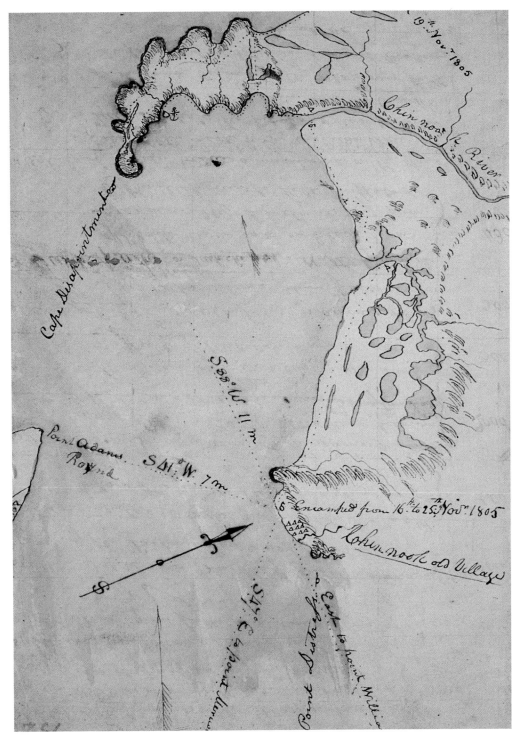

"*OCIAN in view!* O! the joy," Clark's notebook exclaims—prematurely, as it turned out. The large body of water the expedition had sighted was Gray's Bay, not the Pacific. Clark's later map shows the configuration of the bay, defined on the north by the curve of Cape Disappointment, so named because the Corps failed to find the hoped-for trading ships that might provide supplies and passage home. Stormy weather pinned the expedition down for more than a week at Point Distress, near the south end of the bay. Four days after his elated journal entry, Clark recorded that the Corps suffered cold, damp, and hunger. "Our situation," he concluded, "is dangerous."

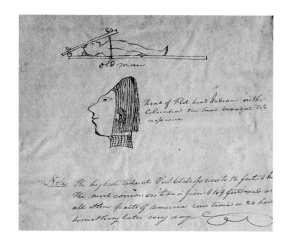

"A GREAT mark of buty," the flattened foreheads of the Chinook and other tribes west of the Rockies earned them the collective name Flatheads. The effect was achieved, Lewis explained and Clark illustrated in his quick sketch, "by compressing the head between two boards while in a State of infancy...." Slaves were forbidden to engage in the practice, so a flat forehead also served as a badge of rank.

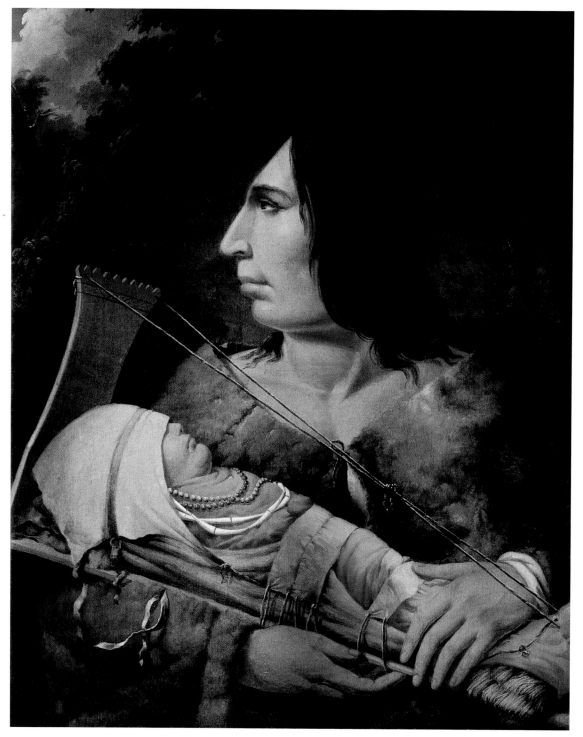

but great for growing things. We were first there in August 1976 and gorged ourselves on berries, peaches, and plums, and are firm in our opinion that the Columbia River valley produces America's finest fruit. The country is lush and verdant, just as the Corps of Discovery found it to be. The color of green fairly bursts out at you, strikes you almost physically.

As was our experience, the Corps found the fog frequent and often thick; many days the party could not set out until afternoon. Life was all around them. Salmon in the river. Migrating waterfowl, described by Clark: "Swans, Geese, white & Grey Brant Ducks &c were emensely noumerous and their noise horid."

Chinook villages dotted the banks, Indian visitors were frequent. The natives made a poor impression on the whites, except as canoeists, where their superiority was obvious and acknowledged. Otherwise, they were judged to be "low and ill-shaped, badly clad and illy made."

On November 2, the expedition passed the mouth of Sandy River, east of modern Portland, the highest point upriver reached by European or American explorers entering from the Pacific coast. Lt. William Broughton of Vancouver's 1792 expedition had gone this far up the Columbia. The following day the Corps reached present-day Vancouver, Washington, and camped opposite the mouth of the Willamette River. For the first time since leaving Fort Mandan in April, the expedition was in country previously explored and mapped by whites. Here the maps from west and from east came together.

A historic moment, but unnoticed by the captains, as they did not have a copy of Vancouver's map. They were well aware of his previous presence, however, and readily accorded his expedition pride of place by calling the great individual mountains of the Cascades by the names the British explorer had given them: Mount St. Helens, Mount Hood, and Mount Rainier. Although the explorers sighted the other Mounts Jefferson and Adams, those peaks would not be named until later, the first by Lewis on the return journey, the latter in 1841. These mountains were their landmarks. Knowing that white men had been here before them had no effect on their ardor or determination, nor diminished their uniqueness—no white man had come to the mouth of the Columbia from the east before them. The high hope was that they would find white men in trading vessels, and the use of English names for landmarks encouraged the hope.

By early November the expedition was making better than 30 miles a day down the lower Columbia. On November 5 it met its first coastal canoes, a flotilla of four different sizes, with a bear's image carved into the bow and a human image on the stern of the largest. The following evening, they camped on bluffs that crowded in on the river. All was wet and disagreeable. In the morning, fog. As it slowly lifted, the expedition set off. By midafternoon, the sky was clear.

A shout went up. In his field notes, William Clark scribbled his immortal line, *Ocian in view!* O! the joy." The canoes sped along as the men dug in. They made 34 miles that afternoon. It was raining. Still, Clark wrote, "Great joy in camp we are *in view of the Ocian,* this great Pacific Octean which we been So long anxious to See." He could distinctly hear waves breaking on rocks.

Without comment (but no doubt some pride), Clark added up the miles since the first falls (Celilo, 190 miles upriver). Then he wrote: "Ocian 4142 Miles from the Mouth of MissouriR." He wasn't off by as much as 40 miles. "How did he do it?" our family has marveled. With his primitive tools, we can only assume: line of sight, dead reckoning, feel.

CLARK HAD BEEN A BIT PREMATURE: WHAT HE HAD SEEN was not the Pacific Ocean but the Columbian estuary. A week of pure misery followed the moment of exhilaration. The Corps of Discovery was pinned down by the tide, the waves, and the wind at Point Ellice, unable to go forward, to retreat, or to climb out of their campsite because of overhanging rocks and hills.

Clark's journal, November 12: "It would be distressing to a feeling person to See our Situation at this time all wet and cold with our bedding &c also wet, in a Cove Scercely large enough to Contain us, canoes at the mercy of the waves & driftwood, robes & leather clothes are rotten."

Worse got to be worse. November 22: "The wind increased to a Storm…blew with violence throwing the water of the

river with emence waves out of its banks almost over whelming us in water, O! how horriable is the day."

And worse. November 27: "The wind blew with Such violence that I expected every moment to See trees taken up by the roots, Some were. O! how Tremendious is the day."

At last they were rescued by the Clatsop Indians, a Chinookan people who lived on the south bank of the estuary. The Clatsop were able to cross the estuary easily in their coastal canoes, in conditions that absolutely defeated the white men. "Certain it is they [the Clatsop] are the best canoe navigators I ever Saw," Clark wrote. The Clatsop saved the expedition by selling the men roots and fish.

Eventually the Corps of Discovery did see the ocean, when they managed to get around Point Ellice and establish a camp in present-day Fort Canby State Park, near MacKenzie Head, looking out on the Pacific. The camp provided access to the interior, so that some exploration by land could be done. Lewis went first, rounding a point about eight miles west of Point Ellice and going up the coastline for several miles. He was hoping to find a ship. With Jefferson's unlimited letter of credit in his pocket, he could have replenished his store of trade goods for the return voyage, and given a copy of the journals to the ship's captain to deliver to Jefferson. But alas, no ship. He carved his name into a tree at the extremity of the place he called Cape Disappointment.

My journal, July 29, 1976: "When we arrived at the ocean we waded in and swam a bit but it was too cold to stay long.

"The end of the American dream—there is no more west. From this point we must turn back."

Stephenie's journal: "Pacific Coast at last!"

On November 18, 1805, it was Clark's turn to ramble. He set out with York and ten men on a reconnaissance to Cape Disappointment, where he found Lewis's name carved in the tree, and followed the example, but greatly improved on it by adding to his name and the date the magnificent line: "By Land from the U. States in 1804 & 1805."

Later that day a group of Chinook, including two chiefs, paid a visit. They sat for a smoke. The captains handed out medals and an American flag. One chief wore a robe made of sea-otter skins that Clark declared "more butifull than any

fur I had ever Seen." Lewis agreed. Each captain tried to strike a bargain for the robe, offering different articles.

No, said the chief. He pointed at Sacagawea's belt of blue beads. The captains looked at her, questioningly. She made it clear that if she gave up the belt, she wanted something in return. One of the captains brought her a coat of blue cloth, she then handed over the belt, and the captain—we don't know which one—got the fur coat. We can suppose that the lucky one never thought to thank her.

The next day an old Chinook woman appeared with six of her daughters and nieces in tow. She was selling their favors.

Meanwhile the word had gotten out among the Clatsop that the captains would pay almost any price for sea-otter furs. But the price was too high. The Indians wanted blue beads, and the captains were all but out of them. Still, the captains found they liked the Clatsop much better than their relatives on the north bank of the river, the Chinook, mainly because the Clatsop were not thieves, while the Chinook picked up anything laid aside for a moment.

That became a factor in the decision that now had to be made: where to spend the winter. The expedition could stay on the north side, among the Chinook, or go to the south side, where the Clatsop lived and where there were more elk, or they could go back upstream to the high, dry country and get out of the coastal rain. Lewis wanted to go to the south shore, where a camp could be established close to the ocean and men could be put to work boiling saltwater in the kettles, which when scraped would yield a fine salt. Salt was a luxury most of them craved.

Lewis had a better reason than his taste buds for wanting to stay near the coast. There was a chance that a trading vessel would arrive during the winter months. Clark agreed. But instead of imposing their decision, as they had done at the mouth of the Marias River, the captains decided to let everyone participate in the decision. They put it to a vote.

The south shore won. Only Private John Shields voted against it. York's vote was counted and recorded. So was Sacagawea's. This was the first vote ever held in the Pacific Northwest. It was the first time in American history that a black slave had voted, the first time an Indian woman voted.

JOHN Clymer's dramatic "Salt Makers" captures the imagined scene on a Pacific beach as the Corps kept "the kettles boiling day and night" to extract salt from seawater. The work required five men and five kettles to make four quarts a day of the "great treat."

By early December, Lewis had explored the area near present-day Astoria, Oregon, and settled on a spot to the south, up today's Lewis and Clark River. In early August 1976, on the first of our many visits to Fort Clatsop, Moira and I paddled up Lewis and Clark River to the landing at the site of the replica of Fort Clatsop, on the original spot. Sitka spruce, Douglas fir, western hemlock, and other trees dominate the area, giving it a dark and dripping atmosphere.

But it had what the captains needed. It stood on a bluff rising some 30 feet higher than the high-tide mark, some 200 feet back from the river, and about three miles up from its mouth. It was near a spring, with big trees to make shelter and provide fuel. It was a few miles from the ocean, where salt could be made. Best of all, it promised good hunting; Drouillard and another hunter had killed six elk and five deer. On December 7, the entire expedition moved to the site of what the captains would call Fort Clatsop. Clark took one look and pronounced it a "most eligable Situation."

WINTER AT FORT CLATSOP

FROM DECEMBER 7, 1805, TO CHRISTMAS DAY, everyone hustled. The hunters were off before dawn, returning after dark. About half the others were cutting grand fir trees, splitting them, shaping them; the remainder were putting the lumber into place on the huts they were building, or building fireplaces. The wood split beautifully, even to the width of two feet and more, much superior to the cottonwood they had been forced to use at Fort Mandan. The first hut to go up was the smokehouse, the captains having determined that the preservation of meat in that rainy climate required it.

Because of the constant rain, the work went slowly. Sometimes it went not at all, so bad was the weather. On December 16, Clark recorded, "The winds violent. Trees falling in every direction, whorl winds, with gusts of rain Hail & Thunder, this kind of weather lasted all day. Certainly one of the worst days that ever was!" Many of the men were sick or injured. Some had tumors. Pvt. William Werner had a strained knee, Pvt. Joseph Field had boils, Pvt. George Gibson had dysentery, Sergeant Pryor had a dislocated shoulder, York suffered from "Cholick & gripeing."

The food was bad, lean elk meat with no salt, spice, or sauce of any kind, nor any grog, whiskey, coffee, or tea to wash it down, nothing but water. "We eat it through mere necessity," Clark wrote. He added that the fleas, picked up from the Indians and inescapable, "torment us in such a manner as to deprive us of half the nights Sleep."

As at Fort Mandan, the local Indians found the Corps of Discovery to be both fascinating and good customers, and came often to visit and trade. Chief Coboway of the neighboring Clatsop village was a regular. The captains gave him the usual medal and traded for roots.

Despite the weather and the visiting Indians, the work went forward. Soon enough of the walls were up so some of the men could begin filling the chinks, then putting on the roofs. The captains moved into their unfinished hut on December 23. On Christmas Eve, Pvt. Joseph Field made writing tables for the captains. That day the men moved into their as-yet-unroofed huts.

Fort Clatsop was some 50 feet square, with two long facing structures joined on the sides by palisaded walls. It had a main gate at the front and a smaller one at the rear, with easy access to a spring some 30 yards distant. There was a central parade ground some 50 by 20 feet. One of the structures was divided into three rooms, or huts, which served as enlisted men's quarters. The other contained four rooms: one for the captains; one for Charbonneau, Sacagawea, and their son; one for an orderly room; and a fourth, the smokehouse.

The replica of the Fort was built from a floorplan Clark had drawn on the cover of his elk-skin journal. It is certainly near the exact site of the original—something we know from Lewis's description of the location—but not necessarily on the spot itself. Ken Karsmizki is directing a dig, hoping to pinpoint the original. In that wet climate, not much survives. In August 1997, Ken, Dayton, Moira, and I watched him at work. He sifts the dirt carefully, with squares precisely marked out by strings; his patience is an example to us all. It pays off; shortly before we got to the fort, Ken found beads and wooden tools on the site. He thinks, too, that he has located the men's "sinks," or latrines; he is having the soil analyzed for mercury content. The captains regularly used mercury as an antidote for the venereal disease the men picked up from the Clatsop and Chinook—mercury did not cure the disease, but it masked the symptons.

IN 1805, ON CHRISTMAS MORNING, THE MEN WERE UP at first light. They woke the captains with a volley, a shout, and a song. There was an exchange of presents: Private Whitehouse gave Captain Clark a pair of specially made moccasins; Private Goodrich gave him a woven basket; Sacagawea gave him two dozen white weasel tails and Captain Lewis gave him a vest, drawers, and socks. The captains divided the small quantity of tobacco they had left, keeping one part for use with the Indians and dividing the other among the men who smoked. The eight nonsmokers each got a handkerchief.

The celebration didn't last long. It was a wet, disagreeable day, and as Clark wrote, "We would have Spent this day the nativity of Christ in feasting, had we any thing either to raise our Sperits or even gratify our appetites, our Dinner concisted of pore Elk, So much Spoiled that we eate it thro' mear necessity, Some Spoiled pounded fish and a fiew roots."

The fort was completed on December 30. At sunset, the captains informed the Clatsop that from now on, when darkness fell, the gates would be shut and they must all get out of the fort. "Those people who are verry forward and disegreeable," Clark reported, "left the huts with reluctiance."

At dawn on New Year's Day, 1806, the men woke the captains with a volley and shouts of "Happy New Year!" There was no other celebration because the volley "was the only mark of rispect which we had it in our power to pay this celebrated day."

ON THE 1997 VISIT, MOIRA AND I, ALONG WITH DAYTON and Ken, spent a night in the replica at the Fort, where Ken and Dayton had put on a preview of their documentary to a few hundred guests, on a huge outdoor screen (fortunately it didn't rain). Like the Corps we had only candles for light, and in the midst of those trees it was exceedingly dark. We read aloud from the journals and we talked.

"It was here," Dayton remarked, "that the captains showed the first signs of being homesick." And he read Lewis's January 1, 1806 entry: "Our repast of this day consisted principally in the anticipation of the 1st day of January 1807, when in the bosom of our friends we hope to participate in the mirth and hilarity of the day, and when with the zest given by the recollection of the present, we shall completely, both mentally and corporally, enjoy the repast which the hand of civilization has prepared for us."

The passage got me going on the subject of verb tenses. Lewis almost always used the past tense, even when describing contemporary events, even when anticipating the future, as in his "has prepared" rather than "will prepare" phrase. That got us going on when Lewis and Clark did their writing. We had no conclusive answer. Dayton, who used to be a reporter, figured they often wrote during the day, basing this judgment on the physical form of the journals, which are very like the notepads a modern reporter scribbles in. But, I objected, surely they didn't take ink and quill with them into the field.

Ken remarked that the homesick feeling Lewis expressed in his January 1 entry was in part due to relations with the Clatsop and Chinook, which were inferior in every way to the relations with the Mandan and Hidatsa. Dayton pointed out that this was due, in large part, to the difficulty in communicating: At Fort Mandan, there were translators (British traders, French voyagers, Sacagawea), but at Fort Clatsop, all communication was by sign.

As in most frontier fortifications, life at Fort Clatsop was almost unbearably dull. There was work to be done, but besides hunting or making salt it was mostly "woman's work," detested by the men: making leather shirts, trousers, jackets, and moccasins—338 pairs, according to Sergeant Gass.

In 1997 the Fort's reenactors, all college students, showed us how to make moccasins, jerk elk meat (the highway department brings in road-killed elk), fire weapons. We knew from research how these things were done. But there is nothing like seeing them done, or doing them yourself and realizing how much skill the tasks require. Where the students' hands flashed, ours fumbled; where they got a fire going almost as quickly as you could light a match, using flint, a steel striker, and a tiny piece of charred cotton flannel, we finally gave up.

Most daunting to me was hewing out a canoe. It was a Sitka pine, about 30 feet long, 4 feet wide. You stand on the gunwales, bend over, and swing a bowlike tool, an adze. The

reenactors had taken out enough wood, chip by chip, to have it nearly completed, which meant reaching down 3 feet to swing. I got one chip out, but couldn't get the feel for it. Ken and Dayton did much better.

Through the dreary winter of 1806, daydreaming and fantasies helped pass the time. The men dreamed of home, and talked about their parents, friends, girls. At night, they sang and danced to Cruzatte's fiddle, and told stories, stories from the Revolutionary War, from Indian battles, from encounters with grizzlies.

Unlike most frontier garrisons, there were no fights or breaches of discipline. Partly this was because the garrison was so small, partly because the men had been through so much together, and partly because they had no whiskey. "Nothing worthy of note today," Lewis wrote in his journal, day after day. The weather continued to be a misery.

Although the local people provided far less entertainment than had the Mandan the previous winter, Lewis spent his usual amount of time mingling with them for scholarship's sake. His portrait of the Clatsop and Chinook is thus the fullest available, and is quite fascinating in its details.

They were always barefoot, for example, and women as well as men covered themselves only from the waist up, for the good reason—as Lewis took care to note—that they lived in a damp but mild climate and were in and out of their canoes in waist-deep water much of the time. Lewis remarked that he could do a visual examination for venereal disease on every man who came to the fort. He described their cloaks, furs, hats, and ornaments in considerable detail, then rendered his final, scathing judgment: "I think the most disgusting sight I have ever beheld is these dirty naked wenches."

Their hats, he admitted, were a masterpiece of design. Conic in shape, they were made of the bark of cedar and bear grass (obtained in trade from the Nez Perce) woven tightly together and held in place by a chin strap. The shape "casts the rain most effectually," Lewis wrote. He and Clark ordered two made-to-measure hats from a Clatsop woman. They "fit us very well" and answered so well that the captains ordered hats for each and every man.

CLARK's plan for Fort Clatsop, sketched on the cover of his elk skin journal, called for a 50-foot square with seven huts and a central parade ground. Today's recreated fort reflects his original design and is built of the same magnificent pines cut from the surrounding forest.

"Hat made by a C[l]atsop woman, near the Pacific Ocean," Lewis noted simply of one artifact that he and Clark carted thousands of miles home. Lewis's journal notes that Clatsop women, and those of other Northwest Coast tribes, did much of the work. Their virtue, he wrote, was not "held in high estimation" by the men, whose conversations turned "upon subjects of trade, smoking, eating or their women; about the latter they speak without reserve in their presents, of their every part, and of the most formiliar connection." Whereas Lewis kept notes on the sexual mores of the locals, Clark kept a weather diary (far right). In January, it repeated day after day varied versions of the same dreary news: "Rained verry hard...."

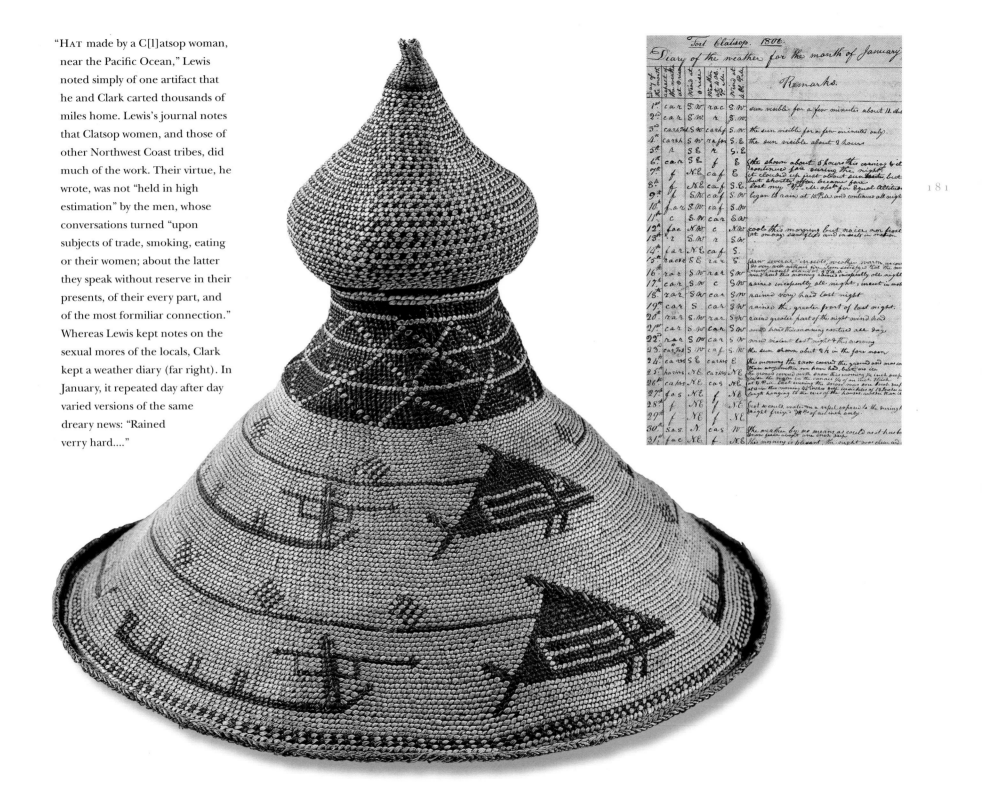

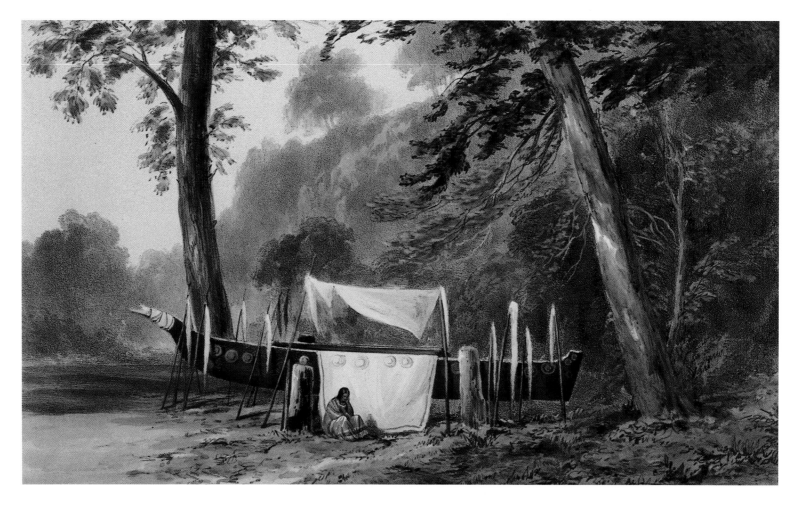

Skilled canoe builders—and canoeists—the Clatsop and Chinook of the Pacific Northwest amazed the Corps with their prowess in the rough coastal waters. The dugouts, as long as 50 feet, could carry up to 30 people and were used for transportation, fishing, even for coffins. With only primitive files as tools, carvers quickly turned out vessels that, Lewis wrote in his journal,

were "ornimented with *Images* on the bow & stern" (left). Each craft took only a few weeks to make. Above, Indians prepare a burial canoe on a scaffold, which will be filled with a paddle, furs, utensils, and other articles, then covered by fastening another canoe on top. Lewis presumed, "from their depositing various articles with their dead, that they believe in a state of future existence."

The canoes beat everything. "I have seen the natives near the coast riding waves in these canoes with safety and apparently without concern where I should have thought it impossible for any vessel of the same size to live a minute," Lewis wrote. So impressed was he that he came as close as he ever did to praising the Clatsop and Chinook. Their canoes, he wrote, along with "the woodwork and sculpture of these people as well as these hats and their water-proof baskets evince an ingenuity by no means common among the Aborigenes of America."

The food at Fort Clatsop contributed to the monotony. Getting enough of it was a daily worry for Lewis. The expedition lived on elk. Over their more than three months on the coast the hunters killed 131 elk, along with 20 deer, a few beaver and otter, and a raccoon. All these species are still present today. Drouillard was the most effective hunter, sometimes killing a half-dozen elk in a day.

Despite his success, not enough game was coming in to feed the party. The captains supplemented the meat with dried fish and roots purchased from the Clatsop. Occasionally they were able to purchase dogs, whose meat, Lewis believed, answered for the party's being "much more healthy strong and more fleshey than we had been since we left the Buffaloe country." Fortunately, the men loved the dog meat. Clark, for his part, commented, "I have not become reconsiled to the taste of this animal as yet." Lewis remarked that he didn't care what kind of meat he got, so long as it had some fat on it. But what he got mostly was elk—dried and jerked elk, leftover elk from the previous meal, fresh roasted elk, more elk.

Fresh elk, fall-killed elk with plenty of fat on it, is fine meat. In Montana, where we now live for half the year, it is the preferred game, partly because of the size of elk, of course, but also because it is the best tasting—comparable to corn-fed beef, better than venison or buffalo. But nearly four months of lean elk, often jerked elk, on a daily basis, is obviously too much of a good thing.

In our good fortune, on our 1997 trip to the fort we feasted on broiled salmon. As Ken, Dayton, Moira, and I talked late into the night, Moira said that the fish tasted so good,

she wondered why the captains didn't have more of it. Because, I explained, they couldn't afford it—the Indians' prices were too high.

"Then why didn't they go catch their own?" she asked.

"Because," Ken replied, "they didn't know how and besides they could hardly maneuver their dugouts in the high waves of the estuary, and anyway it was winter and the salmon weren't running." But, I commented, there were other fish, and Private Goodrich was an avid fisherman— come to that, so was Lewis—yet if any of the men attempted to catch fish, which were all around them in great quantities, the captains never thought to mention it in their journals.

After more talk, more speculation, we retired to our rooms. Ken and Dayton took the captains' quarters. Moira and I got the Charbonneau family room. We each had a small fireplace. They slept on wooden plank beds, with buffalo robes for blankets; our luxury was a foam rubber mattress with sleeping bags.

As the fire dwindled, a damp cold settled in. The night was black. I felt as close to the men as I ever have. In the morning, at first light, we were all up, all claiming to have seen the ghostly figures of the captains and their men.

For the men of the expedition, a welcome change in diet came on January 10, when Clark returned from the coast with whale blubber. He had heard of a beached whale in late December, but bad weather prevented him from setting out to find the carcass until January 6. He took a party of 11 with him; among the party was Sacagawea. Lewis explained how she got to go along: "The Indian woman was very importunate to be permited to go, and was therefore indulged; she observed that she had traveled a long way with us to see the great waters, and that now that monstrous fish was also to be seen, she thought it very hard she could not be permitted to see either."

"I should hope so," Grace remarked after I read that passage aloud on our first trip. "You've got that right!" Stephenie chimed in. They were always alert to any mention of Sacagawea in the journals and critical of the captains for not putting her in often enough. Indignant, they point out that not one journal entry describes her appearance and

that she is often dismissed as "the Indian woman" or "Charbonneau's squaw." Thus Lewis's passage is pure gold to them—in one sentence he gives us a picture of a young woman sure enough of herself and her place in the party that she could confront the captains directly and forcefully, and get her way. The captains may have felt they "indulged" her; Stephenie and Grace figure she insisted.

The party reached the ocean near Tillamook Head. "We proceeded on the round Slipery Stones under a high hill which projectred into the ocian about 4 miles further than the direction of the Coast. After walking for 2 miles on the Stones, my Indian guide made a Sudin halt and made signs that we could not proceed any further on the rocks, but must pass over that mountain....which was obscurred in the clouds...." He continued, "after about 2 hours labour and fatigue we reached the top of this high mountain, from the top of which I looked down with estonishment to behold the hight which we had assended, which appeared to be 10 or 12 feet up a mountain which appeared to be almost perpindic-ular." Panting, huffing, puffing, but proud to have made it, the soldiers dropped their jaws when they saw 14 Indian women loaded down with blubber pass them.

The hike over Tillamook Head is today a well-marked trail, very popular despite its difficulties. The ascent is through old-growth Sitka spruce and the view from the top is majestic. In the ocean below, gray whales still pursue their route of migration from Alaska down the Pacific Coast to Baja, and up again in the spring.

Descending to the ocean, Clark's party "arived on a buti-full Sand Shore, found only the Skelleton of this Monster on the Sand; the Whale was already pillaged of every Valuable part by the Indians in the Vecinity." Clark traded for 300 pounds of blubber and a few gallons of oil. "Small as this stock is I prise it highly," he wrote, "and thank providence for directing the whale to us; and think him much more kind to us than he was to jonah, having Sent this Monster to be *swallowed by us in Sted of Swallowing of us* as jonah's did."

The blubber didn't last long. Soon it was back to elk. Lewis wrote on February 7, "This evening we had what I call an excellent supper it consisted of a marrowbone and a brisket of boiled Elk that had the appearance of a little fat on it. This for Fort Clatsop is living in high stile."

Most hours of most days, the captains were in their quar-ters, at their writing desks, dipping their quills into their ink-stands, writing and drawing, candles providing the only illumination, smoke from the wet wood on the fire in the air, everything cold and damp. They wrote on. They were the writingest explorers of all time. Lewis described birds, plants, animals, and methods, while Clark worked on his map of the country from Fort Mandan to Fort Clatsop.

Clark had no formal training as a cartographer, but he had a natural genius for mapping. Each day of the journey he had taken compass readings at every bend of the river or twist in the Trail. He used dead reckoning to figure the mileage. He made his notes on different sheets of paper (once using the back of a blank certificate meant for Indian chiefs), later transferring them onto larger strip maps that marked different sections of the journey. At Fort Clatsop, he pulled everything together. At Fort Mandan, he had estimat-ed they had come some 1,592 miles from St. Louis; at Fort Clatsop, he figured they had come 2,550 miles from Fort Mandan. On February 11 he finished the work, an invalu-able contribution to the world's knowledge. He had charted the American West for the first time.

"We now discover," Clark wrote on February 14, after three days of going over the completed map with Lewis, "that we have found the most practicable and navigable pas-sage across the Continent of North America." That note, almost triumphant, hid a deep disappointment. The real headline news from the Lewis and Clark Expedition was that there was no all-water route across the continent. The short portage from the Missouri to the Columbia did not exist. The Rockies were not a single chain of mountains, and there were more mountain chains beyond: the Cascades and Coastal Mountains. It was not at all as they had imagined it.

For the men of the Enlightenment, there was no arguing with nature. Surely Jefferson would be unhappy with the death of his dream, but still glad to know the truth. Sitting on his rough-hewn stool at his rough-hewn desk at Fort Clatsop, Lewis could imagine sitting in the drawing room at

the President's House, reporting to Jefferson. He could imagine Jefferson taking in the news, nodding, accepting the fact, and already beginning to think of how to deal with the newly discovered reality.

That the winter at Fort Clatsop went so relatively well for the expedition was a tribute to the captains' abilities as leaders. They had welded the Corps of Discovery into a team, indeed into a family. Shared hardships, shared dangers, shared triumphs—the essence of travel—were their experience, and in our own way in modern times, our family's experience as well.

In late March 1806, Lewis and Clark checked supplies for the return. "Two handkercheifs would contain all the small articles of merchandize which we possess," Lewis lamented.

"On this stock," Lewis realized, "we have wholy to depend for the purchase of horses and such portion of our subsistence from the Indians as it will be in our powers to obtain." Thinking it over, he added, "A scant dependence indeed, for a tour of the distance of that before us." They did have sufficient rifles and ammunition, a good thing, as they were "now our only hope for subsistence and defence in a rout of 4000 miles through a country exclusively inhabited by savages."

The captains needed another Indian canoe to go up the Columbia as far as The Dalles. For "an indifference canoe," Lewis paid an exorbitant price: his prized "Uniform coat."

Poverty and the great need for yet another canoe put the captains in a foul and desperate mood. They made a decision: to steal one. On March 18, the crime was committed. When they got back to the fort, Chief Coboway was visiting, so they hid it. Lewis admitted that the deception of Coboway "set a little awkward," but he did it anyway.

Lewis and Clark wanted to get going immediately, but on March 19 a three-day storm pinned them down. On the 22nd, the storm began to slack off and the men prepared to push off in the morning. Coboway paid a parting visit. Lewis gave him the fort. And he wrote of Coboway, in whose canoe he was about to leave, "He has been much more kind an hospitable to us than any other indian in this neighbourhood."

Although neither captain ever acknowledged it, obviously the Corps of Discovery could not have gotten through the

winter on the coast without the Clatsop and Chinook. They provided information and critical food supplies. It was only thanks to the natives' skills as fishermen and root collectors that the white man survived. Lewis called them savages, even though they never threatened, much less committed, acts of violence, however great their numerical advantage. Their physical appearance disgusted him. He condemned their petty thievery, sexual morals, and sharp trading practices. Except for their skill as woodworkers and canoe- and hatmakers, he found nothing to admire in his winter neighbors.

And yet the Clatsop and Chinook, without rifles, managed to live much better than the white men on the coast of the Pacific Northwest. They had mastered the environment far better than the men of the expedition managed to do. The resources they drew on—the ocean, rivers, and forests—were renewable and endure today, whereas the Americans had shot out all the elk in the vicinity in just three months. With the coming of spring, the Corps of Discovery had no choice but to move on. These tribes stayed, living prosperous lives on the riches of the Pacific Northwest, until an epidemic of malaria decimated the Clatsop in 1825; the handful of Chinook survivors, whose descendants live on the Quinault Reservation on the Washington Coast, mingled with whites and lost some of their culture. Thus Lewis's portrait of the tribes is the fullest available.

Clark's last words at Fort Clatsop: "At this place we have wintered and remained from the 7th of Decr. 1805 to this day and have lived as well as we had any right to expect, and we can say that we were never one day without 3 meals of some kind a day either pore Elk meat or roots, notwithstanding the repeated fall of rain which has fallen almost constantly since we arrived here."

Lewis wrote that "Altho' we have not fared sumptuously this winter at Fort Clatsop, we have lived quite as comfortably as we had any reason to expect we should." Then came the last words he wrote during his long wet winter at Fort Clatsop. Appropriately, they were botanical: "The leafing of the hucklebury riminds us of spring." Spring in Virginia, that is, where he intended to be when the leaves started to come out in 1807.

"In every direction... the Countrey is one Continued plain low and rises from the water gradually...."

WILLIAM CLARK ~ OCTOBER 16, 1805

VEIN of blue, the Snake River interrupts the emptiness of Washington State's sere eastern side. Even the Snake's treacherous rapids did not deter the Corps as they sped toward their goal—the continent's western edge and the vast Pacific.

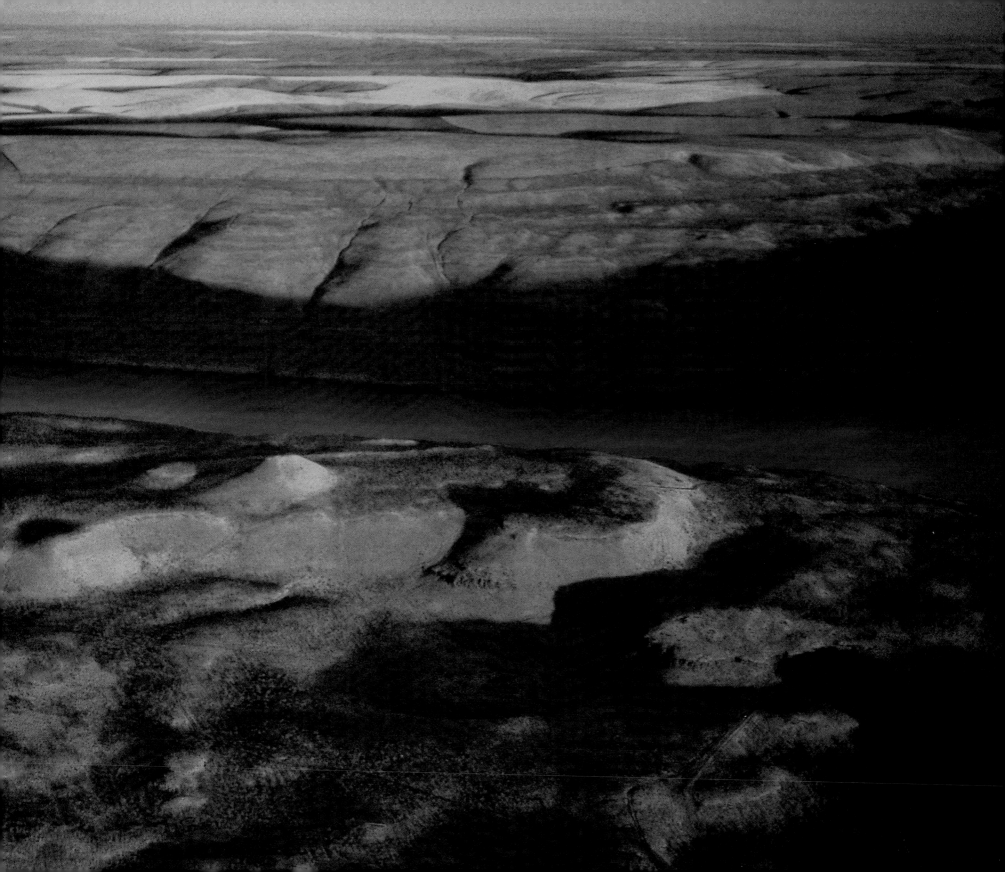

BEADED by prairie fires, a ridge outside Lewiston, Idaho, ignites in a quick-moving blaze. Hot summer weather often causes dry grasslands to ignite in a natural burn, but native tribes once set such fires deliberately, to clear grasslands of saplings or to signal one another. Early on, Lewis described the catastrophic results of one fire in his journal: "The Prarie was Set on fire (or Cought by accident) by a young man of the Mandins, the fire went with such velocity that it burnt to death a man and woman, who Could not Get to any place of Safty...."

ON OCTOBER 16, the rushing Snake River brought the expedition into the Columbia (opposite) at last. The Corps paused at the confluence "to smoke with the Indians who had collected there in great numbers to view us...they formed a half circle around us and Sung for Some time," Clark wrote. Continuing downriver through a semidesert punctuated by buttes like the landmark Sisters (right), they were hailed by other Indian groups who gathered on the riverbanks to greet them.

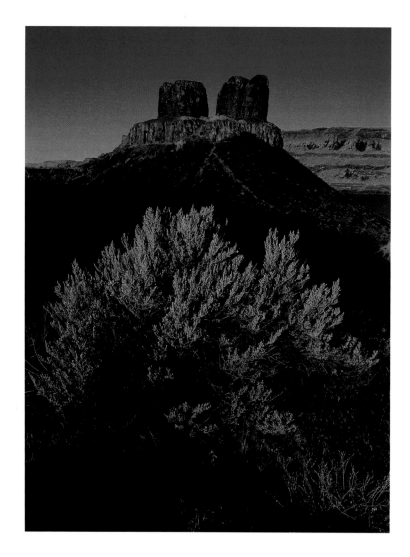

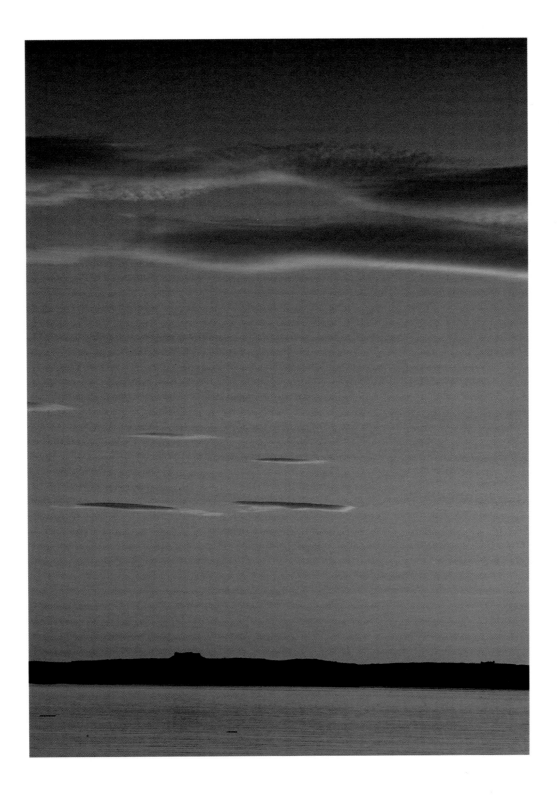

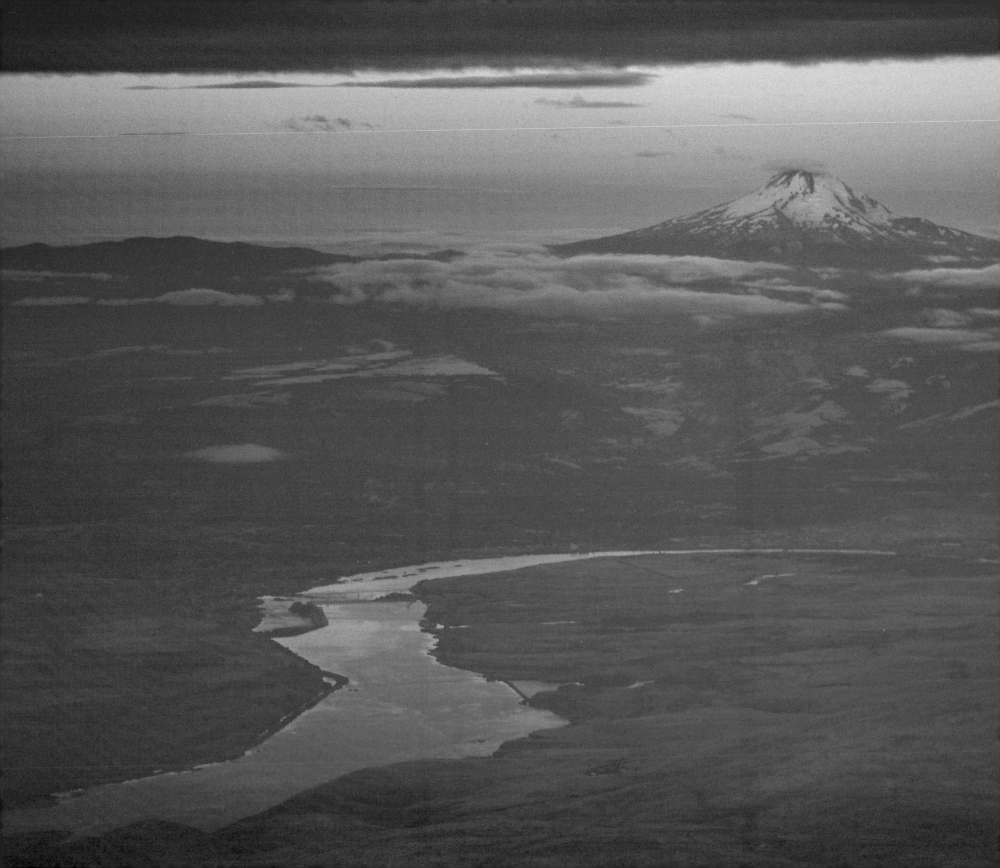

MOUNT Hood Gorge greets dawn. Here Mount Hood and its sister Cascades, Mount Adams and Mount St. Helens, form a gateway to the Pacific, only a hundred miles away. "This must be one of the mountains laid down by Vancouver," Clark conjectured. He was referring to the British explorer who had been there in 1792. The Corps of Discovery had returned to the maps of the known world. The goal—the "great Pacific oceian"—was at hand.

"A REMARKABLE high detached rock...about 800 feet high and 400 paces around," Clark described the pinnacle he named Beacon Rock (right). One of the world's largest free-standing monoliths, the eroded volcanic plug marks the western end of the Columbia River Gorge. After weathering the gorge's daunting rills and rapids, the expedition had finally reached tidewater and was entering the lush, rain-soaked world of the Pacific Northwest. Waterfalls and small tributaries (opposite) still feed the mighty Columbia, but modern dams have largely tamed its once "agitated gut swelling, boiling & whorling" waters.

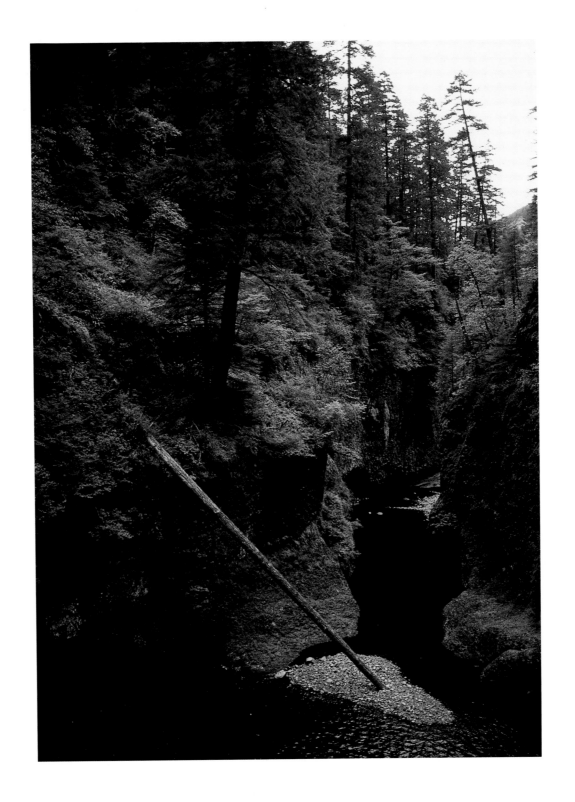

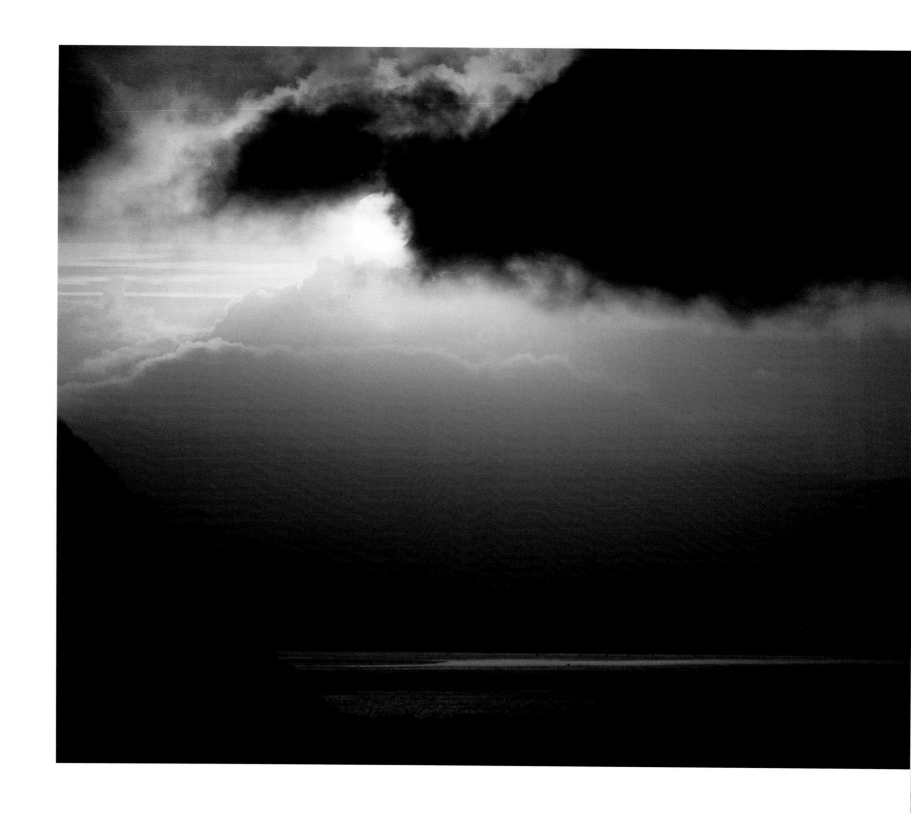

EARLY morning sun breaches a banner of clouds above the mouth of the Columbia. Eleven straight days of heavy weather plagued the Corps here, pummeling them with wind, high tides, and heavy seas. "Our present Situation a verry disagreeable one," Clark complained. The wet weather presaged the long, tedious winter to come at Fort Clatsop.

NIGHT rains and morning sun set steam rising from the roof of replicated Fort Clatsop. The original Lewis and Clark fort survived the damp climate only a few years before melding back into the forests; the current copy of it stands on the actual site, outside present-day Astoria, Oregon.

The soggy, cramped quarters (opposite) strained the men's spirits, but Lewis wrote sanguinely in late March that "Altho' we have not fared sumptuously this winter and spring at Fort Clatsop, we have lived quite as comfortably as we had any reason to expect we should...."

"THE GRANDEST and most pleasing prospect which my eyes ever surveyed," Clark wrote of present-day Oregon's Cannon Beach, uncharacteristically rhapsodizing over its "romantic appearance." Here Lewis set the men to work boiling seawater to produce an "excellent, fine, strong, and white" salt—a commodity the Corps had long lacked and craved.

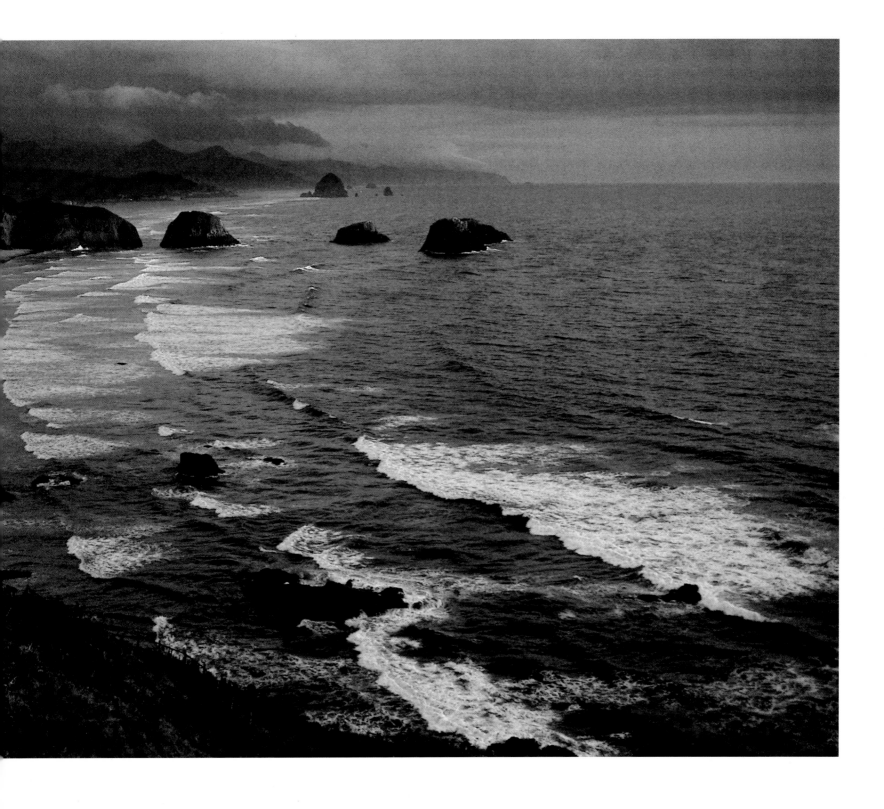

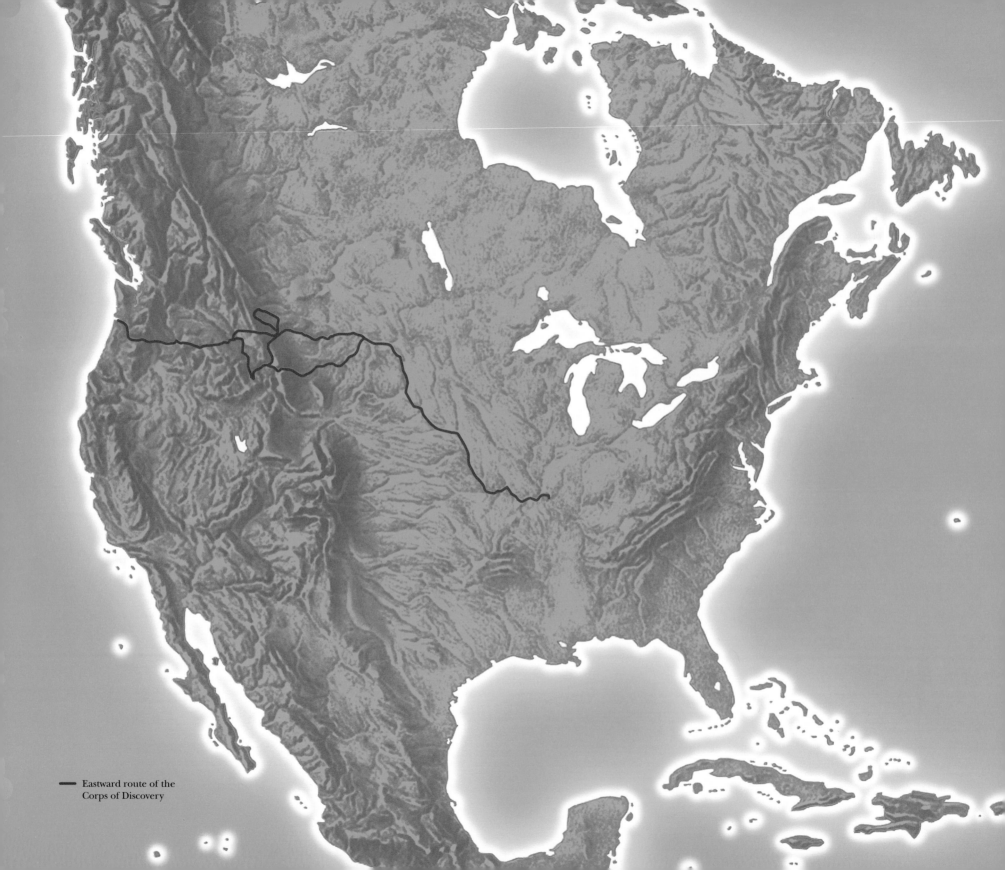

— Eastward route of the
Corps of Discovery

The Return Home

"Patience, patience...."

MERIWETHER LEWIS ~ MAY 17, 1806

HEADING HOME

"AT 1 P.M. WE BID A FINAL ADIEU TO FORT CLATSOP," Lewis wrote in his journal the night of March 23. The next day, an Indian claimed the stolen canoe as his. Lewis offered him a dressed elk skin for it. Surrounded by 32 riflemen in five canoes, and without a clear title in his possession, the Indian accepted. Maybe this "payment" assuaged Lewis's conscience. It didn't alter his act. The theft of the canoe showed how desperate the captains had become.

The party that had set out from Fort Mandan on April 7, 1805, had canoes jammed with boxes, canisters, kettles, bales of trade goods, blankets, tobacco, whiskey, flour, salt pork, corn, dried squash and beans, writing desks, a tepee, scientific instruments, tools of many descriptions, knives, rifles, and more. On March 23, 1806, as it set out from Fort Clatsop, it was down to powder, scientific instruments, kettles, and rifles. The Corps of Discovery was only halfway through its journey, but it had spent 95 percent of its budget.

On the other hand, in 1805 the captains and men didn't know what lay ahead. In 1806 they did. And they had put supplies into caches stretching from all the way back to Great Falls, so they would be able to replenish as they moved east. Knowing what was ahead was a mixed blessing, however, for part of it was the Bitterroots. From the moment the men left Fort Clatsop, the rigors of those mountains were on their minds. "That wretched portion of our journy," Lewis called it, "the Rocky Mountain, wher hungar and cold in their most rigorous forms assail the waried traveller...."

The ordeal of crossing the Bitterroots was coming; the ordeal of going up the Columbia was here. It was hard work. The current was always strong; in rapids, the canoes had to be towed; falls had to be portaged. Food was a constant problem. The party stopped at The Dalles, to give the hunters time to kill and dry sufficient meat to sustain the men until they reached the Nez Perce. Lewis figured that the party could live on horse meat as it crossed the Bitterroots.

On April 2, Clark went on a side exploration, paddling some ten miles up the Willamette River to the site of present-day Portland, Oregon. "I entered this river called *Multnomah* River by the nativs.... From the enterance of this river, I can plainly see Mt. Jefferson which is high and covered with snow S.E. Mt. Hood east, Mt. St. Helians and a high humped mountain [Mount Adams] to the east of Mt. St. Helians." The next day, "I deturmined to return to the main body. The enterance of Multnomah river is 142 miles up the Columbia river from its enterance into the Pacific Ocean."

In the party's haste to continue, Clark did not explore the triangle of mountains the captains had twice cited in their journals. Unlike the Rockies, which rise in unison like a spine along the continent in a more or less continuous zone of tectonic uplift, Mount Hood and it sister peaks stand separately, as much as 60 miles apart, each sprung from an isolated volcanic source. It would have taken weeks to explore their separate realms. But how the views must have appealed to the party. The snow-covered, cone-shaped peaks are far more symmetrical than the Rockies' jagged frames, and as the sun breaks their cloud cover, they appear to float.

On our 1976 voyage, we found Mount Hood, Oregon's highest at 11,235 feet, to be irresistible. We took time to explore it. My journal, July 26: "We drove as far up Mount Hood as the pickup would go, hiked up another few miles to a glacier, and spent the day sliding on plastic sheets on a snow slope, in a bright warm sun." July 27: "Backpacked to a lake on one of Mount Hood's slopes. This mountain is like

those in Colorado, heavily used. Oregon claims to have more campgrounds than any other state. Many trails and backpackers. People of Oregon must love their out-of-doors, they take such good care of it and use it so much. A number of families backpacking—nice sight."

As the party slowly, painfully made its way upriver, local Indians from the extended Chinook tribe surrounded the men. "These people are constantly hanging about us," Lewis complained on April 6. "I detected one of them in steeling a peice of lead," he wrote the next day. "I sent him from camp." He also inspected the rifles and held a target practice in front of a group of Indians, who shortly "departed for their village," presumably with stories about the white men's firepower. But the following evening, the sentinel detected an old man trying to sneak into the expedition's campsite. The soldier threatened with his rifle and "gave the fellow a few stripes with a switch and sent him off."

Tempers were running high; never before had one of the men whipped an Indian. But never before had the party been so provoked. One group of warriors tried to wrest a tomahawk from Private Colter, but they had picked the wrong man. "He retained it," Lewis dryly recorded.

On the evening of April 11, the Indians stole Lewis's dog, Seaman. It threw him into a rage. He called three men and snapped out orders to find those thieves and "if they made the least resistence or difficulty in surrendering the dog to fire on them." The soldiers set out; when the thieves realized they were being pursued, they let Seaman go and fled.

The men had no patience left and the temptation to use their rifles was strong. Lewis complained to a chief, who lay the trouble at the feet of two bad boys of his nation. They alone had caused "these seenes of outradge of which we complained." The village as a whole wanted peace and good relations. So did Lewis, who concluded his account, "I hope that the friendly interposition of this chief may prevent our being compelled to use some violence with these people."

The captains knew that when they got to The Dalles, the falls and rapids of the Columbia upstream would force them to go overland. They traded with local Indians for horses—two large kettles for four horses, the first time they had been willing to part with a kettle.

Nothing was safe from the Chinook, however. The morning of April 22, Indians stole a saddle and robe. Lewis's blood rose past a danger point. He swore he would either get the stolen goods back or "birn their houses." Fortunately, the men found the stolen goods hidden in a corner of one of the houses before Lewis reached the village.

Despite the captains' cold-blooded words and resolutions, what stands out about their journey up the lower Columbia is that they got through it without ever once ordering a man to put a torch to an Indian home, and no man ever fired a rifle at a native. Lewis had, however, four times lost his temper and twice threatened to kill, for offenses that were hardly as serious as his theft of a Chinook canoe. His behavior was erratic and threatening to the success of the expedition.

By early May, the party was making progress across the great sweep of desert grasslands of today's eastern Washington, north of the Columbia River, but in miserable conditions. Rain, hail, snow, high winds all assailed the men. At dinner on May 3, the captains divided the last of the dried meat and the balance of the dogs. Their luck held. The next day, near the place where they camped while making canoes the previous September, they encountered a band of roving Nez Perce, led by Chief Tetoharsky, the man who had accompanied Twisted Hair down the Columbia with the party the previous fall. He took the white men to Twisted Hair's village, on the banks of the Clearwater River, where they attempted to purchase roots and dogs, with little success. But then they discovered that Captain Clark had quite a reputation with these Indians as a doctor.

The previous fall, Clark had washed then rubbed liniment on an old Indian's sore knee and thigh, with "much seremony." The man recovered. Since then, this band "has never ceased to extol the virtues of our medecines," as Lewis put it. The captains could pay for their keep by running a hospital, which, indeed, did much good for the Nez Perce. The Indians kept coming because they were benefiting from Clark's therapy, which they paid for with dogs and roots.

The Nez Perce ate horseflesh only to ward off starvation, and never ate dog. The white men had come to relish

dog. On May 3, Lewis related a dog-meat anecdote in a piece of concise storytelling: "While at dinner an indian fellow verry impertinently threw a poor half starved puppy nearly into my plait by way of derision for our eating dogs and laughed very heartily at his own impertinence; I was so provoked at his insolence that I caught the puppy and threw it with great violence at him and struck him in the breast and face, seized my tomahawk and shewed him by signs if he repeated his insolence I would tommahawk him, the fellow withdrew apparently much mortifyed and I

continued my repast *on dog* without further molestation."

That day, the Bitterroot Mountains came into view. They "were perfectly covered with snow." The Nez Perce had bad news: The winter snows had been so heavy that no passage was possible until early June, at best. "To men confined to a diet of horsebeef and roots," Lewis wrote, "and who are as anxious as we are to return to the far plains of the Missouri and thence to our native homes this is unwelcom inteligence."

Today as then, snow conditions in the Bitterroots are not predictable. After a winter of little snow, three feet and more

can come down in April and May. Our family experiences on the Lolo Trail, stretching over two decades, are decidedly mixed. Some years it is open to vehicles and horses by mid-June; other years it is mid-July. In 1986 we were driven off the mountains on the Fourth of July by a heavy snow.

In mid-May 1806, the Corps of Discovery moved closer to the mountains, to the village of Chief Broken Arm, where the Clearwater and Kooskooskee (today's Lochsa) join. Broken Arm was an honored chief who had ended up with the horses entrusted by the party to Twisted Hair. At his village the expedition recovered 21 of their 38 horses, along with about half the saddles and some ammunition that had been placed in a cache. The captains paid Twisted Hair an old, beat-up British trading musket obtained from the Clatsop for two elk skins. When the captains then explained their supply situation, Broken Arm produced two fat colts and demanded nothing in return. Clark commented that those Indians who had no contact with whites before the expedition were much more hospitable than those who had, such as the Chinook.

Clark's medical practice flourished; patients lined up daily for treatment. He used eyewash, hot rubdowns, and simples for sore eyes, scrofula, ulcers, and rheumatism. One difficult case involved an old chief who had been paralyzed for three years. He was "incapable of moving a single limb, but lies like a corps...." Nothing Clark tried worked.

At last he decided on heat therapy. The men built a sweat lodge for the chief and put him in, fortified with 30 drops of laudanum for relaxation. It worked. The chief regained the use of his hands and arms, and soon his legs and toes. "He seems highly delighted with his recovery," Lewis wrote on May 30. Sweat lodges are still widely used by the Nez Perce.

In 1997, Ken, Dayton, Moira, and I accompanied Sam Penney, chairman of the Nez Perce Tribal Executive Committee, and Carla HighEagle, co-chairman of Idaho Governor's Lewis and Clark Bicentennial Committee, to a small mountain stream near the Corps of Discovery's camp and at the spot where the Nez Perce (or Lolo) Trail over the Bitterroots begins. There Penney pointed out a small sweat lodge, a conical-shaped, robe-covered structure. Historically, the sweat lodge was used by the Nez Perce for cleansing pur-

poses and relaxation. Another purpose for "taking a sweat" was in preparation for a special event or traditional ceremony. To use a sweat lodge, you heat stones, use sticks to bring them inside, then pour water over them. At intervals during participation, it's out of the lodge and into an almost ice-cold stream. Exhilarating. In contemporary times, the lodge is mostly used for socialization and relaxation.

Clark's medical fees provided food, but not enough for the Corps of Discovery. When the men discovered that brass buttons were "an article of which these people are tolerably fond," the men cut off all their buttons to trade for roots, and the captains cut the buttons from their dress coats, which brought in three bushels of roots.

The young men among the Nez Perce were fond of gambling and games. So were the young men of the Corps of Discovery. The result was a tournament. There was a shooting match, which Lewis won with two hits at a mark at a distance of 220 yards. On horseback, the Nez Perce put the soldiers to shame. Lewis was amazed at how accurately they could shoot an arrow at a rolling target from atop a galloping horse. The Indians could do feats that the whites could only watch. "It is astonishing," Lewis wrote, "to see these people ride down those steep hills which they do at full speed."

Horse care, horse trading, horse racing brought the white and red men together. On the evening of May 13, "we tryed the speed of several of our horses" in races against one another and Indians. It is an irresistible scene: the young men, red and white, racing from point to point over that beautiful vale, snow-topped mountains looming behind, whooping and whipping their horses, digging in their heels, while crowds of onlookers, also mounted and also a mix of red and white, cheered them on. Wherever one looked, there were horses, Appaloosas mostly, selectively bred, "active strong and well formed." They were present in "immence numbers. 50, 60 or a hundred hed is not unusual for an individual to possess."

The Nez Perce's careful breeding of the elegant spotted horses produced animals unequalled in endurance, agility, and speed. Confiscated by white settlers and sold to ranchers in the late 1800s, the vast herds diminished. A recent

donation of 13 Appaloosas by a Southwest rancher has initiated the Appaloosa Horse Club, in which Carla HighEagle and others reacquaint children with their heritage, teaching them to become horsemen like their forefathers.

For the Corps, passing time included frequent footraces. The captains were impressed by one Indian who proved to be as fleet of foot as the Corps' fastest runners, Drouillard and Reubin Field. There were games of prison base (an Indian game in which each side tries to make prisoners of those who run out of their base area), and pitching quoits (a white man's game of throwing flattened rings at a pin). The captains encouraged the contests, which gave the men who were not hunters badly needed exercise. They "have had so little to do that they are getting reather lazy and slouthfull."

Mainly what they did was look at the Bitterroots to see how much snow was left. The expedition's energy was as tight as a coiled spring, ready to vault itself over those mountains, in an agony of anticipation of being released.

Waiting for snow to melt is rather like watching grass grow. The first discernible sign of progress is greeted with the greatest joy. Thus, Lewis on May 17: "I am pleased at finding the river rise so rapidly, it no doubt is attributeable to the melting snows of the mountains." Still they had to wait.

"Patience, patience," Lewis advised himself as he concluded his journal entry. Not until May 26 did he let a little optimism into his journal. "The river still rising fast and snows of the mountains visibly diminish," he wrote.

Our 1976 camping in the Nez Perce country was at a hot springs, a mile and a half off the Lochsa River. A wonderful, magical spot—a cold, clear stream, rocky bottom, swift, about 30 yards wide and a couple of feet deep. The hot springs starts on a hillside—the water drops down through a series of man-made pools, hot where it begins, bathtub warm at the lower pool—and flows into a four-acre meadow bursting with wildflowers, where a stand of giant cedars forms a cathedral-like grove beside the stream, a perfect spot for tents. The place, called Jerry Johnson Hot Springs, is well known to University of Montana students. Some gathered as we read the journals and, like everyone else this summer, were entranced.

My journal: "I am terribly proud of our kids, and pleased with how this journey is proceeding. They have grown, physically and emotionally, are much more self-confident than when we began. And self-sufficient—even Hugh and Grace take care of themselves now. In a half hour or less, the kids can all be packed and ready to take off into the wilderness. They can hike all day, toting the 40 pounds or more, up and down mountains, never complaining and even eager for further adventures at the end of the hike. The fighting and teasing is down to a minimum. Like the men of the expedition and their Nez Perce friends, our kids are in constant competition, testing who can jump the highest, run the fastest, lift the heaviest weight. They have learned to entertain themselves by reading and writing. Indeed, they have done more of both this summer than during years of school.

"They are getting homesick. Mickey packed up and left us, hitchhiking into Portland to catch a plane home. Hugh misses him something terrible, Barry too. Hugh wants to go to New Orleans to see his friends. 'Soon enough,' I tell him. 'Patience. Patience.' 'Oh, Dad,' he groans. 'Enough with the Lewis and Clark quotations already.'"

On June 3, 1806, the captains were surprised and pleased to learn that "today the Indians dispatched an express over the mountains to travellers rest." The "express" was a teenage boy who went to ask the Flatheads about "the occurrences that have taken place on the East side of the mountains" that winter. If the Indians could send a boy over the Lolo Trail to pick up gossip, Lewis "thought it probable that we could also pass." The Nez Perce said that although their boy could make the trip, white men could not; the creeks were too high, there was no grass, and the snow was deep on the roads, which were extremely slippery. Twisted Hair told the captains to be patient. In 12 to 14 days they could set out.

The captains decided to go ahead right away. On June 8 they held a farewell party at the campsite they had occupied for nearly a month. But as the festivities went on, one of the chiefs again warned the captains. They set out anyway. The mood was exuberant. "Our party seem much elated with the idea of moving on towards their friends and country," Lewis happily noted. "They all seem allirt in their movements today." The expedition was about to resume its march.

THE LOLO TRAIL, AGAIN

ON THE MORNING OF JUNE 10, THE PARTY SET off for Weippe Prairie, full of enthusiasm and bolstered by the welcome news from Chief Cut Nose of the Nez Perce that two of his young men would join the expedition in a day or so to guide it through the mountains. Each man—and Sacagawea—was mounted and leading a packhorse. There were several spare horses. "We therefore feel ourselves perfectly equipped for the mountains," Lewis wrote. The captains established camp at the *quawmash* flats. Quawmash was camas, the root that had warded off starvation for the men in September and then almost killed them. By now, after more than a month with the Nez Perce, stomachs had adjusted and the men could eat the roots without consequence. No one ever liked it. Lewis's concluding sentence on camas was, "This root is pallateable but disagrees with me in every shape I have ever used it."

One thing about camas; it was appealing to the eye. "The quawmash is now in blume," Lewis wrote, "and from the colour of its bloom at a short distance it resembles lakes of fine clear water, so complete is this deseption that on first sight I could have swoarn it was water."

We agree with him. Camas still covers the ground at this spot today and, when in bloom, looks like a mountain lake. It is still gathered and its roots eaten by the Nez Perce. It has to be an acquired taste. The root is small, black, hard even when boiled. I tried it once at Lewiston, Idaho, at a reenactment, and that was enough.

The party waited at the quawmash flats for three days for the Indian guides, but they failed to show up. On the evening of June 14, the captains decided to wait no longer. "From hence to traveller's rest," Lewis wrote, "we shall make a forsed march." This was risky in the extreme, but Lewis and Clark felt an urgent need to get going. They decided to do it without guides.

They admitted to apprehension. The snow and the lack of grass for the horses "will prove a serious imbarrassment to us as at least four days journey of our rout in these mountains lies over hights and along a ledge of mountains never intirely destitute of snow," Lewis wrote. Clark added, "Even now I Shudder with the expectation of great dificuelties in passing those Mountains."

The men agreed with their captains; they had been sitting around long enough, it was time. "Every body seems anxious to be in motion," Lewis wrote, "convinced that we have not now any time to delay if the calculation is to reach the United States this season; this we are detirmined to accomplish if within the compass of human power."

Dawn, June 15, 1806, came before 5 a.m., but the party was already up, fed, packed, and ready to set out, despite a cold, driving rain. The going was difficult, due to fallen timber crisscrossing the Trail and to the slippery path caused by the rain. Still, the party made 22 miles. Lewis did a bird count, and found a hummingbird nest. So far, so good. No snow.

June 16, another early start. The party climbed a ridge and nooned it at a "handsome little glade" where there was grass, along with dogtooth violet, bluebells, yellow flowering peas, and the columbine all in bloom, with honeysuckle, huckleberry, and white maple putting out their first leaves— signs of spring in the mountains. But in the afternoon, after two hours of marching, the party found itself in winter conditions. Snow was eight to ten feet deep. After covering 15 miles, the captains made camp at the small glade where Clark had killed and hung a horse for Lewis and his men the previous September. No grass.

"THE LARGE leafed thorn" that
Lewis discovered in bottomlands
of the Northwest Coast was
probably the salmonberry
(above). Its fruit "resembled the
raspburry and....is reather ascid
tho' pleasantly flavored," Lewis
noted, adding that he had
"preserved a specimen" of it.

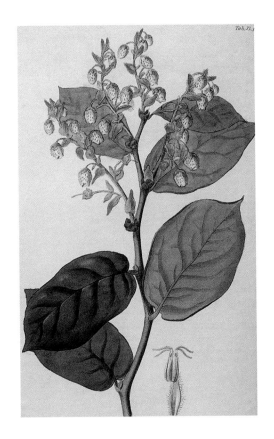

AMONG the some 240 plant specimens that Lewis collected during the course of the expedition, the bitterroot (opposite), or rock rose, gave its name to the mountains that so stymied the Corps. Lewis carried specimens of the plant all the way from Traveler's Rest, on the 1806 stop, to Philadelphia, where botanist Frederick Pursh conferred on it the scientific name *Lewisia rediviva*. Of salal (above, left), Lewis noted that it served as the principal food for the elk around Fort Clatsop. Bear grass (middle), which he found "on high land, Rocky Mountains," is a member of the agave family, and was used "by natives to make baskets and other ornaments." The delicate western spring beauty (right), which Lewis collected on the far side of the Rockies, was not cataloged by him until he began his return journey in the spring of 1806.

In the morning the going was "difficult and dangerous," but the captains plunged ahead anyway. The climb was steep, the elevation gain dramatic. After three miles of climbing, "we found ourselves invelloped in snow from 12 to 15 feet deep even on the south sides of the hills with the fairest exposure to the sun." The captains thought they had prepared themselves for the worst, but they hadn't. "Here was winter with all its rigors," Lewis wrote that evening.

The expedition was six or seven day's march from Traveler's Rest, provided it was lucky enough to stay on the Trail, and "of this Drewyer our principal dependance as a woods-man and guide was entirely doubtfull."

The captains conferred. They reached an obvious conclusion: "We conceived it madnes in this stage of the expedition to proceed without a guide." They therefore resolved "to return with our horses while they are yet strong to an encampment with sufficient grass."

Into a deposit they put their instruments and journals and some roots, placing them on scaffolds and covering them with boughs. Those journals were by far the most precious of all the expedition's possessions, save only the rifles, powder, and lead. The reason the captains left them in the deposit shows what a risk they had taken in starting too soon; as Lewis wrote, "they are safer here than to wrisk them on horseback over the roads and creeks which we had passed." The men made the deposit on scaffolds and covered the contents with boughs. Then, at 1 p.m., the expedition started down the mountain. The captains and the men hated to turn around. "The party were a good deal dejected," Lewis explained. "This is the first time since we have been on this long tour that we have ever been compelled to retreat or make a retrograde march."

On our first trip, we shared a bit of that feeling when we came down the mountain after our fourth day on the Lolo Trail. It was bad planning on my part. My most basic mistake was inviting my students to fly up from New Orleans for a few days of backpacking. There is no way even a 20-year-old can step off a plane from the semitropics and start serious hiking at 7,000 feet. After four days, we had to get those sore-foot, blistered students off the mountains, out of the Bitterroots.

Also, we didn't bring enough rain gear and needed more variety in our food. In my family, turning around, going back, retreating, is not an option—but on this occasion, it was necessary, no matter how much it hurt.

On June 18, 1806, the captains sent Drouillard and Shannon on ahead to the Nez Perce, with authorization to offer one army rifle as a reward for anyone who would lead the party to Traveler's Rest, and two additional rifles if the guide would continue on from that point to the Great Falls. This was the first time the captains had even contemplated giving away a rifle, much less three. That evening, the main party made camp in a meadow on the edge of the mountains. There was plenty of grass. One of the men found some black morel mushrooms, which Lewis "roasted and eat without salt pepper or grease...truly an insipped taistless food." We have roasted morels at that site and agree with Lewis.

On June 21, two Indian boys passed through the flats. They told the captains that they intended to cross the Lolo the next day to visit with their friends the Flatheads on the other side of the Bitterroots.

The captains' eyes lit up at the news. They asked the boys to wait until Drouillard and Shannon returned, then serve as guides. The boys said they would wait two days, at their own camp, closer to the mountains.

On the afternoon of June 23, to the relief of all, Drouillard and Shannon returned, with three guides. One was a brother of Chief Cut Nose. Lewis described them as "all young men of good character and much respected by their nation."

On the morning of June 24, the expedition was off at first light and caught up with the two Indian boys. The campsite that night had good grass. After dark, the Indians set some fir trees on fire, telling the captains it was "to bring fair weather for our journey." Lewis wrote, "They are a beautiful object in this situation at night. This exhibition reminded me of a display of fireworks."

At first light, the party was climbing. In midmorning, the five Indian guides—in the lead—got to the deposit the expedition had left nine days earlier. Everything was in good order. The snow had subsided from 11 feet to 7. But the

Indians urged haste. They said it was a considerable distance to the place they had to reach before dark, the only spot where there was grass for the horses. In two hours, Lewis wrote, "We set out with our guides who lead us over and along the steep sides of tremendious mountains entirely covered with snow."

In the evening, they camped on the untimbered south side of today's Bald Mountain. The grass was ten days old, lush and green. The next grass, according to the Indians, was a day and a half's march away. On June 27, after another early start, the guides reached an elevated point where there was a conic mound of stones eight feet high, still there today, called Indian Post Office. The guides stopped for a ceremonial smoke, in effect a prayer for good weather as the most arduous and dangerous part of the Lolo Trail lay just ahead.

This is one of our favorite sites along the Trail. It is accessible only by foot or horse. The rock mound called Indian Post Office is at the highest point on the Lolo Trail, at 7,033 feet. The purpose and origin of these rock cairns are uncertain. Indians may have left messages for each other here, or the rocks may have had ceremonial significance. The view is spectacular.

"From this place we had an extensive view of these stupendous mountains," Lewis wrote. The sight filled him with awe, dread, and an even greater respect for the Indian guides. "We were entirely surrounded by those mountains," he commented, "from which to one unacquainted with them it would have seemed impossible ever to have escaped; in short without the assistance of our guides I doubt much whether we who had once passed them could find our way to Travellers rest." But he had confidence in the guides. These fellows are most admireable pilots," he wrote. Whenever the party came to a place where the snow had melted away, sure enough it found itself on the Trail. After smoking with the Indians and "contemplating this seene sufficient to have damp the sperits of any except such hardy travellers as we have become, we continued our march."

That day they made 28 miles and camped on the side of today's Spring Mountain. At Bald Mountain they had been at 6,000 feet; at Spring Mountain they were 500 feet higher.

Both places make fine campsites today—if you have plenty of food and little or no snow. For the Corps, however, it was another story. There was no grass for the horses, and the men had exhausted their meat supply. The captains distributed a pint of bear's oil to go into each of the four kettles, there to be mixed with roots. Lewis judged it "an agreeable dish." To my taste, bear meat is okay, bear fat is terrible, bear's oil I haven't tried.

In the morning, when Lewis cast his eye over the horses, he was disturbed to see them looking "extreemly gant." The guides reassured him; they would be at good grass by noon. Sure enough, after 13 miles, at 11 a.m., "we arrived at an untimbered side of a mountain with a Southern aspect.... Here we found an abundance of grass." They made camp right there.

June 29, 1806. They marched down to 5,200 feet and there was plenty of grass. The horses grazed while the men munched on their roots-and-bear's-oil lunch. Then the party set off down the valley toward the Bitterroot River. At seven miles, it again reached today's Lolo Hot Springs, where the men had soaked the previous September. Now the men, red and white, plunged into the rock-enclosed pools. The Indians would stay in the hot bath as long as they could stand it, then leap out and run to the creek, which was icy cold, and jump in, whooping and hollering and splashing. When they got too cold they ran back to the hot bath.

On June 30, 1806, the party marched down the valley of Lolo Creek. It was well out of the snow by now, but the Trail was often difficult, sometimes dangerous. At one steep hillside, Lewis's horse slipped "with both his hinder feet out of the road and fell." Lewis fell off backward and slid 40 feet before he could grab a branch to stop himself. "The horse was near falling on me" as he slid, Lewis wrote, "but fortunately recovers and we both escaped unhirt."

Just before sunset, the party rode into Traveler's Rest. It had covered 156 miles in 6 days. The previous fall, the expedition had been slowed by Old Toby's losing the way and it had taken 11 days to cover the distance. On this crossing the horses had grass every day but one. To the captains' delight, they had stood the journey surprisingly well. Most of them

were in fine order "and only want a few days rest to restore them perfectly."

This was thanks to the skill of the guides. The five Indians' sense of distance and timing, not to mention their sense of direction and ability to follow a trail buried under as much as ten feet of snow, was a superb feat of woodsmanship.

The party stayed at Traveler's Rest for three days. The captains spent the time conferring about the explorations north and south they had decided to make. The plan was for Lewis, with nine men and 17 horses, to follow the Nez Perce route to the Great Falls. There he would drop off some of the men to dig up the caches and prepare to help in a portage. With the remaining volunteers, Lewis would ascend the Marias River "with a view to explore the country and ascertain whether any branch of that river lies as far north as Latd. 50." If it did, the Louisiana Purchase territory would extend well into Canada. That mission completed, he would go to the mouth of the Marias.

In the meantime, Captain Clark would go with the others from Traveler's Rest to Camp Fortunate, where the expedition had left its canoes before crossing Lemhi Pass the previous August. There he would send Sergeant Ordway and a party of ten men down the Jefferson and the Missouri Rivers in the canoes. They would get assistance in the portage around the falls from the men left there by Lewis. Once around the falls, the combined force would run downriver to the mouth of the Marias, there to pick up Lewis and his party. Reunited, they would descend to the mouth of the Yellowstone, where they would meet Clark and his group.

Clark's independent exploration would begin after he got to the Three Forks. After dispatching Sergeant Ordway's party, he and the remaining ten men and Sacagawea and Pomp would cross the divide between the Missouri and the Yellowstone. When Clark's group reached the Yellowstone, the men would make canoes to descend the river to its junction with the Missouri, where almost the entire expedition would come together again.

Missing would be Sergeant Pryor and two privates. The captains gave them an independent assignment, to take the horse herd to the Mandan villages, to give to the Mandan,

with the hope that it would help persuade them to send one or more of their chiefs to Washington to meet Jefferson.

It was a highly ambitious plan, exceedingly complex, full of promise about what could be learned, dependent on tight timing. It showed how confident the captains were about their men. For the first time, they were dividing the party to pursue different missions, giving large responsibilities to the sergeants, counting on their men to be able to handle independent operations without a hitch.

Lewis's mission was the most dangerous, as it was going into Blackfeet country. Nevertheless when he called for volunteers on July 1, "many turned out, from whom I scelected Drewyer the two Feildses, Werner, Frazier and Sergt Gass."

Clark made a charming entry in his journal that day: "Capt. L. showed me a plant in blume which is sometimes called the ladies slipper or Mockerson flower. It is in shape and appearance like ours only that the corolla is white marked with small veigns of pale red longitudinally on the inner side, and much smaller." No matter their circumstance, the captains never forgot their scientific responsibilities. That same day, Lewis found time to do a bird count and write a 500-word essay on the prairie dog.

The next morning Lewis wrote, "I took leave of my worthy friend and companion Capt. Clark and the party that accompanyed him." As the captains and men shook hands and said their good-byes, there must have been a question in every man's mind—I wonder if I'll ever see you again. The proposed site of the rendezvous was at the Missouri-Yellowstone junction, a full 500 miles east of Traveler's Rest, as the crow flies. Clark's proposed route would cover nearly 1,000 miles, Lewis's nearly 800, much of it through territory neither captain had seen before. But such confident travelers had the captains become that what they said as they parted was, See you at the junction in five or six weeks.

Talk about hubris! As to whether their confidence in themselves and their men had swelled past all reason was theirs to discover. That Lewis felt at least a tinge of apprehension is clear from his comment on the parting: "I could not avoid feeling much concern on this occasion although I hoped this seperation was only momentary."

His horse knee-deep in snow, an Indian braves the Bitterroots in winter. Ignoring Nez Perce warnings of heavy snows, Lewis pressed the Corps forward into the mountains in early June—with no guides. By the second day the men were plowing through snows 12 to 15 feet deep and were forced to retreat for "the first time on this long tour," Lewis wrote dejectedly. Returning to the Nez Perce, the Corps engaged three young Indians, "most admireable pilots," who safely led them east across the formidable mountains.

CLARK'S YELLOWSTONE EXPLORATION

On July 3, Clark and his party set off on their horses, headed south, going up the Bitterroot River. Progress was good; by the 7th they reached today's Gibbons Pass on the Continental Divide. The party kept to an Indian trail the Flathead had shown Lewis the summer before. At six miles it "entered an extensive open Leavel plain in which the Indain trail scattered in such a manner that we could not pursue it. The Indian woman wife to Shabono informed me that she had been in this plain frequently and knew it well...."

She gave a perfect report, remarkable in every way, on what lay ahead, "in our direction to the canoes." Sacagawea had not been more than seven or eight years old when last she had been in this area, and that was seven or eight years ago. Yet once they got to the top of a rise in the plain Clark saw exactly what she had told him he would see. Then "the Squar pointed to the gap through which she said we must pass which was S. 56 E she said we would pass the river before we reached the gap. This is the great plain where Shoshones gather quawmash & roots &c."

The party made 26 miles that day and camped very near what would be the site of the Battle of Big Hole, August 9, 1877, when the Nez Perce under Chief Joseph survived a surprise attack and escaped.

We have visited the battlefield many times. It is today a national monument, set on a lovely mountain stream, with markers to show the various highlights of the battle. What makes it so fascinating is the scope of the thing—you can see the whole of the battlefield from the visitor's center, then walk it in an hour or two, unlike, say, Gettysburg, which requires two or three days to get a real feel for what happened, and the symbolic impact—there were with Chief

Joseph older Nez Perce people who had been children when Lewis and Clark camped with the tribe in 1805 and again in 1806. Without them Lewis and Clark never would have made it. Thus did the United States repay the tribe.

On July 10, Clark reached the cache that the expedition had made the previous fall, at Camp Fortunate. The canoes that had been left were in good order, as was most everything else. On July 13, his group arrived at the junction of the Jefferson, Madison, and Gallatin Rivers—the Three Forks.

That afternoon, Sergeant Ordway and a party of ten men in six canoes set off down the Missouri, to meet some of Lewis's party at the Great Falls, make the portage, then continue down the Missouri until they met with Lewis and his men at the mouth of the Marias.

Clark, with Sergeant Pryor, Privates Shields and Shannon, and five other soldiers, plus York, Charbonneau, Sacagawea, and Pomp, with 49 horses and a colt, set off riding east along the bank of the Gallatin River. Clark could see two passes ahead and started toward the one to the north, but "the indian woman who has been of great service to me as a pilot through this country recommends a gap in the mountain more south which I shall cross."

The pass to the north was today's Bridger; the one Sacagawea recommended, the Bozeman. How good a guide was she? Today's Interstate Highway 90 goes over the Bozeman Pass.

Clark went where she pointed, and sure enough he "struck an old buffalow road, the one our Indian woman meant," which took him over the mountain and then down to and through present-day Bozeman. He struck the Yellowstone River near today's Livingston. The Yellowstone is the longest free-flowing river in America and the longest

river without dams on it. It is a lovely river to paddle, swift but without bad rapids.

The Yellowstone is named for its walls of yellow rock, originally brown rhyolite colored and shaped by thermal heat and chemical action. It rises in Yellowstone National Park, which is some 60 miles south of where Clark struck the river. The park was first discovered the following year, 1807, by the expedition's own Pvt. John Colter, a favorite in our family for his spirit, grit, and independence. His descriptions of Yellowstone's geysers were initially greeted with skepticism and the place derided with the name "Colter's Hell."

Clark proceeded down the river on horseback searching for suitable trees to make canoes. Not until he got nearly to today's Billings did he find two cottonwood trees that answered. Today's Interstate 90 parallels his route, almost exactly, to its split with Interstate 94, which from Billings eastward sticks close to the river and thus his route. There is little human intrusion along the Yellowstone, which for the most part is as Clark saw it.

Morning, July 21: "I was informed that Half of our horses were absent." Two dozen were gone, two dozen remained. "I Suspect that the horses are taken by the Indians and taken over the hard plains to prevent our following.... My suspicions is grounded on the improbibility of the horses leaveing the grass of the river bottoms of which they are very fond, and taking imediately out into the open dry plains where the grass is but Short and Dry. If they had continued in the bottoms either up or down, their tracks could be followed very well." A nice piece of deductive logic, typical of Clark.

Nothing was going right. That night, "wolves came into our camp and eat the most of our dryed meat which was on a scaffold." The canoes were ready; it was time to get on. On July 24 they set out. That day the party made 69 miles; in the process it passed the site of present-day Billings.

Now well out of the mountains, the party had entered a country that was paradise for the grass-eating animals and their predators. "Killed the fatest Buck I every saw," Clark wrote. "My man york killed a Buffalow Bull, as he informed me for his tongue. For me to mention or give an estimate of the differant Species of wild animals on this river particularly Buffalow, Elk Antelopes & Wolves would be incred-

itable. I shall therefore be silent on the subject further."

But when Pryor came into camp, he reported that all those animals were causing him big problems. "He informed me that...the loos horses as soon as they saw the Buffalow would imediately pursue them and run around them.... The Indian ponies had been so trained since they were colts."

Pryor would need another man in his party if he was going to get the horses to the Mandans, many hundreds of miles to the east. Pvt. Hugh Hall volunteered.

In the morning, some 20 miles downstream from today's Billings, the party came to "a remarkable rock situated in an extensive bottom on the Starboard Side of the river & 250 paces from it. This rock I ascended and from it's top had a most extensive view in every direction. This rock which I shall call Pompy's Tower is 200 feet high it being a perpendicular clift. The Indians have ingraved on the face of this rock the figures of animals &c near which I marked my name and the day of the month & year."

This sandstone rock is one of our favorite sites, first because Clark's graffiti is the only remaining evidence that the expedition passed this way, but also because three of the men whose trail we have followed over the past three decades climbed the rock—Crazy Horse, George Armstrong Custer, and William Clark. In 1872, Crazy Horse stood where Clark had stood 66 years earlier. He was doing a reconnaissance as part of the Sioux campaign to drive the surveyors for the Northern Pacific Railroad from Yellowstone country. In 1873 Custer, with a contingent of cavalry sent to protect the surveyors, climbed the rock. While he was there, Crazy Horse and a party of Sioux fired on him from the north bank. The site is less than a mile off Interstate 94, and some 60 miles north of the site of the second meeting of Crazy Horse and Custer, in 1876 at the Battle of Little Bighorn.

The Clark etching, in script, reads:

Wm Clark
July 25 1806

It is clearly visible today, thanks to the Northern Pacific Railroad. In 1882, when the line was building up the Yellowstone Valley, officials noted that vandalism was effacing the etching. They had a double-iron grating installed over it,

ELEGIAC image of the West, Karl Bodmer's 1830s painting of the Missouri River depicts elk and bison congregating for the fall rut. Returning to the Plains during mating season, Lewis reported that "the bulls keep a tremendious roaring we could hear them for many miles and there are such numbers of them that there is one continual roar."

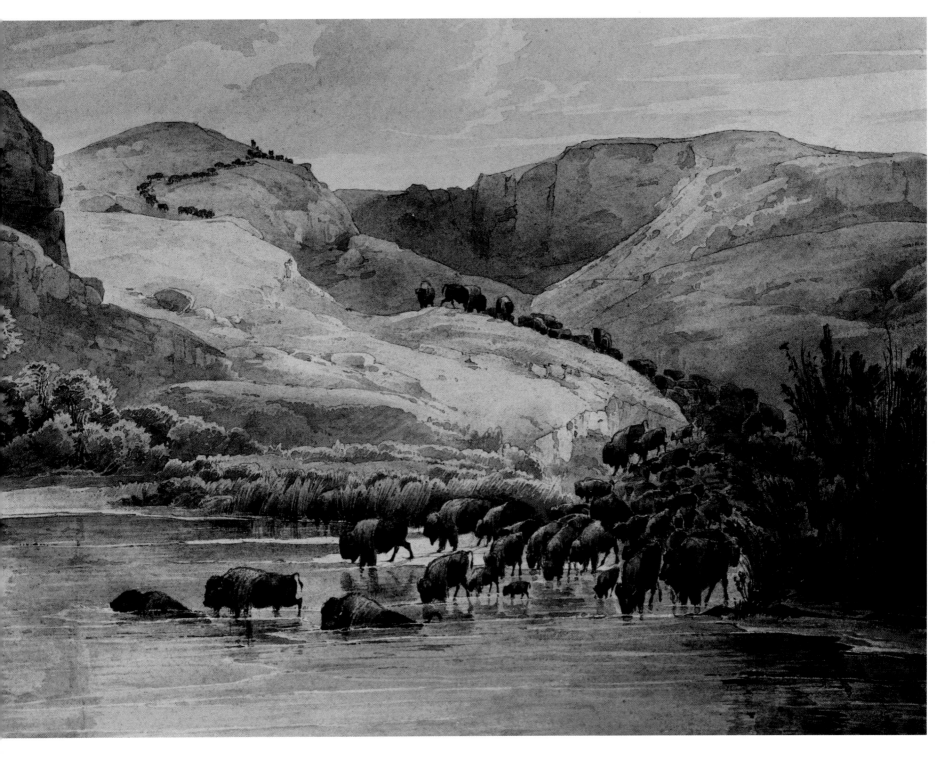

IN PRESENT-DAY Montana, Clark's signature graces the sandstone rock he called "Pompy's Tower" in honor of Sacagawea's young son.

which kept people out, but did not impede weathering. The inscription became hard to read and almost impossible to photograph. In 1956, the year after a new private owner acquired the rock to preserve as a historic monument, the grating came down. The owner put up a shatterproof glass cover, edged in bronze. The inscription is fully visible and protected from erosion. By contrast, you need a lot of imagination to find the Indian inscriptions Clark saw.

Clark named the rock for Sacagawea's boy, Jean Baptiste Charbonneau ("Pomp"). Eventually, the recognized name became "Pompeys Pillar," by which it is known today.

July 27 was a record day—80 miles. On the 28th, it was 73 miles. In the whole of the day's journey, Clark concluded his journal entry, "The Elk on the banks of the river were so abundant that we have not been out of sight of them to day." What a wonderland! Not only 73 miles of continuous elk on the riverbanks, but elk so tame that they scarcely looked up from grazing even when the canoes passed within 20 or 30 yards of them. They are not there today. Neither are the buffalo. But there are still plenty of deer and pronghorns.

Over the next few days the party averaged about 50 miles a day. On August 1, Clark saw a sight that staggered even him. "At 2 P.M. I was obliged to land to let the Buffalow cross over." The river was a quarter of a mile wide on each side of an island, that was itself a half mile wide. In that whole stretch "this gangue of Buffalow was entirely across and as thick as they could swim." It took the herd more than an hour to cross. Later that afternoon, "two gangues of Buffalow crossed a little below us, as noumerous as the first."

The presence of all those buffalo meant grizzly bears, living a soft life from feeding on drowned buffalo. The war between the bears and the Corps of Discovery was still very much on. August 2: "about 8 A.M. this morning a Bear of the large vicious species being on a Sand bar raised himself up on his hind feet and looked at us as we passed down near the middle of the river. He plunged into the water and swam towards us with a disposition to attack. We Shot him with three balls and he returned to Shore badly wounded."

The hoofed animals may have given the Yellowstone Valley a Garden-of-Eden quality, but such thoughts were quickly discarded when the wind fell off and the mosquitoes came out. Clark opened his August 3 journal entry: "Last night the Musquetors was so troublesom that no one of the party Slept half the night. For my part I did not sleep one hour. Those tormenting insects found their way into My beare [bier] and tormented me the whole night."

The bighorn sheep was a species Lewis had been unable to obtain to send to Jefferson, so Clark was especially eager to get a specimen. He spotted one at dawn, climbed a bluff to get at it, and then discovered "the Musquetors were so noumerous that I could not Shute with any certainty." He gave it up, returned to the canoes, and that morning "I arived at the junction of the Rochejohne [Yellowstone] with the Missouri." There he made camp.

He added up the miles since he had struck the Yellowstone coming down off Bozeman Pass: It was "837 Miles, 636 Miles of this distance I decended in 2 Small Canoes lashed together." He was amazingly accurate in measuring distance, doing it with instinct and experience only. It is impossible to tell today how far off he was, because the Yellowstone is constantly changing its course, but it wasn't by much, if any. That he took pride in the accomplishment we may assume from his listing the members of the party: "John

Shields, George Gibson, William Bratton, W. Labeech, Tous. Shabono his wife & child & my man York."

The following day, waiting for Lewis to join him, Clark put the men to work making clothes, but the "Musquetors were excessively troublesom so much so that the men compalined that they could not work at their Skins."

On July 4, 1996, Moira and I canoed the Yellowstone with Tom and Meredith Brokaw. We pulled into a cottonwood grove, set up for a picnic lunch, and were overcome by the descendants of Clark's pest. Like him, we got out of there.

Clark decided to drop down the Missouri River to find a campsite free of mosquitoes. After attaching a note to a pole stuck in the point of land where the rivers met, telling Lewis of his intention, Clark and party dropped down to what "appeared to be an eligable Situation for my purpose [but] on this point the Musquetors were so abundant that we were tormented much worst than before. The child of Shabono has been so much bitten by the Musquetors that his face is much puffed up & Swelled."

For almost a quarter century now, Moira and I have spent weeks on various parts of the Missouri River in the months of June, July, and August. Only rarely have we experienced anything like what Clark described. One incident came in July 1996, when I was on the river with some of my college fraternity brothers and their families. A mile or so above the campsite for that night I spotted a pile of driftwood, perfect stuff for the campfire. I was paddling alone. I ran the canoe into shore, got out, walked over to the pile, began pulling out likely wood, and in seconds was almost smothered by mosquitoes. They covered my back and bit through my T-shirt; they covered my arms, legs, ears, face. I could scarcely breathe or see. It was a unique experience and so frightening I went into something akin to panic. I ran into the river, dove, swam underwater downstream as far as I could, surfaced, and was free of my attackers. I swam ashore, waited 30 minutes for things to quiet down, snuck back up to the canoe, piled in, paddled away, routed by the mosquitoes.

Despite that experience, I cannot believe the insects are as plentiful on the river today as in 1806. Perhaps it is the absence of a food supply; although cattle do graze along the riverbanks, they are nowhere as numerous as the buffalo and elk of Clark's day.

Over the next two days Clark continued to fall downriver, hoping for relief. On August 8, at 8 a.m., he saw an unexpected sight: "Sergt. N. Pryor, Shannon, Hall & Windsor came down the river in two canoes made of Buffalow Skins." They had a story to tell. The night after they departed from Clark, Crow Indians stole their herd of horses. Pursuit on foot was impossible. They were isolated in the middle of Indian country, with nothing but their rifles, lead, powder, knives, and compass. It scarcely gave these young lions pause. Clark described what happened: "they packed up their baggage on their backs and Steared a N.E. course to the River Rochejhone which they Struck at pompys Tower, there they killed a Buffallow Bull and made a Canoe (Shannon killed Buff. & made the Canoe) in the form and shape of the mandans." That is, Shannon had recalled how the Mandan made their bull boats and made two himself. The bull boats were so serviceable that the party sped down the Yellowstone almost as fast as Clark's party in canoes.

Their adventures continued. In camp one night, a wolf bit the sleeping Sergeant Pryor through his hand then almost got to Windsor before Shannon shot it. Clark reported all this matter-of-factly. What we stand astonished at today, he took for granted. Pryor, Shannon, Hall, and Windsor were in a tight situation; they used their ingenuity to work their way out of it; that is what he expected them to do.

Over the next five days Clark continued to drift a few miles downriver each day, still looking for a mosquito-free campsite and confident that Lewis would overtake him soon. On August 11, he met Joseph Dickson of Illinois and Forrest Hancock of Boone's Settlement in Missouri, fur trappers out on their own. They had lots of news, nearly all of it bad: The worst was that the Indians along the Middle and Lower Missouri River were at war with one another—the peace Lewis and Clark had established had not lasted one season.

At noon on August 12, the Lewis contingent of the Corps of Discovery "hove in Sight." Clark's pleasure in being reunited was cut short by the alarming news "that Capt. Lewis was wounded by an accident." It seemed…but that is another story, for the next chapter.

LEWIS'S EXPLORATION OF THE MARIAS

JULY 3, 1806, TRAVELER'S REST. AFTER SAYING GOOD-bye to Clark and his party, Lewis and nine of his men plus the five Indian guides and 17 horses set out north-ward, down the Bitterroot River. At ten miles, they crossed the river by raft and continued their march east-ward along today's Clark Fork River to within a couple of miles of today's Missoula. His hunters brought in three deer, which Lewis split with the Indians. He tried to persuade them to continue on as guides as far as the Great Falls, but they said he didn't need them as the trail was so plain that even a white man couldn't miss the way. The following day, Independence Day, the Indians rode north along the bank of the Clark Fork. "These affectionate people our guides betrayed every emmotion of unfeigned regret at seperating from us," Lewis wrote.

After leaving Missoula, Lewis and his men came to today's Blackfoot River, called the River of the Road to Buffalo by the Nez Perce. They headed up it. It is one of the many beau-tiful valleys in Montana but made especially so by clarity of the water in the trout-filled Blackfoot River. Norman McLean made it famous in his story, "A River Runs Through It." Moira and I like the valley so much that in 1996 we bought a cabin on the North Fork of the Blackfoot.

Lewis and his party made 30 miles a day on the average and by July 7 had passed up Lander's Fork, crossed to Alice's Creek, and made their way to a spring coming from the side of a low, untimbered mountain. The trail wound up the north side of the creek, then switched back a couple of times before disappearing over the top of the pass. This was "the dividing ridge between the waters of the Columbia and Missouri rivers." At the top, the Great Plains of North America stretched out in front of Lewis, apparently without

limit, under an infinity of bright blue sky. He took a step—and he was back in U.S. territory.

It is named Lewis and Clark Pass today (even though Clark never saw it) and is at 6,284 feet of elevation. From 1976 on, we have climbed to the pass each summer. It can be reached by driving up Alice Creek Road, off Montana Highway 200 about ten miles east of Lincoln, Montana. The site is close to pristine, marked only by a Forest Service sign. The trail up follows the road the Nez Perce made from their Idaho home to the buffalo country. At places the travois marks from the thousands of Nez Perce who used it are plainly evident. The hike takes an hour and a half or so.

From the top you see what Lewis saw: "From this gap which is low and an easy ascent on the W. side the fort moun-tain bears North East and appears to be distant about 20 Miles." Lewis's "fort mountain" is today's Square Butte, a rock with nearly vertical sides, sculpted over time by streams that cut through an ancient plateau, further shaped by weathering and erosion. And it is more like 30 miles distant. It is the backdrop in many of Charles M. Russell's paintings.

In the 1980s, Sam Abell took one of his all-time great shots of Square Butte, for a GEOGRAPHIC article on the C. M. Russell Museum in Great Falls. In 1997, I was driving south from Great Falls on a stormy afternoon with Sam and Will Gray, director of National Geographic's Book Division. I found out the lengths Sam goes to to capture not only the place but also its essence.

Sam yelled, "Stop!" There was a thunder-and-lightning storm over Square Butte. Will hit the brakes, backed up, turned around, and raced back to a rise. When we got there, Sam leaped out of the car and all but sprang to the roof, a camera in each hand and another around his neck. "Damn!"

he exclaimed, using his favorite and roughest expletive. There was lightning over the butte, but also a power line in the shot he wanted. He jumped down, Will roared off for another rise to the right. When we got there, the scene was repeated, because by then the storm had passed the Butte. Lewis would have approved of Sam's naturalist's eye.

Lewis descended from the pass to the Dearborn River, then cross-country to the Medicine (today's Sun) River. The party was back in buffalo country and savoring it. When Joseph Field brought in the first one, Lewis ordered an immediate halt to the march, got a fire going, roasted the meat, and "we feasted on the buffaloe."

When the party reached the Missouri, the men made bull boats and paddled over to the east bank, where they dug up the caches made in June 1805. The papers and maps and much of the gear were in fine order, but Lewis's botanical specimens had been mostly ruined by high water.

As the men prepared dinner the evening of July 15, Lewis talked to them about their various assignments. Sergeant Ordway would be coming down the Missouri from Three Forks to help the five men Lewis was leaving at Great Falls; the combined parties would make the portage, and then meet Lewis and his band at the mouth of the Marias. For his exploration, Lewis selected Drouillard and the Field brothers to accompany him.

In the morning, Lewis and his party of three rode north, along the Marias, looking for the northernmost source of the Missouri River. His ride put him back in wonderland. "The whole face of the country as far as the eye can reach looks like a well shaved bowlinggreen...."

On the afternoon of July 21, Lewis came to a fork in the river. Today's Cut Bank Creek came in from the northwest, and Two Medicine River flowed in from the southwest to form the Marias. He followed Cut Bank Creek and the next day arrived at "a beautifull and extensive bottom of the river," in a clump of large cottonwoods. From that point he could see the creek emerging from the mountains of today's Glacier National Park. And the creek was coming from southwest, not northwest of his position. He had reached the northernmost point of Cut Bank Creek. He was well short of the 50th parallel and knew it. Clouds made it impossible for him to make his observations to establish exactly how far north he was (his position was at latitude 48 ° 30'). When he left the place, on July 26, "we set out biding a lasting adieu to this place which I now call camp disappointment."

Camp Disappointment is just about the hardest Lewis and Clark site to reach that we know of. We have done it only once, in 1977, following directions given to us by Wilbur Werner, a lawyer in the town of Cut Bank for a living, a Lewis and Clark scholar for an avocation. He told us to go 20 miles west, a couple of miles north, park the vehicle, hike cross-country another couple of miles north, then scramble down the bluff to the creek. He warned us it wasn't easy going but added that it was worth it. He was right on both counts. It is a lovely spot. The creek, cold and clear, meanders through the high-plains country, with Glacier Park—a magnificent sprawl of knife-edged peaks and cliffs carved by glacial ice, rich with pine and aspen forests and alpine lakes, appearing to be only a few miles away. There is a buffalo jump, or pishkin, along the creek near Lewis's campsite; so remote is the place that in 1997 it was undisturbed, with thousands of bones still lying at the base of the cliff.

In most cases, as at the Ulm Pishkin near Great Falls, the tremendous piles of buffalo bones at the bases of pishkins were gathered up during World War II and ground into fertilizer. But no trucks could get back to Cut Bank Creek, so those bones were undisturbed. It is part of the vast Blackfeet Indian Reservation and is today protected by law, so those bones should remain untouched.

Lewis rode south, toward Two Medicine River, which he struck about midday. There he was alarmed to see, about a mile away, a herd of 30 horses. He brought out his telescope and discovered several Indians sitting their horses. "This was a very unpleasant sight," he admitted. They figured to be Blackfeet: "From their known character I expected that we were to have some difficulty with them." He thought of flight and immediately gave it up. To run was to invite pursuit, and the Indians' horses looked better than his.

He resolved to "make the best of the situation." He told the men that no matter how many Indians there were, he

223

THE

RETURN

HOME

was resolved to resist "to the last extremity prefering death to being deprived of my papers instruments and gun."

But the Indians weren't looking for a fight. They were teenage boys, probably out on a lark. The two groups agreed to camp together. They rode down the steep bluffs to the river, where they came to a delightful spot on a bend, a bowl-shaped bottom with three large cottonwoods in the center and excellent grass. Running through it was a bubbling stream of pure mountain water. In 1989, Wilbur Werner led us there—you can get to within a mile or so of the site with a four-wheel drive vehicle. Lewis's account of what happened there is one of his most vivid pieces of storytelling, rich with images, anecdotes, site description, and personalities. I read his account aloud, for me a thrill beyond compare:

The Indian boys made a rough dome with willow branches, threw some dressed buffalo skins over it, and invited the whites to join them in the shelter. Drouillard and Lewis smoked with the Indians, handed out medals, then asked questions. The boys said they were part of a large band that was one day's march away. Another, larger band was hunting buffalo on its way to the mouth of Marias River. This was alarming news, as Sergeant Ordway and his party would be waiting for Lewis at that spot.

When full dark came on, Lewis took the first watch. At half past eleven, he roused Reubin Field. Drouillard took the next watch, then Joseph Field. At first light, Joseph carelessly laid down his rifle beside his sleeping brother.

One of the Indian boys, thinking he was seizing opportunity, made a big mistake—he grabbed the rifle and ran off. The Field brothers took off after him. At 50 yards they caught him and wrestled the rifle out of his hands. Reubin pulled his knife and plunged it into the young warrior's heart. The Indian, Field later said, "drew but one breath and the wind of his breath followed the knife and he fell dead."

Drouillard, meanwhile, woke to discover two Indians taking his and Lewis's rifles. He grabbed one of them and called out, "Damn you! Let go my gun!"

Drouillard's shout woke Lewis, who jumped up, reached for his rifle, found it gone, pulled his horse pistol from its holster, and took off after the Indian running away with his rifle. He signaled to the boy to lay down the rifle or get shot. As the Indian carefully put the rifle down, the Field brothers came up, in a state of the highest excitement. They took aim to kill the warrior, but Lewis forbade it, as the Indian was complying with his order.

Then Lewis noticed that the remainder of the Indians were trying to drive off the horses, both their own and those of Lewis and his party. He called out orders: Shoot those Indians if they try to steal our horses! The Field brothers ran off after one group, Drouillard another, while Lewis pursued two men who were driving off a few horses, including Lewis's. He sprinted some 300 yards, at which point the Indians had reached an almost vertical bluff that was a hundred feet high. They drove the horses before them and hid in a niche, a sort of alcove, in the bluff. Lewis, breathless, could pursue no farther. He shouted to them that he would shoot them if they did not give back his horse; if they didn't know the words they surely knew what he meant.

One of the boys, armed with a British musket loader, turned toward Lewis. Lewis brought his rifle to his shoulder, took aim, fired. He hit the Indian in the belly.

But the warrior wasn't finished. He raised himself to his knee, took quick aim, and fired at Lewis. "Being bearheaded," Lewis noted, "I felt the wind of his bullet very distinctly."

He retreated, back to camp, without his horse. There he found Drouillard had rounded up four Blackfeet horses and three that were part of Lewis's original bunch. That was enough. Lewis called the Field brothers back from their pursuit and began to pack up. As the men arranged saddles and the placement of baggage on the packhorses, Lewis started burning the articles the Indians had left behind: four shields, two bows, two quivers of arrows, sundry other articles. Enraged, he left the medal he had given out at last night's campfire hanging around the neck of the dead Indian, "that they might be informed who we were."

"That was a bit of hubris," Barry commented when I finished reading. "True," I replied, "but it was less insulting to the Blackfeet than taking the kid's scalp."

Andy didn't like the idea of a teenage boy getting killed and said so. I agreed that Lewis had lost his composure, "but

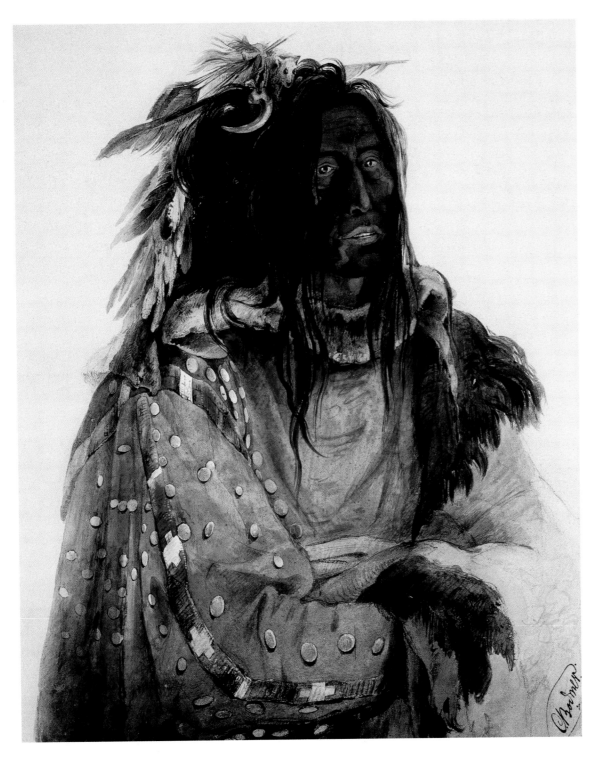

IN FULL ceremonial regalia, a Piegan chief, of the Blackfeet people, seems to exude the reputation for ferocity enjoyed by his tribe. "From their known character, I expected we were to have some difficulty with them," Lewis wrote prophetically as he and his small band entered Blackfeet country. He was right. On July 27, a group of Indians who had camped with Lewis's party attempted to steal the white men's guns. The Corps, though outnumbered, fought back with characteristic ferocity, and two Indians were shot, the only Indian casualties of the entire journey.

remember this was the only Indian the Corps of Discovery killed—unless the one Lewis shot died—and Lewis didn't start the fight."

Wilbur nodded and added, "If those boys had gotten away with the rifles and horses, Lewis and his men would have had no chance whatsoever of joining Ordway at the Marias."

For Lewis, after burning the equipment and hanging the medal around the dead boy's neck, it was time to get out of there. One Indian boy had been killed, another critically wounded. These four whites had no place in the middle of a land with hundreds of Blackfeet warriors who would seek revenge the instant they heard the news.

Lewis and his men rode off, at a trot, covering about eight miles per hour. With only two stops they rode into the night.

It was a night to remember. The tension was high, so too the concentration. The setting was magical. The Plains were as flat as a bowling green. There were thunderclouds and lightning "on every quarter but that from which the moon gave us light." Throughout the night, "we continued to pass immence herds of buffaloe."

At 2 a.m., July 28, Lewis finally ordered a halt for sleep. The day had begun 22 hours earlier with an Indian fight, followed by a hundred-mile ride. Two hours later he woke, so stiff he could scarcely stand. He roused the others. They begged for more rest. Lewis got them going, saying that the lives of their friends depended on them. Ordway's party could well be caught unprepared by a party of revenge-seeking Blackfeet.

That worked. The men came alert and the ride was resumed. After 12 miles they came to the Missouri, rode down it another 8 miles, and "heared the report of several rifles very distinctly. We quickly repared to this joyfull sound and on arriving at the bank of the river had the unspeakable satisfaction to see our canoes coming down."

There were brief greetings. Lewis explained the need for haste. The men quickly dug up last summer's cache, loaded it into the white pirogue and five small canoes, and headed downstream as fast as possible. The job now was to reunite with Clark and head on to St. Louis.

With a rendezvous to look forward to, and after that St. Louis—whiskey! tobacco! women!—the men dug in with a

will. By August 7, they reached the mouth of the Yellowstone. Clark wasn't there but signs of an encampment indicated he had been a week earlier.

Early on August 11, still playing catch-up, Lewis spotted elk on a thick willow bar and decided to replenish the meat supply. He took Private Cruzatte with him. After some success, the hunters reloaded and plunged further into the willow. Lewis saw an elk some yards ahead. He took aim and was about to fire when he was hit by a rifle bullet. No bone had been hit, but he was spun around by the force of the blow and had a three-inch gash across his buttocks.

"Damn you," Lewis shouted. "You have shot me."

Cruzatte gave no answer. Lewis limped back to the canoes. Cruzatte absolutely denied firing the shot. "I do not believe that the fellow did it intentionally," Lewis wrote, but neither did he believe Cruzatte's denials. He had the ball in hand; it was a .54 caliber, from a U.S. Army Model 1803. There was no way an Indian could have had one of those rifles.

Lewis dressed his wounds himself. Then he lay face down in the canoe and the party set out again. He spent the night on his stomach aboard the canoe. He had a high fever.

In the morning, off again. Shortly after noon, Lewis finally caught up with Clark, who ran to the riverbank when he heard Lewis had been wounded. He was much alarmed, but Lewis raised his head to assure him that the wounds were slight. "This information relieved me very much," Clark wrote.

That evening, Clark washed Lewis's wounds. Then Lewis wrote in his journal. After describing the day, he declared that "as wrighting in my present situation is extreemly painfull to me I shall desist untill I recover and leave to my friend Capt. C. the continuation of our journal."

This entry was his last one in the journals of Lewis and Clark. Fittingly, to close it, he felt compelled to write a final botanical description: "I must notice a singular Cherry." It was the pin cherry. Despite his pain and "situation," he gave it a complete going over: "The leaf is peteolate, oval accutely pointed at it's apex...."

It was new to science. So were dozens of other descriptions and pressed plants he had in his bags. It was time to get them back to the civilized world.

HOME

Going downstream, with the men plying their regular rhythm with the paddles—in each canoe, the five or six paddles dipping into the water simultaneously, then drawing back as the men put the whole power of their shoulder, arm, and back into the stroke, then coming out, the water dripping off the paddles flashing in the sunlight—it looked from on shore almost like a ballet. They sped along at seven miles an hour and better, and could make up to a hundred miles in a day. By August 14, the expedition had completed its 1805-1806 voyage into the unknown and closed the circle when it arrived at the Mandan villages.

"Those people were extreamly pleased to See us," Clark reported. There were reunions with such old friends as the Mandan chiefs Black Cat and Big White, among others. Hugs and small presents and a smoking ceremony marked the occasion. Then it was time to exchange news. After the captains told the chiefs a bit about where they had been and what they had seen, the chiefs informed them, as the traders Dickson and Hancock had told Clark earlier, that the whole middle and upper Missouri River was at war, that the Sioux had raided the Mandan, the Hidatsa had sent a war party into the Rockies and killed some Shoshone—possibly from Cameahwait's band. The Arikara and the Mandan were fighting. This was a blow to Lewis's hopes for an American fur empire, which depended on peace prevailing in the valley. To balance that, Chief Big White (along with his wife and son) agreed to accompany Lewis to Washington, D.C., to meet President Jefferson.

The Charbonneau family planned to stay with the Mandan. On August 17, Clark settled up with Charbonneau. He received $500.33 ⅓ for his horse, his tepee, and his services. Sacagawea got nothing. Another member of the expedition stayed behind when the party set out for St. Louis, Pvt. John Colter. Dickson and Hancock had returned for some unexplained reason to the Mandan villages. Ready to head west again, they asked Colter to join them in their Yellowstone venture. He accepted, subject to the captains' approval. They gave it, on the condition that no other man ask for a similar privilege (Colter's enlistment would not expire until October 10, 1806). None did, so when the Corps of Discovery set off downstream that afternoon, Colter turned back upstream, back to the wilderness, back to the mountains, on his way into the history books as America's first mountain man and the first to give a report of Yellowstone National Park.

Whether the men, as they watched him depart, thought, What a fool! or felt envy, Clark did not record. But his conditional approval of Colter's request indicates that he thought at least some of the others might well be tempted to return to the Yellowstone country.

Instead, they went downstream as fast as the current and their muscle power could take them. Lewis was still on his belly, with Clark washing out his wounds twice a day. On August 22, Clark wrote a medical report: "I am happy to have it in my power to Say that my worthy friend Capt. Lewis is recovering fast, he walked a little to day for the first time."

Soon they were meeting trappers, traders, and rivermen heading upstream.

On September 6 the captains purchased a gallon of whiskey from a trading boat—paying for it with a chit—and gave each man a dram, "the first Spiritous licquor which had been tasted by any of them Since the 4 of July 1805." Three days later, the expedition passed the mouth of the Platte

THE BUCOLIC image of an Indian trapping beaver on the upper Missouri was soon lost in the wake of the expedition. The Corps' reports of abundant beaver sent white men flocking to the area, and within a few decades, their over-zealous trapping had brought the animal to near extinction.

River. In so doing, it passed out of the Great Plains. It was on the homestretch.

On September 20, the men saw cows on the bank, a sight that brought out spontaneous shouts of joy. They had not tasted milk in two and a half years. They put in at the village of La Charette, where "Every person," Clark wrote, "Seem to express great pleasure at our return.... They informed us that we were Supposed to have been lost long Since."

They stopped at St. Charles, then Fort Bellefontaine, established in their absence—in 1805—as the first U.S. Army fort west of the Mississippi.

On the morning of September 23, the canoes set off for their last day's voyage. In less than an hour, they were swinging into the Mississippi River, past the old camp at Wood River, last seen 28 months and 8,000 miles ago. The one thousand citizens of St. Louis, alerted by a messenger from St. Charles that the Corps of Discovery was coming, were on the riverbank, firing salute after salute. As the canoes came ashore, there were three cheers and a hearty welcome. One resident reported, "They really have the appearance of Robinson Crusoes—dressed entirely in buckskins."

The voyage had begun when Meriwether Lewis left Washington on July 5, 1803. It wouldn't be completed until he returned to Washington to report to President Jefferson.

So Lewis's first question, as he scrambled out of his canoe, was: When does the post leave?

It had just left. Lewis wrote a note to the postmaster at Cahokia, Illinois Territory, and sent it on by messenger: Hold the post until the next day. Lewis took a room and began to write—his first writing since being shot. He wrote through the night, so far as we can tell. It was his first chance to report to the President since April 1805.

He opened by announcing his safe arrival in St. Louis, along with "our papers and baggage," an assurance to Jefferson that the expedition had brought back its scientific discoveries. The second sentence went to the heart of the matter: Lewis said, "We have discovered the most practicable rout which does exist across the continent by means of the navigable branches of the Missouri and Columbia Rivers." In a long paragraph that followed, Lewis said the rivers of the west were navigable, mostly, but that the passage by land from the Missouri to the Columbia's waters was another matter altogether. It was Lewis's unhappy task to tell the President that his hope for an all-water route linking the Atlantic and Pacific was gone.

So, even as he pulled into St. Louis in triumph, he carried the burden of knowing that the headline news to come out of the expedition was that the Northwest Passage did not exist. The portage from the Missouri waters to the Columbia waters was 340 miles, 200 along a good road, the other 140 "the most formidable part of the tract over tremendious mountains which for 60 mls are covered with eternal snows."

With those words, Lewis put an end to the search for the Northwest Passage.

That was the bad news. In his third paragraph, Lewis turned positive, opening with a sentence that became the most-quoted one he ever wrote: "The Missouri and all it's branches from the Cheyenne upwards abound more in beaver and Common Otter, than any other streams on earth, particularly that proportion of them lying within the Rocky Mountains." It was sure to set off a rush for the mountains.

He gave Jefferson an inventory of the furs he was bringing back, along with a "pretty extensive collection of plants." Lewis knew his man. He gave no more details, counting on it that Jefferson would be greatly excited by the thought of all those new-to-science plants and animal descriptions.

Before closing, Lewis added a paragraph that began with a splendid tribute to his dearest friend and closest companion, followed by a typically generous gesture: "With rispect to the exertions and services rendereed by that esteemable man Capt. William Clark in the course of our late voyage I cannot say too much; if sir any credit be due for the success of the arduous enterprise in which we have been mutually engaged, he is equally with myself entitled to your consideration and that of our common country."

That put it directly before the President: Whatever rank Clark carried on the War Department rolls, Lewis wanted him treated as captain and co-commander. This was what he had promised, what Clark had earned. To Lewis, any other action was unthinkable.

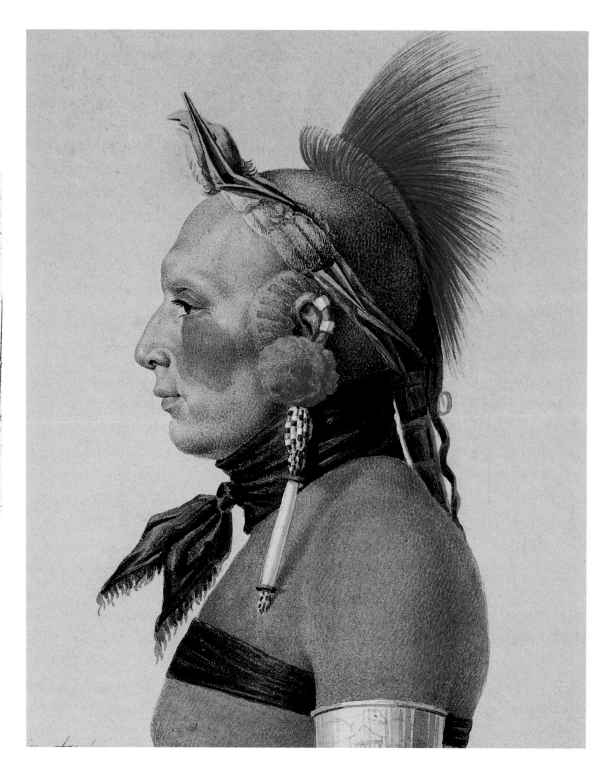

Oct. 1, 1806.

By the last Mails.

MARYLAND. BALTIMORE, OCT. 29, 1806.

A LETTER from *St. Louis* (*Upper Louisiana*), dated *Sept.* 23, 1806, announces the arrival of Captains LEWIS and CLARK, from their expedition into the interior.—They went to the *Pacific Ocean*; have brought some of the natives and curiosities of the countries through which they passed, and only lost one man. They left the *Pacific Ocean* 23d March, 1806, where they arrived in November, 1805;—and where some American vessels had been just before.—They state the Indians to be as numerous on the *Columbia* river, which empties into the *Pacific*, as the whites in any part of the U. S. They brought a family of the Mandan indians with them. The winter was very mild on the *Pacific*.—They have kept an ample journal of their tour; which will be published, and must afford much intelligence. ————

Mr. ERSKINE, the new British Minister to the United States, is warmly attached to the U. States. He married, about seven years since, an American lady, daughter of Gen. CADWALLADER, of *Pennsylvania*. He has a daughter now in the U. States. ————

NEW YORK

A NEWSPAPER announces the Corps' return after 28 months. Lewis's own hastily written letter to Jefferson informed him that "In obedience to your orders we have penitrated the Continent...to the Pacific Ocean." Jefferson had already reaped rewards from the journey, including a visit from Osage chiefs Lewis had sent in 1804 (right): "The finest men we have ever seen...." noted Jefferson.

Besides his praise of Clark, Lewis gave each enlisted man a handwritten testimonial. For instance, he praised Sergeant Gass's "ample support, manly firmness, the fortitude with which he bore the fatigues and painful sufferings." Each man had earned "the consideration and respect of his fellow citizens." Lewis hoped that each would "meet a just reward in an ample remuneration on the part of our Government."

A good company commander looks after his men.

Lewis signed the report, then dipped his quill into the inkstand for a postscript: "The whole of the party who accompanyed me from the Mandans have returned in good health, which is not, I assure you, to me one of the least pleasing considerations of the Voyage."

On October 24 Jefferson received Lewis's report "with unspeakable joy." In his reply he allowed himself to express a bit of the terrible anxiety he had felt for his young friend and for the expedition that he had fathered: "The unknown scenes in which you were engaged, & the length of time without hearing of you have begun to be felt awfully."

In St. Louis, after many celebrations, the captains held an auction in which they sold off the public items that had survived their voyage. These included the rifles, powder horns, the pouches, kettles, and axes. They brought $408.62. In November, Lewis and Clark set off with their entourage, which included Big White and his family, a delegation of Osage, Sergeants Gass and Ordway, two privates, and York. As they proceeded east, citizens of every town of any size insisted on giving them a banquet and ball. They were the first national heroes since the Revolutionary War, genuine superstars of the post-war generation. Their contemporaries appreciated their accomplishment even more than we can today, because their contemporaries had a better idea than we do of what it took to overcome the challenges involved in crossing the continent.

For us the return from our first journey was a less festive one, but in content our experience was enduring. For Stephenie and Hugh, it was a commitment to frontier history. For Barry, it was the beginning of his life as a modern mountain man. For Moira and me, it marked the start of 20 years of research. More than anything, we all learned that our experiences were jumping-off points for the great deal we had left to learn. We got so hooked on Montana that we have returned every summer since on camping trips. Five of us live in the state today and the other two visit frequently. Our summer of 1976 on the Lewis and Clark Trail changed our lives.

On November 13 the captains separated, with Clark going to Fincastle, Virginia, to see friends and family, while Lewis set out, with Big White, for Charlottesville, then Washington and the President. Things had worked out exactly as he had hoped; a year earlier, he had written that what kept him going was the anticipation of January 1, 1807, when he would be in the bosom of his friends, participating in the mirth and hilarity of the day. Indeed, Lewis was the guest of honor at the President's House on New Year's Day.

We have no account of Lewis's first meeting with Jefferson since his departure three and a half years past. One can suppose that Jefferson overwhelmed Lewis with his curiosity about the natural wonders Lewis had encountered, the adventures he had experienced, the Indians he had seen. And such tales he had to tell! Of grizzlies and gigantic trees and great storms and the incredible animal life of the Great Plains and the fierceness of the Indians of the Plains and the numbers of Indians on the lower Columbia and the generosity of the Nez Perce and Shoshone and the portage of the Great Falls and the trek over the mountains and sickness and numbing fatigue and mosquitoes and gnats and prickly pears and that moment of triumph when the ocean was in view.

Lewis and Clark had crossed the continent. No United States citizen had ever done it before, and no one else could ever be first. They had mapped it and described it, including its inhabitants, human, botanical, animal. They had been the first white men into the great Northwest empire and had established an American claim on what would become Idaho, Washington, and Oregon. They had brought back the news that there was an immediately exploitable resource in Louisiana, namely furs, as well as lands ideal for farming, thus starting thousands of Americans on the trek westward.

They blazed the path. Every American living or traveling west of the Mississippi River today goes in the footsteps of Lewis and Clark, or paddles in their wake.

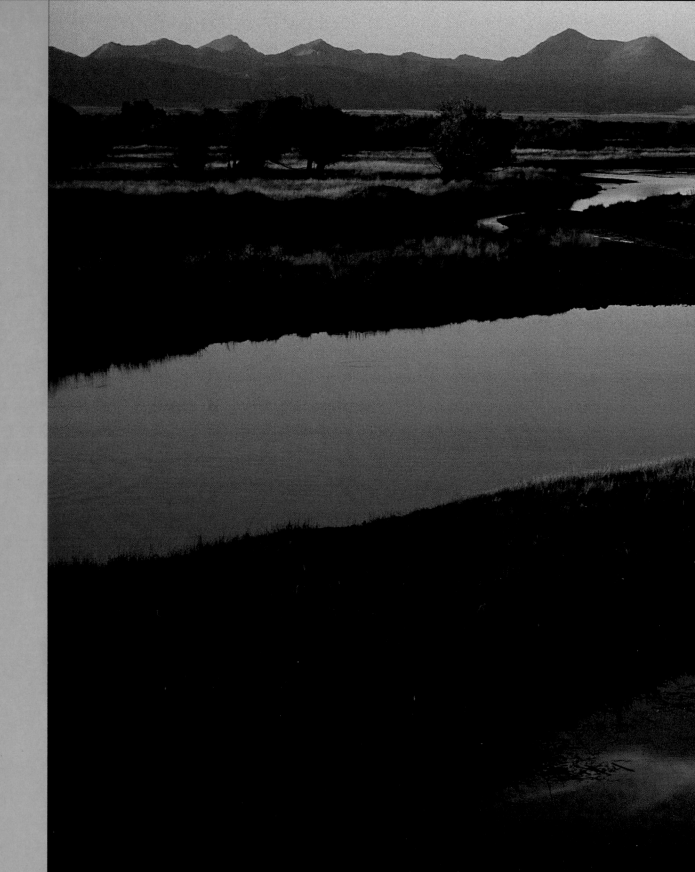

"I took leave of my worthy friend and companion Capt. Clark, and the party that accompanyed him."

MERIWETHER LEWIS ~ JULY 3, 1806

MIRRORING the big sky above Montana's Big Hole Valley, the Bitterroot River bends through prairie land that Clark explored on his route south toward Yellowstone country.

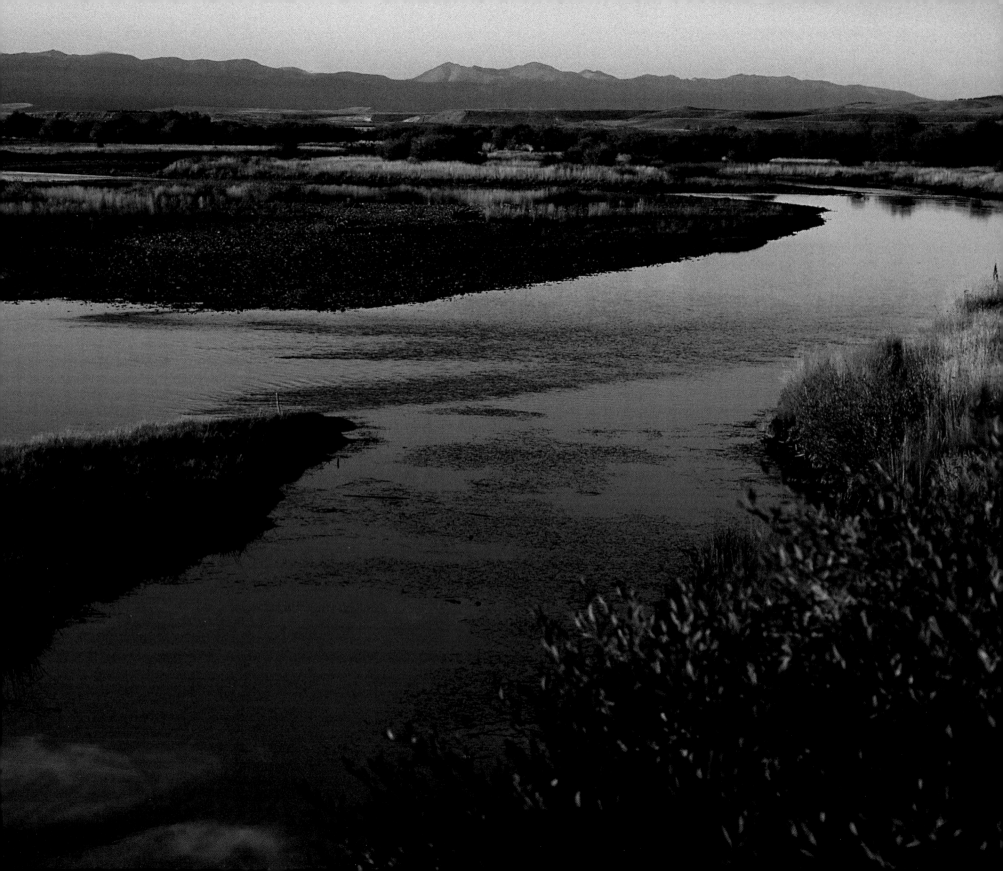

ON JULY 7, Lewis and his party
crested "the dividing ridge
between the waters of the
Columbia and Missouri rivers..." at
a "gap which is low and an easy
ascent." From the 6,264-foot
pass—now named for the
captains—Lewis came in sight
again of the Great Plains and of
Fort Mountain (now called Square
Butte), the landmark that had
guided him west the previous fall.
The explorers were back on
American soil, and, even more
welcome, in buffalo country. "I
find the fat buffaloe meat a great
improvement to the mush of...
roots," Lewis wrote in his journal.

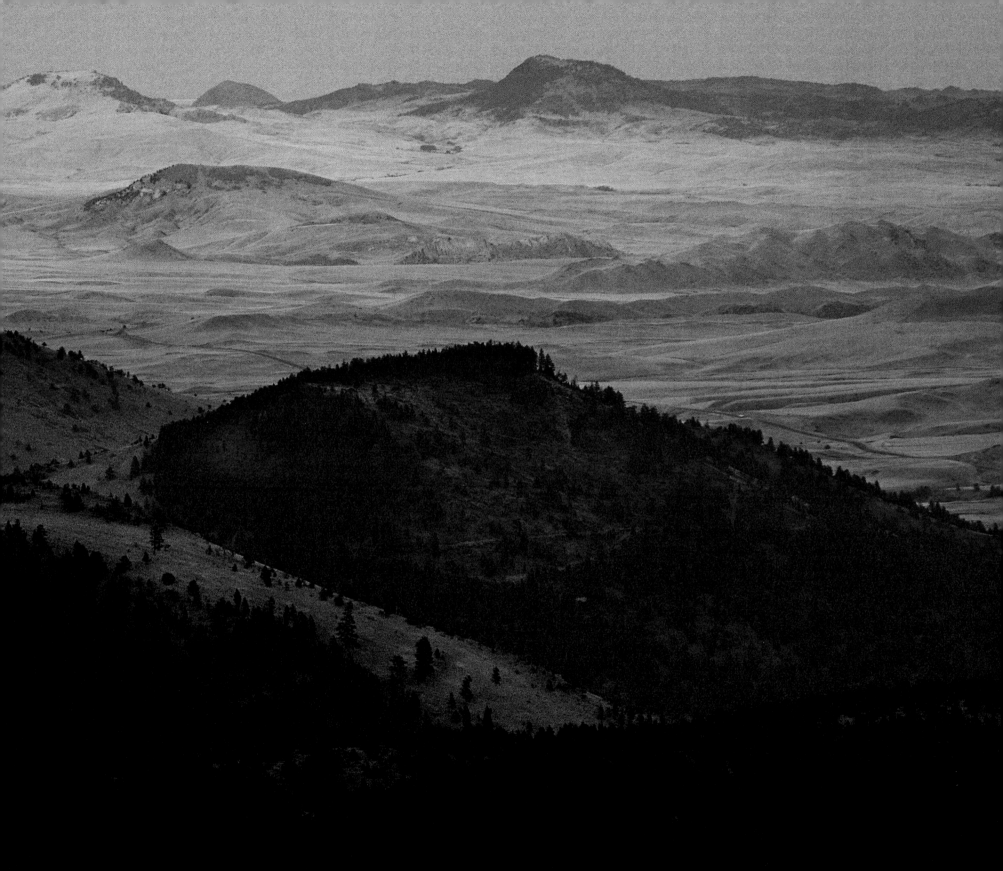

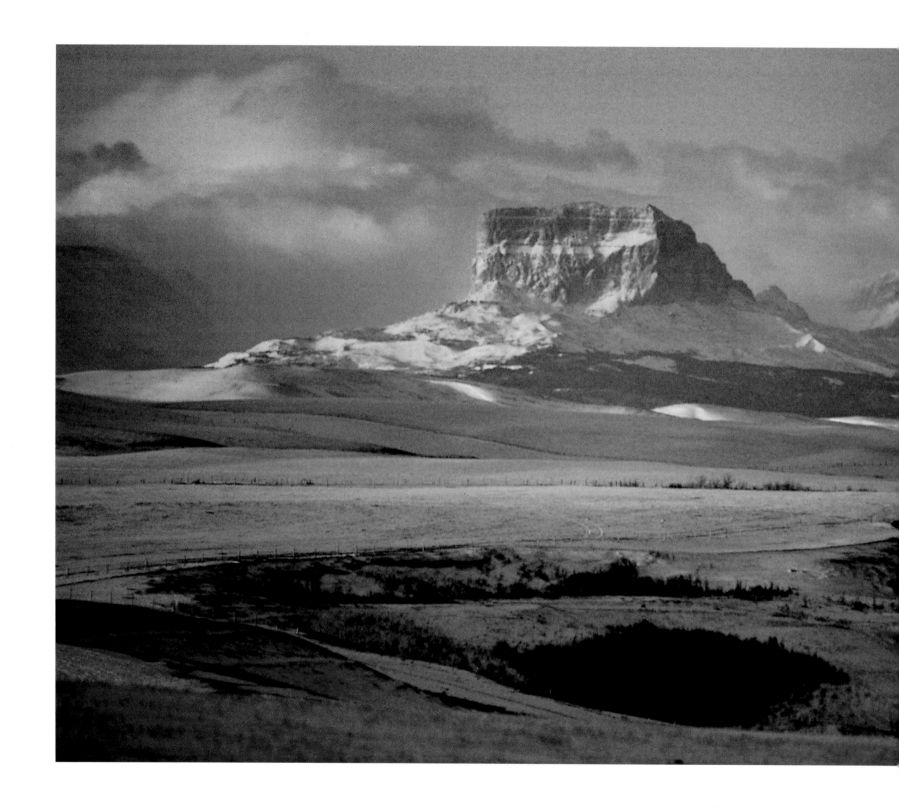

SNOW-WHIPPED peaks of Glacier National Park characterize the wild country Lewis saw as he explored the Marias River and its tributaries. His route took him within 20 miles of the present park boundaries, though no sign of his passing now exists. Clark however, following another route along the Yellowtone River, left a calling card for posterity, carving his name and the date into a sandstone bluff (above) known today as Pompey's Pillar. Clark named the formation after Sacagawea's two-year-old son, Pomp, "the little dancing boy" who often rode in Clark's canoe.

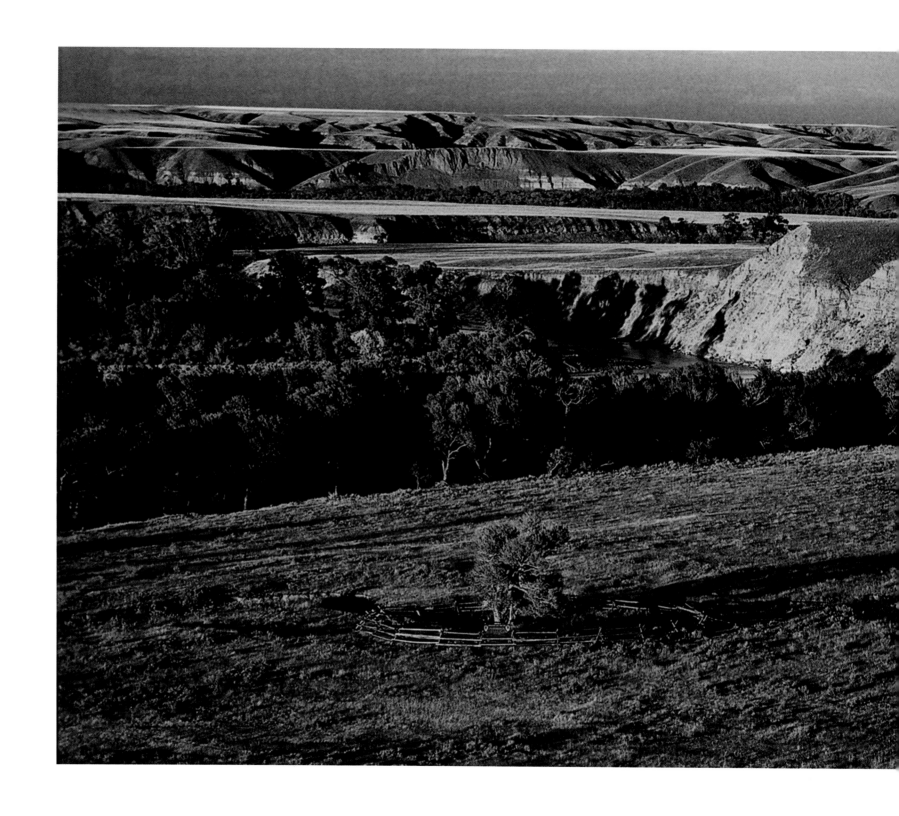

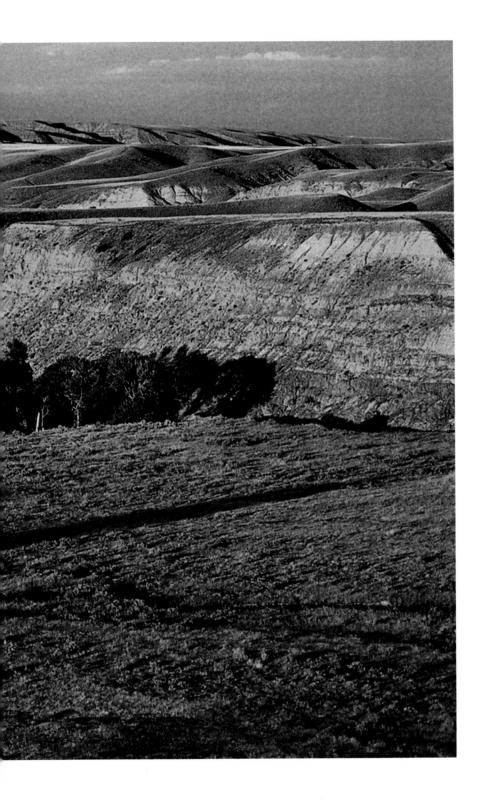

Cottonwoods darken the serene banks of the Two Medicine River, where Lewis and his party ran into a group of young Blackfeet warriors, "an unpleasant sight," he noted in his journal, as "from their known character I expected that we were to have some difficulty with them." Despite attempts "to make the best of our situation" by sharing an evening campsite, a skirmish broke out when the warriors made off with the soldiers' guns and horses. In minutes one Indian was dead, stabbed through the heart by Reubin Field; another was critically wounded, shot by Lewis through the belly—the only Indian casualties of the expedition. Angrily and ironically, Lewis left a peace medal around the neck of the dead warrior, "that they might be informed who we were."

LIGHTNING stabs at the Rocky Mountain Front, a formidable wall marking the edge of the broad Montana prairie. Now, as in Lewis and Clark's day, such electrical storms can create spectacles of uncanny beauty— as well as set forests and prairies on fire in devastating conflagrations.

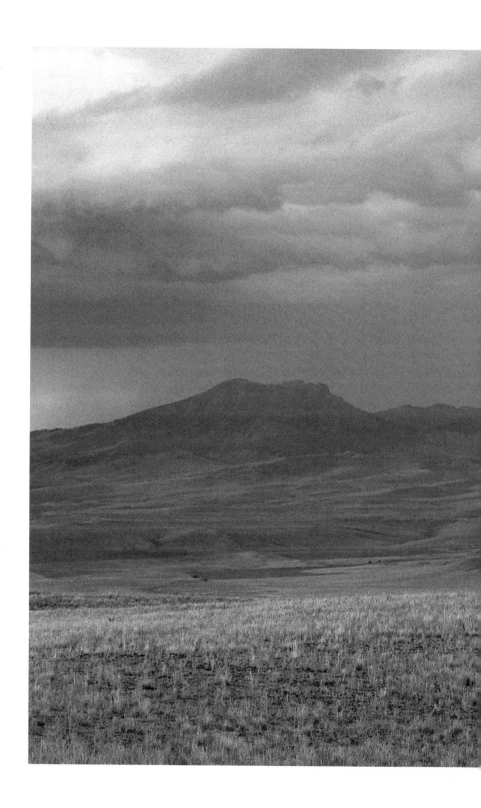

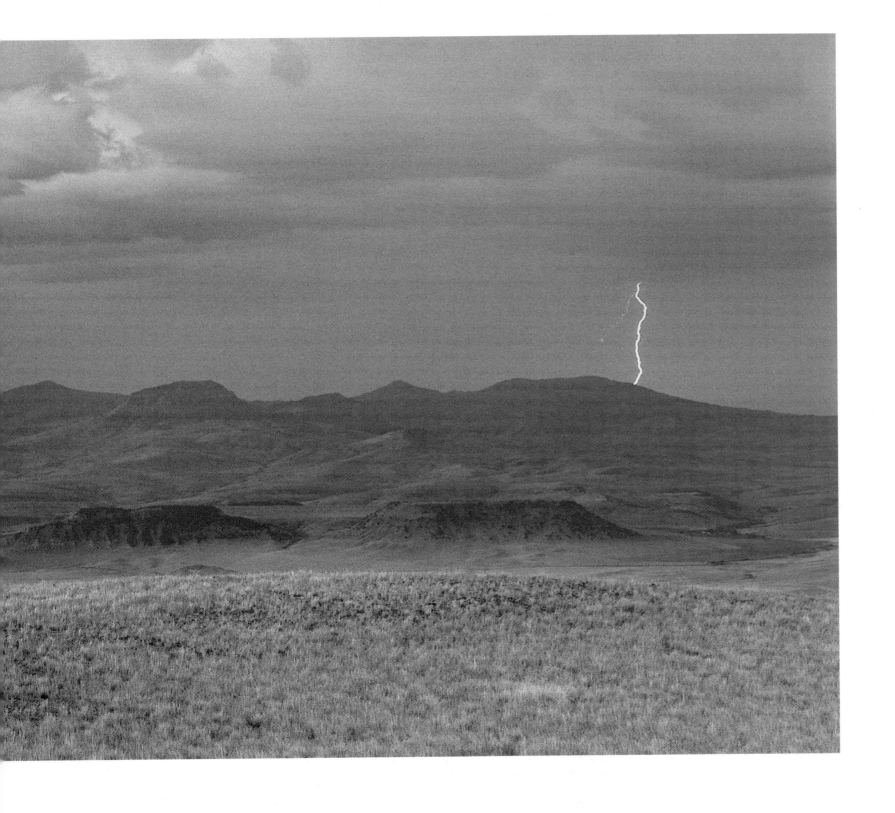

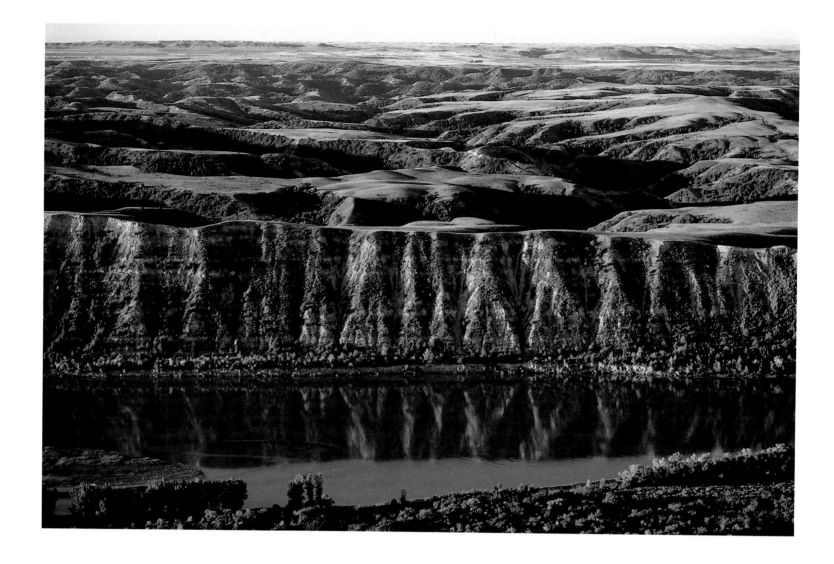

"THE LARGE river which runs towards the rising sun," Lewis called the Missouri (above) when describing it to the Blackfeet. It also ran toward the rendezvous point with Clark and his party. On August 12, 1806, the two captains and their men reunited at the confluence of the Yellowstone and Missouri Rivers (opposite). From here the Corps of Discovery followed the river downstream to St. Charles, Missouri, and the "civilized" world they had left some two and a half years and 7,000 miles before.

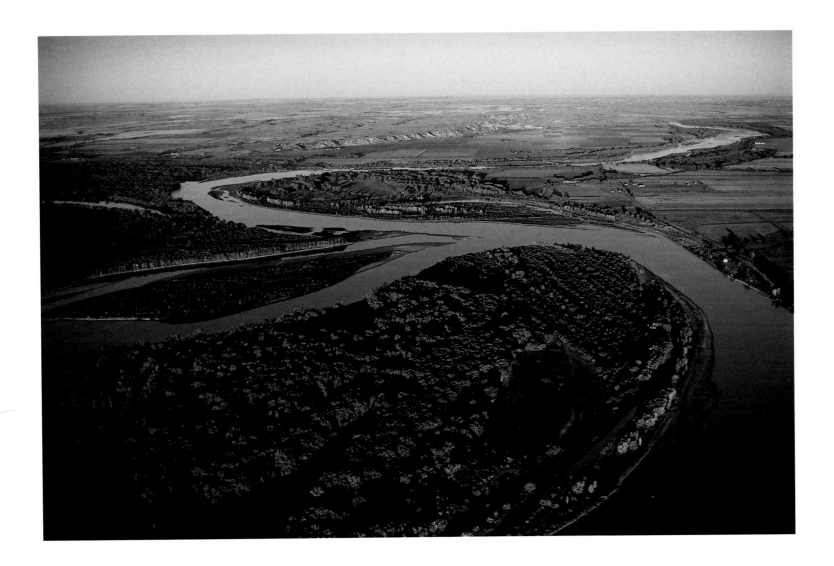

RED-RIMMED by twilight, a Blood Indian encampment in Alberta, Canada, recalls America's past, when great nations of Indians claimed the West. During their odyssey, Lewis and Clark glimpsed the wealth of Indian cultures in encounters with Plains Indians, Plateau Indians, and tribes of the Pacific Northwest. Far from hindering the Corps, most Indians aided them on their way, providing food, shelter, and direction. Thus these peoples from different worlds crossed barriers of language and culture. However, the epic journey of Lewis and Clark prompted other white men to follow, signaling permanent change in the cultures and lifestyles of the first Americans.

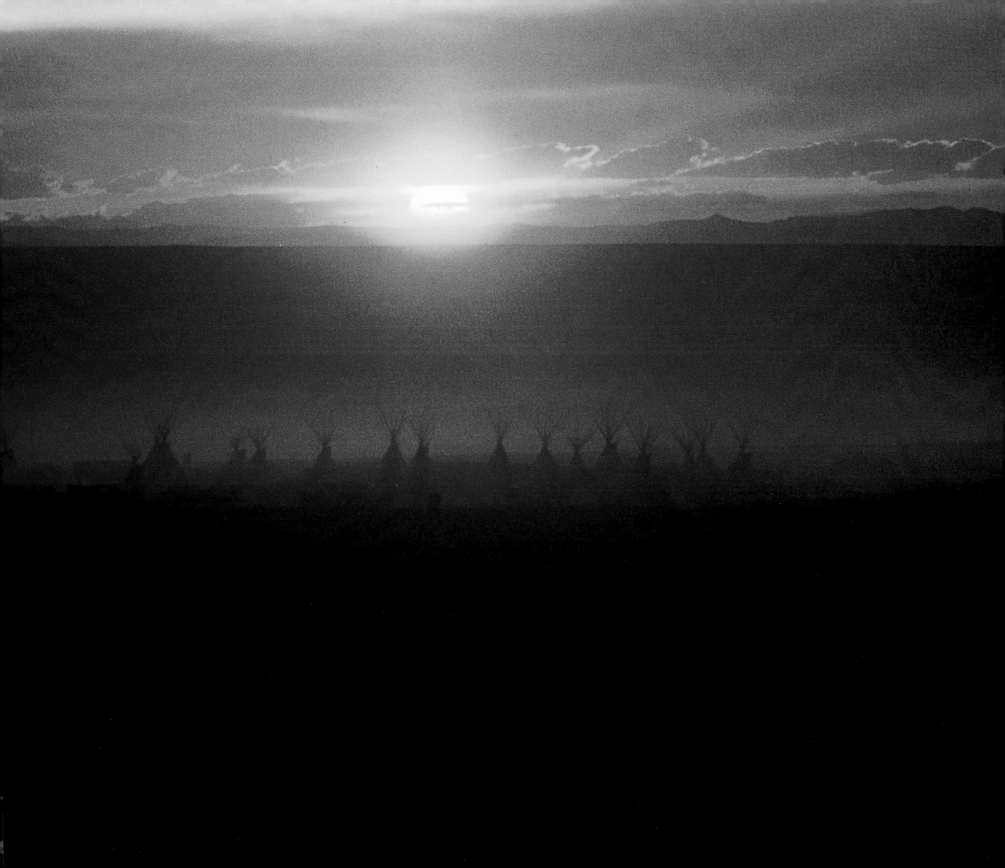

AFTER

BY FAR THE MOST VALUABLE THINGS LEWIS AND Clark brought back were their journals and map. The pressed plants, the exotic furs, the skeletons, the stuffed animals, the Indian vocabularies they had collected were all of the highest degree of interest—but it was the journals and the map that were primary. Clark's map was soon published and widely distributed and used and added to, and it made an invaluable contribution to the beginnings of the American penetration of the West. The journals, alas, were not to be published for a hundred years.

Lewis had promised Jefferson he would do the work necessary to turn the journals into books, and indeed he made a contract with a Philadelphia publisher, arranged for drawings of birds and plants, put out a prospectus, and otherwise did all that was required for publication—except to prepare the manuscript. He developed the writer's block of all time. He never prepared a line for the printer.

Because of his failure to get the journals published, among other causes, Lewis went into a terrible depression. In courting a wife, his advances were rejected. Jefferson appointed him Governor of Upper Louisiana, but he proved utterly unsuited to politics. He lost money in land speculation in Missouri and was later criticized for getting involved in a public-private fur trade enterprise, a conflict of interest with his position as Governor. The federal government questioned his expense accounts and the chits he was signing. On top of all that he had grown addicted to opium and was drinking heavily. His decline eventually ended in suicide on the lonely Natchez Trace, on October 10, 1809. He was 35.

Clark's post-expedition career and personal life were as full of success and fulfillment as those of Lewis were of depression and self-destruction. Clark married his cousin Julia Hancock. They had five children. The firstborn, a boy, was named Meriwether Lewis Clark. After Julia's death Clark married a widow and adopted her three children. He had two sons by his second wife, for a total of ten. He served as superintendent of Indian Affairs for 30 years. In addition, he was Governor of the new Missouri Territory from 1813 to 1821. As superintendent of Indian Affairs, Clark did more to help the Indians than any of his successors. He was fondly known to the Indians who came downriver to call on him as the "Red-Headed Chief." On September 1, 1838, he died after an eight-day illness. He was 69.

As to the others, most of the enlisted men soon passed into obscurity. By and large they are a group of forgotten men about whom little is known. A considerable number became farmers; a few are of special note.

Several played epic roles in the early history of the organized fur trade, including Potts, Wiser, and Collins, but most of all Colter and Drouillard. Colter remained in the wilderness longer than any white man of his time, and perhaps ever: After leaving Wood River in the spring of 1804, he was in the wilderness until May 1810. During that time, he had innumerable experiences and adventures with the Indians. But even Colter grew older; in 1810 he married an Indian woman and settled on a farm near Daniel Boone's in Missouri. He died in 1813. Potts and Drouillard stayed in the fur trade until 1808 and 1810 respectively, when each man was killed by Blackfeet in the Three Forks area.

In 1808, York complained to Clark that he had done everything every other man had done, but he got nothing. How about his freedom as a reward? Clark refused. Much of the evil of slavery is encapsuled in this little story. York had helped pole Clark's keelboat, paddled his canoe, hunted for

his meat, showed that he was prepared to sacrifice his life to save Clark's, crossed the continent and returned with his childhood companion, only to be beaten after being refused his freedom because he was "insolent and sulky." Clark at last did free York and gave him a six-horse team and wagon, which he used for a freighting business between Nashville and Richmond. He died at an unknown date in Tennessee.

Charbonneau, Sacagawea, and Pomp stayed at the Hidatsa village on the Knife River until 1810, when they responded to Clark's long-standing invitation to visit him in St. Louis. Pomp was by then six years old. Sacagawea and Charbonneau stayed through the winter with Clark, but in the spring of 1811 returned to the Knife River, leaving Pomp in St. Louis with Clark as his guardian. Clark put him to school with the Jesuits. The boy already knew Hidatsa, Shoshone, French, and English; the Jesuits taught him Greek and Latin. His mother accompanied his father to Fort Manuel, on the Missouri just below the North-South Dakota boundary, where she gave birth to a daughter, named Lizette. Sacagawea apparently died there in December, 1812, at around age 22. Charbonneau outlived his wife by nearly three decades, living most of the time among the Mandan and Hidatsa, working as an interpreter. In 1839, or thereabouts, at around age 80, he died.

After finishing with the Jesuits, Pomp returned to the Hidatsa village to live. In 1824, at age 20, he met Prince Paul of Wurttemberg, who was making a safari up the Missouri, at the mouth of the Kansas River. Paul invited Pomp to be his guide; it was done. Paul taught him German and the two became friends. With Clark's encouragement, Pomp accepted Paul's invitation to travel in Europe together. In his five years abroad he turned out to be as natural a musician as he was a linguist; he is reported to have played the violin with Beethoven. He picked up Italian. Returning to the United States, he told Clark he had seen it all now, and he was going home to his people. He returned to the Hidatsa. But he was much too footloose to stay in one place long. He became a mountain man, traveling the ranges from New Mexico to Oregon. He served many Army officers and explorers as an interpreter and guide. In 1849 he guided Philip St. George

Cooke and his Mormon Battalion to California, then took up a temporary residence there, where he contracted gold fever. He never shook it. He died of pneumonia in 1866, at age 61, headed toward the goldfields of Montana. He is buried near the town of Danner, Oregon.

After Lewis's death, Clark persuaded Nicholas Biddle of Philadelphia to prepare a volume of narrative from the journals. The book appeared in 1814. It paraphrased the journals, true to the original, retaining some of the delightful phrases, but with the spelling corrected. Biddle left out the scientific material. For the next 90 years, Biddle's edition was the only printed account based on the journals. As a result, Lewis and Clark got no credit for most of their discoveries. Plants, rivers, animals, birds that they had described and named were newly discovered by naturalists and the names that these men gave them were the ones that stuck.

In 1893 the naturalist Elliott Coues published a reprint of the Biddle narrative, with footnotes on many subjects, including material on birds, animals, and plants, and especially geography. In 1904, on the hundredth anniversary of the beginning of the expedition, Reuben Gold Thwaites of the Wisconsin State Historical Society published the complete journals, in eight volumes, including the journals of two of the enlisted men. His editorial work was outstanding. Often reprinted, "Thwaites," as the work is known by Lewis and Clark fans, is an American classic. In 1962, Donald Jackson edited the *Letters of the Lewis and Clark Expedition*. Together with Jackson's notes, it is a work of scholarship almost unequaled anywhere, and certainly never surpassed. In the 1980s, Gary Moulton edited a new edition of the journals, in 11 volumes, for the University of Nebraska Press. He added much new material, and his is the definitive work today.

Biddle, Thwaites, Jackson, and Moulton together make the rock on which all Lewis and Clark scholarship stands. With them as guides, the journals speak to all of us. Those journals drew us onto the Trail in 1976 and continue to do so. They repay repeated study, as each reading opens a new vista. Thus the power of the book to change one's life. The journals are our national epic, and the basis for our continual, in Stephenie's words, "journey into America."

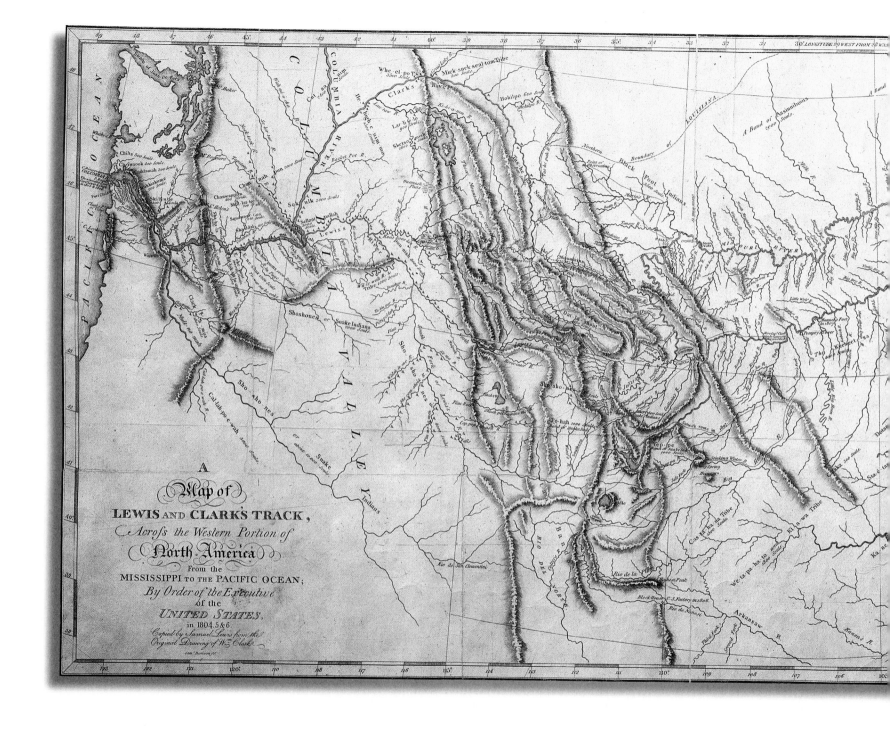

A Map of LEWIS AND CLARK'S TRACK, Across the Western Portion of North America From the MISSISSIPPI TO THE PACIFIC OCEAN; By Order of the Executive of the UNITED STATES, in 1804.5.&6. Copied by Samuel Lewis from the Original Drawing of Wm. Clark.

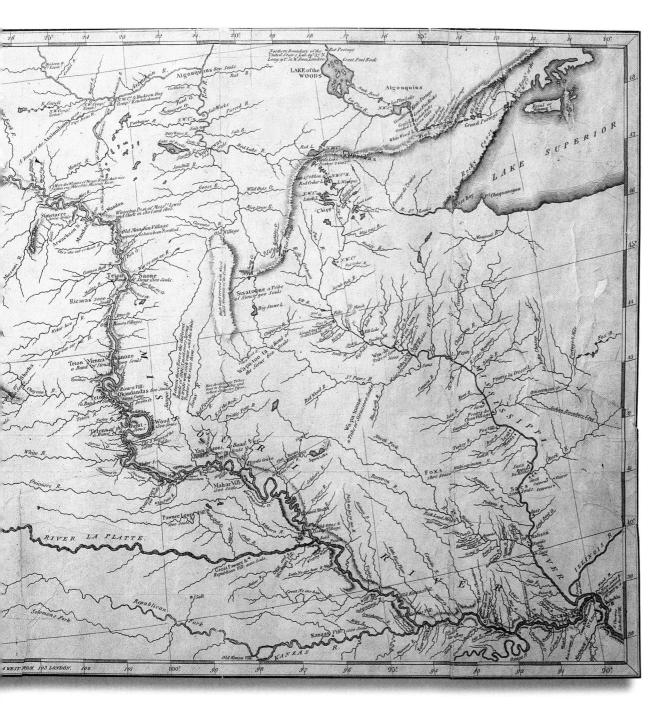

CLARK's historic map of the West, more than four feet wide, both inspired and discouraged dreams of expansion. His record of the forbidding Rocky Mountain barrier dispelled for all time any hope of a Northwest Passage. But his detailed rendering of river systems, broad plains, and other topography depicted a continental swath ripe for settlement. Clark compiled his map during the dreary winter spent at Fort Clatsop, using the compass readings he had diligently taken on every day of the trek west. The amazingly accurate document was described with characteristic understatement in Clark's journal entry for February 14, 1806: "I compleated a *map* of the Countrey through which we have been passing from the Mississippi at the Mouth of the Missouri to this place."

INDEX

Boldface indicates illustrations

A

American Philosophical Society (APS) 28, 37

Antelope **11**, 61, **62**, 68, 81, 98–99, 116, 135, 220

Appaloosas 146, 207–208, 217

Arikara Indians 69–72, 74–75, 227

Arrowsmith, Aaron 29

B

Baker, Gerard 70, 74, 78–79

Barton, Dr. Benjamin Smith 37

Battle-axes 79, **80**

Beacon Rock **194**

Bear grass 81, 180, **211**

Bears, grizzly 21, 63, 70, 99–100, **101**, 106, 108–109, 180, 220

Beaverhead River 114–115, **130–131**, 135, 146

Beaverhead Rock 114, **130**, 131

Beavers 56, 69, 140, 183, 228–229; trapping **228**

Biddle, Nicholas 33, 247

Big Hole N.M., Mont. 216, **232–233**

Big White (Mandan chief) 21, 70, 72, 74, 227, 231

Bighorn sheep 110, **111**, 220

Bison *see* Buffalo

Bitterroot **210**, 211

Bitterroot Range **10**, 115, 135, 141–142, **143**, 145, **150–151**, **154–155**, 156, **158–163**, 164,

166, 204, 206–209, 211–214, **215**

Bitterroot River 141–142, 213, 222, **232–233**

Black Buffalo (Teton Sioux chief) 63–64, 68

Black Cat (Mandan chief) 72, 227

Black Rock (Mandan chief) **73**

Blackfeet Indians 110, 135, 149, 214, 223–226, 242; Piegan chief **225**

Blood Indians: encampment **5**, **244-245**

Boats: bull boats 69, 221, 223; dugout canoes 45, 63–64, 81, 98–99, **100–101**, 108–110, 113, 140, 146, 149, 164, 168–169, 180, **182**, 183, 185, 214, 217, 220–221, 226–227, 229, 237; keelboat 36–37, 40, **41**, 42–43, 45, 63, 69–70, 81, 98, 108–109, 149

Bodmer, Karl: paintings **44**, **218–219**

Boley, John 45

Bozeman Pass 216, 220

Bratton, William 42, 220

Broughton, William 175

Buffalo **4**, 5, 63–64, 69, 77, 98–99, 104, 110, **116–117**, 119, 135, 217–218, **219**, 220–223, 226, 234; hunting 21, 56, **59**, 61, 70, 75, **76–77**, 79, 221, 223–224; rut 218, **219**; skins 221, 223–224, shirt and robes made from **51**, 64, **65, 73**, 74–75, **77**, 81, 98

Burns, Ken 74, 78, 104, 108–109, 145, 168

C

Camas root 145, 164, 209, 216

Cameahwait (Shoshone chief) 21, 134–136, 138, 140, 227

Camp Fortunate 138, 140, 214, 216

Candlefish **148**

Cannon Beach, Oreg. **200–201**

Cascade Range **12–13**, 21, 168–169, 175, 184, **192–193**, 204–205

Catlin, George: paintings **52–53, 59, 66–67, 73**

Cedar 142, 145–146, 172, 208; pine **126–127**

Charbonneau, Jean Baptiste "Pomp" 78, 98, 102–103, 108, 214, 216, 220–221, 227, 237, 247

Charbonneau, Lizette 247

Charbonneau, Toussaint 21, 74–75, 78, 98–99, 139, 216, 220–221, 227, 247

Chinook Indians **174**, 175–176; canoes 169, **182**, 183, 185, 205, 207; *see also* Clatsop

Citadel Rock **120**

Clark, George Rogers 33, 42, 98–99

Clark, William **27**, 32–33, 40, 42, 55, 226; army career 32–33, 46; compasses **38–39;** correspondence with Lewis 37; death 246; hunting shirt **51;** journal entries 10–12, 15, 41, 46, 49–51, 54–64, 67–69, 74–75, 81–86, 93, 108, 114, 133–134, 140–146, 149, 156, 160–164, 167–179, 184–186,

190, 193–194, 197, 200, 214–217, 220–221, 249; mapmaking 55, 81, 106–107, 173, 184, 246, 248–249; marriages 246; medical skills 205, 207, 226–227; rock inscriptions **217**, 220, 237; sketches **41, 100, 111, 171, 174, 179;** slave *see* York; weather diary **181;** Yellowstone River exploration 214, 216–217, 220–221

Clatsop Indians 148, 176, 178–181, 207; canoes **182**, 183, 185; hats 180, **181**, 185

Clearwater River 146, 164, **165**, 205, 207

Coboway (Clatsop chief) 178, 185

Collins, John 46–47, 55–56, 246

Colter, John 21, 42, 45, 63, 205, 217, 227, 246

Columbia River 21, 30–31, 34, 37, 109, 114–115, 148–149, 168, 172, 175, 184, 190, **191**, **195–197**, 222, 229; The Dalles 169, 185, 204–205; Great Falls 146, **171**, 204, 212–213, 223; Kettle Falls **170**; portage 28, 169, 204, 214, 223

Columbia River Gorge **194**

Continental Divide 30, 33, 109, 115, 134–136, 152, 216, 234

Cooke, Philip St. George 247

Corps of Discovery 21, 35, 77, 82, 84, 105, 111, 128, 131, 152, 185, 200; camps 42–43, 45, 50, 56–57, 73–75, 103, 106, 114, 141–142, 162, 171, 179, 207–208, 221, 229, 239; crossing Bitterroots **143**, 152,

ACKNOWLEDGMENTS ~ ADDITIONAL READING ~ CREDITS

ACKNOWLEDGMENTS

In late June 1998, I had the pleasure of making a nine-day journey tracing Lewis and Clark in Montana and Idaho with an extraordinary group of experts. It consisted of Dayton Duncan, Gary Moulton, Ken Karsmizki, and John Logan Allen. We led a special group of Lewis and Clark fans, put together by Dusty Rhodes. It was the best of experiences. It reminded me that what I like most about being a Lewis and Clark fan is the friends you make. I've made them all along the Trail: Cindy Orlando at Fort Clatsop; Barb and Harlan Opdahl from the Lolo Trail; Harry Fritz and Joseph Mussulman of Missoula; Ken and Marie Duncan of the Horse Prairie Ranch near Lemhi Pass; Jane Weber, Dale Gorman, Marty Erickson and Marcia Staigmiller of Great Falls; Bob and Florence Tubbs, and Tim and Doris Crawford of the Gates of the Mountains; Diana and Bill Wellman and Kurt Brekke of the White Tail Ranch near Lincoln; Bob Singer, Larry and Bonnie Cook, Dave Parchen, and Bob Schoonover of Missouri River Outfitters in Fort Benton; Wilbur Werner of Cutbank; David Borlaug at Fort Mandan; Glen Bishop of Saint Charles; Jim Wimmer of Madison, Wisconsin; Ken Burns at various sites along the Trail; Rebecca Wodder of American Rivers; Michelle Bussard of the National Lewis and Clark Bicentennial Council; and so many others, including those named in the introduction and Dayton, John, Gary, Jim, and Ken. They are all scholars who enjoy researching from the saddle of a horse or the seat of a canoe. They know what they are talking about, and are always eager to pass on what they know. In my experience, when Lewis and Clark are the subjects of conversation, there is always something new—a point of view, a piece of information—that is compelling.

So rich is this story and so generous are the people listed above (along with others) in passing along what they know, that as long as I'm alive I'll always be learning something new. This is by way of thanks. STEPHEN AMBROSE

I would like to thank Mimi and Darold Jackson at the Lewis and Clark Center in St. Charles, Missouri; Crosby Brown, of Washington, Missouri; and Victoria and Brad Hamlett, of Sun River, Montana. SAM ABELL

The Book Division wishes to thank the other individuals and organizations mentioned or quoted in this publication for their guidance and help. In addition, we are grateful to the following: Kitty Deernose, Mark Hekert, Cesare Marino, George Stephens, Jim Williams, Macy Yates, and Fort Clatsop National Memorial and Fort Stevens State Park, in Oregon. We are grateful to Martha Christian for her review of the text.

ADDITIONAL READING

The reader may wish to consult the National Geographic Society Index for related articles, and to refer to the following books:

Stephen E. Ambrose, *Undaunted Courage: Meriwether Lewis, Thomas Jefferson, and the Opening of the American West*

Ralph Andrist, and the editors of American Heritage, *To the Pacific with Lewis and Clark*

Robert B. Betts, *In Search of York: The Slave who went to the Pacific with Lewis and Clark*

Bernard De Voto, ed., *The Journals of Lewis and Clark*

Dayton Duncan and Ken Burns, *Lewis and Clark: The Journey of the Corps of Discovery*, a film by Ken Burns (videorecording)

Dayton Duncan, *Lewis and Clark: An Illustrated History*

David Hawke, *Those Tremendous Mountains*

Alvin Josephy, *The Nez Perce Indians and the Opening of the Northwest*

Meriwether Lewis, Nicholas Biddle, ed., *The Expedition of Lewis and Clark.*

Robert J. Moore, *Native Americans: A Portrait*

Gary E. Moulton, ed., *The Journals of the Lewis and Clark Expedition*

Gerald W. Olmsted, *Fielding's Lewis and Clark Trail*

James P. Ronda, *Lewis and Clark Among the Indians*

Gerald S. Snyder and the National Geographic Society, *In the Footsteps of Lewis and Clark*

Charles Coleman Sellers, *Mr. Peale's Museum*

Mark Sufrin, *George Catlin: Painter of the West*

Davis Thomas and Karin Ronnefeldt, eds., *People of the First Man*

Reuben Gold Thwaites, *Original Journals of the Lewis and Clark Expedition 1804-06.*

Olin D. Wheeler, *The Trail of Lewis and Clark 1804-1904.*

CREDITS

Cover, Sam Abell, National Geographic Photographer. 2-15 (all), Sam Abell, National Geographic Photographer. 18 (left), Courtesy Independence National Historical Park; 18 (right), Joslyn Art Museum, Omaha, Nebraska, Gift of the Enron Art Foundation. 19 (left), Courtesy Mrs. Doris S. Clymer and The Clymer Museum of Art; 19 (center, both), Sam Abell, National Geographic Photographer; 19 (right), Curtis's Botanical Magazine, 1863. 27 (both), Courtesy Independence National Historical Park. 29, Map by Aaron Arrowsmith, 1802, photographed by Joseph H. Bailey at Library of Congress, Geography and Map Division. 31, Courtesy Independence National Historical Park. 35, Missouri Historical Society. 38, Missouri Historical Society. 38-39 (both), National Park Service. 39 (left), American Philosophical Society; 39 (right), Smithsonian Institution Photo No. 95-3550. 41, Yale Collection of Western Americana, Beinecke Rare Book and Manuscript Library. 44, Joslyn Art Museum, Omaha, Nebraska, Gift of the Enron Art Foundation. 47, Eric P. Newman, Numismatic Education Society. 51, Peabody Museum, Harvard University, Photo by Hillel Burger. 52-53, National Museum of American Art, Washington, D.C./Art Resource, NY. 59 (up), National Museum of American Art, Washington, D.C./Art Resource, NY; 59 (low left), Reproduced by permission of The Huntington Library, San Marino, California; 59 (low right), American Numismatic Society. 62 (both), Ewell Sale Stewart Library, The Academy of Natural Sciences of Philadelphia. 65, Peabody Museum, Harvard University, Photo by Hillel Burger. 66-67, National Museum of American Art, Washington, D.C./Art Resource, NY. 67, Joslyn Art Museum, Omaha, Nebraska, Gift of the Enron Art Foundation. 71, Courtesy Montana Historical Society, Gift of the Artist, Photo by J. Smart. 73, National Museum of American Art, Washington, D.C./Art Resource, NY. 76-77, National Museum of American Art, Washington, D.C./Art Resource, NY. 77, Karl Bodmer, 1833, Collection of Mr. and Mrs. Paul Mellon. 80 (left), Peabody Museum, Harvard University, Photo by Hillel Burger; 80 (right), American Philosophical Society. 82-95 (all), Sam Abell, National Geographic Photographer. 100, Missouri Historical Society. 100-101, Courtesy Mrs. Doris S. Clymer and The Clymer Museum of Art. 105 (left), Olaf Seltzer, From the Collection of Gilcrease Museum, Tulsa; 105 (right), Missouri Historical Society. 106-107, American Philosophical Society. 107, A.E. Mathews, Courtesy Montana Historical Society. 111 (up), Ewell Sale Stewart Library, The Academy of Natural Sciences of Philadelphia; 111 (low), Missouri Historical Society. 112, A.E. Mathews, Courtesy Montana Historical Society. 116-131 (all), Sam Abell, National Geographic Photographer. 136, Collection of the New-York Historical Society. 136-137, Courtesy Mr. W.T. Richards and The C.M. Russell Museum. 143, Courtesy Mrs. Doris S. Clymer and The Clymer Museum of Art. 147, Courtesy Royal Ontario Museum © ROM. 148 (left), Museum of Comparative Zoology, Harvard University © President and Fellows of Harvard College;

148 (right), American Philosophical Society. 149, Oregon Historical Society. 150-165 (all), Sam Abell, National Geographic Photographer. 170-171, Royal Ontario Museum © ROM. 171, Missouri Historical Society. 173 (both), American Philosophical Society. 174 (left), Missouri Historical Society; 174 (right), Royal Ontario Museum © ROM. 177, Courtesy Mrs. Doris S. Clymer and The Clymer Museum of Art. 180, Missouri Historical Society. 181 (left), Peabody Museum, Harvard University, Photo by Hillel Burger; 181 (right), American Philosophical Society. 182 (up), Royal Ontario Museum© ROM; 182 (low), Missouri Historical Society. 186-201 (all), Sam Abell, National Geographic Photographer. 210 (left), Ewell Sale Stewart Library, The Academy of Natural Sciences of Philadelphia; 210 (right), Curtis's Botanical Magazine, 1863. 211 (all), Ewell Sale Stewart Library, The Academy of Natural Sciences of Philadelphia. 215, National Cowboy Hall of Fame and Western Heritage Center. 218-219, Joslyn Art Museum, Omaha, Nebraska, Gift of the Enron Art Foundation. 220, Florentine Films, Photo by Allen Moore. 225, Joslyn Art Museum, Omaha, Nebraska, Gift of the Enron Art Foundation. 228, The Walters Art Gallery, Baltimore. 230 (left), New York Public Library; 230 (right), Courtesy Winterthur Museum. 232-245 (all), Sam Abell, National Geographic Photographer. 248-249, Photographed by Victor R. Boswell, Jr. at Library of Congress, Geography and Map Division. 256, Sam Abell, National Geographic Photographer

Composition for this book by the National Geographic Society Book Division. Color separations by Quad Graphics, Martinsburg, West Virginia. Printed and bound by R. R. Donnelley & Sons, Willard, Ohio. Dust jacket printed by Miken, Inc. Cheektowaga, New York.

Visit the Society's Web site at www.nationalgeographic.com.

Library of Congress Cataloging-in-Publication Data

Ambrose, Stephen E.
 Lewis & Clark : voyage of discovery / Stephen E. Ambrose ; photographs by Sam Abell.
 p. cm.
 Includes index.
 ISBN 0-7922-7084-3 —ISBN 0-7922-7085-1 (deluxe)
 1. Lewis and Clark Expedition (1804-1806) 2. West (U.S.)--Discovery and exploration. 3. West (U.S.)—Pictorial works. 4. West (U.S.)—Description and travel. 5. Ambrose, Stephen E.-Journeys—West (U.S.) I. Abell, sam. II. Title.
F592.7.A488 1998
917.804'2—dc21 98-20061
 CIP

Lewis and Clark gaze across the Missouri River at Fort Benton, Montana, in "Explorers of the Marias," by artist-historian Bob Scriver.